Screen Savers

Also by John DiLeo

100 Great Film Performances You Should Remember -
But Probably Don't (2002)

And You Thought You Knew Classic Movies:
200 Quizzes for Golden Age Movie Lovers (1999)

Screen Savers

40 Remarkable Movies
Awaiting Rediscovery

John DiLeo

Hansen Publishing Group, LLC
East Brunswick, New Jersey

Trademarks

All terms mentioned in this book that are known to be trademarks or service marks have been appropriately capitalized. The publisher and author cannot attest to the accuracy of this information. Use of a term in this book should not be regarded as affecting the validity of any trademark or service mark.

Warning and Disclaimer

Every effort has been made to make this book as complete and as accurate as possible, but no warranty or fitness is implied. The information provided is on an "as is" basis. The author and the publisher shall have neither liability nor responsibility to any person or entity with respect to any loss or damages arising from the information contained in this book.

All photographs courtesy of Photofest.

Hansen Publishing Group, LLC
302 Ryders Lane
East Brunswick, New Jersey
732-220-1211
www.hansenpublishing.com

For Earl

In memory of Michael Biondi, my Groucho.

Preface

Isn't it great that film fanatics can never run out of movies? Just when you think you've seen them all, some new window opens—an introduction to an offbeat director or an unsung leading lady—and you realize that the well is indeed bottomless. Too many exemplary films have been overshadowed by the screen's dominant classics, those few hundred movies comfortably regarded as the best (and subsequently written about most exhaustively). I am putting the spotlight on 40 outstanding films of the twentieth century that have, to varying degrees, unfairly fallen by the wayside. This isn't a "best" list; it's a collection of vital, significant works that I'm giving a boost. It's time they received their due, or, in some cases, got a shot of renewed recognition. People who might love these films perhaps don't know that they even exist. I haven't included any of the many appropriate titles that appeared in *100 Great Film Performances You Should Remember But Probably Don't*, choosing instead to write only about movies I've never written about before. I've done my best not to reveal the films' endings (except where it's a foregone conclusion), hoping not to deprive you of your own pleasures and discoveries.

Though most of the forty titles are available on DVD, see my "availability guide" at the back of this book for the lowdown on each film's accessibility. I've included VHS status because that cast-aside format is often still attainable in libraries. There would have been no point in limiting my selections only to films on DVD because obtainability changes so quickly. In a book about overlooked films, would it have been fair to punish these films further with exclusion? Just remember that each week sees the release of new DVD titles, and it's only a matter of time before all forty films are a Netflix® envelope away.

Whether they be underseen critics' darlings (*Pretty Poison, Three Kings*), brushed-aside classics (*I Am a Fugitive from a Chain Gang, Seven Brides for Seven Brothers*), undeserved box-office losers (*Portrait*

of Jennie, The Iron Giant), dismissed commercial successes *(Cover Girl, The Big Country)*, never-heralded gems *(The Raid, Bad Company)*, or taken-for-granted treasures *(Isle of the Dead, Pat and Mike)*, the movies in *Screen Savers* deserve a place of honor in our screen heritage.

John DiLeo
New York, N.Y.

Acknowledgments

My thanks to Jim Azzara, Amy Ferris, Diana Finch, Richard Parks, and the gang at 7th Street Coffee in Milford, PA.

There can't be anything but continual thanks to John and Vera, my parents, Tony Razzano, my pal, and Earl McCarroll, my partner of 25 years.

Finally, I wish to thank my publisher, Jon Hansen, for being the right guy at the right time.

TABLE OF CONTENTS

Screen Savers

I. Musicals Written Directly for the Screen

There have been marvelous movie musicals adapted from Broadway hits—including *The Gay Divorcee* (1934), *The Pajama Game* (1957), *Cabaret* (1972), and *Chicago* (2002)—and there have been classic film musicals with original screenplays tailored to match scores comprised of great old tunes by esteemed songwriters—notably, *An American in Paris* (1951), *Singin' in the Rain* (1952), *The Band Wagon* (1953), and *Funny Face* (1957). However, this chapter pays tribute to musicals created for the screen from scratch. Even if based on plays or stories, they were brand-new as musicals. Inspired collaborators fashioned them with never-before-heard scores and a completely cinematic approach to song and dance, achieving a blissful fusion of the aural and the visual. Though it pains me not to have a Fred Astaire offering, the following casts are nonetheless knockouts. Cue the orchestra...

Love Me Tonight (1932)
Hollywood's First Musical Masterwork

C an anyone doubt that *Love Me Tonight* is the screen's first great musical? The landmark films that preceded it, including the Oscar-winning backstage musical *The Broadway Melody* (1929), which was the first all talking-singing-dancing triple threat, and Ernst Lubitsch's Ruritanian romance *The Love Parade* (1929), now look like relics; their onetime freshness can only be taken on faith. Though incalculably important to the genre's growth, and technologically state-of-the-art, they (and all other 1929-32 movie musicals) can only be recommended to those with forgiving natures toward the static, antiquated aspects of early musicals. *Love Me Tonight,* though indisputably silly, has much more going for it: it is a film whose innovations *still* look innovative. Though it stars Maurice Chevalier and Jeanette MacDonald (the genre's reigning king and queen) and boasts an original score by Broadway's Rodgers and Hart, its chief asset is the ceaselessly inventive direction of Rouben Mamoulian, one of Hollywood's rising talents during the shaky transition to sound. In his first two films, the burlesque drama *Applause* (1929) and the gangster picture *City Streets* (1931), Mamoulian proved to be one of the first directors to treat the addition of sound as a creative, stylistic component of moviemaking, rather than a necessary evil. This made him a natural for musicals.

The visually splendiferous, triumphantly frivolous *Love Me Tonight* made it clear to anyone interested that the movie musical was a force to be reckoned with, yet it did not spring from a vacuum. It resembles the Lubitsch musicals that came before it, sharing their high-born romances and risqué European sophistication, not to mention Chevalier and MacDonald, whose best work thus far had been under Lubitsch's guidance. This was their third film together, following two for Lubitsch, *The Love Parade* and the trifling *One Hour with You* (1932). And each had a Lubitsch vehicle of their own, MacDonald in *Monte Carlo* (1930) and Chevalier in *The Smiling Lieutenant* (1931). This series of naughty

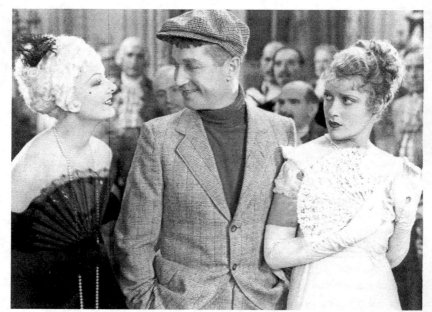

LOVE ME TONIGHT. Myrna Loy, Maurice Chevalier, and Jeanette MacDonald at the costume ball.

films, all made for Paramount, were the genre's highest praised to date, with all except *Monte Carlo* nominated for Best Picture Oscars. There are intermittent pleasures remaining in each of them, yet all seem somewhat rickety today (and lack top-notch scores). *Love Me Tonight,* ignored at Oscar time, combines a sweeping yearning for fairy-tale romance with the winking wit of its tongue-in-cheek sensibility. You cannot laugh *at* a movie so ready to smile at itself, and it is too lighthearted to be impressed by its inestimable worth. Only its penchant for rhymed dialogue has a whiff of staleness. And in casting Chevalier and MacDonald as characters named Maurice and Jeanette, the script announces that it is uninterested in having audiences *lose themselves* in the plot.

Maurice, a Parisian tailor, pursues the Vicomte Gilbert de Vareze (Charlie Ruggles) to his family chateau, seeking payment for Gilbert's extensive new wardrobe. Spendthrift Gilbert avoids confrontation with his purse-holding uncle, the crotchety Duke d'Artelines (C. Aubrey Smith), by introducing Maurice as a baron, and the family embraces him immediately. Maurice reluctantly goes along with the ruse, heartened by the fact that the lovely woman he encountered (and flirted with) on his journey turns out to be Princess Jeanette, the Duke's standoffish

niece. The two eventually fall in love, but all hell breaks loose when it is revealed that Maurice is a mere tailor.

Love Me Tonight has no production numbers and no real dancing. Yet when you see it, you may come away thinking it does because several of its major sequences have the scope, ambition, and rousing charge of "big" numbers. The film opens with Paris waking up and never has this kind of symphony-of-a-city thing been more beautiful or stirring. After establishing shots of Paris, featuring a haze-shrouded Eiffel Tower standing tall over chimneyed rooftops and a lone cyclist whizzing by Notre Dame, the transition to Paramount's back-lot Paris is seamless. The excitement builds not only from the constant addition of people as the city begins its workday, but by the escalation of sounds—a pickax, a sweeping broom, horns, etc.—which serves as a percussive accompaniment to the visuals. Mamoulian is renowned for his aural ingenuity, and it is heart-racing to see and hear one block come to life before our eyes and ears. As the people and sounds increase, the scene has the palpitating drive of a full-scale opening number, which, of course, it is, even without song and dance. Crisply edited, it furnishes an exquisite sense of place. Rarely has a movie begun better.

It is clear what a big star Chevalier was in 1932 by the kind of entrance Mamoulian gives him. The camera enters an open window and observes a full-length wall drawing of a forward-strutting male, topped by a real straw hat (presumably hanging by a nail). Chevalier's body language and headgear were *that* identifiable. The camera then swoops right to catch a head squirming its way into a turtleneck, and out pops our star! As he finishes dressing and preening, Chevalier sings "The Song of Paree," an upbeat ditty about his noisy hometown. His grand gestures and stylized grace bring panache to the tune, vitalizing the simple setting. After rakishly tilting his cap, he makes his way to the street and engages his neighbors in a series of rhymed interactions, segueing from his private song to a public one ("How Are You?"). These two brief musical moments constitute one harmonious character-defining number, effectively setting up the tailor and his world, and carrying him smoothly from his dwelling to his shop. (When a musical is this "right," it is easy to overlook the skill involved.) Though Chevalier's enthusiastic growl can be charming, his French accent is not exactly a friend to Lorenz Hart's lyrics. This may be the moment to say that many people will wince at the notion of seeking out a movie starring the excessively ooh-la-la Chevalier. He can be off-putting when he overworks his Gallic charms,

but he is undeniably unique, and I'm won over by his suave razzle-dazzle, bohemian sex appeal, and ferocious showmanship.

Love Me Tonight is the film that introduced "Isn't it Romantic?" It arises in response to a satisfied customer of Maurice's. Chevalier sings the introduction, which is all about tailoring (and I assume never sung by anyone again). He sits atop his desk and begins the melody, assisted by a chorus: his three reflections in the mirrored panels beside him. At one point, the camera gives each of the mirror images a solo moment before returning to the man himself. But the transporting use of the mirrors is just the beginning of the grandest set piece in the film. The catchy tune is passed casually from person to person, from the customer to a taxi driver to his fare (a composer) to a trainload of soldiers to gyp-sies, until finally arriving at the princess's balcony. The lyrics change to suit the song's temporary owners. All this provides some deliriously nutty moments, especially the transition between the marching-soldier chorus to the violin-led rendition by campfire gypsies. But within the high-spirited lunacy is an imaginative bit of musical storytelling: the lovers have been joined, even fated, through this song, though they have not yet met. When an opulently gowned MacDonald launches into her legit version of the song (up to now it has been comic), it resonates, at last, as the sublime ballad it is. But, in a telling example of the film's impishness, this "serious" scene comes to a comic end with the thud of a ladder slamming into the balcony, belonging to the Count de Savignac (Charles Butterworth), an ineffectual suitor with a rose in his teeth.

MacDonald is another old-time star that gives many people pause nowadays. Whether staunchly singing "San Francisco" or "Indian Love Call," the two songs most associated with her, MacDonald is often remembered as a clueless, humorless actress and a less than first-rate soprano. In this film, MacDonald is not as self-assured a performer as Chevalier. She sometimes suggests someone obediently executing whatever her director asks of her, whether or not she really understands what it is she is doing. She acquits herself ably, but she is not exactly overflowing with spontaneity. By the time of *The Merry Widow* (1934), another Lubitsch affair, and her fourth and final film with Chevalier, she was far more accomplished and confident. She was at her absolute best—funny and vibrant—in *Naughty Marietta* (1935), the first and best of her eight teamings with Nelson Eddy. In *Love Me Tonight,* and throughout the early 1930s, MacDonald could be playfully suggestive (before the Production Code purified her and all the other lusty ladies of

the screen). The film makes much of the contrast between this beauty's shapeliness and her unnatural, nun-like existence. Her persistent fainting spells are the result of her pent-up sexual urges. MacDonald is often scantily clad, and the film is not above leering, as when her doctor tells her, "You're not wasted away, you're just wasted." Her evolution from prim, snippy princess to available sex kitten has surprising smolder. (MacDonald never behaved this way with Eddy.)

Love Me Tonight is a film so rich in melody that a soon-to-be standard like "Lover," introduced by MacDonald as she rides alone on a horse-drawn carriage through sunny woods, is practically a throwaway. A vision in white, MacDonald sings quite liltingly of amatory dreams. But, again, the movie cuts through any potential loftiness: her longings are jerked back to reality by Hart rhymes that not only complete her thoughts but also serve as firm directives to her horse: "woe" is uttered as "whoa!" and "hay" comes out as "hey!" Things cannot get too gooey this way, yet, if anything, the cleverness makes the scene's ravishing simplicity even more entrancing. She then meets Maurice—his car has broken down and she has fallen out of her carriage. (Has her song conjured him?) He flirts; she resists. He breaks into "Mimi," the film's severest test for those with a low Chevalier threshold (mostly because the camera closes in on his impassioned mugging), though his pleasantly deranged abandon is exactly what is required.

Once Maurice has been welcomed into the chateau, there is an enjoyable ensemble number that is actually solo bits edited together to create a feeling of communal spirit. This reprise of "Mimi" begins with the aged Duke waking up and laughing, then jauntily (and uncharacteristically) singing the tune he obviously heard from Maurice. From here it is off to Gilbert, who is shaving as he amuses himself with "Mimi," then to Jeanette's three maiden aunts, who sing it merrily while having their tea, and finally to the silly Count's deadpan version as he exercises. It is interesting that there is no night-before scene—Maurice has barely been seen in their company—but this reprise makes it neatly clear what a festive time it was (and how well-liked Maurice has become). Not only is this economical storytelling, but it also defines these characters further. Later, just after Maurice's true identity is exposed, other isolated moments are assembled into a medley of varying points of view. "The Son of a Gun Is Nothing But a Tailor," a wordy up-tempo tune, begins with the Duke's outraged rendition, but, unexpectedly, the song is primarily delivered by the appalled servants—the majordomo, a valet, a maid, the chef, and the

laundress—from their individual work stations. Like the "Mimi" reprise, this number astutely offers multiple perspectives on a single event.

Not all of the movie's wonders are music-related. There's an elaborate stag hunt, in which Maurice is given a dangerous horse, "Solitude," to ride. (The same joke was used twenty-six years later when Auntie Mame was placed on the similarly wild and ironically named "Meditation.") For the hunt, Mamoulian uses both speeded-up film and heavenly slow motion, and he even creates whimsical counterpoint between the light prancing of the stag and the maniacal pursuit by the dogs. Another non-musical standout is Chevalier's arrival at the cavernous chateau, without a soul in sight. After entering through the massive doors, beneath the foyer's colossal chandelier, the straw-hatted figure tiptoes around in search of signs of life, moving from room to room, across the black-and-white chessboard floor, jogging up staircase after staircase at increasing speed. This is a delightfully dizzy tour of some amazingly lavish art direction.

Chevalier's best moment—a career highlight—comes at the extravagant costume ball. He arrives in his street clothes (featuring turtleneck and cap), and it is assumed to be a costume, one that enchants the hoity-toity crowd. He explains the costume's "character" in "Poor Apache," the only time anyone in the movie formally performs. Chevalier assumes a tough stance and looks down into the camera, looming above it. As he sings, the camera pulls back, and Chevalier's enormous shadow is emblazoned upon the back wall. It is visually breathtaking. His physicality is so distinctive that you need only look at the shadow to know exactly who it is. The duplication of the star (two of him here; four in "Isn't It Romantic?") multiplies the pleasure, as you can more easily marvel at his posturing swagger and angular dexterity. The song's dirge-like strains and Chevalier's pose of brutality are satiric components of this fun-poking number. Rodgers' melody is actually rather lovely, and Hart has characteristic fun with the words—speaking of his lady's derriere, Chevalier sings, "The spot that no one dares touch, the spot that only chairs touch." It is a full-blown music-hall turn—a singular entertainer doing his thing—and if you do not like Chevalier here, you never will.

The love story takes center stage when, during the ball, the stars finally land in each other's arms on a garden bench. Chevalier is rather touching once Maurice wins the princess' love but is still carrying the burden of his concealed identity. When he is not trying hard, Chevalier can be a tender presence, and he infuses the love scene with intimate feeling. He asks her to "love me tonight," which is a song cue if I've ever

heard one, but we don't get a traditional love duet. The scene shifts to a moonlit sky. The camera enters the open window of Maurice's bedroom, zeroing in on his sleeping face against its pillow. He *dreams* Jeanette singing the title tune, yet all that's visible is his sleeping face. (Who but Mamoulian would have the guts to shoot it this way?) Maurice joins in, making it a duet, and the screen splits diagonally, with the lovers now seemingly sleeping together, sharing the same musical dream. This is so much more memorable and interesting than having them sing on the bench as we might have expected. Mamoulian is breaking conventions that were still relatively brand-new to the screen.

A luscious sideline to all this is Myrna Loy (just two years away from stardom in *The Thin Man*) as Countess Valentine, another of the Duke's nieces but the opposite of Jeanette. Valentine is man-hungry in a one-track-mind kind of way, and Loy gets to deliver many of the movie's best lines as she slinks around in sumptuous gowns hoping for some action. Her requisite light touch makes the most of her role's racy mischief. And when she shows up at the ball in a black, strapless gown and powdered wig, she even outshines MacDonald. When the film was being readied for re-release in 1949, the then-mighty Production Code Administration insisted on deleting Loy's verse in the "Mimi" reprise because of the actress' transparent negligee and, so, in what can only be described as a criminal act, *they destroyed the footage.* Loy is delicious, but then the entire supporting cast is a joy: C. Aubrey Smith, Charles Butterworth, and the great Charlie Ruggles, each of whom has superlative material with which to work. The screenplay, based on a play by Leopold Marchand and Paul Armont, and written by Samuel Hoffenstein, Waldemar Young, and George Marion, Jr., incorporates operetta-like whimsy, screwball energy, and pre-Code sexual innuendo, which makes for a very funny mix.

Love Me Tonight was photographed quite magnificently by Victor Milner. The film is a non-stop visual intoxicant. As for its soundtrack, the wondrous score by Richard Rodgers and Lorenz Hart is definitely the best they ever wrote for the movies, one that is perfectly wedded to the cultivated giddiness of the story and its characters. Their *Hallelujah, I'm a Bum* (1933), a vehicle for Al Jolson, has its moments (and one great song, "You Are Too Beautiful"), but it is a true oddity. (Rodgers must have been impressed with Mamoulian's work on *Love Me Tonight* because the director later helmed the original Broadway productions of *Oklahoma!* and *Carousel*.)

The picture is carried by Mamoulian's zest for the possibilities of the medium. He had great ideas in abundance, and the film craft to get those imaginings onto the screen. The cumulative power of this picture comes from the fact that Mamoulian finds ways to make just about every scene something more than expected, something truly special. I would also like to mention the kooky scenes in which the three maiden aunts evoke the *Macbeth* witches, sitting before a smoking chalice of herbed brew in hopes of affecting Jeanette's future, and also the deliberately fake, and utterly magical, miniature exteriors of the chateau, which heighten the doll-house feeling of this toy world. Finally, there's an exuberant moment when the footmen spread in all directions across the chessboard floor after learning that Maurice is only a tailor, creating, in their strides, a mobile mosaic.

Mamoulian followed *Love Me Tonight* with, among others, *Queen Christina* (1933), in which he staged Garbo's daring, enigmatic final close-up, and *Becky Sharp*, the first three-strip Technicolor feature. He swung from genre to genre (*Dr. Jekyll and Mr. Hyde* [1932], *Golden Boy* [1939], *The Mark of Zorro* [1940]), and made two near-forgotten '30s musicals, *The Gay Desperado* (1936) and *High, Wide and Handsome* (1937). His final two films were musicals, both disappointments. *Summer Holiday* (1948), designed to be another *Meet Me in St. Louis*, was a failed adaptation of *Ah, Wilderness!* It is one of those legendary flops that people are always trying to make a case for as a neglected masterwork. (It plays like scenes from an unfinished film, one waiting to be edited into *something*.) His *Silk Stockings* (1957) is not much better; it is bereft of any visual spark or even much enthusiasm. (Only Cyd Charisse's mesmerizing whirl to the title melody catches fire.) The heights of *Love Me Tonight* were not to be repeated.

Love Me Tonight was no box-office smash when it came out (and it has never been as well known as it should be). By the time of its release, the nascent genre's popularity was all but burned out, suffering from overexposure by studios who churned out too many shoddy pictures, glutting the audience's appetite. But the genre was soon resuscitated by the Busby Berkeley extravaganzas at Warners and the Astaire-Rogers dance musicals at RKO. The groundbreaking *Love Me Tonight* burned brightly before moviegoers even knew who Fred Astaire was (if you can imagine that there was such a time), and its place in movie-musical history is every bit as substantial as that of, say, *Top Hat* (1935).

Cover Girl (1944)
Gene Kelly, Rita Hayworth
and the New Breed of Musical

The movie musical, though commercially still in the chips, had started to look pretty ragged by the early to mid-forties. That the 1930s were at last over, and that something new in musicals was needed to recharge the genre, was reflected in the kind of house cleaning that went on at the studios at this time: MGM's Jeanette MacDonald and Nelson Eddy seemed passé after Pearl Harbor and made their last co-starring songfest, *I Married an Angel,* in 1942; Eleanor Powell hung up her tired, MGM-sponsored taps in 1943; *Girl Crazy* (1943) was the last of MGM's Mickey-Judy put-on-a-show romps; MGM's *Broadway Melody* series died with *Broadway Rhythm* (1944); Universal's teen soprano Deanna Durbin grew up and tried the glamour route, and it wasn't pretty; Dick Powell ended more than a decade in the genre with MGM's lackluster *Meet the People* (1944), then headed for film noir; and Fox's Alice Faye would retire from musicals before the war's end. Was anybody left? Betty Grable was now the reigning box-office darling via a series of interchangeable Fox musicals set in festive locales and periods that looked suspiciously alike. Fred Astaire was still dancing, but his 1943 RKO vehicle, *The Sky's the Limit,* with the limited Joan Leslie as his partner, plays like a bargain-basement version of the films he made with Ginger Rogers. (Astaire would have to wait until 1948's *Easter Parade,* the film that brought him out of retirement, to inaugurate the second great phase of his movie career.) As for Rogers, she rarely deigned to appear in musicals after her 1940 Best Actress Oscar *(Kitty Foyle)* made her "legit." Bing Crosby continued to croon a tune, but his studio, Paramount, never concerned itself with devising top-notch musicals for him, even after his Oscar win for *Going My Way* (1944), a comedy-drama with songs but not a musical. *Holiday Inn* (1942) teamed Astaire and Crosby, and while it had its classic moments (Astaire's phenomenal firecracker dance and Crosby's introduction of "White Christmas"), it was hardly first-rate. The most beloved and

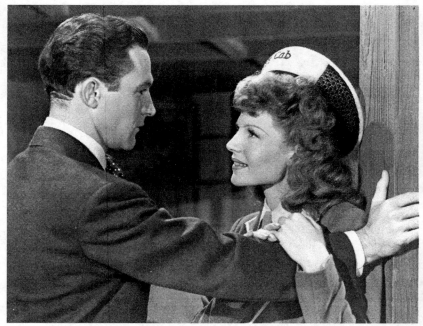

COVER GIRL. Backstage romance for Gene Kelly and Rita Hayworth.

admired of early '40s musicals was undoubtedly *Yankee Doodle Dandy* (1942), a slickly engineered bit of nostalgia and flag-waving from Warner Brothers, anchored by the astounding magnetism of James Cagney. But Cagney and his director, Michael Curtiz, were only occasional visitors to the genre, and *Yankee Doodle,* for all its success, did not have much impact on the future of movie musicals.

It was also in 1942 that Broadway song-and-dance man Gene Kelly made his screen debut opposite Judy Garland in MGM's *For Me and My Gal,* which shared *Yankee Doodle*'s black-and-white nostalgia for the previous war's era (plus another trunkful of oldies with which audiences could sing along). It is not a good movie, but it was a huge hit, establishing Garland as an adult star and setting up Kelly as a threat to Astaire. MGM didn't seize the moment, dumping Kelly into a supporting role in the inane *DuBarry Was a Lady* and a starring role in the lumpy *Thousands Cheer,* plus a few low-budget war dramas. While Kelly was trying to find his way at Metro, the studio machinery at Columbia was putting all its weight behind a dancing beauty named Rita Hayworth. She had become a star in 1941 on loan to Warners for *The Strawberry Blonde* and to Fox for *Blood and Sand,* then back home

to Columbia for *You'll Never Get Rich* opposite Astaire. In 1942, she starred in Fox's *My Gal Sal,* a Technicolor period musical in the Betty Grable mold, and was then reteamed with Astaire for *You Were Never Lovelier,* a pleasing, modest musical with divine Jerome Kern-Johnny Mercer tunes. As with Kelly, it was time for Hayworth to get a vehicle that maximized her potential and raised her position to the superstar level. It came for Kelly and Hayworth in the same package: Columbia's *Cover Girl* (Kelly was borrowed from MGM). With this picture, the forties musical seemed to have found a forward-looking identity. In its freshness, *Cover Girl* also sowed the seeds for the sublime exuberance of the genre's best works of the 1950s.

It is not a great musical, sometimes it's not even a good one, but when it works, and it works often, it has a kind of dream-factory vitality that can still get hearts racing. Its impact would be felt throughout Kelly's career, and it is easy to spot its influence on specific works of his. It must be said that much about *Cover Girl* is conventional, even for 1944: the turn-of-the-century flashbacks, the backstage showbiz tribulations (even "Pop" at the stage door), the love-conquers-all notions. Yet, it is what's new about it that dominates: Kelly's virile dancing; Hayworth's emergence as a screen goddess; a terrific Jerome Kern-Ira Gershwin score; the stylized use of color; and the razzle-dazzle camerawork and editing.

Rusty Parker (Hayworth), a beautiful redheaded dancer with ambition, is a chorine at a lowbrow Brooklyn nightclub run by Danny McGuire (Kelly), a war veteran returned home after being wounded in Libya. (This able-bodied young man's appearance on the home front had to be explained to 1944 America.) Danny also performs in the club's revue (his wounds have obviously healed beautifully), and he and Rusty happen to be in love. Their situation is upset when Vanity magazine chooses Rusty to be their "Golden Wedding Girl." She becomes a celebrity, even lures the elite to Brooklyn (!) to see her dance, and is soon being wooed professionally (and personally) by Broadway producer Noel Wheaton (Lee Bowman). Will Danny fight to keep Rusty, or will he refuse to stand in the way of her glittering future? Rusty is torn between Danny and everything she has dreamed of attaining. (I told you that in terms of plot it was no groundbreaker.)

Refreshingly, the movie does not turn into one of those career-or-marriage struggles so prevalent in forties films. Rusty will have to choose between two men, represented by two New York boroughs, but there is never any discussion about her not performing. The movie has not

worked so hard to put her over as a dancing goddess only to make her a housewife at the end. It is worth noting that *Cover Girl*'s screenplay was written by a woman, Virginia Van Upp. However, there is still plenty of old-style Hollywood moralizing: it is better to do things the hard way than to grab the easy, quick ride to fame; money and luxuries will not make you happy (and may even make you *un*happy); and, my favorite, that Manhattan represents the sins of material excess whereas Brooklyn represents the values of decent, hardworking people. To be fair, the Manhattan and Brooklyn portrayed here are fantasy places— states of mind—from which Rusty must choose. She has to figure out what she wants, what she is willing to do to get it, and if the dues-paying way is really the better course. This is compounded when her success surpasses her dreams. Even if the ending is a foregone conclusion, these are still interesting questions for a 1944 female screen character, especially one in a musical.

Even though *Cover Girl* is set in wartime and makes frequent references to the conflict, it is utter escapism, one of the more effective reality-distracters of the period. It opens with "The Show Must Go On," performed at the club by a troupe of flimsily clad chorus girls. The number affords us the pleasure of discovering Hayworth in the ensemble, the way a talent scout might. (She certainly stands out, even alongside seven other beauties.) It is essentially a striptease yet it would not be nice, in this movie's fairyland world, to suggest that burlesque exists. Along the same lines, we are told (and therefore must accept) that Danny's club is a dive, a place for dead-end careers, even though what we see is clean, bright, and upbeat.

The first showstopper is "Make Way for Tomorrow" (with lyrics by E. Y. Harburg), begun by Kelly, Hayworth, and Phil Silvers (as their sidekick and the club's comic) late at night at a Brooklyn oyster bar, site of their weekly pearl-hunting ritual. In a spontaneous outburst of song and dance, they express their undying belief in their showbiz destinies. The eatery is quickly too small to contain them, so they explode onto the streets of the waterfront, making use of whatever props they find (such as boat paddles and garbage-can lids), and making contact with passersby (a smooching couple, a milkman, a drunk, and, of course, a cop). Mixing tap with other synchronized movement, the trio's pure pleasure creates an infectiously giddy ride, assisted by a finger-snapping up-tempo song. Kelly and his assistant, Stanley Donen (also on loan from MGM), obviously remembered this number when constructing

Singin' in the Rain's "Good Morning," another opportunity for two men and a woman to unleash their positive energy. Kelly's classic *Rain* solo was also influenced by "Make Way for Tomorrow" in the way he reacts to a nighttime street and those he encounters (including a cop) on it. Even garbage-can lids would be back when Kelly danced with Dan Dailey and Michael Kidd in *It's Always Fair Weather* (1955), the final Kelly-Donen musical.

After Rusty becomes a media sensation (but before Broadway beckons), she and Danny put a snazzy new number into the club's revue. "Put Me to the Test" is the first sexy duet of Kelly's career, and Hayworth's too. (I love her numbers with Astaire in *You Were Never Lovelier,* but their dynamic does not have the amatory friskiness she shared with Kelly.) It is set in a dress shop, with Kelly as an employee (with a feather duster) and Hayworth one of the store's six models. He sings the lyric to each model as she teasingly dances by him, finally settling for a dance with a mannequin. When Kelly isn't looking, Hayworth assumes the mannequin's place, surprises him, and thus begins their coupling. (You know they are fated to dance together because she is the only one of the models whose costume matches his green and yellow outfit.) Without the shenanigans of "Make Way for Tomorrow" (and without Phil Silvers), their dancing here, mixing tap and ballroom, has a sensual abandon. As they jump, glide, and embrace, the number is a celebration of their freedom, their beauty, their possibilities. It is unlike the Fred and Ginger dances; libido is explicit rather than subtextual. "Put Me to the Test" is more akin to the numbers that Kelly, and even Astaire, would do with Cyd Charisse and Vera-Ellen in upcoming musicals. *Cover Girl* does have one sequence that is more in the classic spirit of Fred and Ginger, set to the gorgeous ballad "Long Ago and Far Away." After-hours at the club, Hayworth, wearing an off-the-shoulder pale-blue gown with three rows of ruffles on its skirt, sings (dubbed by Martha Mears) to Kelly, in the film's most awkward burst-into-song transition. The brief, lilting dance that results is lushly romantic, more as a worship service for Hayworth's beauty than as memorable choreography, but the song is so good that it hardly matters what they do.

Cover Girl is probably best remembered as the film that contains Kelly's first real innovation as a movie-musical artist. With Stanley Donen, he devised the "Alter Ego" dance, a rather sophisticated nervous breakdown. Alone on a late-night street, Danny is torn between giving up on Rusty or fighting for her. A second Danny, transparent

as a ghost, appears to him in a store window and speaks to him. The alter ego thinks Danny should let Rusty go, but Danny can't accept that. Dressed identically (in a plain suit and a bow tie), they dance their power struggle, with the alter ego trying to manipulate and control Danny, who is sometimes weak and malleable, sometimes combative. That's the psychological drama being waged, the fight within Danny himself. Kelly's intensity and the darkness of the concept make for a thrilling sequence, marked by the double-exposure wizardry that made it possible for him to partner himself, plus the soaring athletic movement devised to express internal strife. It is Kelly's finest, most alive moment in the movie. For much of the rest of the picture, there is a monochrome quality in his acting. Danny's in a lousy mood for most of the story, but in the "Alter Ego" dance Kelly gives that sullenness a release, a choreographed probe inside a not-often-happy guy. It is the downer version of his "Singin' in the Rain" street romp. With the "Alter Ego" dance behind him, Kelly returned to MGM ready for more challenges.

After Rusty is selected to be on the cover, she is sent to hair and makeup by John Coudair (Otto Kruger), the publisher, with the words, "Climb aboard my magic carpet…" And he's not kidding. Why, you may be asking, would Rita Hayworth need a makeover? Well, to be on the cover of Vanity, apparently, even the drop-dead gorgeous can use a boost. This wordless sequence begins with Rusty in the makeup chair (being cold-creamed, lip-glossed, and powdered) and finishes with the completed magazine cover. It is a ninety-second montage, a kaleidoscopic rush of color. It's not a musical number, but it surely feels like one because the soundtrack's use of the title tune's melody further enlivens the flow of images. The sheer excess (the MTV-style editing, the colored gels passing through the frame, the lights and camera swooping in on her, all the hustle and bustle of a phalanx of beauty technicians) delivers a very pleasurable sensory overload. (The first time I saw *Cover Girl* was on television in the 1970s in *black and white,* the reverse torture of watching, say, *Casablanca* colorized.) Late one night, Noel shows Rusty his darkened Broadway stage—hers if she will just say the word. In a gray strapless gown trimmed in gray fur, and with an endless gray wrap *also* trimmed in gray fur, she starts to dance after Noel turns on some lights (which conveniently put a swath of red on the back wall). Hayworth twirls and twirls, holding the diaphanous layers of her gown, looking like a Hollywood Isadora spinning in rapture.

Now if Columbia still hasn't convinced you that their Rita is a goddess—and if this film had one purpose it has to have been the mortal Rita's rise to the status of immortal—there's the title number, Rusty's Broadway debut, in which she is the centerpiece of Noel's extravagant revue. After the Ziegfeld Follies-like parade of cover girls as a prelude, there she is. Taking the goddess notion literally, she is perched high atop an enormous set, just beneath clouds, wrapped in a gold-spangled robe that she soon removes, revealing a strapless gold lamé gown. Descending to earth down the snaking path of a sky-blue slope (the sky appears to have become solid so she can make the journey), her graceful arms awaken to life as she nears the surface. She quickens the pace, holding her skirt so she can run, and arrives as the music crescendos and chorus boys in pale-blue suits meet her as they burst into the lyrics of "Cover Girl." Armed with cameras, they are there to dance with her, carry her, essentially adore her. Against the blues of the set and the boys, the number is lighted by the gold of Hayworth's dress, the auburn of her hair, and the warmth of her flesh. This is a good time to say something about Hayworth's luxuriously unwieldy mane of hair. Alive and aflame, it was substantial enough to enhance her dancing and become an additional choreographic element of her numbers. When she turns, her hair flips a beat later, a staccato accent to her bodily movement, as important to the total effect as tap sounds and orchestral flourishes. It is most satisfying to watch her hair keep up with her feet. Did any other dancer find so much expressiveness in a hairdo? After swirling around the stage with her boys, our goddess must make her ascent back to heaven. As confetti falls, the boys follow part of the way, then stop because she must make the climb alone. The number is beyond taste, but with its surging melody, accelerating rhythm, color contrasts, fluid film technique, nutty idea, and stunning central creature, it is strangely beautiful and every bit as transporting today as it was then. It has a Busby Berkeley kind of outrageousness, yet it is fairly simple: she comes down, has some fun, then returns.

Cover Girl also has a parallel plot, involving John Coudair who, it turns out, picks Rusty as his cover girl because of her exact resemblance to her grandmother, stage star Maribelle Hicks (also played by Hayworth). John had loved Maribelle, but she chose to marry a poor piano player, her very own "Danny," leaving wealthy John brokenhearted. There are flashback scenes of the young John (Jess Barker) with Maribelle, and we see two numbers from her music-hall shows. So,

history has repeated itself and Rusty has the same dilemma that befell grandma. The flashback scenes do not have the snap-crackle of the 1944 scenes, but they serve their purpose in making Coudair a sympathetic figure, and they add to the drama of Rusty's final decision (even though there is little suspense on that score). The modern-day Coudair scenes allow for the film's greatest nonmusical asset: Eve Arden. As Coudair's assistant—his right hand—she has got a quip for every occasion (and she is far funnier than Phil Silvers, who is ostensibly there for big laughs). She sarcastically cuts through the picture's starry-eyed fantasy whenever she feels like it. While maintaining her amusingly jaded and cynical air, she is unerringly dependable to her boss. She is the old maid who can be one of the boys, but she's also got a softer, sentimental-sucker side. There is something that separates her from the Thelma Ritter school of wisecrackers: her wardrobe. In the color-saturated, fashion-conscious world of this movie, even the brainy, plain type is dressed for Vogue. And why shouldn't the smart mouth like to dress up? In fact, I would say that Arden wears the most terrifying hats in the movie (and that is saying something). Her get-up as maid of honor at the climax is inde-scribable: a red and purple Grecian drape, dark purple opera gloves, and a blue-flowered muff with matching hair *thing*. Arden got her only Oscar nomination the following year for an identically good performance as Joan Crawford's all-purpose gal in *Mildred Pierce*.

If the disparate forces at work here (the Kelly-Donen influx from MGM, the Columbia-backed push for Hayworth's superstardom, the wartime ambiance, the time-worn flashbacks, the spectacle of the color design) seem to be at cross-purposes, it hardly matters since it is all in the name of putting on a humdinger of a show. At the directing helm was Charles Vidor, an underrated figure of the studio system, who made several fine films noted for their striking visual sense. He was particularly good with color, making his palette a crucial part of the dramatic content in films like *Love Me or Leave Me* (1955) and *The Swan* (1956). *Cover Girl,* despite its flaws, knows how to raise your pulse; Vidor provides a constant waterfall of color and movement. I would have cut the "Poor John" flashback song because one number in that period ("Sure Thing") is plenty. The routine that Kelly and Silvers perform for the troops (on a moving truck) should also have been cut because it is infantile. The scene where "Pop" quietly tells off Rusty is a bit much (not dear old Pop!), as is Rusty's drunk scene, a cliché-ridden heap. Hayworth may not have been up to a self-pitying drunk scene,

but her overall performance works in the way that star performances do when said star is at her peak. Her mere presence is so entrancing that it trumps the question of whether or not she can act. That said, she has sweetness, tenderness, even humor. She had already worked with Vidor on *The Lady in Question* (1940), and following the success of *Cover Girl* he directed her in her most famous role, *Gilda* (1946), the film that completed the goddess-making process for posterity. Their fourth film was *The Loves of Carmen* (1948), a nonoperatic (and bad) version of the tempestuous tale and as sexless as *Gilda* is steamy. Of these four, only *Cover Girl* does not feature Glenn Ford at Hayworth's side.

Produced by composer Arthur Schwartz without any noticeable wartime belt-tightening, *Cover Girl* was no assembly-line production. On its team were *two* cinematographers (Rudolph Maté and Allen M. Davey), *three* costume designers (Travis Banton, Gwen Wakeling, and Muriel King), *two* choreographers (Seymour Felix and Val Raset), not to mention Kelly and Donen's uncredited contributions to Kelly's numbers. The hypnotic world of artifice created by the entire crew hovers near kitsch but transcends it. It is a film in which a receptionist has a pink phone, a grand staircase seems never to end, a cabbie costume (Hayworth's) sports a mini-skirt. *Cover Girl* received Oscar nominations for color cinematography, color art direction, sound, and song ("Long Ago and Far Away"). It won the Oscar for "scoring of a musical," beating MGM's *Meet Me in St. Louis,* which was released at the tail end of 1944. *Cover Girl* may not be artistically or dramatically as accomplished as *Meet Me in St. Louis,* but it paved the way for the kind of vigor that Kelly and Donen would bring to the New York locations of *On the Town* (1949). With the Kelly-Donen influence on such exhilarating display, Columbia's *Cover Girl* is figuratively the first important MGM musical of the 1940s. Kelly then made *Anchors Aweigh* (1945), beginning his glorious decade of *actual* MGM musical successes. He would reteam with Phil Silvers on MGM's *Summer Stock* (1950).

Yes, *Cover Girl* is dated: it features Silvers' number, "Who's Complaining?," a song about war rations, and it makes a big deal about real-life model Jinx Falkenburg, who stops by for no reason but to give the film the fashion world's seal of approval. It is easy to dismiss *Cover Girl* as manufactured, silly, and overproduced, yet it is a knockout of Hollywood craftsmanship, and the invention and zest that went into it should not be disregarded.

The Harvey Girls (1946)
MGM's Answer to *Oklahoma!*

Second only to Fred Astaire as the key performer of the Hollywood musical, Judy Garland was a talent whose gifts went beyond a glorious singing voice and the ability to put over a song. Signed by MGM in 1935 at age thirteen, she had her first attention-getting moment when she crooned "Dear Mr. Gable" to Clark's photo in *Broadway Melody of 1938* (1937). It was instantly clear that she made direct emotional connections to her material and imbued her work with a specificity and depth of feeling that would continue to keep audiences in her thrall. This is certainly what made her Dorothy in *The Wizard of Oz* (1939) one of the most beloved characterizations in movie history. Garland invested herself utterly in the truth of the songs and scenes at hand, and her screen performances remain crisp and spontaneous, piercingly human, and eternally aglow.

After *Oz*, Garland was primarily occupied with Mickey Rooney in both Andy Hardy pictures and black-and-white, showbiz-worshipping musicals. Today, the Rooney-Garland songfests, especially *Babes in Arms* (1939), often make you glad that vaudeville—their movies' chief inspiration—is dead, so suffocating is the desperation inherent in the kill-the-audience material. Garland's non-Rooney musicals of the early '40s include *Ziegfeld Girl* (1941), which plays like a tame (yet equally bad) warm-up for *Valley of the Dolls,* and *For Me and My Gal* (1942), which secured her adult stardom despite its overall mediocrity. Director Vincente Minnelli and his *Meet Me in St. Louis* (1944) gave Garland the musical her talent warranted, after which there would be no more black-and-white musicals or youngster roles. Garland had never looked lovelier than as *St. Louis*'s Esther Smith, and the Hugh Martin-Ralph Blane score gave her opportunities to create some of the top moments in movie musicals: "The Trolley Song," "The Boy Next Door," and "Have Yourself a Merry Little Christmas." Minnelli's film was the most emotionally resonant movie musical since *The Wizard of Oz,* a textured

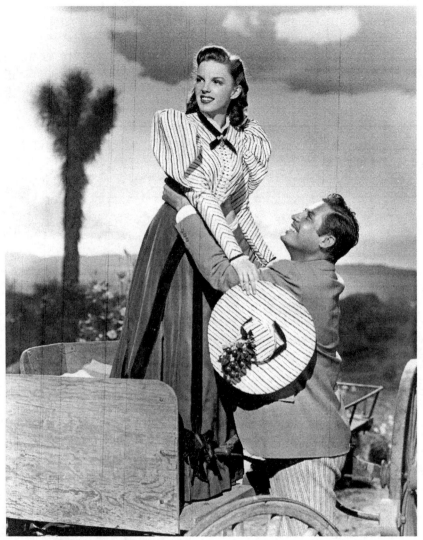

THE HARVEY GIRLS. Judy Garland finds love out West with John Hodiak.

look at a family's varied experiences over four seasons. *St. Louis* was the yardstick by which Garland's subsequent vehicles would be measured, and the paragon of quality for which they aimed.

The Clock (1945), Garland's only nonmusical at MGM, also directed by Minnelli, is a well-made if minor wartime romance in which she's very effective (though weighed down by overglamorization). In *Ziegfeld Follies* (1946), again directed by Minnelli, she's mannered fun in her

musical guest shot (spoofing diva stars), even though the material does not really suit her.

The Harvey Girls was Garland's first vehicle in response to *Meet Me in St. Louis,* a movie hoping to emulate the earlier picture's scrupulous skill in establishing a sense of place, character, and theme through music. It is a boisterous, action-packed, picturesque, funny musical, and, though it is uneven, Garland holds it together with her unassailable dramatic and comic instincts, her soulful presence, and her immense likability. Instead of *Meet Me in St. Louis*'s 1903 Midwest, *The Harvey Girls* occupies a late nineteenth-century Southwest. This is a western musical, based on the real-life Fred Harvey restaurants that helped tame the territory, and the impact of the recent Broadway sensation *Oklahoma!* (1943) is evident. You cannot quite describe *The Harvey Girls* as a full-fledged, *Oklahoma!*-style integrated musical—one in which the songs advance the plot—yet it still makes some small strides in the genre's progress, notably in its memorable "On the Atchison, Topeka, and the Santa Fe" production number.

Produced by Arthur Freed, *The Harvey Girls* is a product of MGM's celebrated "Freed Unit," a team of artists who turned out the best musicals being made, people committed to making musicals and great movies *not* mutually exclusive. This film is not one of Freed's masterworks, like *Singin' in the Rain* (1952), *The Band Wagon* (1953), or *St. Louis,* but it's still an impressive piece of musical film craft. Garland is its radiant center, and she and the sheer energy of the production surmount the sporadic corniness and the odd continuity lapses to create one of the best musicals of the decade. And *The Harvey Girls* surely has a hefty theme: the civilization of the West, no less.

Ohioan Susan Bradley (Garland) treks west in answer to a matrimonial ad, swept off her feet by her new fiancè's letters. On arrival in Sandrock, she meets her husband-to-be, H. H. Hartsey (Chill Wills), a self-described "mangy old buzzard," and learns that it was saloon owner Ned Trent (John Hodiak) who, on Hartsey's behalf, wrote the stirring letters. After she and Hartsey agree not to wed, Susan decides to stay in Sandrock and join the Harvey girls, a group of young women she met on the westbound train who are going to be waitresses in a new restaurant. Tensions rise between the Alhambra, Ned's saloon, and Harvey House, a new force for decency, as both try to woo the male population (and secure the West's future). This large theme is miniaturized in the triangle between Ned and the two women who

love him: "nice girl" Susan, who can't forget his prose, and dance-hall tootsie Em (Angela Lansbury).

The influence of *Oklahoma!* can be felt in the film's opening moments. As a rule, movie musicals open "big," with a production number or, say, establishing shots of a city—something to grab you. Here, as in *Oklahoma!*'s "Oh, What a Beautiful Mornin'," a musical begins very gently (and extols nature). With the camera on a patch of clouds against a pale blue sky, we hear the instantly identifiable Garland voice before the camera drifts down to find her leaning against the back of a moving train. Her song, "In the Valley (Where the Evening Sun Goes Down)," sets up her longing for a new, different kind of life than she's known. In Garland's yearning rendition, the song plays like a westernized "Over the Rainbow." For all the bluster ahead, *The Harvey Girls* begins tenderly with the private thoughts of its central character.

One of the significant pleasures of this movie is its acknowledgment of Judy Garland as a priceless comedienne. After all those years playing straight man to the more broadly inclined Rooney, Garland gets her first major comic role in Susan Bradley, and her success in it is reflected in the remainder of her MGM vehicles, each providing a variation on the character she molded here. Look at *The Pirate* (1948), *Easter Parade* (1948), *In the Good Old Summertime* (1949), and *Summer Stock* (1950), and you'll find the same irresistibly funny mix of spunk and insecurity, the same flair for finding the humor in the erotic longings of sexually repressed young women, that Garland established so winningly with her Susan Bradley. Sometimes hotheaded and impulsive, sometimes bordering on neurotic, Garland, as with her singing, gets to the heart of things and responds intuitively.

Garland's first comic moment in *The Harvey Girls* comes quickly, after she, in her train seat, reaches for her lunch basket expectantly. After she gazes longingly at the chicken legs being consumed by the nearby Harvey girls, she discovers that her basket contains only two half-eaten crackers, then nibbles on one of them as if it were delicious. Garland makes an expert double-take at the sight of a little girl suddenly in front of her and staring enviously at her "lunch." Watch her try to ignore the determined waif by looking all around, then give in and hand the cracker over to her. The moment is capped when her second cracker crumb is popped quickly into her mouth at the sight of a second wandering girl, who receives a triumphantly close-mouthed smile from Garland. This incidental scene is a gem of essentially silent-screen comedy.

After the Harvey girls strike up a conversation, Susan reveals the nature of her cross-country journey, her romantic adventure, and her eagerness to escape "old-fashioned" Ohio. Garland gives us both the enchanting innocent and the plucky rebel, and the conflict in these disparate personae provides not only comedy but an honest internal struggle. Even though Susan and Ned (the actual letter writer) have never met, they are already bound by love, whether or not they know it and whether or not they can survive their differences. (Though Susan evokes the tale of John Alden when describing their story, you could also say that it's *Cyrano de Bergerac* in reverse, with the handsome guy hiding behind the unattractive one.)

Ned's saloon, the Alhambra, represents everything that Harvey House is out to defeat: booze, gambling, and loose women. Designed with heavy, blood-red draperies, the Alhambra is a musical's idea of a den of iniquity. No one represents the Alhambra like Angela Lansbury's Em (in no way to be confused with Judy's "Auntie" Em). Matching Garland every step of the way in terms of commitment and verve, Lansbury is remarkably convincing and sympathetic in her bad-girl role. Her glacial exterior, featuring blond hair piled high and a heavily painted face, conceals a soft, unsure center, meaning that Lansbury takes a stock role—the saloon tramp—and endows her with vulnerability and sadness, without stinting on the formidability. This was Lansbury's fourth film, after *Gaslight* (1944), *National Velvet* (1944), and *The Picture of Dorian Gray* (1945); the first and third brought her Oscar nominations. She was nineteen when *The Harvey Girls* was filmed in the first half of 1945, and it's positively stupefying that a British teenager could pull off a tawdry western tart so assuredly. It sounds like disastrous casting, but Lansbury gives herself over to the role completely and makes it her own. Her surprisingly knowing depiction of unrequited love (for Ned) and sexual competition (with Susan) is a testament to the imaginative powers of acting talent. And she revels in her outlandishly lavish costumes and extravagant hats, never in danger of having them wear *her*. After she sings a ballad (dubbed by Virginia Rees) in the saloon, her piano player compliments her voice. "He's so young," she says of him, knowing full well it's her figure that sells her songs. The real wonder is that Lansbury could say such a line at age nineteen and have us accept it. Later, in her "Oh, You Kid" number, she wields a huge boa, does some can-can moves, and gets to sing (still dubbed) bawdily, "If you like chicken, grab a wing!"

Fifteen minutes into the movie comes the Oscar-winning tune "On the Atchison, Topeka, and the Santa Fe," the film's sizable production number. What's noteworthy about this sequence is how much is accomplished in terms of setting, character, and plot in a little over eight minutes of screen time. It begins inside the Alhambra after the train whistle is heard, with a black waiter the first to sing it. He moves the song outdoors where a cluster of cowboys hum the tune, and, increasingly, townsfolk get caught up in the anticipation of the train's arrival. We're now in the center of Sandrock, on a very large outdoor set. The camera then cuts to the train itself, its wheels racing, followed by solo lines for, among others, the engineer, the conductor, and eager Harvey girls looking out their windows. After having established the mounting excitement of Sandrock, the number has now done the same for those *on* the train. The two groups converge in an expansive, all-inclusive shot as the train pulls into the station. The song continues with the cowboys interacting with the Harvey girls, and the obvious clash between east and west. The girls then introduce themselves in sung bits about their pasts, individualizing them to Sandrock (and to us). Gunshots quiet the crowd and cue Garland's exit from the train and takeover of the number. This moment is rather ridiculous because everyone reacts as if Judy Garland had arrived rather than the unknown Susan Bradley. (There's no way Judy is going to miss singing the best song in the movie!) Garland slows the tempo and offers a churning rendition, with the crowd now her own personal chorus as she mingles among them. The "all aboard" cry livens the tempo again, leading the entire ensemble to do the "train step" alongside the departing locomotive, with their arms moving like wheels. As the train speeds off, Garland, perched atop a trunk and surrounded by the company, cuts loose with the rousing final notes. So, now we have a feel for Sandrock and its cowpokes, a vivid sense of period, and snippets of backstory on the Harvey girls. "Atchison, Topeka" was staged by choreographer Robert Alton with clarity, scope, and muscle.

The awkward first meeting of Susan and Hartsey, soon after her arrival, is another comic highlight. Garland lurches back when he steps forward to take her trunk and, as they talk, she plays with her handbag nervously, kneading it like dough. She's a delight trying to mask her obvious disappointment, and her attempts to talk him out of matrimony anticipate the final scene of *Some Like It Hot* (1959): she tries to exit gracefully by citing her awful housekeeping and terrible cooking but

nothing seems to bother him. After they agree to part amicably, Hartsey reveals Ned as the letter writer and Susan heads off to the Alhambra to tell him off for toying with her heart. Garland keenly makes it plain that part of Susan's eagerness to confront this rascal is to get a look at the man she loves. Her first look at him signifies that she likes his face as much as his letters, but she'll not show it or even admit it to herself. In this, and all her subsequent confrontations with him, Garland conveys Susan's subconscious need to be near this fellow even if she hides behind righteous hostility. Her delivery of her chirpy tirades is consistently funny; unstoppability only makes her more endearing. Her riled spirits accentuate her helpless feeling for Ned, and she surely finds enough excuses to keep showing up inside the Alhambra. Garland's scenes inside the saloon are classic fish-out-of-water moments; she's a pipsqueak who has to fight hard even to be noticed. At 4' 11", Garland is a sight gag, swallowed up by a roomful of he-men and long-legged showgirls.

There are two extended comic sequences set inside the Alhambra in which Garland's comic mettle shines. When all the Harvey steaks are missing, Susan, now a Harvey girl, suspects foul play and hightails it over to the saloon, her starched uniform accessorized by a pistol in each hand. (It is not easy being tough with a fat white bow in your hair.) Her swaggering resolve evaporates when she drops the guns and lets out a squeal; she gingerly picks them up (finding one under her long skirt) and resumes her mission. There's a great shot, taken from inside the saloon, in which she crouches down, below the swinging doors, and looks inside the Alhambra; even armed, she's puny. She slams her way in, shaking her guns and shouting but not causing much stir until a charmed cowboy assists her in getting folks to pay attention. After she shoots in the direction of the bar (without looking) to get the bartender to talk, she lets out a fearful sigh, but then sees the fear she's aroused in the room and cockily blows on her gun. After the meat is retrieved, she begins an exit speech but then accidentally shoots down a light fixture. She whispers to her trusty cowboy, "Did I do that?" then makes a hasty, giggly, apologetic retreat. Later, when a waitress (Cyd Charisse) gets involved with the saloon's pianist (Kenny Baker), it leads to an all-out girl fight between the Alhambra gals and the waitresses. The multi-colored bad girls take on the black-and-white good girls (whose uniforms are unsettlingly similar to nuns' habits) in an enjoyably nonsensical brawl featuring one Harvey girl swinging from a light fixture like a zeppelin.

Garland is hopelessly ineffectual at causing anyone harm (though her fists are rigidly aimed upward). It's odd that the scene has no repercussions, even though the ladies have trashed the joint.

The movie employs an efficient, breezy musical number to enliven the potentially mundane process of watching the women learn how to become waitresses. In a musical montage, they become acquainted with their uniforms, get instruction in place settings (from great old Marjorie Main), and the sequence takes us all the way to the restaurant's opening. This is musical construction that results in swift, precise storytelling. The scene is further distinguished by the fluid camera moves of cinematographer George Folsey, the man who filmed *Meet Me in St. Louis.*

One of the reasons *The Harvey Girls* moves so quickly is that its visuals are in almost constant whirl, which provides particular charge and momentum to the musical numbers, such as "Swing Your Partner Round and Round," set at a party at Harvey House. This song, which teaches the newfangled waltz, is not merely an excuse for melody and opulence. The waltz is yet another civilizing force, another chance for the town to be won by what the Harvey girls represent. There's a cloying quality to this tune that's nicely diffused by well-timed comic-relief interruptions throughout the number. Through the course of this beautifully photographed sequence, in which the camera seems to be waltzing along with the dancers, the cowmen and the waitresses connect.

With John Hodiak as her leading man, Garland suddenly had a macho type opposite her. Having just scored a big hit with Tallulah Bankhead in Hitchcock's *Lifeboat* (1944), Hodiak was something of a low-rent Gable, the likes of which Garland had never encountered on-screen. She had worked with the childlike Rooney, dancers Gene Kelly and George Murphy, character man Van Heflin, and lightweight types like Tom Drake and Robert Walker, but no one so obviously in movies for his virility as Hodiak (who bears a striking resemblance to John Travolta at times). Even though *The Clock* featured a post-wedding-night breakfast (with boyishly unthreatening Robert Walker), the notion of sex had never hung in the air of a Garland film as explicitly as it does in *The Harvey Girls.* When Susan and Ned have their first kiss, fittingly overlooking a valley (like the one she sang about), Garland reacts in a daze, woozily melting, then planting herself against a rock to stay vertical, all the while trying to downplay her obvious ecstasy. Hodiak, as a tough guy with the soul of a poet, has an easygoing confidence, a

welcome gentleness, and a ready laugh. Ned teases, Susan gets feisty, and they seem a good match. As the film nears its end, it's novel that instead of the characters making tiresome ultimatums regarding their future together, they both privately choose to make sacrifices for the other. (Hodiak died from a heart attack at only 41 in 1955.)

It's a joy when Ray Bolger (Dorothy's Scarecrow) appears in the "Atchison, Topeka" number, but isn't he too well-known to show up without receiving a proper introduction into the film? You'll smile when Garland takes his arm here, and later when they waltz at the party, because they look at each other as if this were a Dorothy-Scarecrow reunion. But why isn't there a scene on the train with Bolger meeting the Harvey girls, specifically Alma (Virginia O'Brien), the one he's later linked to? He plays a blacksmith without courage (rather than without brains), but there's no reason for him to be in the movie. Even so, he does a terrific eccentric dance at the party, comic dancing of a kind that no one does anymore, followed by a slapstick waltz with Marjorie Main, whose bulk sends his string bean figure flying. It's even more bizarre that Virginia O'Brien, the most prominent Harvey girl besides Garland in the first half of the picture, disappears from it after her ironic, deadpan (and just mildly amusing) solo, "The Wild, Wild West." This is especially strange because though Bolger seems only to be on hand as O'Brien's love interest, his best screen time occurs *after* she vanishes. Why isn't she at the party or the all-girl brawl or the finale? (O'Brien's pregnancy during filming isn't sufficient explanation.) Cyd Charisse becomes more conspicuous once O'Brien exits. This film marked the first significant screen time for the lovely, statuesque Charisse. She does a brief dance, a series of entrancing twirls, as Kenny Baker warbles the bland "Wait and See." (The scene is aided by the suspense-building appearance of Lansbury and her gals from the saloon's second level, which will eventually lead to the female fisticuffs.) Marjorie Main makes her presence known throughout, especially at the party, decked out in a purple gown and red plumes in her hair. When she sings—croaks and bellows rather—about the dainty waltz, it's outrageous and wonderful.

The film's climax, despite a rip-roarin' Technicolor fire, is the confrontation between Garland and Lansbury. Of course, the nice girls win in this story, but Lansbury gives the bad girls their due. This open, touching conversation, set aboard a train, is beautifully acted by these two great pros, their characters joined by their shared love for Ned. Hodiak may be the prize, but he's just not in their league.

Director George Sidney was just coming off the hit *Anchors Aweigh* (1945), a Best Picture Oscar nominee, when he helmed *The Harvey Girls*. Sidney, who would go on to make *Annie Get Your Gun* (1950) and *Show Boat* (1951) for Freed, never displayed the distinctive talent of a Minnelli or a Stanley Donen but was a reliable craftsman whose work is marked by precision, movement, and color sense, all of which you'll find in abundance here. Though known primarily for his musicals, Sidney did his best work on *Scaramouche* (1952), a marvelous comic adventure starring Stewart Granger and a stunning Eleanor Parker.

Aside from "Atchison, Topeka," the words and music provided by Johnny Mercer and Harry Warren, two songwriting giants, are rarely more than serviceable. And Garland should have a big ballad near the end of the picture! "It's a Great Big World," a trio performed by Garland, O'Brien, and Charisse in their nightgowns is bittersweet, yet it's marred by inorganic choreography (which Garland apparently doesn't think much of) and some lame lyrics. The movie has a slew of writers credited for source material, story, screenplay, and dialogue, the most familiar name among them being Samson Raphaelson, a frequent collaborator of Ernst Lubitsch. The script contains some banal slobberings about values, and wholesomeness does triumph in Sandrock, but that doesn't negate or diminish the deliriously jangled emotions or the continuous good cheer with which the stupendous Judy Garland infuses *The Harvey Girls*.

Seven Brides for Seven Brothers (1954)
Reclaiming a Classic

For those of you puzzled by my inclusion of such an obvious musical classic as *Seven Brides for Seven Brothers* in a book about over-looked movies, I have news: the reputation of *Seven Brides* isn't what it was back in 1954, when it was an unexpected box-office smash and nominated for the Best Picture Oscar. Though even its detractors recognize the dynamism of its choreography and dancing, *Seven Brides* has been unfairly victimized by political correctness. Unlike the other masterful MGM musicals of its day—*Singin' in the Rain* (1952) and *The Band Wagon* (1953)—*Seven Brides* doesn't have the satiric bite of a Betty Comden-Adolph Green screenplay, nor does it tell a glamorous showbiz tale; it's a celebration of homespun values set in the Oregon Territory of 1850. Anyone who's seen it undoubtedly remembers its magnificent barn-raising dance, one of the screen's all-time greatest dance sequences, yet *Seven Brides* is every bit as winning for its story and characters as it is for its songs and dances. People fell in love with this movie because of its emotional pull, its character transitions, and the strength of the relationships forged. The smile on your face at the end of it comes pri-marily from the satisfaction of having seen its undomesticated "broth-ers" mature into good men. Those who find *Seven Brides* dated, and its sexual politics offensive, aren't looking very closely; they're dwelling on the bad behavior and missing the life lessons learned.

Backwoods farmer Adam Pontipee (Howard Keel) comes to town in search of a wife to cook and clean for him and his six scroungy younger brothers. At an inn, he meets Milly (Jane Powell), who falls in love with him on sight and agrees to go off with him, imagining a romantic adventure. Milly is hurt and betrayed by the discovery of Adam's brothers, a detail he neglected to mention, but she sets about taming these Neanderthals. She wins the boys over quickly, but Adam remains emotionally distant. After Milly spruces them up, the boys fall in love with six local girls whose families don't approve of the rough-

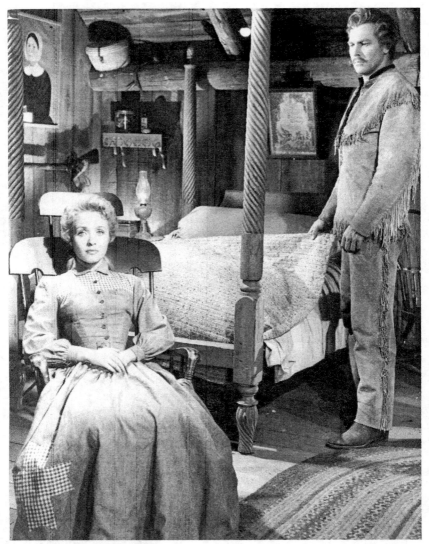

SEVEN BRIDES FOR SEVEN BROTHERS. It's no honeymoon for Jane Powell and Howard Keel.

housing Pontipees. Milly is incensed when, at Adam's suggestion, the boys abduct the girls and cause an avalanche that prevents their immediate return.

This synopsis clearly raises the question of the film's treatment of women. What it doesn't convey is the film's handling of these events. *Seven Brides* doesn't congratulate the brothers for their insensitivites;

it's a movie about uncivilized men becoming respectful, thoughtful human beings. I won't go so far as to call it feminist but it's a rare old movie that addresses mistreatment of women and demands an apology. Some viewers are bothered by the abducted girls eventually choosing to marry their abductors, but this ignores the fact that they're already in love with them before the abduction.

When he directed *Seven Brides,* Stanley Donen was best known as Gene Kelly's sidekick. Kelly and Donen had codirected *On the Town* (1949) and *Singin' in the Rain,* but Donen had recently branched out on his own, directing Fred Astaire in *Royal Wedding* (1951) and Marge and Gower Champion in *Give a Girl a Break* (1953). With *Seven Brides,* Donen made a leap that decidedly ended his perceived dependency on Kelly. (Kelly's solo directorial ventures would prove that he had little to offer from behind the camera.) No one expected *Seven Brides* to be the success it was. After all, it was produced by second-string Jack Cummings rather than Arthur Freed, the studio's top musical maker. Freed's unit was pouring MGM's money into *Brigadoon* (1954), starring Kelly. But the modestly budgeted *Seven Brides* was not only better reviewed than *Brigadoon,* it trounced it at the box-office.

Seven Brides is so well built in terms of musical construction that you'd swear it was based on a Broadway musical. It wasn't, yet it used the contemporary Broadway model of integrating songs into the plot so that they move the story forward and enrich the characters. The picture begins with Adam riding his wagon into town, set on returning with a wife. Husky, bearded, and redheaded, Howard Keel cuts an imposing figure, unflappably sure of himself. After eyeing four females as if they were for sale, he utters, "I'll keep you in mind." The film's first song, "Bless Yore Beautiful Hide," is eased into by Keel's whistling the melody before singing it. It's a jaunty, upbeat tune, in which Adam surveys the local females while sauntering through town. With his rich, commanding baritone, Keel gets the movie off to a frisky start. Before the song is over, Adam will have spotted Milly (chopping and carrying wood), seen her fight off a brute, and decided that she's the one for him. It's an excellent opening number, succinctly introducing Adam as a single-minded man with a mission, and propelling the story to its introduction of Milly. Inside the inn, he sits down to sample her stew. She sees him and loses her bearings, so immediate is her attraction; conversely, he falls for the stew. Later, as she milks a cow, he appears and abruptly proposes marriage; there's no time for courting. He can't see what we

see—that she loves him—yet it's still a jolt when she responds, "I'd have to finish my chores."

The contributions of Howard Keel and Jane Powell to the film's success cannot be overestimated. Keel had been MGM's premier male singer since his ideal casting in two major moneymakers, both adapted from Broadway shows: *Annie Get Your Gun* (1950) and *Show Boat* (1951). After another plum stage-based role, in *Kiss Me Kate* (1953), came Adam, a prime musical role *created* for the movies. Keel is utterly believable as a rugged outdoorsman, yet equally good at depicting the elusive, rough-edged personality inside the brawn. Best of all, he expertly fulfills Adam's transition from a closed-minded man into one able to see things from a perspective outside his own, without it seeming a pasted-on necessity for the happy finale. As for Powell, well, she's even better. Groomed by MGM in the mid '40s to be a teen soprano in the Deanna Durbin mold, she had scored a success with *A Date with Judy* (1948). Since then, her only film of note was Donen's pleasant *Royal Wedding*, in which she held her own as Astaire's dance partner. (Despite a 30-year age difference, Astaire and Powell were strangely acceptable as siblings.) But if Powell hadn't played Milly, we might never have known how talented she was. The strength, warmth, and joy in her performance sets her apart from the manufactured emoting of her soprano rivals at MGM: Kathryn Grayson and Ann Blyth. If Grayson or Blyth had played Milly, the character would have been arch and insufferable. The vigorous spunk in Powell's Milly feels authentic rather than cute. If *Seven Brides* had been made five years earlier, Judy Garland would have been a suitable Milly, but I don't think even Garland could have surpassed Powell in the role.

Powell's first song, "Wonderful, Wonderful Day," is the film's loveliest, the standout of a melodious score with music by Gene de Paul and lyrics by Johnny Mercer. The movie's budgetary restraints are apparent in this number; instead of singing on a real expanse of trees and flowers, Powell performs on an obvious indoor set, against a painted backdrop. It's sort of the studio-bound version of Julie Andrews singing on the Alps. Like Andrews' mountain-top outburst, Powell's song is an uncontained expression of pure happiness. It's an amusing touch that she launches into the song just as Adam is about to tell her about his brothers, a fact that would prevent the song from being sung (and thereby deprive us of knowing just how hopeful Milly is). Donen overcomes the static, cheap set by keeping the camera gliding along with an energized

Powell, whose buoyant, enveloping voice ensures that the number is among the film's musical highlights. Milly's arrival at the disheveled farmhouse deflates the boundless enthusiasm we've just witnessed. It's not the work that cows her; it's the realization of what it is Adam wants from her, and the surprise of their overpopulated nest. The brothers make Adam look refined; they're filthy, ill-mannered boys, untamed and itching to brawl. (They're named A-to-G, from Adam to Gideon, the youngest.) Powell absorbs Milly's disappointment and heartbreak, but she doesn't feel sorry for herself. She retains her positive attitude and rolls up her sleeves.

Milly's subsequent relationship with Adam may be described as a truce. Rarely has a movie musical offered such an interesting central romance. On their wedding night, she refuses to sleep with him because she feels more like a "hired girl" than a wife. There's also her lingering embarrassment at having already sung about her ecstatic feelings regarding their future. Though there's no question that he's attracted to her, Adam doesn't know what love is. Positioned to sleep on a tree branch outside their window, he listens as she sings—in the film's clumsiest (and most abrupt) transition into a song—"When You're in Love." What's unusual is that it's a one-sided love song. Milly expresses her feelings, but Adam can't reciprocate. We're deprived of a love duet because the characters aren't in sync. (She does relent and let him into her bed, though.) Keel reprises the song on the front porch when Adam responds to a question about love from Gideon (Russ Tamblyn), but he's only quoting Milly; he doesn't understand what he's singing about. His rendition brings Milly hopefully to the doorway, unseen, but she realizes the song isn't meant for her, and a duet is thwarted a second time. Keel and Powell never do sing together, which is a mistake. Logically, the Adam-Milly conflict should resolve with a joint rendition of "When You're in Love."

Perhaps the most appealing thing about *Seven Brides* is watching Milly transform the unkempt brothers into presentability. More like a mother than a big sister, she employs a tough love approach: dumping food on them in response to their table manners; insisting they remove their underwear so she can wash it, or she won't feed them. Instead of fighting back, they soon adore her. In seeing their potential, she inspires their devotion. Powell really takes charge, particularly delightful since she's so tiny, whipping these strapping boys into shape. Because of Powell's easy humor and the genuine regard she displays for

the boys, Milly is never a pain, the kind with an off-putting penchant for reforming people. Her conversion of these fellows, grooming them into clean-shaven, redheaded heartthrobs, is rapidly achieved, anchored by the caring connection forged between Powell and the tightly knit ensemble of men playing the brothers.

The brothers are thankful that she's come into their lives, and their unguarded affection for her only makes them more likable. (It's Adam who's the odd man out.) The bond between Milly and the boys is solidified in "Goin' Co'tin,'" the living-room number in which she teaches them how to woo girls. The unspoken poignancy behind this number is that Milly was not wooed by Adam in the romantic ways she'll impart to the boys. After singing about etiquette, Milly comes to the dancing aspects of courting, to which the boys shout, "Goin' dancin'?" This is a very funny line because it's uttered by five amazing male dancers, including Jacques D'Amboise, who adds, "You mean men are learning how to dance?" (The remaining brother is played by non-dancer Jeff Richards, on hand to augment the beefcake quotient.) The boys have no trouble releasing their inner dancers; the number is a rowdy, foot-stamping, heel-kicking hoe-down, but merely a prelude of what's to come.

Seven Brides was filmed in cost-effective Ansco color rather than Technicolor, so it doesn't have the saturated hues that one associates with MGM musicals. However, since it's an earthy, woodsy tale, the muted colors are not a severe detriment. The one scene in which colors really stand out is the legendary barn-raising dance, the brothers' debut into polite society (like Eliza Doolittle at Ascot). Each of the brothers wears a different colored shirt, one more vibrant than the next, forming a CinemaScope rainbow every time they form a line. Before the dance, there's an irresistible scene in which Adam sees Milly's work in action. Surrounded by six intrigued girls, the boys display their gentlemanliness, offering to carry things for the girls and be their escorts. In a series of baffled reactions, Keel's Adam wonders who the hell these sweet guys *are*.

Broadway's Michael Kidd choreographed *Seven Brides* and with it his place in movie-musical immortality was secured. Kidd had just done brilliant work on *The Band Wagon,* ingeniously transforming Fred Astaire into a sexy Mike Hammer clone in the film's fabulous "Girl Hunt." With an ensemble of classically trained men, his barn-raising choreography took male dancing in the movies to new heights. Athletic and acrobatic, and continually increasing its degree of difficulty, the

barn-raising dance also advances the plot; the brothers establish who they are and what they want through a competitive dance-off with the townsmen for the six girls' hearts. The sequence—set to the "Bless Yore Beautiful Hide" melody—begins formally, as the townsmen lead the girls in a rigid folk dance. The brothers soon begin stealing the girls away, enlivening the proceedings and turning it into all-out masculine rivalry. At one point, Powell enters the dance to relieve the tension. She and Tommy Rall (as her brother-in-law Frankincense) perform a sprightly routine, and Powell acquits herself ably. (After you've danced with Astaire, can you ever again be intimidated on a dance floor?) Back to the competition, the dancing is ever more challenging, featuring astonishing displays of balance and breathtaking flips. With their astounding acrobatic skills, Rall and Tamblyn steal the show, but that doesn't diminish the flawless participation of the other dancing brothers—D'Amboise, Matt Mattox, and Marc Platt—or the dancing townsmen, or the girls. In six minutes of screen time, the barn-raising dance—filmed on a soundstage, against a painted backdrop—is the most exuberant display of youthful male potency that musicals have ever seen.

During the actual barn-raising, the brothers disarm us further by trying to heed Milly's plea not to fight, an increasingly difficult prospect once the townsmen begin baiting them with blows from hammers and wooden planks. It's an endearingly funny scene because the boys' determination to remain well-behaved reinforces how much Milly means to them. A big old comic brawl is unavoidable, collapsing the barn and sustaining the Pontipees' reputation for trouble. (Perhaps someone thought a butch free-for-all was a necessary assurance of the brothers' heterosexuality after all that balletic dancing.) Later, Gideon apologizes to Milly and she says she understands. It's a little moment but it stresses the attachment between her and the boys and their ability to communicate openly.

Russ Tamblyn's Gideon is another important reason for the film's appeal. A child actor in films like *Samson and Delilah* (1949) and *Father of the Bride* (1950), Tamblyn came into his own here. Gideon is the baby of the family, and Tamblyn gives a funny, unaffected performance that visibly progresses from child to adult. In a late scene, he sees Adam as a flawed man, outgrowing his rose-colored view of his big brother and saying so to his face. Gideon becomes a full-fledged man before Adam does, and he's the only one of Adam's brothers delineated as an individual. Tamblyn would go on to be among the best things in both

Peyton Place (1957), for which he was nominated for an Oscar, and *West Side Story* (1961), for which he wasn't.

One of the movie's most admired numbers is the wistful "Lonesome Polecat," in which the lovesick brothers pine for their in-town girls while chopping and sawing wood. Shot in a single take (again, on a sound-stage with a painted backdrop), it's a formalized expression of plaintive longing. Matt Mattox is the featured dancer here, gracefully swinging his axe against the wind, but the overall sequence is self-conscious and lacks spontaneity. Much better is the raucous barn number "Sobbin' Women," in which Keel sings to the boys about aping the Romans, who carried off the Sabine women, and going into town to steal the girls. (In accordance with the Production Code, he also mentions stealing a parson, but they forget to do it.) This catchy, roof-lifting tune rouses the boys' spirits, proving their enduring susceptibility to Adam's will despite Milly's influence, and they are soon singing and clapping along. The kidnappings are comic—one of the girls flies out her window as she sets a pie to cool outside her window—but the scene climaxes with an impressive wide-screen avalanche, thus separating the girls from their families for months. The comic hijinks and the snowy adventure come to a sudden end when Milly finds out what's happened. Powell lashes out here, releasing Milly's painful disappointment in the boys, even making the house (and therefore the girls) off limits to them, while Keel maintains Adam's easygoing arrogance. Powell also stands up to him firmly, without concealing the abiding sore wound of Milly's broken heart. Later, to Gideon, she says plainly, "He's gotta learn that he can't treat people this way." With his ego wounded, Adam goes off by himself to his trapping cabin to spend the winter.

The girls take the boys' room, prompting a reclining Dorcas (Julie Newmar, then Newmeyer) to wonder naughtily, "Which of the boys slept in this bed, do you suppose?" (anticipating Newmar's slinkiness as Catwoman in the 1960s television series *Batman*). The girls' num-ber, "June Bride," is a bit treacly but it's nicely staged, with the girls dancing a mock wedding in their white, form-fitting undergarments. This tribute to matrimonial bliss is vitalized by Kidd's choreography (which incorporates the room's wooden poles), a pretty tune, and the yearning beneath the wide-eyed sentiments. After the thaw, "Spring, Spring, Spring" musicalizes the happy reunion of the six couples as they wander the farm. This number benefits from being staged in the real outdoors, with actual sunshine instead of studio lighting. The fantasies

of "June Bride" are set into realistic motion in the lulling pleasures of "Spring, Spring, Spring."

A favorite scene of mine is an incidental one that emphasizes the bond between Milly and the brothers without a word spoken. While Adam is away, Milly gives birth to their daughter. In bed, with her baby swathed against her, she is greeted by the brothers and the girls. After each presenting a gift, four of the brothers take turns kissing Milly on her cheek. These kisses are so tenderly dispatched, and the scene such a loving ritual, that the point resounds: this is a family, whether or not Adam returns. But, naturally, the emotional climax of the movie must be Adam's transition, his learning something. *Seven Brides* is a joyous musical, so there's no worry that the situation can go unresolved, yet the reconciliation between Adam and Milly is far more than the tying up of loose ends. Adam's heartfelt desire to commit to his wife and be part of this family is touchingly credible rather than dramatically convenient. The movie ends without a sing-along or a dance, but merrily nonetheless.

Seven Brides got five Oscar nominations, for picture, screenplay, film editing, color cinematography, and scoring of a musical, winning only in the last category. Its eight songs are first-rate yet none became individually popular. The handsome camerawork of George Folsey, who also shot *The Harvey Girls,* fills the CinemaScope frame attractively but is undermined by the use of rear projections (another cost cutter). Based on Stephen Vincent Benet's short story *The Sobbin' Women,* the screenplay was penned by Dorothy Kingsley and the married team of Frances Goodrich and Albert Hackett, whose screenwriting credits include the first two *Thin Man* movies and *It's a Wonderful Life* (1946); they would go on to win the Pulitzer Prize in 1956 for their play *The Diary of Anne Frank.* (In Benet's story, it is Milly who instigates the abduction of the girls, even participates in it!) Musicals written for the screen rarely plumb the emotional depths of this intimately felt story, or have characters who undergo such rewarding changes. Despite the grand barn-raising dance and the avalanche, *Seven Brides* isn't as big a movie as you might think. Most of its numbers are scaled small, made to feel large because of their ingratiating impact rather than their size.

Stanley Donen endowed *Seven Brides* with an airy zest and comic charm that soared over its budgetary woes and carried its heartwarming story to audiences without feeling syrupy or labored. *Seven Brides* is so trim and brisk that it flies by. Donen and Michael Kidd, who would

both win honorary Oscars more than forty years after *Seven Brides,* reunited on *It's Always Fair Weather* (1955), the last of the Kelly-Donen codirected musicals. It's a fine, underrated film with an inventive, downbeat script, in which Kidd contributed as a performer rather than as choreographer. A setback for Donen was the disastrous *Deep in My Heart* (1954), a musical biopic about Sigmund Romberg (played by a grotesquely bad José Ferrer), but he bounced back with two musical winners in 1957: the ultra-chic *Funny Face* (1957), and *The Pajama Game* (1957), one of the best film adaptations of a Broadway musical. *Seven Brides* doesn't really fit with the more characteristic Donen films, the ones with sophisticated characters and urbane locations and dialogue, but it's nonetheless one of his finest achievements, and it should be reinstated, alongside *Singin' in the Rain* and *The Band Wagon,* to the highest ranks of film musicals because it is still everything they said it was back in 1954.

The Umbrellas of Cherbourg (1964)
The Rule Breaker from Abroad

The musical, be it for stage or film, was a form created to showcase the talents of those who could sing and dance, a venue for gifted people to dazzle us with their pleasure-giving skills. As vehicles, musicals were expected to be fairly disposable, as long as they let Fred Astaire *dance* and Judy Garland *sing*. By the mid 1950s, with the competition of television variety and the collapse of the studio system, musicals written for the screen—a quarter-century staple of moviegoing—were a dying breed. Hollywood was increasingly relying on the safer bets of adaptations of hit Broadway musicals, with *Gigi* (1958) the last triumphant gasp of the era of original Hollywood musicals. Four "Broadway" movies—*West Side Story* (1961), *My Fair Lady* (1964), *The Sound of Music* (1965), and *Oliver!* (1968)—were not merely popular and acclaimed but also Best Picture Oscar winners in a decade in which, ironically, musicals were marching, and overspending, their way into extinction. The prevalence of vocal dubbing meant that lead roles could be filled with the biggest box-office names; non-singing stars and tried-and-true properties had somehow become more important to movie musicals than great singers and dancers. Though the '60s brought Julie Andrews and Barbra Streisand to the movies, for every *Sound of Music* and *Funny Girl* (1968) there were many more stage-to-screen duds, elephantine horrors like *Can-Can* (1960), *The Unsinkable Molly Brown* (1964), and *Camelot* (1967), with the biggest stink bomb, *Hello, Dolly!* (1969), saved as the decade's capper. Is it any wonder that the genre—despite an unforeseen miracle like *Cabaret* (1972)—would be comatose by the mid 1970s? Film musicals had had a spurt of originality in 1964, with *A Hard Day's Night,* a delightfully screwball look into Beatlemania, and *Mary Poppins,* Disney's tuneful family picture, but the most extraordinary original screen musical of the 1960s came not from Hollywood, Broadway, or even England. French director Jacques Demy wrote and directed *The Umbrellas of Cherbourg,* a musical that breaks the rules of what a musical is and how it works.

THE UMBRELLAS OF CHERBOURG. Painful parting for Nino Castelnuovo and Catherine Deneuve.

The one common thread between *The Umbrellas of Cherbourg* and most of the Hollywood musicals of the '60s is its use of dubbed vocals for its principal players. There's no musical star here, no Astaire to wow us, but *Umbrellas of Cherbourg* oddly doesn't really require one. The piece is so intimate that none of the cast is asked to "perform" in the energized manner we associate with musicals; there's no trace of show-biz anywhere. The dubbed voices are good but rightly unspectacular, believably matched to the actors and their ordinary characters. The lip-synching is so impeccably achieved that the singing seems as organic as speech. No one *breaks* into song in this film because they never do anything *but* sing. With all the dialogue sung, there are no "numbers" to speak of; the film is sustained musicalized storytelling, a cinematic chamber opera. As you become absorbed into this world, you almost forget that everyone, including the postman and bartenders, is singing rather than talking. There is no dancing except for social dancing, and the plot being served is essentially a soap opera. How could the result have been anything but a travesty? Two key reasons for the film's success are Michel Legrand's rapturously beautiful and haunting music and Demy's enchanting and voluptuous color palette, yet neither fully

explains the unique magic at work here. What makes *The Umbrellas of Cherbourg* a wonder rather than a vulgarity is its utter simplicity. People may be singing, and they may live in a world of fervent color, but the story is acted and directed cleanly, naturally, and personally. The slightest overacting would destroy the illusion; the actors just had to *be*. This is an unusually interior musical, one in which emotional resonance springs from romantic clichés. Demy's visual style may not be realistic, but his artifice enhances the simply human story being told, an acknowledgment of the intensity of ordinary lives. (Cherbourg residents allowed him to paint their buildings to suit his vision.) The color, the music, the singing, and the buoyant camerawork enrich the feelings expressed naturalistically by the cast, and the purity of the performances grounds the film's fanciful trappings. The all-singing structure carries the advantage of obliterating those potentially awkward talking-into-singing transitions in musicals that can provoke titters.

The film is set in the port town of Cherbourg and begins in the fall of 1957. Guy Foucher (Nino Castelnuovo), 20, a gas-station mechanic, and Genevieve Emery (Catherine Deneuve), 17, a girl who works in her mother's umbrella shop, are madly in love. They delay their plans to marry when Guy is drafted into the army for a two-year stint. While he is fighting in Algeria, Genevieve learns that she's pregnant. Their time apart takes its toll, and Genevieve marries a wealthy man who loves her in spite of her condition. When Guy returns, Genevieve has moved to Paris. He tries to get on with his life but seems unable to forget her. *The Umbrellas of Cherbourg* is about time, how it races and crawls, punishes and heals, and how its impact cannot be anticipated.

We experience Cherbourg—an ordinary, if damp, French town—through the romanticized view of a pair of ecstatic young lovers. Our perceptions are heightened by the wall-to-wall music and vocalizing, the mesmerizing colors, and the soaring amorous feelings. It's Cherbourg, but it's Demy's Cherbourg, a first-love fairyland, and the stylistic consistency of his concept allows us to accept his view as an alternate reality. (For stylistic wrongheadedness, go to the film of *West Side Story* and note the ludicrous incongruity of balletic male dancers strutting on real, mundane New York streets.) Even before we meet Guy and Genevieve, Demy sets his tone of magical simplicity in the opening credits. The camera is placed in an overhead position, above a cobble-stoned street. A passerby opens a red umbrella, beginning a series of different-colored open umbrellas coming in and out of the frame, moving in various

directions. Rain pours, seemingly from our own eyes as we gaze down on the scene. The umbrella patterns complement the placement of the credited names, as do cyclists and other pedestrians dotting the scene. The camera observes motionlessly, and even before a note is sung an aura of graceful wonderment is in place.

The Umbrellas of Cherbourg is broken into three sections (followed by an epilogue), beginning with "The Departure." Legrand's jazziest music is applied to Guy's gas-station scenes. Instead of seductively easing into the no-spoken-dialogue conceit with a romantic scene, the film starts with Guy under the hood of a car, soon singing dialogue with a customer and coworkers. The music is loose and spirited, as is the camera, and the colors—even in the gas station—already strikingly vibrant. The singing of the most banal bits of dialogue doesn't play as dumb or annoying or, worse, self-consciously "artistic." This recitative is straightforward, charming, and casually witty. In the employee washroom, one fellow sings, about opera, "All that singing gives me a pain," a sly wink at what this film has chosen to tackle. Guy is introduced as a handsome youth in a rush to see his girl. He rides his bike to the umbrella shop, and we get our first glimpse of Catherine Deneuve's Genevieve, framed behind the shop window, in a yellow sweater, black ribbon in her blond hair, with a pink wall as background. The film derives a considerable amount of its beauty from the mere presence of its two stars. Deneuve and Nino Castelnuovo are rare creatures, she with her golden radiance and he with his dark Italianate allure (and cleft chin). Not only do they make a gorgeous couple, but they connect with uncommon tenderness, making it easy to believe their on-screen love. True, they can't keep their hands off each other, but the depth of their bond is reflected in their eye contact, in the way they come to life at the sight of each other and are diminished by separation. The story enacted is familiar, but the stars' specificity of feeling and the power of their chemistry make this not only a great musical film but a great romantic one.

This is the movie that made Deneuve an international star, and it's not hard to see why. Her beauty reminds me of Garbo's, not because they look anything alike, but because it transfixes me in the same way. I never want the camera to leave Deneuve's face because it *belongs* there. Her performance displays her innate gift for screen acting: infallible instincts; subtle expressivity; and the luminosity of her presence. Young Deneuve turned in a remarkably mature piece of acting, moving delicately from the flush of young love to the confusion

of separation and the pain of making choices. How can this musical ever seem trite or fey when it's built on a foundation of recognizable humanity? Castelnuovo—as handsome as Warren Beatty—also gives a memorably unaffected performance. (Why didn't he become as big a star as Deneuve?) Nobody in this movie shows off or ever tries to sell you anything, which is unusual since "selling" a song or a dance is commonplace even in great musicals (though it's often a sign of desperation in bad ones). There's never any danger of your wanting to burst into applause because no one is putting on a show.

"The Umbrellas of Cherbourg" is the name of the pink-walled shop owned by Madame Emery (Anne Vernon), and she and Genevieve live in the apartment above. The relationship between Genevieve and her widowed mother is perhaps the film's most complex. Genevieve is composed, serious, and practical, whereas Madame Emery is highstrung, self-dramatizing, and overtly glamorous. In an example of the film's nonchalant humor, Madame Emery passes a mirror and can't resist looking at herself, singing "Should I change my hair style?" then blithely continues on. Though opposites on the surface, and often in disagreement, they support each other when it counts. Sadness over Guy's imminent departure puts Genevieve crying at her mother's knee, and Madame Emery realizes the depths of her daughter's feelings. When she says, "People only die of love in movies," Demy perversely exacerbates our concern for Genevieve's future. Though not in favor of her daughter's ongoing devotion to Guy, Madame Emery never plays unfairly. When one of his letters arrives, you'll be pleased that she delivers it to Genevieve rather than tear it up (as in a melodrama). Her daughter's well-being is the most important thing, and actress Anne Vernon makes a lovely transition from a seemingly frivolous woman into someone of sensitivity and awareness. Deneuve and elegant, animated Vernon create a communicative, tangible mother-daughter bond.

The film's centerpiece is the section revolving around Guy's army departure. The film cuts from the couple's street embrace to an identical embrace inside a cafe. Will they be able to detach themselves? They sing "I Will Wait for You," the score's Oscar-nominated hit, with Deneuve and Castelnuovo acting the lyrics with heartfelt restraint. The scene continues as they walk to his apartment, yet they seem to be gliding above the pavement. We can't see their feet but it's obvious that they aren't taking any steps, seemingly propelled by the bicycle at Guy's side but more persuasively carried by the swelling music and their acute

agony of separation. (They end up on his single bed.) When Guy's train leaves, Demy devises one of the great farewell scenes, following a station-café reprise of "I Will Wait for You." As the orchestration surges, Castelnuovo gets on the train. The camera pulls back, the train moves in the direction of the camera, and Deneuve walks forward. Three objects—the camera, the train, and Deneuve—are moving in the same direction but at different speeds. Then Deneuve stops, and the train accelerates past the camera. These variations of movement and speed provide a breathless and disorienting sensation. Deneuve becomes small and isolated, and the camera stops once the train has passed it, lingering to observe Deneuve walk away.

The film's second part, "The Absence," brings Roland Cassard (Marc Michel) into the main plot. He has loved Genevieve since the moment he first saw her in a jewelry shop. He's a well-fixed diamond dealer, but also a shy and gentle man. When he tells Madame Emery the tale of his former heartbreak, he speaks of Lola. Here, Demy is referencing his ephemeral quasi-musical film *Lola* (1961), in which Marc Michel had already played Roland. As Roland talks about Lola, Demy cuts to the shopping arcade in Nantes, the site of *Lola*'s farewell scene. (If you haven't seen *Lola,* you'll be wondering why *Umbrellas* has suddenly bolted from the Emerys' apartment while Roland is in mid-story.) Roland's theme music in *Umbrellas,* reprised from the black-and-white *Lola,* eventually became "Watch What Happens," a popular '60s ballad recorded by *every* easy-listening vocalist. Marc Michel may not be a dreamboat of Nino Castelnuovo's caliber but he's handsome and gentlemanly (with a prominent shaved gap at the center of his mustache). The most important revelation of this section is Genevieve's frightening and depressing realization that her connection to Guy, despite their correspondence, is dwindling. Inside the shop, Demy has Deneuve bemoan Genevieve's increasing detachment while carnival merrymakers revel outside the window. The contrast is beautiful but also augments Genevieve's dislocation from joy. Deneuve piercingly conveys Genevieve's emptiness and pain as her love moves slowly but helplessly from her consciousness: "Why is Guy fading away from me? I would have died for him. Why am I not dead?" Roland's warm acceptance of her pregnancy is too generous to ignore, and she agrees to marry him. There's a brief yet stunning visual in a bridal shop as Madame Emery, clad in red, walks between two rows of wedding-gowned mannequins until she gets to Genevieve in a bridal veil and blue dress. Deneuve

turns and looks directly into the camera and the scene abruptly cuts to her face during the ceremony.

The last part, "The Return," deals with Guy's homecoming and crushing disappointment at losing Genevieve and their baby. He finds comfort with Madeleine (Ellen Farner), the young woman who takes care of the dying aunt (Mireille Perrey) who raised him and with whom he lives. It's been clear from the film's early scenes that Madeleine is secretly in love with Guy. Like Roland, she is no homely second-best, but a loving and lovely girl. But whereas Genevieve was losing her memory of Guy, he can't forget her. Castelnuovo's vulnerability is as affecting as Deneuve's; the story, which began generically, is increasingly character-driven. It's vivifying to watch Castelnuovo make his way back to Guy's initial exuberance and poignant to see Ms. Farner acknowledge and overcome Madeleine's fear of Genevieve's hold on him. It's for us to decide how much Guy's and Genevieve's new arrangements are "real" or simply examples of settling. The film ends with a coda set at an Esso station in December, 1963. It's the first time Guy and Genevieve (in a whopper of a piled-high '60s hairdo) have seen each other since he left the train station (to the ironic strains of "I Will Wait for You"). The scene is unforced, though the mood undeniably bittersweet and the tension potent. You may not believe that an ambitious sung-through musical would have the guts to set its finish at an Esso station, but the more surprising thing is that a gas-station finale could be so moving and, once seen, never forgotten.

Winner of the Golden Palm at Cannes, *The Umbrellas of Cherbourg* was nominated for 1964's Best Foreign Film Oscar, and was eligible the following year in all other categories, garnering three music nominations and one for Demy's story and screenplay. In Demy's case, "screenplay" mostly means lyrics since he wrote the sung dialogue. His work, as both director and scenarist, isn't coy, never pushes, and flows seamlessly. (Do not see this film in its vastly inferior English-dubbed version!) Demy even makes a cameo in a mother-daughter shop scene, as a lost shopper who opens their door and delightfully interrupts with his one line: "The paint shop, please?" To which Madame Emery sings, "Next door." Michel Legrand's score is one of the more heavenly ever composed for a film musical, notable not just for its melodic abundance but also its heartrending longing. His score is lush without being saccharine. In 1992, the saturated colors of Jean Rabier's cinematography and Bernard Evein's art direction were restored to their original glory. I

never thought that combinations like green and pink or red and purple could be so stimulating. Perhaps the most outrageous moment comes when the pattern of Deneuve's blue-and-pink flowered dress is practically identical to the wallpaper behind her.

Demy, Legrand, and Deneuve made two more musicals together. *The Young Girls of Rochefort* (1967), co-starring Deneuve's sister Françoise Dorléac, was a full-out attempt to make an old-fashioned Hollywood-style musical, even incorporating Gene Kelly and George Chakiris into its cast, but it was a barren, faltering picture, charmlessly trying too hard. Then came *Donkey Skin* (1970), a Cinderella-like fairy tale in which Demy overworked the magical elements with a heavy-handed whimsy. The rapture of *The Umbrellas of Cherbourg*—its capacity for simplicity, emotion, and intimacy—is utterly absent from these two misguided ventures, which would seem to have been made by Demy imitators rather than the man himself. Legrand's and Deneuve's contributions don't measure up either. Then again, *The Umbrellas of Cherbourg* is too special a film for its sorcery to be easily duplicated, even by the estimable artists who created it.

II. Film Noir and Variations

Film noir is the mid 1940s to mid 1950s phase of Hollywood film-making in which, in lustrous black and white and shadow, tales of crime and lust were told with a cynicism and fatalism that apparently has ageless resonance. Though you can identify early noir style and content in minor pictures like *Stranger on the Third Floor* (1940) and major ones like *The Maltese Falcon* (1941), film noir emerged as a distinct form with Billy Wilder's smoldering *Double Indemnity* (1944), complete with its ordinary guy who goes "bad" thanks to his gullibility to a femme fatale, its portrait of a non-Tinseltown Los Angeles, and its emphasis on sex and violence, not to mention ironic, pungent, and eminently quotable dialogue. When World War II ended, film noir came into its own, providing alternative dissonance to the post-war euphoria with downbeat, anti-heroic main characters. The fusion of pulp stories with Expressionistic visuals created a series of films that, for the Hollywood of the time, had unsettling ambiguities and uncommon pessimism. Some of these movies, such as *Murder, My Sweet* (1945) and *The Postman Always Rings Twice* (1946), are recognized classics, while others, like *Out of the Past* (1947) and *Gun Crazy* (1949), are highly esteemed cult favorites whose popularity widens with each passing year, but other fine examples are still waiting to receive their due. Underappreciated in its heyday, film noir continues to influence American movies in today's seemingly neverending onslaught of twisty thrillers. This chapter includes two examples of pure film noir, but also two hybrids (a docudrama noir and a period noir) and a post-noir reconfiguration of the genre's basic elements.

Criss Cross (1949)
A Quintessential Film Noir

Universal's *Criss Cross,* a textbook example of film noir, features the familiar noir trappings: it revolves around a good Joe who risks everything for a beautiful woman; has an elaborate crime scheme and a sadistic villain; uses narration and flashbacks as storytelling devices; and unfolds with an air of pervasive doom. *Criss Cross* was directed by Robert Siodmak, a film-noir pioneer with *Phantom Lady* (1944) and *The Killers* (1946), the latter an enduring noir benchmark that made names of Burt Lancaster and Ava Gardner. Siodmak used Lancaster again for *Criss Cross,* and, though it's not as renowned as *The Killers,* it surpasses it. The films are equals in propulsive plotting, directorial dazzle, and black-and-white beauty, but *Criss Cross* is superior in its more complex characters. It's also leaner, less convoluted, and features a more accomplished Lancaster performance. Both films follow his undoing by a femme fatale, but this noir plot was routine fare by 1949, so *Criss Cross* didn't generate the kind of excitement that greeted *The Killers,* yet it's just about perfect. *Criss Cross* derives its power from its sobering and inexorable portrait of what people are capable of doing when in the grip of an obsessive, self-destructive love.

Steve Thompson (Lancaster) returns home to Los Angeles after a year of unsuccessfully trying to get over his divorce from Anna (Yvonne De Carlo). He moves back into his mother's house, gets back his old job as an armored-car guard and, before long, rekindles his relationship with a very willing Anna. When Anna suddenly marries Slim Dundee (Dan Duryea), a sleazy crook with a flush bank account, Steve is taken aback. But after Anna explains how she was trapped into the marriage, she and Steve resume their affair. Hoping to offer Anna cash as well as sex, Steve impulsively proposes an armored car robbery to Slim and his gang. With Steve as "the inside man," and Anna agreeing to run off with him after the job's completion, what could go wrong?

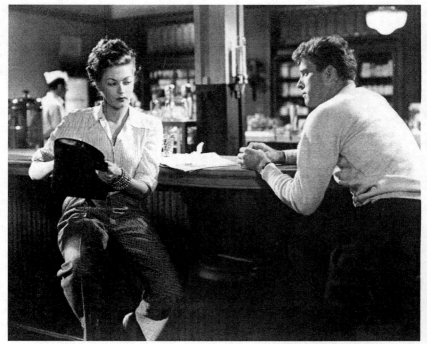

CRISS CROSS. Yvonne De Carlo spells trouble for ex-husband Burt Lancaster.

Criss Cross opens on a darkened parking lot. A car moving in reverse reveals the smooching Steve and Anna, and it's clear by their reaction to the lights illuminating them that they don't want to be seen together. She's another man's woman. They speak about something big happening tomorrow and make references to a hideout. We're immediately thrust into a juicy situation that raises more questions than it answers. The beauty and erotic heat of Lancaster and De Carlo are irresistible lures into a shady scenario. The 1940s Lancaster, with his chiseled handsomeness, toned muscularity, and magnetic presence, was almost exclusively a film-noir star. Following *Brute Force* (1947) and *I Walk Alone* (1948), among others, *Criss Cross* was his last excursion in film noir, a genre he managed to bypass in the 1950s. The role of Steve gave him an opportunity to expose the tenderness and vulnerability that could coexist with masculine grit. De Carlo is another stunning specimen, yet she displays little in the way of acting chops. Steve and Anna were married two years ago and their union lasted seven months. Lancaster's Steve is a man restless to repair the part of himself that's been broken since the split, yet he knows deep down that Anna is the only cure. Steve's

only motive is love, a decided disadvantage in film noir; his longing brands him a chump.

Thirteen minutes into the movie — once the robbery is set in motion, with Steve at the wheel of the armored car — his flashback begins. At forty-eight screen minutes, the flashback is an almost real-time daydream for what we're told is a forty-minute drive. Steve drifts back eight months to his return to L.A. and his powerlessness at avoiding Anna. That first night, at an L-shaped club called the Roundup (their old hangout), he sees her on the dance floor doing a rhumba with a good-looking partner (young Tony Curtis). This is a heady, pulsating sequence contrasting the easy abandon of the dancing De Carlo with the still intensity of the onlooking Lancaster. Siodmak rhythmically intercuts flashes of the musicians and their instruments, the twirling De Carlo, and the mesmerized Lancaster, creating a stirring mélange of images, abetted by the provocative, percussive music. Though Anna makes no attempt to disguise her delight in seeing him, Steve remains cool. In a rare move, the object of desire in a film noir is an ex-wife and therefore not a woman of mystery. Speaking of their marriage battles, Anna says that the making up was the best part, implying that sex was the main reason they were together, a force apparently strong enough to re-ignite their passion. Steve has tried to convince his family and friends that he hasn't returned to L.A. for Anna, but he isn't kidding anyone (least of all himself). Lancaster narrates that "it was in the cards," exonerating Steve's inability to go in any direction other than the one that leads to Anna. *Criss Cross* may be artful trash but it's also an unexpected, valid exploration of dealing with the grief and regret of divorce.

Anna and Steve meet next, at her invitation, in a drugstore. Lancaster barricades Steve's feelings behind a façade of indifference. The actor makes the subtext vivid: he can't control or even admit his need for her, and so he fights temptation with irritability. He can't see the big picture, the fact that they're a terrible match. Steve is a soulful, somewhat self-examining guy, whereas Anna is hedonistic, inconstant, and impulsive. Though she wants him back, you somehow know she hasn't spent these last months pining for him the way he has for her. De Carlo's effectiveness as Anna is a triumph of casting. Anna is fairly vacuous, and De Carlo's incapability of giving her an inner life is no detriment to the movie because Anna doesn't have an inner life. She's not a brainy beauty like Jane Greer in *Out of the Past*; she's a dimmer model, selfish and streetwise but more bratty than bright. Anna is simply too shallow

to warrant a more talented actress uncovering depths within her; her banality suits De Carlo's limitations precisely.

With a title like *Criss Cross,* the film has you waiting for a climactic double-cross, yet what you get is an ongoing series of twists—romantic, familial, occupational—of varying sizes, in which characters are dealt emotional and physical wallops. For Steve, there's the discovery that Anna has married Slim, which puts him back in his rudderless, post-divorce funk. He sees her again, months later, when a newsstand clerk inside Union Station squats down, thereby revealing her—a vision in white—at the information counter, a tingling visualization of fate stepping in once more. They have unfriendly words outside. He watches her walk to the curb to hail a cab and the scene dissolves into their tryst at her place; their reconnection is so inevitable that it isn't necessary to show us exactly how it was initiated. At this rendezvous, we see her playing a piano, but, even in those censorious days of the Production Code, no one can imagine Steve has dropped by to hear show tunes. With the tension mounting, Steve three times calls Anna a "tramp" for running off with cash-flowing Slim. She then recounts how she was harassed by Steve's boyhood pal, police lieutenant Pete Ramirez (Stephen McNally), with threats of jail time if she didn't stay away from Steve. De Carlo has sharp, vain lines about prison meaning "my hair cut short" and "wearing striped cotton." Quickly back together again, they need money to get away from her husband, prompting Steve to suggest the armored-car robbery to Slim and his mob: "You're the only crooks I know."

Lancaster plays Steve as someone with the tunnel-vision to set aside all that he knows is right in favor of his overriding vision of the ultimate happy ending with Anna. But there's no way that the rancor between Steve and Slim isn't going to manifest itself during the crime. The flashback ends; arrival at the scene of the crime is imminent. This is an extraordinarily suspenseful sequence, internally as well as externally, because Steve is concerned for the safety of his armored-car co-worker, Pop (Griff Barnett), who not only knows nothing of the plan but is also a father figure for Steve. Steve's sense of guilt and responsibility hasn't been completely overtaken by his desire for the money, which adds significant subtextual tension to the film's superb action centerpiece. Siodmak begins with an impressive overhead shot of the armored car arriving at a factory via a strip of road, one of several long, narrow spaces that the director favors throughout the movie—the Roundup's

bar, a hospital's hallway, a back alley—which emphasize a feeling of walls closing in. Slim and his cohorts show up in assorted disguises so that they'll blend into the scene outside the plant. Holding their guns, Steve and Pop carry the bags of money across the street when an explosion from a manhole cues the holdup. The smoke-filled space takes on a nightmarish look, a cloudy underworld of gas-masked criminals, fiery smoke bombs, and the staccato of gunshots. Figures step in and out of the murk like apparitions. This is the hell Steve has willingly entered and to which he now belongs. The fatal shooting of Pop unleashes Steve's furious change of heart; he turns on Slim and the gang in mid-robbery.

The wounded and hospitalized Steve is proclaimed a hero for salvaging half the loot, which leads to an even more nail-biting sequence, yet one of quietude and little activity. The scene endows Steve's hospital room with a haunted-house atmosphere, with moving shadows across the transom window, a suspiciously perky nurse, and the justifiable psychological paranoia gripping Steve over whether or not Slim has dispatched an assassin to finish him off. With Steve going in and out of consciousness, the remainder of the movie has a dreamlike, almost surreal, mood. His bureau mirror reveals a shadowed figure in the hall. At his request, the nurse raises his bed, making him able to see that the mirrored figure is a seated man. Steve asks the nurse to bring the man—his assassin?—to his room and, as she does, the action is glimpsed from the mirror, Steve's immobile point of view. In fact, all the subsequent hallway action is seen only in the mirror, an unnerving device that keeps the viewer trapped alongside Steve's bed-bound defenselessness. And our sense of Steve's disorientation is heightened as the male stranger, whom we've been watching at the left of the screen (in the mirror), enters the actual room from the right.

The climax, set at the waterfront hideaway first mentioned in the opening scene, doesn't resort to dealing in easy absolutes of good and evil. Anna loves Steve, even if her brand of love is sub-par. She's no-good in a more realistic way than the ingeniously calculating ladies that often inhabit film noir. In this genre, which is essentially about men, it is, unsurprisingly, men who love more truly and deeply than women. The women in these films tend to be practical and less likely to romanticize sexual partners. Hardly blameless, the men are frequently innocents of the heart who degrade themselves willingly. Considering the foolish things Steve does, it's a tribute to Lancaster that his is a recognizably

human portrait of incurable heartache and sexual obsession. His transition to crime is made believable by his helpless need for her.

All the prime examples of film noir offer striking experimentations with black and white. Courtesy of cinematographer Frank (sometimes Franz) Planer, *Criss Cross* has a lot more "white" than many a film noir, with several scenes set in the harsh glare of day, such as Steve's ironically sunlit return to L.A. or his accidental meeting with Anna outside Union Station. In film noir, daylight scenes don't reveal truth the way night scenes do; in the dark, the characters can more comfortably be their true, frequently unseemly, selves. As for the "noir" in the camerawork, near the end there's a scene focused on a blackened doorway of fathomless depth, when Slim creepily emerges, menacingly slow and walking with a cane. It's a moment worthy of Universal's great horror classics of the 1930s. The look of the film also benefits from fresh, unfamiliar L.A. locations that intensify our immersion in the specificities of this story. As for the sound of the film, Miklós Rózsa's fervent, throbbing score, similar to the one he wrote for *Double Indemnity,* is a valuable accessory to the film's overall impact.

Dan Duryea, an actor who specialized in greasy villainy, had a quintessentially slimy role in Slim. Beginning with his film debut, in which he recreated his stage role of loathsome Leo in *The Little Foxes* (1941), Duryea made a career out of playing reedy punks (with baby faces) in films like *Ministry of Fear* (1944) and *Silver Lode* (1954). His Slim is one of his least monotonous bad-guy turns, particularly smarmy when addressing Steve as "Stevie." Stephen McNally was another actor known for playing baddies, in films like *Johnny Belinda* (1948) and *Winchester '73* (1950), the latter also featuring a Duryea villain, but in *Criss Cross* McNally is the cop. In his display of genuine feeling for Lancaster's character, McNally overcomes a potentially insufferable role. And Tony Curtis, the dancing pretty-boy, would find himself starring beside Lancaster in *Trapeze* (1956) and *Sweet Smell of Success* (1957) in less than a decade.

Criss Cross is based on a spare novel of the same name by Don Tracy, and its screenplay was written by Daniel Fuchs. (In the book, Steve is Johnny, an ugly ex-boxer, and Slim is a good-looking Italian; Johnny and Anna have never been married.) Along with tart dialogue, Fuchs provided a believable unraveling of Steve's character, balancing emotional weight with the kinetic thrills of the genre. The script features a funny incidental bit between two armored-car employees:

while stuffing fat wads of cash into money bags, they obliviously discuss the inflating costs of soap powder and tomato juice. But the best line in the picture goes to Edna M. Holland as Steve's mother. She doesn't like Anna, never did. Steve tells his mother that Anna's "all right, she's just young," to which mother snorts, "Some ways she knows more than Einstein." Hilarious, unexpected, and dead-on. The movie was remade flavorlessly by Steven Soderbergh as *The Underneath* (1995). The remake hews closer to Siodmak's film than Tracy's book, yet it's all technique and no guts.

In addition to his consistent visual inventiveness, Siodmak directed *Criss Cross* with a palpable feeling for the uncontained power of desire and was not unsympathetic toward his characters' unattractive foibles. Siodmak and Lancaster reteamed a third time with the colorful romp *The Crimson Pirate* (1952), a monumental change of pace from their previous pair of devastating film-noir beauties.

Border Incident (1949)
Film Noir Meets Docudrama

A nthony Mann was a major American director with a minor reputation. Never a *name* director, Mann was on the second tier of Hollywood's A list. He belongs with other fine filmmakers who haven't received the due commensurate with the quality of their output, men like Mitchell Leisen *(Midnight; Remember the Night)*, Charles Vidor *(Gilda; The Swan)*, and Henry King *(Twelve O'Clock High; The Gunfighter)*. It didn't help Mann that there were two other Manns directing films at the same time he was: Delbert Mann *(Marty)* and Daniel Mann *(I'll Cry Tomorrow)*. Anthony Mann, who was never recognized with a single nomination from the Motion Picture Academy, is a particular favorite with lovers of screen westerns, the genre in which he most distinguished himself, but he was already a top-notch craftsman before getting anywhere near cowboys and Indians. Mann's movie-directing career began in B films in 1942, with titles like *Dr. Broadway* and *Moonlight in Havana*. After the war, he was one of several unknown directors, such as *Criss Cross*'s Robert Siodmak, who displayed visual and storytelling gifts in the emerging genre of film noir.

Mann's noir efforts bore interchangeably grubby titles like *Desperate* (1947), *Railroaded!* (1947), and *Raw Deal* (1948). Meshing film noir and docudrama, Mann's *T-Men* (1947) belongs to that post-war wave of black-and-white films in which the inner workings of U.S. law-enforcement institutions were brought to the screen in greater detail than ever before. With stories sometimes ripped from the headlines, these movies were part of the screen's new realism, even though today they play as dated, cheerleading glorifications of government infallibility and spotlessness. In the case of *T-Men* (made for low-budget Eagle-Lion), the awe is directed at the U.S. Treasury Department and its counterfeit-ring busters. This mini-genre—*The Street with No Name* (1948), Fox's strenuously inspiring tribute to the FBI, is another example—suffers from laughable, condescending narration, and the films' noir-ish inven-

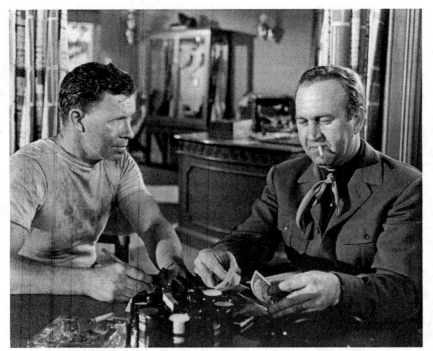

BORDER INCIDENT. Undercover George Murphy infiltrates Howard Da Silva's operation.

tiveness and "criminal" pleasures have outstripped their social worth. These movies feel least lifelike whenever they're supposedly true-to-life. With *T-Men,* you're far more likely to remember its hyperventilating steam-room murder than its rah-rahs for the Treasury.

T-Men was something of a practice run for Mann's *Border Incident,* another socially conscious film noir. Made inexpensively for MGM—a studio whose low-budget pictures looked more expensive than many an A picture made elsewhere—*Border Incident* is nearly a Southwestern remake of the urban *T-Men,* as both films follow a pair of undercover government agents who infiltrate a crooked operation. The fresh (and timely) subject matter of *Border Incident*—abuses at the U.S./Mexican border involving migrant workers—replaces *T-Men*'s more routine doings. *Border Incident* has greater humanity and singular flavor, and it keeps its self-congratulatory government-agency uplift to a minimum. Typically, its weakest scenes are those in which the Feds self-consciously assure viewers that the evil depicted is rare, and that there's nothing to fear with men such as these on the job. Mann's talents for suspense,

brutal action, and the dramatically integrated use of rugged locations—elements that would find their fullest expression when he turned to westerns—are all on view here.

The picture is sparked by its unexpected casting. In a story filled with above-par violence, the four lead roles are occupied by men primarily known as musical players. For Mexican-born Ricardo Montalbán this was his first nonmusical American picture, after three splashfests with Esther Williams and a picture-stealing guest stint (a three-way "Dance of Fury" with Cyd Charisse and Ann Miller) in *The Kissing Bandit* (1948). Tap-dancing George Murphy, of *For Me and My Gal* (1942) and a host of musicals with *Broadway* in their titles, here emulates singer Dick Powell's career path with a similar transition to gritty material. The other two roles went to James Mitchell, a trained dancer and new MGM hopeful, and Howard Da Silva, who'd made a name for himself as Jud in the original Broadway production of *Oklahoma!* (1943).

Pablo Rodriguez (Montalbán), a Mexican agent, and Jack Bearnes (Murphy), a U.S. immigration inspector, join forces in a sting operation designed to expose and dismantle a Mexican-American racket that smuggles desperate-for-work braceros (farm workers) into the U.S., pays them a pittance, then robs and murders them on their return to Mexico. Pablo goes undercover as a bracero, while Jack poses as a thief who is selling phony immigration permits. Both trails lead directly to Owen Parkson (Da Silva). The narration reveals that this story is a composite case based on factual information.

The film begins with vast overhead shots of the verdant farmlands of America's Southwest, an agricultural empire dependent on Mexican labor. But when the movie touches ground, it lands on the corrupt forces at play on the border. With work permits unable to satisfy the Mexican demand for jobs, the situation is ripe for abuse. The story begins and ends in the same locale, the Canyon of Death, the site of ambushes on homebound Mexicans, illegal aliens without lawful protection. This first attack, which ends with bodies buried in quicksand, gets the picture off to an appropriately vicious start. Soon after, the double infiltration plot is set in motion.

It's worth noting just how good Montalbán is as Pablo, a role that offers proof of his unrealized potential as a dramatic star. If more of his subsequent vehicles had been as carefully selected by MGM, he might have had a screen career of substance. Relegated to Latin-lover status, he rarely had opportunities this interesting. Yes, there's lots of

action here, but Montalbán enhances all that's required of him with unmistakable conviction. He's aided in this by the scenes depicting his developing friendship with James Mitchell's Juan Guarcia, a poor bracero unaware of Pablo's true identity. Montalbán brings a big-brother's attentiveness to these scenes, looking watchfully over his naïve friend. And Mitchell, with his believable Mexican accent (and downturning mustache), connects with Montalbán so comfortably that it's easy to root for their shared survival. In a movie this hard and unrelenting, their deepening bond affords viewers a welcome emotional investment in what transpires.

If Montalbán and Mitchell provide honorable male bonding, then Da Silva and Charles McGraw (as Parkson henchman Jeff Amboy) portray the kind of needling boss-underling alliance destined for disaster. Da Silva gives a low-key performance, playing Parkson as a seemingly legitimate, chess-playing businessman who just happens to be a crook. He isn't flashy or larger-than-life: tough and no-nonsense, but no firecracker. Actually, Da Silva's performance would have benefited from a bit more bravado. McGraw, with his growling voice that sounds as if his vocal cords had been fried, was one of film noir's great baddies. True, his best remembered role is as the cynical cop in *The Narrow Margin* (1952), but his overriding persona was that of a nasty thug who enjoyed slapping people around and sometimes killing them (as in *T-Men*). Parkson gets along far better with the undercover Jack, once the lawman finds his way into Parkson's domain. Da Silva plays these encounters—spurred by the selling and buying of illegal permits—as if he's finally found a crony with whom he can really talk, a contrast to the coarser men, including Jeff, with whom he usually deals. Parkson is weakened by his susceptibility to Jack's deception, and then by Jeff's rebellion. His empire will unravel, and Da Silva is effective in portraying the devastating contrast between his ironfisted rule and his pathetic demise.

Mann had already worked with cinematographer John Alton on several films, so by the time of this collaboration their teamwork was both artistically and technically assured. Mann and Alton showed that movies could *move,* and be very cinematic, without a camera that swirled through scenes. They often had the discerning confidence to put the camera in an intriguing place and *leave it there.* A fixed perspective, held in a long take, can be unsettling and thrilling as people and objects (such as cars) move within it, constantly altering the shape of things and

giving the immobile frame a kinetic charge. Often these camera set-ups have enormous depth, with something going on in both foreground and background. Mann favored depth-filled shots throughout his career, texturing his films with a specificity and sense of detail that inspires authenticity. And long takes subconsciously allow the viewer increased, uninterrupted immersion in a story. A scene may play in the foreground for a while, but then someone drifts into the background, changing the focus, and an established scene believably evolves into something new, thanks to the sense of reality inherent in a long take.

Another favorite device of Mann's is to place a scene's two key figures at different distances from the camera. Spatial distances between characters can create powerful, unnerving psychological tensions. Sometimes Mann's foreground figure holds a position of dominance, diminishing the stability of the background figure: as Jack climbs down stairs, away from the camera, a large hand—with a lit cigarette—slips into the foreground menacingly; or, later, when Parkson gets a phone call that reveals Jack's true identity, Jack appears demeaned by virtue of his being a few feet away from the camera-prominent Parkson, whose head is twice the size of Jack's. Sometimes the foreground figures are unaware of their own vulnerability when a background figure enters the scene: two Mexican goons are fooling around in Parkson's office when the man himself catches them in the act. A foreground figure can be knowingly vulnerable, too, as when Jack listens to Parkson and his men while waiting expectantly for the sounds of police sirens that he soon realizes won't be coming. The camera's intimacy with this sweat-inducing situation intensifies the viewer's complicity in Jack's danger-fraught mission. A close-up figure can also step out of position to reveal a surprise, as when Pablo turns from his in-your-face phone call and discovers that a woman is holding a gun on him. A climactic close-up captures the last moments of a character who is shot high atop the canyon, then falls screaming to his death with arms outstretched and his face down, missing the camera by a hair. Mann's masterly alternating use of concentrated close-ups, shots of deep range, and expansive vistas is consistently arresting and unpredictable.

Border Incident is one of those glorious black-and-white movies so jaw-droppingly beautiful that it almost makes you wish that Herbert Kalmus had never invented Technicolor. (Ironically, Alton won his only Oscar, and got his only nomination, for the saturated colors of *An American in Paris*.) This is a very dark movie, a true film noir, and the

visual excitement aroused by its assortment of light sources (headlights, flashlights, matches, etc.) is considerable, yet it never seems gimmicky or overcalculated. The imaginative variety of shadings in the black and white is integral to the movie's atmosphere, suspense, and basic drama. In a film that thrives in shadow, the starkness of headlights can startle.

No matter how much reassurance the film provides regarding U.S. dependability and might, *Border Incident* is more memorable for its scenes of torture and murder. Soon after he's established himself as a "thief," Jack is awakened at night by a long knife that creeps into the frame, pressing and tapping itself against his face. His abductors torture him in a garage, muting his screams with the revving of a truck engine. With headlights in his face, hands tied, and a metal bar crushing into him, George Murphy doesn't play the scene with movie-star bravery. He speaks his lines with tears and terror pouring from his eyes, and the impact is harrowing. In another bit of sustained volatility—something out of Indiana Jones—Pablo slices an opening in the canvas siding of a speeding truck so that he can climb out and take control of it. Eventually, Pablo is in the driver's seat but the expelled driver leaps at the door, lodging his gloved hands inside the closing window. He hangs there until Pablo pushes him to his presumed death. Later, in an abrupt and cruel act that anticipates *Psycho* (1960), a main character is killed off well before the end of the picture. He's shot in the back in an open field, in the dead of night, and then has his head bashed in, but this still isn't his end. One of his executioners mans a tank-like reaper and heads for his barely alive victim. (In another foreshadowing of Hitchcock, specifically the crop-dusting scene from 1959's *North by Northwest*, agricultural equipment is turned treacherously on a human being.) Because of this character's importance, and the fact that he's trying to crawl away, it's assumed he'll be spared. Instead, he's sliced into many pieces. It's a disquieting, stunningly assembled sequence.

Border Incident also has an expertly pieced-together suspense scene that stands out for its unusual quiet. Clay (Arthur Hunnicutt) is guarding Jack's water-tower cell (Parkson wants him watched until the permit transaction is completed). Clay keeps hearing noises: Pablo is trying to get to Jack. With rifle and flashlight, Clay stalks around in the dark, up to the water tower, but cat-like Pablo keeps eluding him, sometimes just barely. Another pain-free pursuit occurs when the Feds trail a motorcyclist headed for Parkson's place. The sequence moves from the cyclist's

appearance at the post office, the unseen observance by the lawmen, the cyclist's retrieval of the package containing the immigration permits, and then the breathless chase. Under the rare glare of daylight, the vehicles cut thin lines through wide-open spaces, with clouds of dust from their accelerating wheels. Sometimes the camera swoops along with them, and sometimes it observes from a stationary position; this alternating method is visually stimulating.

There's a whopper of a finale back at the canyon and the quicksand. The Feds arrive and one of their cars, headed right for the camera, moves in so close before it stops that it almost smashes into the lens with its STOP sign. Amid natural scenery and gun-happy action, this ending anticipates climaxes in Mann's westerns. The crisis in the quicksand— as one hand fights desperately not to let go of another—is an agitating, squirm-inducing finish that even the final narration, which speaks of "the human vultures who prey on unsuspecting victims," can't dampen. In a condescending tone, the film must make explicit that the problem is *fixed*. MGM appears overly fearful of suggesting anything but incontrovertibility when it comes to the American government's know-how, presumably the price of being allowed to tell an "official" story. (The goodwill message that countries can work together and bring forth mutual good goes down much more easily.) Despite the tacked-on feeling of the framing narration, *Border Incident* is Mann's best '40s film, one that's just about unknown. He took pulpy material mixed with social realism and turned it into a small classic of pulsating visual vitality. It may be a B in budget and casting, but it gets an A for artistry.

Border Incident is peopled with many fine character actors, most of them playing low-life scum. Alfonso Bedoya and Arnold Moss, as Mexican bandit-torturer-murderers, capably walk a fine line because they are called upon to be both horrifying brutes and comic relief. (Bedoya was just coming off his classic turn in *The Treasure of the Sierra Madre* [1948].) As with Montalbán and Mitchell, you have a Mexican and a non-Mexican trying to be credible as *equally* Mexican. (They, too, succeed.) Moss, responding to Da Silva's request to wait, has a memorable retort: "What is cheaper than time, Señor? Everybody has the same amount." Then there's Sig Ruman, handling the Mexican side of things for Da Silva. Ruman is most associated with comic roles, in classics like *Ninotchka* (1939) and *To Be or Not to Be* (1942), and is here nakedly bereft of his usually benign, overanimated self. Old-reliable Arthur Hunnicutt makes a coldly obedient Clay, and, finally, there's

Lynn Whitney as Bella (Jeff's wife). No film noir would be complete without a trashy, opportunistic, cigarette-brandishing broad. Whitney suggests Shelley Winters on a bad day, a day without makeup.

Written by John C. Higgins (with a story by Higgins and George Zuckerman), the screenplay provides a hardy, trap-setting, good-and-evil yarn. (Higgins also wrote the similarly structured *T-Men*.) *Border Incident* is set on fresh turf, and it's got brains (aside from the Feds' unfortunate penchant for lame jokes). The characters don't have the depth of those in Mann's best '50s films, but at least they are individuals. Montalbán and Murphy also appeared together, that same year, in William A. Wellman's WWII combat film *Battleground*, a prestigious product that was nominated for the 1949 Best Picture Oscar. *Border Incident* and *Battleground* gave newcomer Montalbán and old-hand Murphy their best taste of what it was like to have movie careers devoid of, respectively, swim trunks and tap shoes.

The Tall Target (1951)
John Kennedy Saves Abraham Lincoln

A nthony Mann's thriller *The Tall Target* is similar in spirit and style to his contemporary film noir works of the late 1940s, including *T-Men* and *Raw Deal*. A crackerjack suspense film produced by MGM, *The Tall Target* also happens to be an uncommonly effective piece of historical fiction and a uniquely vivid period piece. It's about an assassination attempt on Abraham Lincoln, though it's set not in 1865 but in 1861. The movie ingeniously covers a subject that is part of our history, but through an episode in which that history is temporarily averted. Lincoln isn't going to die this time, though the story's villain will utter this warning: "Mr. Lincoln's a tall target; there'll be another day." The foregone conclusion that Lincoln will be alive at the end of the picture doesn't prevent it from being a wildly pleasurable ride as one man risks his life to save the nation's new leader. That character's name just happens to be John Kennedy, providing the drama with an intriguing accidental resonance. Watching a film about presidential assassination, released in 1951, in which the main character is named John Kennedy is not an experience you're likely to forget. Set primarily aboard a speeding train, *The Tall Target* is part of cinema's long-running love affair with locomotive stories, starting with *The Great Train Robbery* (1903), and continuing with *The Lady Vanishes* (1938), *The Narrow Margin* (1952), and *Murder on the Orient Express* (1974), to name but a few. *The Tall Target* is in a class with the best of them.

John Kennedy is played by Dick Powell, near the end of his unpredictable movie career. He became a star as the bright-voiced juvenile of the Busby Berkeley musicals at Warner Brothers, a key participant in Hollywood's escapist output during the Depression. With perennial partner Ruby Keeler, "Dick and Ruby" are as synonymous with the 1930s as "Fred and Ginger." Powell introduced a host of Harry Warren-Al Dubin songs before the WB musicals ran out of steam (and lost their naughty zest thanks to the Production Code). He made one melodi-

THE TALL TARGET. Ruby Dee, Marshall Thompson, Paula Raymond, and Dick Powell aboard the train to Washington.

ous musical at Fox, *On the Avenue* (1937), but was no longer a major star by the decade's end. In the early 1940s, as his career floundered, he found his best roles in comedies, Preston Sturges' *Christmas in July* (1940) and Rene Clair's *It Happened Tomorrow* (1944). But even when he wasn't singing, he was still the upbeat Dick Powell audiences had always known. Then came a picture called *Murder, My Sweet* (1945), in which Powell was cast as hard-boiled private detective Philip Marlowe, as stunning a personality turnaround as when Fred MacMurray plotted murder in *Double Indemnity* (1944) or when Ray Milland hit the sauce in *The Lost Weekend* (1945). With pictures like *Cornered* (1945) and *Johnny O'Clock* (1947), Powell solidified himself as a principal player in film noir, completely divorcing himself from the ever-smiling, musical-comedy energy that had made him a star. To young moviegoers, it was inconceivable that *this* Powell had once been a happy-go-lucky crooner. (Try to imagine his Philip Marlowe romancing Ruby Keeler!) The noir-ish role of John Kennedy was one of Powell's last before he started directing features (the best being *The Enemy Below* [1957]) and appearing on television *(Four Star Playhouse)*. His final important screen role was as part of the ensemble of *The Bad and the Beautiful* (1952).

New York police sergeant John Kennedy is convinced that there's a plot to assassinate Abraham Lincoln, set to take place when the president-elect makes a speech in Baltimore on his way to his Washington inauguration. Kennedy had guarded Lincoln for two days when, as a candidate, Lincoln had been campaigning in New York, and he retained a strong affinity for him. Kennedy is unable to make his superior officer believe his findings (based on his recent infiltration of a secret society in Baltimore), so he acts on his own, turning in his badge and boarding a packed Washington-bound train. Without his badge, he's at a significant disadvantage. It becomes clear, when attempts are made on his life, that he's on the right track. He uncovers several conspirators, but still has trouble getting anyone to believe him and is soon wanted by the police himself. Lincoln, played by Leslie Kimmell, doesn't appear on-screen until the final scene.

In a rare move, *The Tall Target* has no music in its opening credits. As the names of the film's contributors crawl upward, the only audible sounds are those from a train station: whistles, bells, and engines, an eerily hushed beginning to a film of considerable action and stamina. After "Directed by Anthony Mann," a paragraph of text informs us that we are about to see "a forgotten chapter in the history of the United States," and that this movie is "a dramatization of that disputed journey." Okay, so it's not factual, but it's a thoroughly plausible "what if." History doesn't feel predetermined here; the story is unsettling because it dramatizes the randomness of the events that shape our future. The Civil War is presented as inevitable *only* if Lincoln can get to his inauguration. Set in New York and Baltimore, and aboard a train and in several stations, the movie portrays a remarkably urbanized world for 1861, a moment in time that predates both the Civil War and most western tales. The film has a relatively contemporary charge; its period, though impeccably achieved, never feels quaint. When a character says, "Must all you New Yorkers be so insufferably boorish?" it feels like the first-recorded instance of that sentiment.

Powell has a lot of running and fighting to do as Kennedy, but his performance is brought to life not by action-star durability but by the drive and integrity that ignites his outward actions. Kennedy is a likable, honorable guy because Powell endows him with an alert, intelligent, and unstoppable commitment to his task. The character is not, however, political. It's his personal interest in Lincoln that guides his mission and grounds the film beyond the mechanics of a chase. His feeling for the

new president stems from the small contact he had with him over those two days the previous fall. Late in the movie, Kennedy recounts that experience to someone whose help he needs. It's Powell's most emotional moment, even though it's entirely whispered because of the delicacy of his predicament. He speaks of the seemingly insignificant moments he shared with Lincoln, whose kindness made an enormous impression on him, concluding with "I was never so taken with a human man." All the lines are simple and straightforward, and that's how Powell renders them. For Kennedy this experience transcends duty, and for Powell this scene bares the depth of feeling that has been unobtrusively apparent all along. Kennedy is a true hero, and Powell wears that heroism from within, as a natural component of the man.

The Tall Target continually surprises, as in the cast of suspicious characters it assembles, a combustible assortment of Northerners and Southerners. In most films about the Civil War era, the lines are clearly drawn, but here individual ideologies can't be assumed based on what states the characters are from. The film thereby captures a feeling of the volatility in that moment when Lincoln was about to take office. Mrs. Alsop (Florence Bates), the pushy abolitionist from Boston, is an expected Lincoln supporter, but Mr. Ogden (Will Wright), the building-supplies businessman from Hartford, is a reminder that there were Northerners who despised Lincoln because of the money they were going to lose in the impending war. When a trio of Southerners boards the train in New York, heading for "Tall Trees," the scene gives off a strange tingle: I never imagined pre-war Southern belles visiting Manhattan. Atlanta beauty Ginny Beaufort (Paula Raymond) is familiar, but her maid, Rachel (Ruby Dee), is perhaps the most emotionally complex slave character that had yet been seen on the screen. Also aboard are Mrs. Gibbons (Katherine Warren), a severe secessionist, Lt. Lance Beaufort (Marshall Thompson), Ginny's cold, West Point-educated brother who has brought along a rifle, and Col. Caleb Jeffers (Adolphe Menjou), a Lincoln-hating militia man who leads "Poughkeepsie's Finest." And, as in any good thriller, some characters are not what they pretend to be. (Paula Raymond and Marshall Thompson, playing siblings, come through for Mann as they had before in his 1950 *Devil's Doorway*.)

The movie sustains its thrills by constantly changing what its protagonist is up against, raising the stakes at every turn. Once aboard the train, Kennedy searches for his colleague, Tim Reilly (Regis Toomey), the man who has been holding his ticket. With Kennedy desperate to

locate his friend, the film begins as a missing-person thriller (à la *The Lady Vanishes*). Then, after Kennedy finds Reilly's corpse, realizing it was he himself who was the intended victim, it becomes a whodunit. He finds the killer (Leif Erickson), who has not only taken Kennedy's ticket (from Reilly) but also, far worse, his name. Now the movie becomes a paranoiac thriller; Kennedy must work awfully hard to prove his identity. Before the killer's demise, he reveals to Kennedy a clue that moves the lawman closer to identifying the person he's after. The main villain is revealed halfway through the movie (just *before* it might become easy to guess), and Powell makes plain the moment when Kennedy starts to suspect this person seriously, several scenes before the truth comes out. But he does it so subtly that it doesn't impinge on the fun. No longer a mystery, the film turns into a battle of wills and wits, with Kennedy soon wrongly "wanted" by just about everyone and having to conceal himself aboard the train. In the Philadelphia station sequence, there's a troubling scene after Kennedy calls upon the local authority, his old pal Coulter (Richard Rober), for help, only to have Coulter take sides against him because of the word he receives from the New York police, who are no longer supporting Kennedy. Coulter is a good man, sensible in his belief that Kennedy is in the wrong, and merely doing his job. The lines have blurred, and it nettles the viewer to see our hero being pursued by the good guys too, and having to fight them as well. Always upping the ante, *The Tall Target* emphasizes the isolating terrors of acting alone.

Anthony Mann devised shots that dazzle both in their cinematic command and their storytelling ingenuity. In one scene, Powell walks through a train car, moving forward into what becomes a low-angle close-up. Suddenly, his expression changes, and the camera sidles around him, lowering to reveal a gun planted in his back. It's a stunning single move that places the viewer right up against this unnoticed public act. Here, and throughout, Mann and his writers are unstintingly clever at getting Kennedy into no-way-out situations, then providing the pleasure of believable circumstances that save the day. As Kennedy rests on a bed, with a newspaper over his face, a man moves toward him with a gun (after checking to see that it's loaded), then fires point-blank into Kennedy's news-covered head. It's a shocking moment, but it ends up becoming one of several episodes in which Kennedy's resourcefulness bests someone else's. And once it looks as though the assassination has been thwarted, Mann ratchets up the suspense to an even greater

degree for the finale. The build-up to the climax begins with a surefire bit involving the communication of vital information via finger writing on a foggy window of the Baltimore-departing train and culminating with a brutal fistfight set between cars as the train roars along.

A fascinating aspect of this film is the relationship between Rachel, the slave, and Ginny, her mistress. It's in no way reminiscent of Miss Scarlett with either Mammy or Prissy. The feeling expressed between the women is deeply affectionate, even familial, as long as Rachel is obedient. As played by a luminous Ruby Dee, Rachel is a sad-eyed, serious young woman, as introspective as she is kind. She's an open, honest presence who will find herself caught between her desire to do right (by helping Kennedy) and her complicated ties to the Beauforts. The movie is to be commended for not simplifying the matter. Rachel's standing up for herself, against the only life she's ever known, is treated with the weight it deserves, acknowledging the courage and fear involved. Dee conveys the pain and difficulty within Rachel's bravery, gracing the character with an unforced strength and dignity. Regally beautiful Paula Raymond also deserves praise for not making Ginny dismissible as a bitch. Ultimately, their bond feels too emotionally intertwined to be undone even by what the future holds.

In an inspired counterpoint to the picture's impassioned intensity, there are two characters who are defiantly unconnected to the politics of the story but essential to its movement: the conductor and the engineer. Will Geer (best known as Grandpa Walton) is the conductor, Mr. Crowley, a prissy, by-the-book man who will not let anything get in the way of his on-board duties. That this turns out to be a hellish, incident-crammed journey is a consistent source of credible comedy because it derives from the character's persnickety professionalism. He's concerned only with tickets and timetables, so murder and mayhem are pesky inconveniences. Even more extreme is Mr. Gannon (Victor Kilian), the exasperated engineer. His sole interest is in keeping to the schedule, and he takes every delay brought on by Kennedy and company as a personal affront. In caring for nothing but speed and punctuality, he's an irresistible contrast to those passengers in the grip of national intrigue. Kill Lincoln if you must, but do not interfere with the efficiency of either Crowley or Gannon. Their obliviousness grounds the movie in the world of everyday life—two men just doing their jobs—and Geer and Kilian are wonderful in their portrayals of harassed single-mindedness.

Paul C. Vogel's black-and-white cinematography heightens the sensation of a train's claustrophobia by contrasting the tight, narrow corridors and cramped quarters with enormously expansive shots, staggering in their depth, of the train stations (especially New York's and Philadelphia's), often enhanced by cottony clouds of steam. There's also an incidental, but welcome, piece of period detail involving the dragging of the train's cars, by horses, through the center of Baltimore because the local women passed a law protecting their laundry from engine smoke.

It's a great relief that the writers weren't compelled to create a romance between Kennedy and Ginny, mucking things up unnecessarily. Written by George Worthing Yates and Art Cohn (story by Yates and Geoffrey Homes), the screenplay provides the makings for both a twisty, fast-paced popcorn movie and an unexpectedly affecting look at a shaky moment in our history. The assassination of four years later hangs over the final moments, a bittersweet conclusion to seventy-eight minutes of electric moviemaking. Hair-raising thrills and emotional depth in one package is all one could ask for—and that's an apt description of the best of Anthony Mann's work.

The Killing (1956)
The Emergence of Stanley Kubrick

When the awesomely revered director Stanley Kubrick died in 1999, months before the release of his long-awaited *Eyes Wide Shut,* he was as famous for his obsessively long shooting schedules, the increasing number of years between his films, and his reclusive lifestyle in London as he was as the maker of classic films. The Bronx-born director, who made only thirteen features, is most associated with his nonrealistic works: the doomsday satire *Dr. Strangelove* (1964); the sci-fi art film *2001: A Space Odyssey* (1968); the futuristic and cautionary *Clockwork Orange* (1971); and the horror movie *The Shining* (1980). However, the picture that put Kubrick on the Hollywood map bears little relation to the aforementioned titles. *The Killing,* a black-and-white piece of unglamorized pulp, is about the planning, execution, and aftermath of a racetrack robbery. Kubrick had already made two movies, *Fear and Desire* (1953) and *Killer's Kiss* (1955), but they were child's play compared to *The Killing,* probably the last great work of true film noir. Not only is it a visually arresting movie—something to be expected from a 27-year-old wunderkind like Kubrick—but it's also lean, fleet, and unpretentious, three qualities regrettably missing from Kubrick's later work. In *Eyes Wide Shut,* Kubrick's overly painstaking approach resulted in a deadly movie; his talent seemed all but atrophied and his once prodigious sense of humor—see *Lolita* (1962) and *Dr. Strangelove*—dried up. Released by United Artists, *The Killing* is a film that's so kinetic, jazzy, and in love with filmmaking that it appears to be the official granddaddy to the oeuvre of Quentin Tarantino. Though prized by film-noir aficionados, *The Killing* still hasn't received the widespread attention it merits.

To pull off a very ambitious and risky robbery of two million dollars from a racetrack, ex-con Johnny Clay (Sterling Hayden) has organized a quartet of accomplices: a bookkeeper, a crooked cop, and two of the track's employees (a bartender and a cashier). The film charts the reasons for each of the men's involvement in the operation, and why

THE KILLING. Marie Windsor up to no good with no-good Sterling Hayden.

the scheme is destined to go awry. George Peatty (Elisha Cook), the cashier, is married to Sherry (Marie Windsor), a cunning woman with her own plans for the loot.

The Killing is an anatomy of a heist, yet it's no dispassionate, just-the-facts exposé because the characters are red-blooded and their desires vital (even sympathetic). Though decidedly B-grade, the noir-tested cast comes through with first-rate performances conceived with economical brush strokes. Mike (Joe Sawyer), the track bartender, has signed on to be "an inside man" because he needs the money to afford good doctors for his sickly wife. In the brief looks at his home life, Sawyer's Mike comes across as a gentle, loving man who cares for his grateful wife without complaint. Instead of being a generically greedy member of a mob, Mike is a believable individual with a specific reason for resorting to crime. The same is true of Randy (Ted de Corsia), the cop who has come on board because he owes three grand to a loan shark and sees no other way out. As the robbery draws near—as well as during and following it—our involvement is intensified by what we know of these men and what they have at stake.

Another distinctive component of *The Killing* is its tricky structure, which fiddles with time in a nonlinear manner. With ten main characters to keep track of, the movie often jumps back in time so that we can see simultaneous events separately, allowing for a more complete understanding of the operation, witnessed from multiple perspectives. Confronting the structure's potential for confusion, the movie utilizes extensive narration from an omniscient voice (rather than a character in the story). Spoken by Art Gilmore with humorless gravity, the narration now sounds like a *Dragnet* parody. This is the film's one element that feels dated, though it undeniably clarifies the action without being too intrusive. Subtitles might have accomplished the same thing more neatly but, as it stands, Gilmore's drone is a consistent component of the film's makeup, part of its inexorable, energized drive. So, you hear things like "About an hour earlier," "At 2:15 that afternoon," and "Forty minutes before." Movies such as *Citizen Kane* (1941) had already told stories with complicated flashbacks, but *The Killing* owes much of its jangled rhythm, disorienting impact, and potential for surprise to its ongoing use of fast, compact, and unforeseeable time flips. This is particularly effective once the robbery is activated, as loose ends of the mission are tied up *after* we've seen the crime begin. We don't find out how the money left the track until hours after the completion of the job, but *The Killing* plays fair with audiences, never jerking them around pointlessly. The time flips are integral to one's enjoyment, ensuring that this is not just another robbery flick.

Sterling Hayden was a graduate of the crime genre, having starred in John Huston's celebrated caper *The Asphalt Jungle* (1950). *The Killing* is superior to Huston's classic because it lacks the earlier film's talkiness and moralizing. In both movies, Hayden is a mighty lug, used as much for his physique as his acting. He's especially good in *The Killing*, as a commanding leader with a gruff surface, but also a desperation and panic he tries not to expose. After five years on Alcatraz, he jumps right back into the game, hoping that a big pay-off will finance the life he's planning with fiancée Fay (Coleen Gray). In their first scene together, it's clear that they have just had sex (Fay is finishing dressing; Johnny buckles her belt), though they are as yet unmarried. (I guess the censors that year were too swamped condemning *Baby Doll* to notice.) Hayden's Johnny—not to be confused with his title role in *Johnny Guitar* (1954)—truly loves Fay, appreciating her loyalty during his incarceration and handling her with kid gloves. The bland and pretty Ms. Gray seems too

much the naïve girl next door to be credible as someone who waited five years for her criminal boyfriend to get out of the slammer.

If Johnny and Fay, and Mike and his bedridden wife, show us couples committed to each other, then the film finds balance in depicting one of the worst, most twisted marriages in screen history. You don't expect a meticulous dissection of a dysfunctional coupling in the midst of a snappily paced suspense yarn, yet in several concentrated scenes *The Killing* portrays a blackly comic horror of cohabitation. Elisha Cook, best remembered as gunman Wilmer in *The Maltese Falcon* (1941) and billed here without his usual "Jr.," gave the performance of his career as George, a man so in love with his monstrous wife of five years that he can only be described as masochistic. George is a shnook, a weakling doomed to humiliation and hurt feelings, yet Cook conveys his love so poignantly and pitiably that George is never the joke he could have been. His part in the crime is necessitated by his futile quest to hold on to Sherry, to be able to satisfy her with *things*. It's pathetic to watch him absorb or overlook her jibes, but Cook's George is not a dummy; he's just a man irrationally in love and incapable of behaving any other way. Later, after Sherry lies to him about being raped by Johnny, Cook deepens his characterization, becoming scarily unstable and painfully consumed with jealousy.

You would expect a character like Sherry to fit into the mold of hard-boiled, low-voiced broads, yet Marie Windsor finds inventive ways to behave badly. Perhaps second only to Jan Sterling in *Ace in the Hole* (1951) as the screen's most entertaining bad girl, Windsor gives a flashy performance that all but steals this very macho movie. She and George live in a dingy apartment, yet Sherry is mostly seen in expensive-looking lingerie. Her blond hair, enormous eyes, and painted face add to the extremeness of her presence; she sometimes appears to be almost a spoof of womanly allure, though she's not above spitting on her mascara brush. (You can't help but notice Windsor's facial resemblance to Joan Crawford.) She's first seen lounging, reading a magazine, and not making eye contact with George as he speaks to her. Sherry is bored and lazy, clearly imagining herself meant for better things. Standing a few inches taller than Cook, Windsor smilingly cuts him down further with effortless digs at his manhood. Windsor gives Sherry a sweetly feminine voice; her light, melodic inflections wickedly accentuate the acid in her remarks. She's viciously funny because she's so ironically coy, almost playfully so. When George tells her about the big money

coming his way, she says sarcastically yet brightly, "Did you put the right address on the envelope when you sent it to the North Pole?" There's a sly self-conscious tone in Windsor's acting; Sherry's obviousness makes her belittling of him a perverse game. Because he's so gullible and devoted, she's cynical enough not to bother with any subtlety in her pokes at him, sadistically amusing herself in her passive-aggressive power over him. Windsor is immense bad-girl fun here, putting on a heartlessly enticing show; her unflustered demeanor makes Sherry one of the more soulless of film-noir females and possibly the most casually ruthless.

It's no surprise that Sherry has a lover, the dark and studly Val (Vince Edwards). At his apartment, Val makes a comment about her eating him alive, and she provocatively responds, "I may just do that." The screen fades to black, affording Sherry her chance to make a meal of him. When the scene fades back in, Sherry turns Val on to the idea of foiling the heist. Their plan leads to a key scene between Windsor and Hayden, pitting the immoral Sherry against the corrupt yet honorable Johnny. It's refreshing to watch Sherry get nowhere with him, spotted on sight for what she is: "You'd sell out your own mother for a piece of fudge." Even so, she makes plain her sexual availability, eager as she is to learn all she can about the job. Johnny and Sherry are both smart and hard, but she has a veneer of purring softness around her steel center.

Two other guys are added to Johnny's scheme, each fulfilling one specific function for a fixed price rather than a percentage of the take. Maurice (Kola Kwariani) is a hairy-backed wrestler with an unintelligible accent, hired to start a brawl at the track, and Nikki (Timothy Carey) is a sharpshooter hired to assassinate the favored horse during the big race. Carey makes an invaluable addition to the film, an unsettling and unpredictable presence whose loose manner and easygoing laughter only make him more disconcerting. He has uneducated-sounding speech and a teeth-clenched line delivery, as if doing a Kirk Douglas imitation. (Carey appeared with Douglas in Kubrick's sobering 1957 anti-war film Paths of Glory.) A low-rent Jack Palance or an early variation on Christopher Walken, Carey could have stumbled into Pulp Fiction (1994) and been right at home. In the scene in which Hayden offers him the job, Carey cradles a puppy while talking about his gun's capability, a startling mixing of tenderness and brutality. When Nikki is later parked and waiting in his car for the race to begin, the African-American parking attendant (James Edwards) comes by for some polite

conversation. Nikki obliges, but when the fellow returns, and with time now of the essence, Nikki shockingly calls him the N-word just to get rid of him. In this tiny subplot, the film unexpectedly delivers a stinging blow, a callous display of using racism as a surefire and efficient way for Nikki to get what he wants.

Finally, there's Marvin (Jay C. Flippen), the bookkeeper who has put up the front money for the job. Marvin is a pal of Johnny's, and his attachment to the brawny ex-con has a distinctly homosexual connotation. Flippen, who plays Marvin with an adoring gaze aimed Hayden's way, says early on, "There's nothing I wouldn't do for Johnny." His interest in the job seems to be more about being close to Johnny than it is about the money. On the morning of the hold-up, the two men speak briefly. From his bed, Marvin says to his soon-to-be-married friend: "Wouldn't it be great if we could just go away, the two of us, and let the old world take a couple of turns, and have a chance to take stock of things. It can be pretty serious and terrible, particularly if it's not the right person. Getting married, I mean." Hayden's Johnny is oblivious and exits without a second thought. But Kubrick closes in on Flippen's face, exposing the vulnerability and disappointment of such an exposed and hopeless admission. Marvin gets drunk.

It's thrilling to watch the intricacies of all aspects of the stick-up, especially since it's filmed with a lucidity and clarity that allows the audience to feel like participants in the crime. There's a great bit with Randy inside his cop car, about to head off to the track when a bathrobed woman comes out of a building and runs to him gratefully, exclaiming, "Come quick, they're killing each other." It's a chilling moment when he looks at her, then, without a word, ignores her and drives away, leaving her stunned. But it's Johnny who is the main player in the robbery, armed and clown-masked and seeing to it that the racetrack employees fill his duffel bag with the loot. Because the movie gives us foreknowledge about some things and leaves us in the dark about other things, it's stimulating and unbalancing to be partially complicit and partially clueless. When he tosses the duffel bag out a window, we don't know why. Kubrick saves this missing piece of the puzzle—seen in a five-second flashback—for when the other guys are talking about it while waiting in Marvin's apartment for Johnny and the cash.

Two big scenes follow the crime, first a bloodbath in an apartment, featuring jazzy music on the soundtrack and a jagged, hand-held point-of-view shot of the carnage, which includes a comically positioned

face-down corpse splayed across a sofa with his legs stiffly aiming diagonally upward, supported by the sofa back and evoking Superman coming in for a landing. (Tarantino, or what?) The second scene is the airport climax, one of the great ironic endings of film noir, hinging on the actions of a toy poodle! The tension, which has never wavered, is sustained to the film's final seconds. At eighty-three minutes, *The Killing* is a model of succinct storytelling and rhythmic pacing. Kubrick's assured control—he's as skilled with the George-Sherry scenes as he is with the suspense—results in a film that moves with the propulsion of a fired bullet.

Though it surely is enjoyable to watch the men enact their different roles in the heist, you may conclude that Johnny has actually made the whole operation more elaborate than necessary, including more steps and pass-offs than required. But the movie would be less enthralling if Johnny had downsized his imagination. With pulp novelist Jim Thompson, Kubrick wrote the film's biting screenplay, based on the Lionel White novel *Clean Break*. The screenwriters retained the book's zigzagging continuity but added the homoerotic and racial undercurrents (plus the climactic poodle). This is a film noir that prefers daytime to nighttime. Though its dark indoor scenes are marked by stark overhead lighting and bright lamps, much of the film is shot in unsparing daylight, spotlighting the grubbiness of the milieu. There isn't one attractive set or location in *The Killing*, just shabby apartments, bars, locker rooms, betting lines, and terminals. Kubrick and cinematographer Lucien Ballard also make striking use of tracking shots in the apartment scenes. When Hayden walks through several rooms of Flippen's place, the camera seems to break through walls to keep up with him, observing him through furniture and lamps between him and the camera. Such moments make the characters seem like animals roaming freely within cages, almost as if the walls and objects were inching in on them. Gerald Fried's ominous, pounding, and periodically jazzy score works as the film's metronome.

Sterling Hayden went on to play the mad, cigar-chomping General Jack D. Ripper, obsessed with "our precious bodily fluids," in Kubrick's outrageously inspired *Dr. Strangelove*, giving the best (and certainly the funniest) performance of his life. But *The Killing* should not merely be classified as the movie that led to Kubrick masterworks like *Lolita* and *Dr. Strangelove*; it should take its place among those masterworks.

Pretty Poison (1968)
A 1960s Twist on a 1940s Formula

You know the plot—the one in which a tough, smart, cynical man is duped, and perhaps undone, by a beautiful, deceitful, grasping woman—it's a staple of black-and-white films of the 1940s, pictures that came to be classified as film noir. Mary Astor feigned helplessness to manipulate detective Humphrey Bogart in *The Maltese Falcon* (1941), and Barbara Stanwyck and Lana Turner got, respectively, Fred MacMurray in *Double Indemnity* (1944) and John Garfield in *The Postman Always Rings Twice* (1946), to assist them in doing away with their husbands. Jane Greer wheedled Robert Mitchum in *Out of the Past* (1947), and Yvonne De Carlo was bad news for Burt Lancaster in *Criss Cross* (1949). And what about evil psychologist Helen Walker and her destruction of Tyrone Power in the great *Nightmare Alley* (1947)? In most of these cases, and countless others, the men—dazzled by beauty, sexual availability, and ego-bolstering tests of courage—are no matches for a femme fatale's machinations, and they are oblivious to their own susceptibility. In 1968, a little movie named *Pretty Poison* took this decades-old formula and gave it a bracing spin. The film's male character isn't a typically hard-edged realist, but, rather, an emotionally immature arsonist with an overripe imagination. And in place of the expectedly glamorous, experienced woman, there's a seventeen-year-old, honor-roll vixen whose ruthlessness is concealed beneath all-American, girl-next-door perfection. *Pretty Poison* is every bit as eye-opening and disquieting as its classic predecessors, but it ups the ante with comic overtones. Not a flat-out comedy, it's nonetheless a startlingly funny, offbeat mix of smiles and chills. Made in color (and, therefore, not truly *noir*), *Pretty Poison* is played straight, and its twisted story emerges from the most commonplace surroundings.

Dennis Pitt (Anthony Perkins) is released from a psychiatric institution, his home since, at age fifteen, he set fire to his house and accidentally killed his aunt. Now a grown man on probation in the real

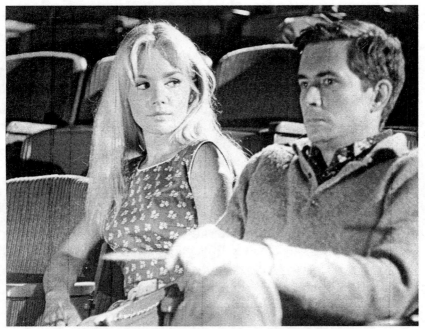

PRETTY POISON. At the movies with Tuesday Weld and Anthony Perkins.

world, Dennis uses his flair for fantasy to make something out of his banal new life as a chemical-plant employee in a Massachusetts town. Passing himself off as a secret agent, he intrigues pretty, blond Sue Ann Stepanek (Tuesday Weld), a high-school senior. The two become romantically linked as Sue Ann assists Dennis in his fabricated mission to protect the northeast's water supply from sabotage. She's such a game pupil that she manages to expand their clandestine activities to include murder. Dennis, merely a play-acting C.I.A. member, finds that the girl he has lied to (and now loves) has a very real and guilt-free capacity for reckless cruelty.

For Anthony Perkins, the role of Dennis came eight years after his Norman Bates in *Psycho,* the character for which he is best remembered and the one that essentially put a choke hold on the rest of his career. His maladjusted Norman—a nervously funny, creepy mama's boy—is an ingeniously deranged piece of work, and Perkins became the poster boy of screen oddballs. Though he had been playing extremely sensitive young men since the mid 1950s, in films like *Friendly Persuasion* (1956), *Fear Strikes Out* (1957), and *The Tin Star* (1957), Norman put him over the edge. In the *Psycho* aftermath, Perkins got only one great

role, and that's Dennis Pitt. It's not exactly a real change of pace from Norman, but Perkins uses his previous performance as a kind of artistic springboard for his more expansive, varied, and self-aware work as Dennis. (Hopeless, browbeaten Norman wasn't capable of Dennis' tricky emotional transitions.) *Pretty Poison,* in a way, picks up where *Psycho* leaves off, if, say, Norman were deemed fit to return to society. Perkins is superbly cast as Dennis because the role begins in expected Perkins territory, then both he and role (and film) shoot off in surprising directions. In the pre-credits scene, he's being released from an institution by his case officer, Mr. Azenauer (John Randolph), who warns him about there being "no place at all for fantasies" in the real world. Perkins plays the scene with a tiny smirk and a coolly sarcastic air, making it clear that Dennis, though undoubtedly a misfit, is not brittle or fearful. Perkins never resorts to cheap, obvious displays of quivering instability; his is a disciplined, smartly worked-out performance. In his mid thirties, and very fit and lanky, Perkins is strikingly handsome in this movie. As in *Psycho,* it's doubly disturbing to see a comely, well-mannered boy revealed as a strange, potentially dangerous force. His first sight of Sue Ann, marching with the high-school drill squad, brings a wide grin to his face. He pursues her in the only way he can.

Dennis replaces the confinement of his incarceration with the loneliness of a dead-end job and a trailer home. When Sue Ann comes to the hot dog stand where he's lunching, there's only one way he can engage her: as a fantasy version of himself. (As Dennis and the stand's proprietor chat, Sue Ann's baby-blue convertible pulls up in the background; the situation is rife with anticipation as she arrives, so much so that the top of the stand's coffee pot blasts off, as if in warning.) At first Perkins, banging his head on the stand's awning when he meets her, is familiarly gawky. Tuesday Weld is luminous, a flesh-and-blood Barbie doll who could pass for Jessica Lange's sister. When she uses the pay phone, he moves in on her with, "Don't say a word; act perfectly natural; we're under surveillance." Perkins is a real treat, speaking very tersely, handing her a small bottle, and rattling off orders about their necessary rendezvous that evening (a movie theatre balcony). Then he darts off. Perkins is suddenly a teenage boy, thoroughly embodying Dennis' James Bond fantasy, a persona that gives the inexperienced character an authoritative role to play, something that hides his non-entity feeling. Because of his total immersion in this make-believe, Perkins is highly entertaining and consistently funny. His all-business seriousness and

his cloak-and-dagger paranoia create a faux world-weariness that is blissfully nutty. He gets the tasty, ironic bite out of every silly thing he says, such as, "Be careful, emotions can be fatal in things like this," or, looking at a small bottle of liquid, "Looks so innocent; what a damn deceptive world." And his penchant for elaborate, made-up acronyms is an ongoing source of loony pleasure. (Perkins had made a delightful Cornelius in *The Matchmaker* [1958], but his Dennis is his most inventive and vivid comic work.) The secret-agent pose makes him seem even more boyish, yet it also allows Dennis to incarnate a man of confidence, buoyed by his show of bravado. (His chemical-plant job is, of course, his "cover.") He's really just a guy with a crush who is too insecure to handle it without pretense.

In contrast to Perkins' zealous antics is Weld's amused self-possession. She knows how desirable she is to him (and most everyone), and as they come together it's like watching Walter Mitty hook up with Lolita. She may have a pink phone, a girly wardrobe, and a painting of ballet dancers over her bed, but she's no ordinary miss. This is a gal who is gleefully available for unconventional thrills. Sue Ann feels cramped by her mother (Beverly Garland), a brassy, sexy single mom who enjoys men herself but keeps a watchful eye on her willful daughter. Garland, best remembered as the new wife on television's *My Three Sons,* is terrific here: shrewd, bitchy, larger than life yet nobody special. She can be a harshly intimidating, cigarette-waving force, tagging Sue Ann a "slut." The women share a competitive relationship that is both physically and mentally combative. In the scenes in which he gets caught in their crossfire, Perkins weakens Dennis' mock self-assurance; when not calling the shots, he's unsure and nondescript.

When Azenauer tracks him down at his job (for violating his probation), Dennis tells him that he's not going back with him, and he means it. Perkins carries the urgency of someone finally making a go of things, someone who'll not let anything, especially the baggage of his past, thwart his progress. Dennis' happiness may be based on lies, but he feels more *real* than ever, and he's in love. Emboldened by the relationship, Perkins emits new strength in what life as an "agent" and a lover has brought Dennis. The actor's vulnerability stems from the character's realization that Sue Ann represents his first chance at living, and he flashes an angry desperation to hold onto this. He convinces Azenauer to leave him alone. Even after Dennis loses his job, Perkins keeps him riding high on a wave of rebellious independence and sexual gratification.

Dennis plans to take revenge on his boss by destroying the exterior chute that discharges the plant's chemical waste into the river. Sporting wrenches, he and Sue Ann go about loosening the structure's bolts, in the dead of night, so that it will collapse in the morning. The sight of the golden-haired, pink-sweatered Weld, wrench in hand, is perversely adorable. And then Sue Ann shows her true colors. When a night watchman's flashlight catches Dennis in the act, Perkins' eyes freeze in terror, revealing a boy stripped of his fakery. When Sue Ann bangs the watchman on the head with her wrench, the game is officially ended. Weld is horrifyingly matter-of-fact here, as we see her casually dump the body in the water, steal her victim's gun (which means, naturally, that it will reappear later), and behave as if all has gone according to plan. Perkins, expressing that for all Dennis' anti-social behavior he's still a feeling human being, looks shaken to his core, watching with contained horror as she straddles, and drowns, the dying man. Her sadism has no context; she's amoral. While Perkins appears dazed, Weld smilingly utters, "God, what a night." Sue Ann wants to make love after all the excitement, as she will later on after another murder, but Dennis, in both instances, is too sickened to oblige. Perkins captures the desolating trauma of seeing something that began so harmlessly—his man-of-mystery ploy—result in something so unalterably dreadful. Dennis can feel the responsibility of his actions, a guilt he has already known with regard to the fiery accidental death of his aunt.

Now more panicky than in control, and decidedly less funny, Perkins continues to flesh out Dennis' daunting, touching realization that the game has turned ugly; the innocence in his performance is sullied by grim, inescapable truth. He is, by now, the cause of two unintended deaths. Yet he still clings to his C.I.A. status, thinking it's the way, however effortful, to sustain his vital connection to Sue Ann, despite having seen what she's capable of. Dennis is a classic film-noir chump; a user who gets used, a manipulator who is manipulated. He eventually tells Sue Ann about his long-ago act of arson (because she finds out about it), and Perkins delivers this monologue with childlike emotionality and painful immediacy, tearing at a weed as he relives a tale of sexual shame, brutal beating, and impulsive spite. It first appeared that Dennis was wielding the power in this relationship, with his no-nonsense espionage swagger, but now the unperturbed Sue Ann is doing the thinking. And it falls to Dennis, the unwitting realist, to see things as they are. As Perkins becomes more tightly wound and confused, Weld

assumes dominance, without breaking a sweat. (In her room, she packs her "getaway" suitcase as blithely as if she were choosing frocks for a spring-break vacation.) Her cold-bloodedness gives off a vibrant heat.

Perkins' performance deepens as Dennis sees more plainly what he has meant to Sue Ann, though his love remains constant and informs the choices he makes. The actor's calm, though numbed, resignation reveals that Dennis has, in a sense, at last grown up. And it's heart-breaking. A fascinating aspect of Weld's work is that she never makes explicit when Sue Ann knows what she knows, or when she decides what she decides. She's seductively enigmatic, devoid of vulnerability, and brazenly unfeeling. Her Sue Ann is every bit as convincing as the fresh, adventure-seeking dreamgirl as she is as the heartless, violence-aroused sociopath. She and Perkins, both naturals at playing the comedy straight, are, individually and as a team, quite sensational. (They appeared together again in 1972 in the unrelievedly glum *Play It as It Lays,* an empty movie about empty lives.) Unfortunately, the movie ends with two cop-out scenes that make it unnecessarily certain that justice will eventually be served. Up till then, though, *Pretty Poison* takes no prisoners.

The most significant element of the film's visual scheme is its use of the color red. From the blouses of Sue Ann and her drill team to the bottled chemicals on Dennis' assembly line, red foreshadows the blood yet to be spilled. The at-work scene, in which Dennis' imagination fe-verishly merges images of the red-clad high-school girls and their bare thighs with the marching red-filled bottles and pulsating machinery set before him (intercut with flashes of his smile and Sue Ann's face), climaxes with a crash of the system; it's a harbinger of the sex and thrills to come, as well as inevitable disaster. Red is also conjured in fleeting flashbacks of the fire that began Dennis' story. Throughout the film, a red barn or a police car's red rooftop light has the power to vivify the image. All this is in contrast to the humdrum, apple-pie America that serves as background.

Pretty Poison is based on Stephen Geller's novel *She Let Him Continue* (bravo to whoever changed the title for the film). The resulting screen-play, which expanded the book's comic potential and psychological intricacies, won the New York Film Critics' award for writer Lorenzo Semple, Jr. Semple did an ace job of fusing the story's comic and dra-matic tones, its mundane and outrageous events, its old-time film-noir elements and late 1960s daring. (Its successful meeting of exhilarating

comedy and explicit violence was in keeping with the previous year's *Bonnie and Clyde*.) The movie was directed by Noel Black in a clean fashion that heightens the ordinariness out of which extraordinary things spring. He gets all of it right: the nowhere town; the comic euphoria of Dennis' gift for invention; the subtle power shifts between the lovers; and the script's fluctuating perceptions of innocence and evil. With a naïve bad boy and a damsel causing distress, *Pretty Poison* remains a knowing, audacious shocker.

III. Love Stories

S creen love stories are as old as movies themselves, so essential is
romance (and the climactic kiss or clinch) to our vicarious pleasure
and satisfaction. Every moviegoing generation has its love-story
touchstones, from *The Big Parade* (1925) to *Casablanca* (1942) to *An
Affair to Remember* (1957) to *The Way We Were* (1973) to *Brokeback
Mountain* (2005). This chapter looks at five different kinds of love stories,
each challenged by a specific conflict: class difference; limited time; an
unexpected love triangle; marital ups and downs; and same-sex love in
a straight world. Though the circumstances vary, all of these relation-
ships have the power to sweep you away.

The Student Prince in Old Heidelberg (1927)
Silent Operetta

I
t seems bizarre that operas and operettas were brought to the screen in the silent era, a period in which such properties would inherently be devoid of their most basic element. Of course, moviemakers weren't aware of just how soon talkies would revolutionize the industry, so why not go ahead and bring these surefire, popular plots to the screen? In 1925, MGM had two major successes in this area, Erich von Stroheim's expectedly lavish reworking of Franz Lehar's operetta *The Merry Widow,* starring John Gilbert and Mae Murray, and King Vidor's adaptation of Giacomo Puccini's opera *La Bohème,* also starring Gilbert, this time with Lillian Gish. In the hands of the esteemed German-born Ernst Lubitsch, who had been a Hollywood director since 1923, *The Student Prince in Old Heidelberg,* based on Sigmund Romberg's 1924 operetta *The Student Prince* (whose source material was Wilhelm Meyer-Förster's novel *Karl Heinrich* and the subsequent play version), was another hit for MGM and the best of their silent opera/operettas. It's a glorious piece of work that manages to bring substantial emotion and visual radiance to what is, admittedly, a slight story. In fact, it's hard to imagine any live performance of the operetta carrying the heartfelt simplicity and rhapsodic sweep of Lubitsch's production. In not trying to inflate the film with any "importance," Lubitsch made a movie whose rather considerable importance is conveyed through its vibrant spontaneity and its carefully constructed investment in its main character, played by Ramon Novarro at the peak of his stardom, soon after his phenomenal success in another title role, *Ben-Hur* (1926). Playing opposite him is Norma Shearer, an up-and-comer of the silent era who was about to reach her zenith with early talkies, just as Novarro was sliding into obscurity. Speaking of obscurity, MGM also made a silent version of the operetta *Rose Marie* (1928), which starred an unthinkably young Joan Crawford.

Even people with a casual knowledge of old movies are probably familiar with the term "the Lubitsch touch." It was the director's sig-

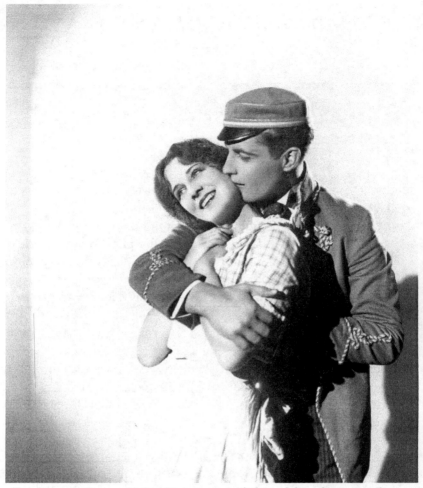

THE STUDENT PRINCE IN OLD HEIDELBERG. It's the real thing for Norma Shearer and Ramon Novarro.

nature way of communicating information to the viewer, a sly, indirect approach that skirts the obvious. Equal parts cleverness, lightness, and suggestiveness, it's easier to recognize than define or describe. But here's an example. In his enchanting sound version of *The Merry Widow* (1934), a full-scale *singing* operetta, a portly king exits his queen's bedchamber. Once he passes, the trim soldier standing guard leaves his post and enters her room. The king then realizes he has forgotten his sword and re-enters the boudoir. The camera remains outside the double doors, expecting a noisy confrontation once the king discov-

ers his wife's infidelity. Nothing happens. Then the king emerges with his sword on its belt, but he's unable to get the belt around his waist: it isn't *his*. So, instead of letting the king catch the philandering queen in her lover's arms, or having him notice some piece of evidence that denotes an intruder, Lubitsch allows the king to make his discovery in a most delightful, suspenseful, and unexpected manner. Wordless, too. The "touch" is particularly prevalent in a silent work like *The Student Prince* because of Lubitsch's mastery at finding purely visual means to convey, enhance, and vitalize emotion.

Karlsburg's king, Karl VII (Gustav von Seyffertitz), brings his young nephew, Crown Prince Karl Heinrich (Philippe de Lacy), to the palace in preparation for his future. He will receive his education from a tutor, Dr. Jüttner (Jean Hersholt, long before his "humanitarian award" immortality). In 1901, Karl (now Novarro) reaches college age and is off to university in Heidelberg with the loyal Jüttner at his side. Having lived an isolated and lonely life, Karl blossoms at school, soon as popular and carefree as any of his classmates. He and Kathi (Shearer), the barmaid at the inn in which he resides, fall deeply in love even though there's no hope for a future together. The king's illness prompts Karl's return to the palace, which leads to the young man's deathbed promise that he'll marry the princess the king has selected for him. Karl becomes king, but before his wedding he makes an impulsive final visit to Heidelberg and Kathi.

Adapted for the screen by Hans Kraly, the film begins with the king's carriage ride to meet young Karl at the train station, zipping through town as adoring crowds amass on the streets. The sight of the king is a cue for all the men to remove their hats, which becomes a beautiful montage of images that go from dark to light as the blackness of the hats gives way to the predominantly gray or balding heads. The chorus-line precision and graceful editing turn the men's rote gestures into something of unanticipated beauty, getting the movie off to a wondrous start. Then comes the arrival of the boy Karl, delivered into the hands of the cold, dour king, and the movie, with this sympathetic situation, is immediately as dramatically compelling as it is visually. A timid child in short pants, Karl is frightened by the cannon blasts that welcome him (displeasing the king), but is soon waving joyously to the ecstatic children that greet him as the royal carriage breezes through town; the king's hand reaches into the frame to pull the boy back in his seat, among the first of many adjustments to his natural impulses. That is

the essential story of *The Student Prince,* a young man's struggle to obey his destiny, forced to deny and suppress his true self. Since Karl is an open, loving boy headed for a formal, arranged life, it's an unfortunate match of man and vocation. In public scenes, there are occasional title cards quoting citizens' envy of Karl's life and future, which serve as a poignant counterpoint to the truth. The bars of the palace gates are a prison, and the course of Karl's life is more about the things he must give up rather than the privileges afforded him. The arrival of Jüttner, who is as warm and obliging as the king is distant and strict, brings the prince his only emotional connection to his new life. As teacher, best friend, and surrogate daddy, Jüttner is a lifesaver.

Novarro first appears when a dapper photograph of the prince is put on public display. Lubitsch takes this glamorous glossy and bleeds it into the contrasting image of the actual prince, staring from a window with eyes downcast and fingers absentmindedly tapping. Karl freezes in the presence of the king and his minions, coming to life only in Jüttner's company. Novarro, who has one of those grins that melt celluloid, is a playful innocent in his early scenes with Jean Hersholt's Jüttner, which intensifies the character's innate conflict with the future set before him. The gap between Karl's animated nature and the pain of stifling his feelings is continually touching. Novarro doesn't play Karl's unbound elation and his mounting despair as two separate gears but rather as ingredients in his performance that feed directly off each other. The affectionate bond he shares with Hersholt is a most pleasing aspect of Novarro's work, highlighting the fact that every other part of Karl's life is unreflective of who he is. He has a great capacity for love, an instinct given little value in the formation of a monarch. With childlike candor and genuine yearning, Novarro gives an ageless performance.

The Heidelberg inn scenes, in which a carousing male ensemble sustains itself with a steady flow of beer, have the uncontained merriment and drive of musical numbers. Lubitsch builds the party atmosphere with boisterous business, such as Kathi being carried on male shoulders as the men march around the tables. When Karl at last joins in, Novarro's buoyant glee makes the scene play as a kind of coming home, a release into a world that lets him be himself without stricture. Even after he reveals his identity, he manages to sustain the festive mood by shaking as many hands as he can, which permits everyone to continue treating him as an equal. Novarro has an artful comic moment in which he drinks what may be his first beer. He gulps, then stops and

takes a quick glance to see how much is left in his glass (about half), then looks heavenward for the strength to finish, closes his eyes, and drinks. Soon, he's the life of the party and drinking thirstily. Novarro is attuned to the significance of this lighthearted scene: Karl's immersion in a brotherhood, an end to his alienation. Much later, when Karl returns as their king, he meets up with the old gang; they are now unable to treat their sovereign with familiarity. As Novarro makes his way down a receiving line, shaking hands with old buddies, he makes an extraordinary transition. Lubitsch films it in one long take, and Novarro, who begins by recapturing the camaraderie Karl once knew in this company, delicately comes to the sobering truth (as he moves hopefully from man to man) that what he sought to reclaim is gone. These one-time party animals are now a stiff brigade, and since Novarro's enveloping warmth can no longer unleash their true selves, the scene stings. In an explicitly painful acceptance of this eye-opening yet inevitable situation—even Karl's lively past has been dulled by his position—Novarro is quite moving.

But even more than the companionship of schoolmates, it's his romance with Kathi that remakes his life. They meet when she rushes outside the inn to greet him on arrival, presenting him with flowers and reciting a prepared speech. It's a delight that she forgets her words, even with strenuous prompting from other inn employees, until Jüttner intervenes and feeds her the next line: Shearer's face lights up and she bursts forth with the rest of the piece (to everyone's relief). As attention surrounds Novarro, the camera follows Shearer as she moves left, behind Novarro, to get a full look at him. She does this twice; she likes what she sees. It's a nice private moment in a public scene. When she shows Karl his bedroom, she inadvertently embarrasses him with her proud display of his mattress' worth. As she obliviously bounces her hand on it, Novarro's eyes dart in all directions, unable as he is to ignore the sexual element of such a demonstration. His discomposure is charming. Karl first steps out of his shell when he's alone with the cake that Kathi baked to welcome him. In a metaphoric dramatization of Karl's burgeoning abandon, he cuts a thin slice of cake and tastes it gingerly. He likes it, and chomps down more of it until it's quickly gone. Then he cuts a big fat slice. (Score another point for the Lubitsch touch.)

In the entrancing infatuation scenes between Novarro and Shearer, the stars perform a courtship marked by bouts of nervous laughter, numbing awkwardness, and unconcealable sparks of mutual attraction.

Following that first late-night beer party, they engage in an amorous outdoor chase, which the camera tracks, moving (from left to right) when they move, stopping when they stop. Novarro grabs at her but she pulls away, and the camera follows, blocked from them every few yards by foliage-covered stone columns. Shearer fights him off again, then hurries off, with the camera in pursuit. Well, the camera comes to the next unblocked view but no sign of Ramon and Norma; they are otherwise engaged. The camera waits patiently for them to emerge. Lubitsch knew that it would be more fun if their smooching weren't visible, and so a potentially standard love scene is made imaginative and memorable. Then comes a scene of sheer visual rapture when Novarro carries Shearer down a flower-covered hill and twirls her in his arms before they settle on the ground, surrounded by white blooms on a black night. It's as if the couple were superimposed upon a background of stars. The dreamlike artificiality is heightened by the hypnotic moment in which a powerful wind blows the flowers fiercely while the lovers remain motionless, transfixed by each other. (This idyllic scene will be contrasted with a later one when they return to the now flowerless hill.) One of the reasons this romance has such force is that, no matter how much fun they are having, Karl and Kathi invariably get to one of those moments in which their eyes meet and the depth of their feeling comes to the surface, humbling them and impelling them to cherish what time they have together. There's never a cloying moment because the two stars communicate first love with persuasive ingenuousness. Their good cheer disguises the impending truth they work so hard to keep at bay.

Reality arrives when the prime minister comes to Heidelberg to inform Karl of his uncle's illness and that Karl must "assume the reins of government." There's such fragility in Novarro's playing of Karl's angry resistance to this end of everything, especially leaving Kathi. Karl doesn't learn of his arranged marriage until he arrives at his uncle's deathbed. The roiling ache and desperation on Novarro's face externalizes Karl's romantic anguish, utterly blotting out everything else: concern for his dying uncle; his nearing ascension to the throne; the end of his studies. Novarro is so good in the role because his emotions are so available, which enriches the story of a man who must learn to guard emotion thoroughly. A more contained actor would lessen the irony. At the very end, crowds cheer the royal coach holding Karl and his princess bride on their wedding day. In a brilliant stroke, Lubitsch

never shows us the woman's face because it doesn't matter who she is. She isn't Kathi, and that's all that counts. Novarro, his face conveying both despondency and resilience, nods graciously to his people. Then he takes a quick glance at the unseen woman seated beside him and smiles slightly, as if to a stranger (which she is). As the film fades out on the melancholy of Novarro's expressionless face, the image is as haunting as Greta Garbo's gaze at the close of *Queen Christina* (1933), or Mia Farrow's at the end of *The Purple Rose of Cairo* (1985). There's something everlasting in these expressions, something so deep and forever ponderable that it's impossible to imagine the characters' next moments.

This is an exquisite physical production, but it's a film that moves with such flow that it never seems heavy, in no small part due to the weightless mobility in the camerawork of John Mescall (who went on to photograph *Bride of Frankenstein* [1935]). The story couldn't be simpler, hardly fresh even for 1927, but the treatment is so honest and detailed that it turns Ruritanian corn into a great romantic movie. (Later films with the same royalty-commoner romantic troubles include two gems, *Roman Holiday* [1953] and *The Swan* [1956].) Lubitsch never passes over any opportunity for the characters to express their feelings, making sure that these operetta figures are never cardboard. There isn't a moment where his energy lags, and he never shows signs of effort.

This has to be Novarro's finest performance. It's full, richly thought-out work, with a mature development, particularly surprising in what might be assumed a frivolous role. As Karl, he often looks strikingly like a Latino Gene Kelly. Novarro's heavily Mexican-accented English would accelerate his undoing once the talkies arrived (let's face it, he sounds a lot like Maria Montez). The talkies severely limited his casting potential, and he would no longer be credible in a Teutonic role like Karl. The fact that he could sing meant that he had some initial box-office success in the early-sound era but it didn't last long. The Depression was creating electric male stars like Cagney and Gable, while Novarro seemed stuck in the exotic romanticism of the 1920s. By 1935, the year of his final MGM star vehicle *The Night Is Young* (similar in plot to *The Student Prince*), the illusion had been irrevocably smashed: Novarro's singing, speaking, and waning looks could never compete with the sublimity of his silent face. Once a screen god, he was brought earthbound by sound (and poor choices) and seemed to be a different person. It's mystifying that he could be so marvelous—not just handsome, magnetic, and pho-

togenic, but really talented—in silents, then appear to be almost clueless about acting if talking were involved. Novarro had a minor Hollywood comeback in 1949 and 1950 as a Latino character man, appearing in four films, including John Huston's problematic yet daring and unfairly forgotten *We Were Strangers*. He would make his final screen appearance in George Cukor's *Heller in Pink Tights* (1960).

Though Shearer isn't as natural as Novarro is here, her Kathi is still one of her better performances. She's spirited and funny and wistful. She married MGM's boy wonder, Irving Thalberg, in the year of this movie and was on her way to become one of the major stars of early talkies, the epitome of a modern: free-thinking, thrill-seeking, and impossibly chic. (She wasn't beautiful but she did have a stunning profile that she made certain got lots of screen time.) Her acting often consisted of posing in satiny Adrian creations, and her charm and presence could quickly be dampened by hopelessly phony attempts at emotion, as in *A Free Soul* (1931). Better at warmth than nuance, she gave perhaps her best performance in the gentle soap *Smilin' Through* (1932). But even George Cukor, who guided her mostly crisp work in *The Women* (1939), couldn't prevent her from mucking up that classic's final moments with her grotesque notion of "acting." Cukor also wasn't able to enliven her heavy "comic" performance in *Her Cardboard Lover* (1942), her screen swan song. The Novarro of the 1930s and the Shearer of the 1940s bear almost no resemblance to the winsome creatures of *The Student Prince*.

Lubitsch found great success in the talkies, helping to launch the new musical genre with *The Love Parade* (1929), then as the premier creator of sophisticated continental comedies, such as *Trouble in Paradise* (1932), *Ninotchka* (1939), and an underrated sparkler called *Angel* (1937). He made stinkers, too, like *Design for Living* (1933) and *Bluebeard's Eighth Wife* (1938), both coincidentally starring Gary Cooper. Lubitsch's prowess carried into the 1940s *(The Shop Around the Corner, To Be or Not to Be, Heaven Can Wait)*, until his death at fifty-five in 1947.

MGM remade *The Student Prince* in 1954 (with Romberg's melodies) and fashioned it as a follow-up for the stars of *The Great Caruso* (1951), Mario Lanza and Ann Blyth. Lanza didn't make it to the screen, but he provided the singing voice for his replacement, the lost-looking Edmund Purdom. The plots of the two films are ostensibly the same, but the remake has the opposite dramatic arc of Lubitsch's picture: instead of an ardent young man who must learn to fit a rigid mold,

Purdom's Karl is a pompous, arrogant snob who must learn to loosen up. The resulting movie, directed by an apathetic Richard Thorpe, is one of those out-of-touch affairs that hastened the demise of the MGM musical. Despite Ansco color and CinemaScope, it's as dated and plastic as the silent version is fresh and invigorating.

One Way Passage (1932)
Kay Francis and the Glamour of Doom

In the case of Kay Francis, the lightly lisping, raven-haired clothes-horse of Hollywood's Golden Age, the age-old question—the one about whether a film personality is an acting talent or simply a movie star—is a no-brainer. Francis was *all* movie star, and her skin-deep approach to emoting could never be confused with acting. And, as with all true movie stars, it doesn't matter a damn. It's not hard to see why Depression audiences made Francis a box-office attraction. Yes, she was beautiful but, more than that, she was exceedingly glamorous. It has often been said that women went to her films just to see what she would be wearing, but her appeal went beyond the mere modeling of the latest fashions. Francis projected a very likable persona, and mov-iegoers responded to the warmth and charm that she exuded in such an easygoing manner. Most of her vehicles are ludicrously melodra-matic, and it's difficult to remember which is which once you've seen a number of them. What lingers in the memory is the image of Francis floating through these movies, suffering and suffering, but always nobly. With titles like *I Found Stella Parish, Secrets of an Actress,* and *Living on Velvet,* you know what you're in for (in the last one, George Brent actually makes fun of her lisp!).

I've recently made my way through most of Francis' movies, and I've been more than a little surprised by how much I've enjoyed her in them. What is a film star if not someone who keeps you coming back for more despite the guaranteed mediocrity of most of her output? Because of her limitations as an actress, there's something very reas-suring about Francis in her soap operas. The characters' problems are usually too outrageous to impinge on real life, and so you're in a world of make-believe, a place where Kay Francis, aglow with conviction, can right wrongs tirelessly and always with a smile. Lacking the depth to create full-blown characters, she obliviously glides through her pic-tures with an air of certainty that's comforting in its blissful unreality.

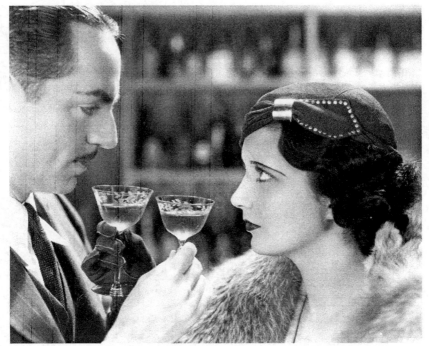

ONE WAY PASSAGE. Paradise cocktails for William Powell and Kay Francis.

And her bouts of saintliness are offset by the sheer magnitude of her costume changes. No one with that much style could ever be dismissed as a drag. Francis usually played professional women, including more than her share of doctors and stage actresses, two occupations that put considerable strain on her credibility while upping the films' escapist quotients. Most of her films are fodder for a Carol Burnett spoof. If they were better, would they be as fun? When it came to suffering in satin, nobody did it as well as Kay.

The film for which Francis is best remembered is Paramount's *Trouble in Paradise* (1932), a supreme sophisticated comedy and one of director Ernst Lubitsch's key works. Alongside skilled pros Herbert Marshall and Miriam Hopkins, Francis needed only to be lovely and captivating (result: she's flawless). Another standout Francis picture is *Confession* (1937), an exceptional you-don't-know-I'm-your-mother saga, marked by Joe May's visually striking direction. But the quintessential Kay Francis movie has to be *One Way Passage,* released the same year as the Lubitsch film, making 1932 the peak of her career. The best product of Francis' time at Warner Brothers (1932-39), *One Way Passage* is one of

the great old-fashioned romantic movies of the 1930s. To some it may play as a virtual checklist of its genre's clichés, yet the film transcends convention. When melodrama is served as expertly as it is here, the outcome is both memorable and moving. Directed by Tay Garnett, *One Way Passage* is a model of compact pacing; it adroitly balances dramatic and comedic material; it features fluid camerawork that enhances the stylishness of its storytelling. Movies were just emerging from the static nature of most early talkies, and *One Way Passage*'s cinematography has a liberating mobility that enlivens the picture. With five extremely likable main characters, a compulsively absorbing plot, and shimmering production values, *One Way Passage* is a film whose heightened reality is always anchored by honest emotion.

After a love-at-first-sight encounter in a Hong Kong bar, Dan Hardesty (William Powell) and Joan Ames (Francis) meet again aboard a San Francisco-bound ocean liner. Their love deepens, yet each carries a secret that would spoil the magic: Dan, an escaped convict, has been caught by police sergeant Steve Burke (Warren Hymer) and will be hanged for murder soon after the ship arrives in Frisco; Joan is dying of a bad heart and any excitement will only shorten what life she has left. They have no future, but nothing is going to stop them from squeezing a lifetime of happiness into four weeks at sea. Near the end of the voyage, they make a date for New Year's Eve, one month away, though it's unlikely that either of them will be able to keep it.

That synopsis probably got you smiling, either from recognition of old-movie narratives or amusement at the era's schmaltzy innocence. I think you'll be surprised at how sincerely affecting this movie still is; much of that is due to the chemistry between Francis and snazzy William Powell. (This was their sixth, and final, film together, the first four made for Paramount, the last two for WB, and all of them released between 1930 and 1932.) Powell, an impeccable screen actor whose gifts are timeless, is ideal for this movie because he's incapable of succumbing to its potential for hackneyed sentiment. His restraint and sympathetic dignity go a long way in putting the story across. There's also a tenderness in his performance that he rarely got to display once *The Thin Man* (1934) made him a light-comic superstar at MGM. Perhaps the most vital virtue of Powell's work here is its impact on Francis. She's nowhere near his class of actor, but his focus on her, his solicitude, breaks through her glazed façade. Though she's able to play only the overall mood of any given scene rather than anything subtler,

she connects with Powell and they make a radiant pairing.

It's not a problem that Powell gives a refined acting performance while Francis delivers a star turn because Powell has the more complex character. Dan has not only found true love, but he's also plotting an escape during the ship's stopover in Honolulu, all the while dealing with a policeman's ever-watchful eye. Dan's mind is always ticking, always thinking ahead, whereas Joan allows her newfound love to banish all other thoughts. Francis has no difficulty capturing the uncluttered zest of someone committed to savoring every last drop that life has to offer. It helps Powell that Dan's problems are reasonably plausible, while Francis' Joan is dying of movie disease. She never looks anything less than devastating in her literally to-die-for Orry-Kelly wardrobe, and her illness manifests itself with nothing grimmer than an occasional fainting spell. (You've never seen anyone look so healthy.) Joan, a perennial innocent, and Dan, the man who lives by his wits, are complementarily united in love. Plus, in evening clothes, who looks as swell as Powell and Francis?

This isn't a love story in which the pair has misunderstandings or rows (they already have enough to deal with), and therein lies one of the story's more appealing strengths. There's something very transporting about a love this absolute, this immediate, with never a doubt or question. It is, after all, love in the movies, based on nothing more than its sheer undeniability. Dan and Joan meet when she accidentally causes him to spill his drink at a Hong Kong bar. They turn to face each other, fall instantly in love, and are soon toasting with their prophetic Paradise cocktails. After they drink, Dan breaks off the top of his cocktail glass by banging it against the bar, then sets down the glass' stem. Joan does the same, placing her stem on his. Not only do they have *their* drink, but also a glass-breaking ritual that they will repeat often (in the second instance, Joan initiates the action). Another hyper-romantic moment comes when Dan and Joan sit on a Honolulu beach. As they speak, the smoke of his cigarette dreamily wafts over their faces. She asks him for a cigarette (against doctor's orders) and, with his hand, he pushes his lit cigarette against the unlit one now in her mouth. They kiss. The camera follows Dan's smoking hand as it moves downward. He flings his cigarette in the sand, and the camera quickly locates it and holds it in the frame. A moment later it is joined by her flung cigarette. End of scene.

One Way Passage's bewitching qualities are compounded by two characters who assume the roles of fairy godfather and godmother to Dan and Joan. Skippy (Frank McHugh) is a petty thief who runs

aboard the ship as it's leaving because the Hong Kong police are chasing him. Barrel House Betty (Aline MacMahon), traveling as the Countess Barilhaus, is a confidence woman focused on the bank account of a wealthy Englishman. Skippy and Betty are old pals of Dan's, and they make it their mission to help him however they can. (The scene in which they finagle to get Dan out of the brig, without copper Steve knowing about it, plays like fairy-tale magic, of the sticky-finger variety.) McHugh's performance is essentially one very long drunk scene, used for comic effect, yet he manages to pull it off without becoming tiresome. His run-ins with the ship's bartender (Roscoe Karns) are particularly funny, but McHugh never loses sight of the fact that underneath the inebriation Skippy is a devoted friend. He also brings relief when he reveals that the guy Dan murdered was "the dirtiest heel that ever lived." In this movie, friendship is as indestructible as love. The affection that Skippy and Betty bestow upon Dan (through their actions) is touching because the film, keeping the tone light, doesn't belabor the point. Like Dan and Joan's love, it just *is*. McHugh's comic antics, most of them brief, are nicely timed, well-constructed bits that do their part in preventing the film from becoming a series of lovey-dovey scenes. Now and then, McHugh employs his trademark singsong laugh, familiar from countless WB films of the 1930s.

Things are more complicated for Betty. She makes it her business to distract Steve (the cop who captured Dan) with her feminine wiles. As played by Warren Hymer, Steve is a goofy flatfoot, one not meant to be taken all that seriously, and he's certainly no match for Betty. Yet even Steve is eventually softened as he witnesses the deep love shared by Dan and Joan, and his transition makes him genuinely attractive to Betty. Hymer moves from one-dimensional copper to sweet, thoughtful lug, and Aline MacMahon poignantly exposes Betty's increasing yearning for a reformed, on-the-level life. (Predating Barbara Stanwyck's Jean in *The Lady Eve* [1941], Betty is a con artist who falls for her prey.) Betty and Steve, both worn out, meet at the right time. As they come together, the movie now has a parallel romance, another one initially built on secrets but one with the possibility of a future. MacMahon, one of the enduring pleasures of early '30s movies *(Five Star Final, Once in a Lifetime, Gold Diggers of 1933)*, has a sharp wit and a seen-it-all humanity that, like McHugh's shtick, help to steer this movie clear of mushiness.

One Way Passage has a great ending. Suffice it to say that director Tay Garnett's roving camera (photography by Robert Kurrle) seems able to

go anywhere, and provides a finale that is unforgettable, both visually and dramatically. How could Depression audiences resist this kind of ravishing escapism? They didn't; it was a big success. (Garnett's most famous film is *The Postman Always Rings Twice* [1946], unlike *One Way Passage* in its emphasis on sex rather than love and nastiness rather than heart.) This is a polished movie-movie, the kind that Mia Farrow's *Purple Rose of Cairo* character would have been delighted to step into. It's only sixty-nine minutes, yet what more could you want?

The screenplay was written by Wilson Mizner (one of the subjects of Stephen Sondheim's musical *Bounce*) and Joseph Jackson. Based on a story by Robert Lord, *One Way Passage* has a bang-up premise; Lord deserved the Oscar he won for Best Original Story. The movie was remade as *'Til We Meet Again* (1940), which is a half hour longer and devoid of magic. Merle Oberon and George Brent played the leads, with Pat O'Brien and Binnie Barnes taking over for Hymer and MacMahon. Frank McHugh, repeating his role, was back for another ride. Oberon, another dark-haired beauty with a flair for clothes, had about the same acting range as Francis but lacked her warmth.

There's a scene in this movie that epitomizes the kind of star that Kay Francis was (she died in 1968). She has just fainted, and Powell is carrying her to her stateroom bed. Francis doesn't let her legs dangle unattractively while in her leading man's arms. Instead, her legs are unnaturally straight and crossed perfectly at the ankles (which makes Powell look like he's hauling a statue). If Francis is to be carted around, she's going to do it beautifully or not at all. I doubt this was a conscious choice, merely the instinct of a movie queen. I'm not complaining.

Rachel and the Stranger (1948)
The Love Triangle

One of the many lovely things about RKO's *Rachel and the Stranger* is its confident refusal to pin itself to one particular genre. It's a comedy, no doubt, yet it's more of a smile-inducer than a laugh riot. Though it's set in the backwoods of the early nineteenth century, it's some kind of western, since it features a fiery Indian attack on a homestead. It certainly contains scenes of tender drama that deal with the paralyzing effect of grief on a family after the death of a loved one. It's very definitely a piece of Americana, a hearty tribute to the backbreaking lives of our forebears. And it almost has enough musical interludes to qualify as a hybrid musical. But, first and foremost, *Rachel and the Stranger* is a love story because that's the way in which its story builds and blooms, the way in which a viewer becomes invested in its characters, and the way in which its plot must find resolution. And within its love story, the film offers one of the more satisfying—both funny and sexy—love triangles of the screen. There are no scenes of physical love, but the romantic and erotic tensions stimulate in their suggestiveness. The reason it all works so beautifully is the casting. Loretta Young, at the apex of her film career, stars as Rachel, and her leading men are two up-and-comers, William Holden and Robert Mitchum, each as talented as he is good-looking, and both about to become superstars of the next decade. This trio works together astoundingly well, each very different from each other yet perfectly in tune. (This was the only time that any of the three appeared together.) As with other blessed Hollywood match-ups of one female alongside two males—*Test Pilot, The Philadelphia Story, The Talk of the Town, Bull Durham*—spending time in their company is exceedingly pleasurable.

When she was fifteen, a radiantly pretty Loretta Young starred opposite Lon Chaney in the silent *Laugh, Clown, Laugh* (1928), a bit of sentimental masochism. She made the transition to talkies as one of

RACHEL AND THE STRANGER. William Holden finds wife Loretta Young with an attentive Robert Mitchum.

the more natural of young actresses, in charmers like Capra's *Platinum Blonde* (1931) and lusty, pre-Production Code quickies like *She Had to Say Yes* (1933). After the Code became the watchdog of screen content, Young's star continued to rise, and she was soon the premier leading lady of the newly conjoined Twentieth Century-Fox, starring in popular pictures such as *Suez* (1938) and *The Story of Alexander Graham Bell* (1939). She was used primarily for her beauty and warmth, and most of her roles didn't demand very much from her. Like the careers of other female stars who began in the silent era—Norma Shearer, Greta Garbo, Joan Crawford—Young's took a dip in the early 1940s. Shearer and Garbo opted for retirement, but Young, like Crawford, waited out the lean years only to become more successful and respected than ever. Two 1947 comedies, *The Farmer's Daughter* and *The Bishop's Wife,* in which Young played the title roles, were big hits and unexpected competitors at Oscar time. The former brought Young the Best Actress Oscar, and the latter was a Best Picture nominee. These likable, featherweight movies were bolstered by the keen professionalism and light touches of Young and her co-stars. In 1949, more whimsy (and another Oscar

nomination) came her way with *Come to the Stable.* It's this cinematic comic threesome for which Young is best remembered, overshadowing *Rachel and the Stranger,* which would be just as beloved if more people knew about it.

Even after serving in World War II, and despite a role as a killer in *The Dark Past* (1948), the William Holden of the late 1940s still embodied the wholesome young man that audiences responded to in *Golden Boy* (1939) and *Our Town* (1940). *Rachel and the Stranger,* like *Dear Ruth* (1947) and *Apartment for Peggy* (1948), is one of the last appearances of the boyishly appealing, sweet-faced William Holden. Billy Wilder would alter Holden's career decisively when he mined the actor's astonishing capacity for cynicism in *Sunset Blvd.* (1950), thus paving the way for his future in films. Robert Mitchum became a star (and an Oscar nominee) in combat in the uncompromising *Story of G.I. Joe* (1945) and followed it with two fine, taut 1947 toughies, *Crossfire* and *Out of the Past.* His specialty—potent masculinity with unexpected gentleness—was already established, but in *Rachel* he found his best showcase for his insinuating comic talent (and his undersung singing skills). This movie was released amid tabloid hysteria surrounding Mitchum's arrest for marijuana possession. Despite this, or aided by it, *Rachel and the Stranger* was a box-office hit.

"Big Davey" Harvey (Holden) has been helpless in putting his life, and farm, back together since the death of his wife Susan. He's determined to give their boy, young Davey (good, unaffected Gary Gray), a real home again, and so he sets off to find a new wife/mother despite the boy's resistance. At the nearby stockade (the closest thing to a town), Davey buys Rachel, a bondwoman, for eighteen dollars now and four owing. To make things decent, he marries her and off they go to his cabin in the woods (though they won't be sleeping together). Rachel is treated as a servant by both father (who is uncomfortable around her) and son (who resents her), even though she works hard to fit in. A visit from Davey's pal Jim Fairways (Mitchum) changes the domestic dynamic. Jim is smitten with Rachel and notices, to her delight, her many wonderful qualities. Suddenly, Davey sees Rachel as Jim sees her, and his friend's attentiveness makes him jealous. Jim thinks Rachel ought to be a real wife (his), and he and Davey will come to blows over her. But not before Rachel is fed up with both of them. (The "stranger" is Davey, the man she marries but doesn't know, but the "stranger" could also be the unexpected Jim.)

No one thinks of Robert Mitchum's singing when this masterful screen actor is mentioned, but he had a remarkably easy, assured, and lullingly beautiful voice. (Can anyone forget his terrifyingly rapturous hymn-singing in *The Night of the Hunter* [1955]?) *Rachel* begins similarly to *Oklahoma!* as Jim ambles into the frame, strumming his guitar and singing for the sheer pleasure of it. Instead of "Oh, What a Beautiful Mornin,'" he croons, "In O-hee, O-hi, O-ho-o…" Jim is a hunter but he might just as well be a strolling balladeer. Mitchum establishes the laid-back tone of the picture, a believable rhythm for a tale of long-ago rustic living. Jim arrives at Davey's place and learns of Susan's death from the boy. (Davey and Jim had been rivals for Susan; Jim lost out because he was too "wild and woodsy.") As Jim talks to the boy, the stunning shot (black-and-white cinematography by Maury Gertsman) includes the far-off, tiny figure of Davey, atop a hill, at Susan's grave.

In a plot move that anticipates *Seven Brides for Seven Brothers* (1954), Davey goes in search of a woman, with love not part of his goal. His boy needs schooling, and the house needs tending, and Davey wants to do right (and be true to Susan's refined values). Holden is both touching and funny in Davey's many expressions of embarrassment and awkwardness. Inside the stockade, it's poignant when he's unable to reveal the fact of Susan's death to a questioning passerby. (It's more than he can bear in such a casual, public setting.) With no time wasted, Davey buys Rachel, marries her, and brings her home. Playing these scenes in a businesslike manner, Holden emphasizes Davey's aching discomfort by trying to conceal it. (He pulls the borrowed ring off her finger seconds after the ceremony.) Of course, Davey is terrified by the notion that Rachel *could* be more than a servant because he's still committed to Susan's memory. He doesn't know how to act: he opts to sleep alone by the fire, giving Rachel the bedroom; he allows her to continue calling him "Mr. Harvey." Holden plainly carries a widower's grief, and also a new husband's shyness and, eventually, a threatened man's anger. Unsure and naïve, and full of crosscurrent emotion, Holden fulfills his role thoroughly.

Like Jane Powell's Milly in *Seven Brides*, Rachel has her hopes for a new start soon dashed. (The film also recalls *Rebecca* as a new wife fights the memory of her seemingly flawless predecessor.) Davey wants Rachel to have all of Susan's skills but not take Susan's *place*. His manner is impersonal, and his son wants nothing to do with her. They don't want to know who she is. (Even Musket the dog resists her.) Rachel,

practical and uncomplaining, doesn't force herself on them. She gets on with her chores and takes everything in stride, but Young makes it clear from the first that Rachel was hoping this marriage would be authentic. Her Rachel is tenderly available to be a wife and mother, hoping to be met halfway and eager to make a home. Young absorbs the hurts, picks herself up, sometimes talks to herself, and builds up our affection for Rachel with every passing scene. Often without words, the actress conveys Rachel's yearnings and disappointments, her spunk and her sensitivity. Let's face it, Young hadn't been a star for twenty years for nothing. She is confidently understated here and fully in control of her ability to communicate with the camera lens. When in a role not as good as this one, Young sometimes appeared to be more aware of the way the light struck her cheekbones, and the presumably adoring gaze of her fans, than on the scene at hand.

The return of Jim changes everything. He's come out of the woods with a sudden yen for domesticity, talking of marrying even before he sets his stunned eyes on Rachel. After all the tension in the Harvey cabin, Jim is a welcome burst of gregarious personality. He's kind and respectful to Rachel, and it's invigorating to see someone make her smile. Davey and Jim are once again romantic rivals. The three central performances are recharged and transformed here. Mitchum is now in charismatic-charmer mode, and his Jim re-enters the film like a magical figure (a bit like Cary Grant's angel in *The Bishop's Wife,* who also got a distracted hubby [David Niven] to appreciate an overlooked wife played by Young). Young is at last allowed to blossom, as Rachel enjoys this newfound attention and is able to be herself. Jim treats her as "Mrs. Harvey" rather than a servant. Finally, someone is interested in *her,* and her warmth and charm flow freely. Holden is comically frazzled as Davey tries to behave as an actual husband so as not to embarrass himself in front of the competition. Jim asks Rachel if she can play the spinet (Davey never asked), and they are soon making some infectious music together, via spinet and guitar. Holden pouts, but he also emits the pain of Davey's loss in this reminder of long-gone evenings of music. He reaches for Susan's metronome (which arrived from Paris after her death), a steadily clicking reminder of her and the fact that she's gone. In Holden, we see both Davey's inability to let go of the past and his burgeoning interest in the newly fascinating creature—his wife—across the room.

When Mitchum says good-bye, Holden puts his hand on Young's shoulder in a blatant, forced display of marital accord and normalcy.

Aided by Young's restrained stupefaction, it's a sublime moment, characteristic of the film's comic ease (laughs are never telegraphed). Now comes the question of how to woo one's own wife. The stop-start love scene that follows is a sweetly romantic coming together of a confounded man trying to find a way to express himself and a woman pleased by his change of heart but not quite able to trust it. It's like they're meeting for the first time. Davey asks Rachel if Jim's behavior was "offensive" to her, knowing full well that it was anything but. "I thought he was mighty nice…and cheerful," is her well-aimed response. Since Davey doesn't really know how far he's willing to take this, Holden plays the scene as a spontaneous leap into uncharted territory. They talk as they never have before. (He learns that she was bound into service to pay off her dead father's debts.) With the hesitations and the tentative forward steps, this engaging scene is their first move toward becoming a couple. The boy's interruptions halt their progress, leading to Davey's "I reckon I ain't ready to fall in love yet." He exits, and the scene ends with Rachel noticing Jim's left-behind guitar; pleased to encounter it, she strums it.

When Jim returns again, to Rachel's pleasure and Davey's displeasure, he's singing, of course, but now he's all dressed up. (Mitchum looks distressingly like Harry Powell, his psycho preacher of *The Night of the Hunter*.) Mitchum places his focus on Young, as if Holden weren't in the scene anymore, which is ideal for Holden as Davey tries to regain his wife's attention. When Jim makes Rachel a gift of a fancy dress, Davey is shown up yet again. Between that and more sing-alongs, Holden gets to raise Davey's temperature steadily, and is amusingly ornery as he watches his virile rival make himself at home in Davey's ready-made life. And this visit drags on past two weeks! When Davey dresses up for dinner (to match Rachel and Jim), Jim says, "You're kind of slicked out, ain't you Big Davey?" With lines such as that one, Mitchum is slyly good at mockery without taking it too far; his use of "Big Davey" surely makes Davey sound small. Mitchum's easygoing, humorous Jim is a fine sparring partner for Holden's uptight, unrelaxed Davey. Mitchum's Jim is a fully formed man: he's direct, knows his mind and heart, and is a free spirit. Holden has a broader arc to play, in turning his befuddled Davey into a man who can admit his needs openly. Technically, *Rachel and the Stranger* is Davey's story; it is he who changes the most and makes the largest discoveries.

Mitchum and Young have a sexy scene by the river. She's drying her lusciously unwieldy hair with a towel when he stops by to do his

laundry. Jim and Rachel connect more directly than Davey and Rachel because there's nothing in their way. Mitchum is such a smooth presence, and his Jim is an expert flirt, a tantalizing contrast to the insecure romantic rumblings coming from Holden's Davey. Rachel deflects Jim's amorous intimations, but that doesn't negate the obvious chemistry they share. Whether or not it's his intention, Jim is the catalyst in bringing Rachel and Davey together. The two men have a talk, with the subtexts being that Davey wants Jim to go, and Jim wants to go too (but *with* Rachel). The situation comes to a head in an overdue brawl after Jim offers to buy Rachel from Davey. Jim will treat her right and, we can assume, consummate their union pronto. It's a good comic fight scene, featuring falling hay, loose animals, and some well-choreographed (in its ineptness) fighting that culminates in a water barrel and is capped by clunks on the head from a swinging pail. For all Rachel's justified indignation at both men, it still looks like she has a win-win choice to make. Not bad for Loretta Young either, with two *younger* leading men vying for her.

The film's climax is a surprisingly serious one (the aforementioned Indian attack), but it does its job, dramatically speaking, in getting us to the final (and first) clinch. Why can't they make feel-good movies anymore without insulting and underestimating audiences? "Feel-good" now usually means sickening and manipulative. *Rachel and the Stranger* warms the heart, but it's still a smart, adult entertainment that, incidentally, can be "fun for the whole family." It's one of the subtler romantic comedies to come out of Hollywood at that time, and it's refreshingly sexy because it dances around the issue of sex so surreptitiously, with its unconsummated union and its third party calling attention to what's been missing. In its discreet way, the movie is as concerned with sexuality and desire as it is with hearth and home.

Rachel and the Stranger was directed with a sure hand and a light touch by the former actor Norman Foster, who happened to be married to Loretta Young's actress sister Sally Blane. Foster had appeared opposite Young in two 1932 programmers for Warner Brothers, *Playgirl* and *Week-End Marriage,* but his most noted on-screen work was in the first and best version of *State Fair* (1933). (He played the son, the role played by Dick Haymes and Pat Boone in the musical versions.) Foster directed several pictures in both the Charlie Chan and Mr. Moto series, and also the superficial wartime thriller *Journey into Fear* (1942), produced by Orson Welles' Mercury company (with Welles contributing to

the direction without credit). Foster's direction of *Rachel* captures not only the delicacies in the romance and the comedy (some of the film's most winning moments are its most offhand), but also the hopeful, heartening spirit of second chances. Foster, Holden, and young Gary Gray reteamed for *Father Is a Bachelor* (1950), another woodsy period comedy and altogether dreadful.

At seventy-nine minutes, *Rachel* is a model of pace and economy, with not an ounce of fat on it. Waldo Salt wrote the screenplay, based on stories by Howard Fast, yet neither name appears on-screen, presumably because of both men's ties to the American Communist Party, which led to their being blacklisted during that shameful period. It's shocking that writing this marvelous—rich in nuances of feeling, humor, and sexuality—could go uncredited, to this day! Roy Webb's appropriately folksy musical score is a textbook example of how to enhance a movie without treading upon it. And it was Edith Head who designed Young's uncharacteristically modest and limited wardrobe.

Young's second half of the 1940s also included Orson Welles' overwrought 1946 thriller *The Stranger* (sans Rachel) and *The Accused* (1949), a worthwhile film noir a bit undone by its laughably dated psychobabble. Young retired from the screen in 1953 after several disappointing films, such as *Key to the City* (1950), a pallid Tracy-Hepburn style comedy opposite Clark Gable. It wasn't long before she became the queen of television drama, garnering three Emmys as playmates for her Oscar. The year that Young left the big screen was also the year of *Stalag 17,* the Billy Wilder film that brought Holden the Best Actor Oscar. I'd say that things worked out pretty well for Rachel and her stranger.

Two for the Road (1967)
The Maturing of Audrey Hepburn

The three-time collaboration between star Audrey Hepburn and director Stanley Donen was a cinematic rarity in that you could describe it as a three-for-three artistic success. Their trio of adult, vastly entertaining films belong to three different genres: the musical *Funny Face* (1957), the thriller *Charade* (1963), and the love story *Two for the Road*. William Wyler, the man who made Hepburn a star (and an Oscar winner) in *Roman Holiday* (1953), was her other three-time director, but their follow-up projects were the drably earnest drama *The Children's Hour* (1961) and the inconsequential caper *How to Steal a Million* (1966). It was Donen who had an unerring knack for showcasing and maximizing Hepburn's charm and talent (not exactly a daunting task, I admit). He explored various facets of a maturing Hepburn, from *Funny Face*'s impressionable waif to *Charade*'s funny and flirty damsel-in-distress to *Two for the Road*'s sensual, knowing wife. She may be a distinctly different Audrey Hepburn in each of these roles, yet the films are connected by their French locations, colorful palettes, height-of-chic fashions, and enviable sophistication. She had formidable co-stars in each, but all three movies belong to her. *Funny Face* may be uneven—it's got some witless satire of beatniks and existentialists—but it sails on its Gershwin score, Donen's visual pizzazz, and Hepburn and her co-stars: a winningly modest Fred Astaire and the seismically dazzling Kay Thompson. After Astaire, Donen put Hepburn opposite Cary Grant, another pushing-sixty leading man, for *Charade*. (At least the age difference is acknowledged this time, to comic effect, as Hepburn chases Grant.) In the lighthearted vein of Grant's recent Hitchcock thrillers *To Catch a Thief* (1955) and *North by Northwest* (1959), *Charade* is a movie equally good at lively twists and romantic banter, and the chemistry between the stars is the charismatic bonfire you expect, though Grant, like Astaire before him, does look worn and more than a mite tired.

TWO FOR THE ROAD. Albert Finney and Audrey Hepburn in happier days.

Fox's *Two for the Road,* the most ambitious of the Hepburn-Donen pictures, is a smart, humorous, and touching examination of a marriage. For her love interest, Albert Finney, an age-appropriate actor (actually seven years Hepburn's junior), was cast. Finney may have caused a sensation as the adorably roguish title character in *Tom Jones* (1963), but he was also one of the key "angry young men" of 1960s British films. The opposites-attract spark in his teaming with Hepburn is a product of their antithetical styles. She was a movie star who could act; he has never been a personality performer. I've always contended that Hepburn's finest performance is in Fred Zinnemann's extraordinary drama *The Nun's Story* (1959), so I'd like to claim her work in *Two for the Road* as her next best. These two performances make intriguing companion pieces since, in the former, her acting strength comes from her containment—the tensions in her internal conflicts—whereas in the later film her effectiveness derives from her looseness and spontaneity. In *Two for the Road,* her character makes the transition from the 1950s Audrey Hepburn, the winsome ugly-duckling beauty, to the 1960s model, who is more complex by virtue of having lived and loved. That she is convincing as both, within the same film, is a tribute to her underappreciated capabilities.

The gimmick of *Two for the Road* is to tell its story without the benefit of chronology, but, rather, to look at the couple in out-of-order snippets from their up-and-down relationship, snapshots from their joint scrapbook. This device may sound annoying and unnecessarily complicated, but it does what it sets out to do: it makes you think about why, and when, people change; why they never *really* change; and how the little things can accumulate into big things. (Contrarily, the nonlinear time line in *21 Grams* [2003] pretentiously tries to make an empty, hysterical story seem *important*.) *Two for the Road* doesn't pretend to be anything but a commercial, star-driven vehicle, and, therefore, it never seems full of itself; it doesn't take on more than it can handle. If it were more self-admiring it would seem shallow, but, instead, it *owns* its escapist glamour and winds up seeming an unusually risky mainstream movie. It's hardly Ingmar Bergman's *Scenes from a Marriage* (1974), but it does steer clear of facile answers and trumped-up emotion. Its flashes of pain and cruelty, which arise without strain, give it a fullness unexpected in such a glittery entertainment.

Two for the Road is, dare I say it, the *journey* of an English marriage, with the road-trip device an obvious metaphor for their "ride." Joanna (Hepburn) and Mark Wallace (Finney) are seen in five alternating time periods (from the mid '50s to the mid '60s), each centered around a trip to France: their meeting, hitchhiking together, and falling in love (and into bed); their newlywed travels (in a station wagon) with an American couple who have brought their horror of a daughter; a holiday in which Joanna announces she's pregnant; a business-related trip—Mark is now a successful architect—with their own little girl in tow, in which Mark's distracted immersion in his work sends Joanna into the arms of another man; and their latest incarnation, a wealthy, resentful couple wondering why the hell they're still together. *Two for the Road* is about the ways in which time passes. When Mark wonders, early on, why their excursion seemed to go so quickly, Joanna says that they made the mistake of enjoying themselves. Later, during a stay with rich acquaintances, she complains that they've been with their hosts "month after month, for two whole days." It's all relative.

The film provides an ongoing, time-setting shorthand for its chronology-defying continuity by the easy identifiability of the couple's different modes of transportation (from their ride-thumbing adventures to their white Mercedes 230), but even more so through Hepburn's hairstyles and wardrobe. In that regard, *Two for the Road* is, in spirit anyway,

the last Audrey Hepburn movie, the final one built around her status as a fashion icon (and she certainly goes out with a bang!). She has a definite "look" for each chapter, making it always clear where we are in their lives. (Finney, however, looks exactly the same throughout.) Her styles run the gamut from the long, straight hair and blue jeans of the early days to the beehive coiffure, black vinyl pant suit, and dress of small, sewn-together silver discs from the high-living times. The movie is comfortable with the notion that it can be an honest look at wedlock *and* an excuse for a fashion parade. Perhaps not since Joan Crawford in *Sudden Fear* (1952) had a star's apparel had so many people to credit: "Miss Hepburn's clothes by Ken Scott, Michèle Rosier, Paco Rabanne, Mary Quant, Foale and Tuffin and others. Miss Hepburn's wardrobe supervised by Clare Rendlesham." Everyone *except* Hepburn's favored Givenchy seems to have pitched in. But, naturally, the fashions inform Hepburn's development from spirited innocent to young bride to disillusioned wife to numbed clotheshorse. Regardless of what she's wearing, and no matter how good she looks, Hepburn is most radiant when Joanna is head-over-heels in love.

For the sake of clarity, I'm going to look at the film's different time periods individually, rather than in the patchwork way in which they are experienced. The film opens with the jaded, barely civil couple on their way to Mark's millionaire patron (Claude Dauphin). Beginning at the end of the story prompts the questions "How did they get this way?" and "Why are they still together?" and the time-traveling is used to provide the answers. The alertness in their sniping suggests that there's still *something* there; people who have given up don't try this hard to score points. Therefore, it can be assumed that Joanna and Mark *are* worth salvaging. Our sympathies are tilted toward Joanna, mostly because Hepburn is a more lovable screen presence than Finney. This does tip the film's balance: Hepburn's ability to *feel* on camera is disarming, as are her impassioned, breathy line readings and the fluidity with which her emotions change. And Joanna's dissatisfactions, like her gripes about their being stuck living in a basement flat, would probably seem less charming coming from another actress. It's just impossible to find Hepburn even momentarily unlikable. Finney, on the other hand, gets a firmer grasp on Mark's selfishness than his appeal. (Alan Bates might have made a warmer and sexier Mark, but perhaps Hepburn wouldn't have responded to him as intensely as she did to Finney.) And yet, Finney's refusal to be endearing, carrying his

angry-young-man sensibility into romantic comedy, gives the film some teeth. It may sound as if I've inadvertently proven why the film doesn't work—she's too likable; he isn't likable enough—but I find it a forgivable matter, one that aptly plays into the question of how right and wrong the characters are for each other. Another flaw is the script's embrace of the cliché that money and success invite unhappiness. The fancier their cars and clothes become, the more miserable they seem. The banality of this idea is circumvented by the bitter specificity in the acting.

When Joanna and Mark meet, he's an aspiring architect bumming through France and she's part of an all-girl choir on its way, by minibus, to a music festival. Hepburn plays their initial encounters as a clear case of love at first sight, yet she's unassuming to the point of barely being noticed by him. When chicken pox waylays the rest of the choir, Joanna opts to hitchhike with the indifferent Mark. (He had his eye on the alluring and available, but ultimately pox-fallen, Jacqueline Bisset, in an early role.) The charm of their coming together is due to their different attitudes: Mark tries to resist his attraction by talking profusely against marriage; Joanna just relaxes and smiles, careful not to scare him off. His grumpiness plays well off her easygoing enthusiasm. The movie offers a hitchhiking nod to *It Happened One Night* (1934) when Hepburn, unlike Finney, can stop a car with a minimum of effort. Other old-movie winks are Finney's occasional Humphrey Bogart impersonations, especially amusing in light of Hepburn having co-starred with the man himself in *Sabrina* (1954).

The script wisely sets up, at the outset, the problems they'll deal with later on: Mark, aware of his imperfections, warns Joanna that he'll let her down, yet she'll not hear of it; there are their identifications of couples who eat in silence, a fate that will befall them, as "married people"; he points out that she's never satisfied; it's apparent he's not the paternal type and probably never will be. But, mostly, this is an idyllic, carefree romance between two young people, set against the splendor of the French countryside and seashore. The playfulness between the stars, the ecstatic bliss they manifest, delivers a vicarious high. (There were rumors of an off-screen affair as well.) By virtue of the piercing tenderness in Hepburn's eyes, it seems unlikely that his love will ever match the depth of hers. Hepburn looks open-eyed about what Joanna is getting herself into, yet starry-eyed enough to be utterly swept away.

Finney's comfort with on-screen sexuality is expected from the actor who made classic the succulent foreplay of the eating scene in *Tom*

Jones, but sex is an indelicate prospect to consider with such a princess of a star as Hepburn. Yet her Joanna *is* a sexual being, instigating physical contact eagerly, open about her desire, even making a joke with a banana, and it never feels unseemly or forced. It's not the spectacle of a ladylike actress desperate to prove she can be "now." Hepburn is not a pedestal creature here, and she's also incisively good with the role's verbal bite. Her performance never feels like a self-conscious, change-of-pace career move. Hepburn's Joanna, in both sting and appetite, is the real thing.

The film's comic centerpiece is the road trip with Mark's American friends: his flirty ex-girlfriend Cathy (Eleanor Bron), her efficiency-obsessed husband Howard (William Daniels, the same year he played Dustin Hoffman's father in *The Graduate*), and their bad-seed daughter Ruth (Gabrielle Middleton). This family is everything the newlyweds fear becoming, as a couple and as parents. Little Ruth's every monstrous whim is indulged by her misguidedly sensitive, psychology-spouting parents. When Ruth says that she doesn't want Joanna to look at her, Cathy asks Joanna to "woo" the brat. Later, Ruth yanks the car key out of the ignition and flings it outside, sending the four adults in search of it for hours. Joanna finally loses her cool and raises her voice to Ruth, scaring the child into pointing out where the key landed. It's a prime moment for Hepburn, who then smilingly tells Cathy, "I wooed her." Comedy is also the order of the day on the trip in which Joanna tells Mark that she's pregnant. Their MG catches fire, and they're forced to stay where they're stranded: at a luxurious hotel. It's the kind of everything-goes-wrong experience—they practically starve to avoid the assumed exorbitant prices of hotel meals—that makes for enduring memories and hilarious anecdotes.

On the trip with their own little girl along, Mark is an inattentive workaholic and Joanna a devoted mother. In this section begins the caustic remarks that become their primary means of communication. Finney plays Mark as trapped and moody, and Hepburn's expressions convey Joanna's crushing sense that he's pulling away. Mark has been unfaithful by this point, and now it's Joanna's turn for an affair in the form of David (Georges Descrieres), a rather hollow character (the kind that later came to be known as Eurotrash). It's hard to take him seriously, though Joanna seems genuinely smitten. (I like to think Audrey Hepburn would have better taste than this.) Donen freezes the frame at the moment when Mark catches the lovers at an outdoor café.

Finney at last gets to show not just wounded pride but a palpable sense of loss. The control and civility of his confrontation with Hepburn has more pain than it would if the scene erupted into ranting emotion. Their subsequent reconciliation is the film's most moving scene, but the post-affair adjustment proves nearly insurmountable, shuffling between gratefulness at being back together and the necessity of making each other pay for his/her sins. Which brings us to the here and now of their relationship.

Two for the Road was written by Frederic Raphael, the Oscar-winning writer of *Darling* (1965), another film dependent on high fashion, tricky editing, and open sexuality. *Darling*—which takes a pretty thin look at mod decadence, has a cipher for a lead character, and now seems to be about nothing—was as overrated as *Two for the Road* was underrated. Raphael's delineation of Joanna and Mark knows its limitations and, with a preponderance of short scenes, the effect is that of a series of vital sketches rather than a painstaking portrait. But, in a film that juggles with time and brims with style, the decision of how deep to delve into the relationship seems economically right. The picture simplifies their coupling to key moments, but I don't think that necessarily means that the treatment is simplistic. And the movie's optimism is hardly rose-colored. The screenplay is peppered with many wonderful lines, such as Claude Dauphin's "I can't hear myself drink." Raphael's story and screenplay were Oscar nominated but lost to William Rose's for *Guess Who's Coming to Dinner,* a talky, soapy sitcom trying to pass itself off as a witty contemporary comedy (like, say, *Two for the Road*).

Hepburn was nominated for Best Actress that year but for her blind victim in *Wait Until Dark* rather than for her superior work as Joanna. She lost to the "other" Hepburn (for *Guess Who's Coming to Dinner*) and was then off the screen for nine years, until *Robin and Marian*. We can only wonder how she would have fared in the uncensored Hollywood just taking shape when she left the movies. Her work as Joanna clearly displayed a willingness to be part of the new permissiveness; she even utters the word *bastard*. Yet, for all its eroticism and newfangled story-telling, *Two for the Road* is just as much a last gasp of the dream factory as it is an offbeat original. After all, it does have a shimmering, lushly plaintive Henry Mancini score. (It may be his very best, surpassing his better-known work on Hepburn's *Breakfast at Tiffany's* [1961] and *Charade*.) This kind of glamorous travelogue-romance, set to a Mancini melody, was to be no more. *Two for the Road* is a one-of-a-kind meet-

ing of the old and new Hollywoods, falling right on the cusp. Stanley Donen handles the movie's clever jigsaw-puzzle structure nimbly, and with both flair and taste. For all the movie's gloss, his work never feels slick or cynical. He also maintains an unsentimental tone. And the way in which the story strands often connect—vehicles zip by and deposit us in the next strand—is perfectly achieved, a visual embodiment of how the past and present are in perpetual overlap. Aside from his splendid work in musicals, like *Singin' in the Rain* (1952), *Seven Brides for Seven Brothers* (1954), and *The Pajama Game* (1957), Donen's top contribution to the movies is his handling of Hepburn, and *Charade* and *Two for the Road* stand as his best nonmusical pictures.

Beautiful Thing (1996)
Celebrating Gay Love

It took nearly seventy years for the English-speaking cinema to deliver a gay love story as winning and upbeat as *Beautiful Thing*. Gay characters had been unmistakably present in talking pictures, such as *Our Betters* (1933), but hardly at the center of them. The Production Code went about neutering presumably gay roles: the females were seen as mannish bachelor-girls or as lurid vampires (Gloria Holden, literally, in *Dracula's Daughter* [1936], with Judith Anderson in *Rebecca* [1940] not far behind); and the males became Franklin Pangborn's fussbudget sissies and Clifton Webb's snooty, "artistic" types. Webb's stardom, from the mid 1940s through the 1950s, is astonishing in what were the most censor-ridden decades of the movies. He became a star as Waldo Lydecker in *Laura* (1944), an overt homosexual: Waldo creates Laura's "look" by molding her taste in hair and clothes; he takes definite notice of the macho detective's appeal; and he can't contain his jealousy of Laura's attractiveness to men. It's not a "positive" gay portrait, but Webb's unapologetically queer persona is revolutionary. (Audiences took Webb to heart for his enviable way with a putdown.) More typical of Golden-Age representations of gayness were coded, ambiguous characters that now seem blatantly gay (even if their films' creators were oblivious to the notion). Amatory longing supersedes male bonding in the cases of Spencer Tracy in *Test Pilot* (1938) or Wendell Corey in *Desert Fury* (1947). And what's going on with Lauren Bacall in *Young Man with a Horn* (1950)? In the 1950s, with the emergence of Tennessee Williams' works, and about-to-burst characters like Mercedes McCambridge's in *Johnny Guitar* (1954) and Stephen Boyd's in *Ben-Hur* (1959), it was apparent that gay subtexts in the movies couldn't be repressed for much longer.

Gays were openly present in the movies of the 1960s, but most of them were headed for suicide, or suffering self-loathing and guilt, or objects of pity, including Shirley MacLaine in *The Children's Hour* (1961),

BEAUTIFUL THING. First love for Glen Berry and Scott Neal.

Don Murray in *Advise and Consent* (1962), and Rod Steiger in *The Sergeant* (1968). This era peaked with the misery-loves-company *Boys in the Band* (1970). British films have always been ahead of American films on this issue. England's *Victim* (1961) is a blackmail drama bravely taking on the illegality of homosexuality, and John Schlesinger's *Darling* (1965) has a supporting character who is gay and *enjoying himself*. It's no surprise that the gay-themed groundbreaker also came from England: Schlesinger's *Sunday, Bloody Sunday* (1971), in which Peter Finch gave the most complex, unsensational portrait of a homosexual yet seen. Playing a successful doctor, Finch offered a detailed depiction of the

pain of "the closet," a lifestyle his character has accepted and spent years mastering. But there's passion and palpable erotic desire beneath his manners. He is an intelligent, gifted man who has fallen for someone unattainable (and unworthy of him). Finch is the center of this movie, and he's never a joke. Al Pacino may have been amazing as the gay man in the extraordinary *Dog Day Afternoon* (1975), but his impact, regarding gay portrayals, was unlike Finch's since Pacino played a bank robber on the verge of a breakdown. The subject continued to be brought to the screen more matter-of-factly in England than in Hollywood. When I saw the English *My Beautiful Laundrette* (1986), I overheard a man, just as the movie ended, say, "Why were they gay?" He and others were caught off-guard by a film in which characters just happened to be gay, without its being cause for "drama."

Primed to be Hollywood's gay trailblazer, *Making Love* (1982), coincidentally about another closeted doctor, showed its male lovers kissing (and in bed) and portrayed the main character's "coming out" as a healthy, happy-making step. Unfortunately, this stilted movie was so poorly written and tepidly acted that its good intentions were reduced to soap opera. Until *Brokeback Mountain* (2005), Hollywood's more recent forays into gay material have been marked by a fear of offending moviegoers, so the biggest of these—notably, *Philadelphia* (1993) and the detestable *De-Lovely* (2004)—are marred by an inhibiting tameness. Made without compromise or timidity, the landmark *Brokeback Mountain* was anchored by honest same-sex intimacy and passion, and by the unforgettable ache in Heath Ledger's wrenching performance. Hollywood had finally produced a homosexual drama to rank with its all-time classic love stories.

While *Brokeback Mountain* breaks your heart, *Beautiful Thing*, a tiny English movie without stars, is the most feel-good gay love story ever filmed. It may be one in a long line of coming-out stories, but the romance that unfolds between the central characters is the cure for their unhappiness rather than its cause. The movie acknowledges the difficulties that lie ahead, but it accentuates the positive, and that's historically unusual and refreshing for gay-themed films. *Beautiful Thing* finds a powerful voice merely by celebrating the love between two young men. Who can resist becoming absorbed in seeing these two lads land in each other's arms?

In addition to its delicacy as a gay love story, the film is also an outstanding depiction of first-love. The yearning, the tentativeness,

and the delirium are all there. It's as innocent and instinctive as anything Andy Hardy ever got himself into…just with *two* Andy Hardys. *Beautiful Thing* is about two teenage boys in Thamesmead (southeast London): Jamie Gangel (Glen Berry), who's being raised by his single mother, Sandra (Linda Henry); and Ste Pearce (Scott Neal), in the flat next door, who lives with his abusive father and drug-dealing older brother. Nonathletic Jamie is picked on at high school; athletic Ste is brutalized at home. When the boys come together, and accept that they're in love, they keep it quiet. After all, they're young, scared, and inexperienced. But not everyone is against them.

This movie is set in the England you *don't* fantasize about living in. Thamesmead is a housing-project concrete jungle, and it's particularly gratifying to watch a love story spring from such a depressing locale. And yet, the film rises from the gloom right at the start, thanks to Mama Cass of the Mamas and the Papas. *Beautiful Thing* uses Cass' voice as its Greek chorus. Her pop-classic vocals are fitted to the plot as carefully as if this were a musical; they arrive on the soundtrack to enhance a scene's emotional content. It works like a charm. The sweetness, the optimism, and the strength in her voice provide a defiantly upbeat foundation for a tale that isn't always pleasant. (You could do worse than have Mama Cass as the soundtrack to your life.) The fact that she was overweight and died young only adds to her resonance as a beacon for those who feel outcast and trod upon. The freedom and possibility in her sound defy the mundane world of Thamesmead. To say that the film wouldn't be the same without her unseen presence may sound extreme, but it's true. The action begins with Jamie bolting from gym class and running home, accompanied by the rousing spirit of Mama's "It's Getting Better." The tune emphasizes the emancipating release in Jamie's escape. The rainbow that's visible above gray Thamesmead is an omen: Jamie will soon be going over it.

The relationship between Jamie and his mother, Sandra, is as central to the film's effectiveness as the affection between the boys. It has believable amounts of contradictory feeling; their love and support are visible, as are their resentments and bitterness. Long before the gay issue could rile them, Jamie and Sandra share a taste for bitchiness, sarcasm, and spite. Their wicked banter keeps them at a distance, yet their well-matched talent and zest for this style of communication inextricably unites them. They have one row that comes to blows, with Sandra slapping him furiously and Jamie trying to fend her off. It's an interesting

prelude: Jamie seems already angry with her for disapproving of his gayness, readying himself to be rejected, even though she knows nothing for sure. It's a loud, prickly relationship, and the loving bond beneath it never plays as sentimental or cliché. The depths of their feelings, when situations test them, are all the more affecting in contrast to their combative tendencies. Sandra is a tough lady, taking care of herself and her boy by working in a pub, and she's looking to advance by managing a pub of her own. She's crass, bawdy, and a real fighter. With a cigarette often dangling from her lips, she appears ready, even eager, for a tussle. Sandra makes lots of mistakes, but her flaws make her virtues stand out all the more. She's *there* when it counts. As Sandra, Linda Henry is terrific, getting all the zing out of her funny lines, unafraid to be seen in unattractive behavior, fierce in her loyalty and protectiveness, and always a surprise. The Jamie-Sandra household is a sitcom compared with the one shared by Ste, his father, and his brother. Ste is the family punching bag, and the only consistency in his home is the verbal and physical abuse he endures. Ste (short for Steven) is Cinderella, tending to those who mistreat him.

The movie makes sure that all its characters are properly set up before the main plot kicks in. Jamie has already been looking at Ste with longing, genuinely happy anytime he crosses his path, but they come together after Sandra finds Ste crying outside. He's determined not to return home, and so she brings him to her flat. For all her bluster, Sandra is innately maternal; her rough edges keep people from noticing. Ste shares Jamie's bed, stretching out with his head at the foot of the bed. Jamie smiles broadly after saying good night to Ste, and both young actors have smiles that make their emergence from unhappiness especially radiant.

In their second bed scene, Ste opens up about his low self-esteem and willingly shows Jamie his red and black-and-blue, family-inflicted bruises across his back. Jamie offers to rub his mother's peppermint foot-lotion on these painful discolorations, resulting in a scene of great tenderness. Their conversation turns intimate, regarding their kissing experience. Jamie is ready to explore, whereas Ste is tense, at first refusing Jamie's request to sleep beside him but then changing his mind. Jamie moves in and gives him a quick kiss. The scene ends soon after, following Jamie stroking Ste's cheek as "Sixteen Going on Seventeen," from *The Sound of Music* (playing on television in the next room), comes onto the soundtrack. The lyrics fit the scene neatly ("totally unprepared

are you to face a world of men, timid and shy and scared are you of things beyond your ken"). The camera cuts away—discreetly, just as in old movies—from the lovemaking about to take place. The boys are next seen asleep in each other's arms as the Rodgers and Hammerstein song continues. In addition to this coy tune, and the treasure trove of Mama Cass singles, the movie also features a gently beautiful love theme by John Altman.

Out of fear of what this means (and of his father), Ste pulls away. But Jamie is emboldened by his feelings, so happy in Ste's presence that he can't really care about much else. These two young actors are available, honest, and unaffected, bringing clarity to their portrait of young love. They really look into each other's eyes, and their characters' feelings for each other perceptibly deepen as the movie continues. The first time anyone suspects that there's something between them, Ste freaks out and avoids Jamie. When Sandra asks what's the matter with Ste, Jamie, without embellishing, astutely answers, "He's in love, that's all." My favorite scene in the movie comes just after the boys' first visit to a gay pub. In a wordless scene, they make their way home in the dark, through the woods, to Mama Cass' "Make Your Own Kind of Music." The song, of course, couldn't be more apt, and as the boys chase each other in a playful game of tag, the scene becomes a peerlessly carefree outburst of newfound love. With an agile camera following their moves, the scene is a rush of joyful abandon. True, they're isolated and in the dark, but it's nonetheless a declaration of love. Then, up against a tree, the scene becomes a make-out session, a full-out kissing scene with the camera coming in closely. The boys stop a moment, smile at each other, then continue kissing. The effect is a fantasy made true, and the rest of the world couldn't be farther away.

The "coming out" confrontation between mother and son is inevitable, but it's acted with such frankness that you won't feel you've seen it before. Sandra has discovered the truth, and when she challenges Jamie he storms to his room, soon weeping on his bed. But Sandra smartly wants to talk about it. For Glen Berry, the young actor playing Jamie, this is the scene in which he allows Jamie's vulnerability to be seen by Sandra, his defenses down and his smart-mouth quickness given a rest. If tears well up in you, it's because of the scene's simple directness rather than any cheap button-pushing. Later, Sandra has a similar scene with Ste. In a touching detail, Scott Neal, who plays Ste, won't make eye contact with Linda Henry's Sandra, shielding his face with his hands.

He, too, cries softly. With Sandra's unsentimental take on things, and the boys' fragility in speaking openly, both scenes are beauties.

Beautiful Thing may have the most satisfying ending of *any* gay-themed film. All I'll say is that it's set to Mama Cass' rendition of "Dream a Little Dream of Me," and that, in it, intoxicating romanticism and intrepid pride become one and the same. A spontaneous, intimate act can have enormous potency beyond itself. We're not asked to ponder the what-next aspect of the story because the film fades to black as this expression of love's transcendence continues in a seemingly neverending manner.

Beautiful Thing was written by Jonathan Harvey, based on his play. While Harvey captures the burgeoning relationship between the boys, and Sandra's bond with Jamie, so sympathetically, he can't find comparable facility with the rest of the roles. His conceptions of Ste's boozing father (an English redneck) and terrorizing brother are two-dimensional; they're loathsome, cruel, and nothing else. Harvey fares better with Sandra's younger lover, Tony (Ben Daniels). It's a funny role in that Tony is a sensitive, politically-correct, good-hearted fellow oddly paired with the raunchy, bossy Sandra. When she refers to a girl as a "bird," he scolds, "Do you have to use words like that? It *really* disempowers you." You expect this guy to be a joke himself, but he's genuinely kind. The subplot involving him and Sandra isn't given enough time to be worth the trouble. Conversely, too much time is given to Leah (Tameka Empson), the young black neighbor who is in an almost constant war of insults with Sandra. Leah is a druggie, a drinker, and a Mama Cass fanatic. She isn't integrated enough into the main story to merit the screen time she gets; her climactic stoned episode is an irritating distraction from the boys' coming out and Sandra's bombshell about her career. It's a case of too much happening at once. Harvey's use of British-isms like "slag," "slapper," and "knackered," will keep American ears, so to speak, on their toes. Even more challenging are the dialects of these characters, which could often benefit from subtitles. There are some lines my ears have yet to decipher.

The direction of Hettie Macdonald, who directed the original production of the play, connects with the budding bliss of the boys and is keen to the nuances of Sandra's behavior. Because that work is so on-target, the missteps really stick out, like the unconvincing gay-pub scene. It's so self-conscious, so "special"—the boys are interviewed by a drag artist in mid-performance—that it just feels phony. The scene would be

so much better if nothing much happened and they just observed. But it's easy to overlook the extraneous scenes and the peripheral characters in light of what the film gets so right. It's a very heady expression of how love changes the terrain of one's life, and I can only imagine the soothing, uplifting impact this film can have on gay teenagers.

I'll leave you with a bit of dialogue that I find particularly pleasing. Jamie, who isn't depicted as a buff of old movies (though we do see him watching one once), reveals his true colors during his second bedroom scene with Ste. *The Sound of Music* is airing in the other room. Sandra knocks on Jamie's door and asks, "Who played the baroness?" and, without missing a beat, and eager to be left alone with Ste, he automatically answers, "Eleanor Parker." He's a young man after my own heart.

IV. Westerns

The classic screen western evokes thoughts of the genre's two giants: director John Ford and his star, John Wayne. Much deserved attention has been given to them and their work in the genre, together and apart—*Stagecoach* (1939), *My Darling Clementine* (1946), *Red River* (1948), *The Searchers* (1956), among others. Though one Ford-Wayne collaboration, *Rio Grande* (1950), would have fit perfectly into this chapter, I choose instead to put my attention where it can do more good. My interest lies in those who have been overshadowed by the looming figures of Ford and Wayne, great western directors like Anthony Mann, Budd Boetticher, and John Sturges, plus some overlooked western stars, such as Robert Taylor, Susan Hayward, and James Garner. And it surely feels good to give Randolph Scott, Robert Mitchum, and Gregory Peck a boost in their contribution to the genre.

Devil's Doorway (1950)
The Native-American Perspective

I t's silver-screen serendipity when a working director seemingly stumbles upon the genre for which he was meant. Just imagine if Englishman James Whale hadn't been the director of Universal's *Frankenstein* (1931). Would he have had the opportunity to prove himself the greatest director of American horror films? (And would *Frankenstein* and *Bride of Frankenstein* have become screen classics without him?) Let's not even ponder the gaping hole in twentieth-century cinema if Alfred Hitchcock hadn't made *The Lodger* (1926) and, thereafter, dominated the suspense genre for the next fifty years. Thankfully, Howard Hawks, the man who directed *Scarface* (1932), got the chance to reveal his knockabout knack for screwball comedy with *Twentieth Century* (1934), leading to his even more delectable *Bringing Up Baby* (1938) and *His Girl Friday* (1940). Quite surprisingly, it was Hungarian-born Michael Curtiz who revitalized the adventure film when he made Errol Flynn a star in *Captain Blood* (1935). Curtiz and Flynn later collaborated on *The Adventures of Robin Hood* (1938), the adventure film of *all* adventure films. Then there's Anthony Mann and his singular association with the western. Mann left behind a body of work in the genre that rivals the best of John Ford. The picture that changed everything was *Winchester '73* (1950), which not only elevated Mann's art but gave moviegoers a new, edgy, more complicated James Stewart. Mann and Stewart made five westerns together and the best of them, *The Naked Spur* (1953) and *The Far Country* (1955), typify what came to be known as psychological westerns, character-driven pictures that shook up the good-guy/bad-guy genre with troubling gray areas, an alarming intensity of feeling, and percolating subtexts. Mann's westerns have more explicit emotions and disturbing undertones than most oaters, and his work, both with Stewart and others, helped make the 1950s the greatest decade for the screen western.

Mann's second western, *The Furies* (1950), is an operatically volatile, incest-laden vehicle for daddy Walter Huston and daughter Barbara

DEVIL'S DOORWAY. Robert Taylor confronts grim reality.

Stanwyck. Next came *Devil's Doorway,* an elegy for the American Indian. Hollywood was at last treating Native Americans with respect and compassion. Released in the summer of 1950, Delmer Daves' *Broken Arrow,* a film that treated the Apaches sympathetically, became a very popular and acclaimed western. Later that year, *Devil's Doorway* opened, but it was soon relegated to obscurity. Whereas *Broken Arrow* starred James Stewart as a scout and put Jeff Chandler's Cochise in a supporting

role, *Devil's Doorway*'s Indian, played by Robert Taylor, is the starring role. Perhaps having a white main character made it easier for *Broken Arrow* to find an audience (even though the prominent Indians are played by white actors in both movies). Both films hold up exceedingly well, yet few people seem to know *Devil's Doorway*. Not only is it a disturbing and powerful work about the inevitability of the Indians' demise, but it's also one of the more haunting westerns ever made.

Robert Taylor was the male version of Joan Crawford. It would be hard to make a case for either as a real acting talent, yet both developed enough stylish proficiency to remain long-standing favorites of the public. You rarely got any more from their sturdy performances than what was written on the pages of their scripts—no surprises, no contrasts, no depths—but they got the job done. Both became stars via the MGM factory; both were extraordinarily beautiful and not taken very seriously; both were favorites of the female audience; and, most significantly, both had a talent for reinvention whenever their careers stalled. Taylor was MGM's "pretty boy" of the mid 1930s, a period in which he provided male decoration to female-driven films, the best being *Camille* (1937). A nervous MGM decided that Taylor needed some butching up, so in 1938 he starred in *A Yank at Oxford* and *The Crowd Roars,* two sports-related pictures. This roughening of his image, which heightened his appeal to male moviegoers, peaked in 1942 with his title-role gangster in *Johnny Eager.* (By this point, he was rarely on-screen without a mustache, a look that turned his beauty into a more rugged kind of handsomeness.) Following World War II service, Taylor's career floundered in search of a hit. None of his dark melodramas of this period, such as *Undercurrent* (1946), with its high-culture kitsch, and the far worthier *High Wall* (1947), were able to restore his pre-war stature. But then, like Crawford snagging *Mildred Pierce,* Taylor got *Quo Vadis* (1951), and this spectacle, along with the following year's *Ivanhoe* (both Best Picture Oscar nominees), put Taylor back on top and secured his stardom for the remainder of the decade. His "heroic" performances in these and other period epics of the 1950s *(Knights of the Round Table, Quentin Durward)* are rather straight faced, but he does look dashing in the colorful costumes. By the 1960s he, like Crawford, took whatever he could get, until his death from lung cancer at fifty-seven in 1969. The on-screen Taylor never developed the pretentiousness of Crawford, whose performances increasingly conveyed that, no matter what anyone else thought, she thought she was hot stuff as an actress.

Despite his popularity as a romantic, yet adventurous, costume-picture leading man of the 1950s, it was as a western star that Taylor was best served during that decade. His first big success in the saddle had been as the title role in *Billy the Kid* (1941), MGM's answer to Fox's *Jesse James* (1939), which had transformed Tyrone Power, Fox's own pretty boy, into an action star. If Power could unleash unexpected virility by playing a Technicolor outlaw, then so could Taylor. Ironically, not long before he played *Devil's Doorway*'s Indian, Taylor starred in *Ambush* (1949), a compact and adult western that had him hunting, fighting, and killing Indians. (Sounds like a neat double bill to me.) In addition to *Devil's Doorway*, Taylor's best westerns of the 1950s are *Westward the Women* (1951), a likable and satisfying saga in which he seems to be channeling Clark Gable, and *Saddle the Wind* (1958), one of the more distinctive westerns of the latter part of the decade.

Lance Poole (Taylor), a Shoshone Indian, returns to his native Wyoming after his decorated service as a Union soldier in the Civil War. (He was awarded the Congressional Medal of Honor.) He intends to raise cattle with his family on Sweet Meadows, fifty thousand acres that belong to him. His wartime acceptance has fooled Lance into believing that race relations are steadily improving. That notion is fractured by the new land laws, which favor westward-moving homesteaders and ignore the rights of Indians. Lance seeks the aid of a lawyer, Orrie Masters (Paula Raymond), but there's little she can do legally. Verne Coolan (Louis Calhern), a rabid anti-Indian racist, is a lawyer who is bent on Lance's annihilation. Though it's futile, Lance refuses to give up his fight to hold on to his land.

There's no getting around the fact that Taylor is oddly cast as Lance. Specializing in romantic leads and cool tough guys, how can he play a role in which "acting" is clearly required? Astonishingly, he gives the performance of his career. Perhaps realizing the potential embarrassment should he not be believable as an Indian, Taylor wisely underplays. He gives an honestly dignified performance that avoids the pitfall of insufferable nobility, and he never condescends to his character. Lance has been east and fought in a modern war, so there's a certain amount of "Americanization" in him, which automatically lessens the burden on Taylor's credibility as an Indian. Since Taylor's stardom was due in no small part to his stunning face, it must have been a very freeing experience for him to play Lance. Wearing dark makeup, and with his hair slicked back, Taylor was released from his classically handsome look and

able to concentrate more on character than movie-star allure. Lance may be firm and proud, but he's never a stoic victim because of the searching intelligence that Taylor imbues him with throughout his struggle.

The incremental collapse of Lance's post-war optimism drives the film emotionally. Now that he's home, he's no longer a distinguished hero; he's an Indian, someone in the way of "progress." Taylor is touching as Lance's eyes are opened, his hopes and confidence dashed (though not his resolve) with each successive scene. The erosion of his faith in peaceful coexistence, even friendship, is internally shattering. After an uneventful and profitable five years, Lance is confronted with just how much things have changed when he goes to a previously welcoming bar and sees the "No Liquor Allowed for Indians" sign. This leads to the first of three key violent sequences in the film, a fistfight between Lance and Ike (James Millican), a troublemaking flunky of Coolan (Lance's most dangerous enemy). After having his glass of water shot to bits and his cowboy hat blown off his head, Lance lunges at Ike. On a sawdust floor, amid avid onlookers, this brawl isn't one of those routinely choreographed, seemingly painless bouts in many a western. Here, the punches hurt, and the men's consuming animosity sustains their weakening bodies. Each uses whatever is at his disposal (sawdust in the face, a flung chair). Lance wins the fight, but his introduction to this new, more virulent strain of racism makes his victory feel more like a defeat.

The movie is already progressive by Hollywood standards for its sensitive treatment of Native Americans and their cruel fate at the hands of the United States. In addition to the liberalism, why not add some feminism? So, in *Devil's Doorway*, we're not only rooting for the Indians, but their staunchest ally comes in the form of Paula Raymond as Orrie, a female lawyer (circa 1870!). When Lance and Orrie meet, each feels the pang of prejudice. Does Lance really want a lady lawyer? Is Orrie comfortable with an Indian client? That they overcome their initial misgivings and forge a valued partnership is the one genuinely hopeful note in the movie. Their quest to challenge the unjust home-steading laws is a valiant, doomed effort, and the growing admiration they feel for one another deepens our involvement in both characters. Orrie doesn't agree with the unfair laws, but she initially accepts them. It's Lance who shakes up her complacency. They become an underdog team: Orrie helps Lance to work within the system before resorting to violence; Lance makes Orrie a better lawyer by inspiring her to fight

injustice. It's interesting that Lance calls her "Orrie," rather than the expected "Miss Masters." They are simply equals. The conception of Orrie is refreshingly feminist for a movie of 1950 (a *period* movie, no less): she's smart, and committed to her profession; the men of the town treat her with respect; she's not pursuing her career until a husband comes along; her beauty is incidental and, for the most part, ignored. Admittedly, there is sexual tension (of the *King and I* variety), the acknowledgment of a potential love that can never be, but it's handled with restraint. It's a dramatic grace note in a film with much more on its mind than unrequited love.

Louis Calhern's Coolan lies, schemes, manipulates good people, and instigates violence. Dressed in black, Calhern plays a thoroughly hateful man but he never appears to be an exaggeration, which is pretty upsetting in itself. Responsible for an influx of sheepmen to the area, and profiting as their lawyer, Coolan is the architect of Lance's destruction. Mann often places Calhern in the foreground of one side of the screen, thereby framing scenes with an encroachment of blackness. It's an effective, subliminal way of visualizing the character's insidious power; he bleeds into the image. Calhern plays Coolan with a chilling malevolence, but he's discerning enough not to allow that viciousness to be obvious to those around him. He has the cleverness and ease to put Coolan over, and it can drive the viewer mad that so many people are taken in by his lies. Incidentally, 1950 was the year of years in the film career of Calhern. In addition to his deviously lethal Coolan, he also made a delightful Buffalo Bill in *Annie Get Your Gun,* received his only Oscar nomination for recreating his Broadway role as Oliver Wendell Holmes in *The Magnificent Yankee,* and, most memorably, was superb at conveying self-loathing and desperation beneath a slick, charming façade in *The Asphalt Jungle.*

You expect the newly arrived homesteaders to turn quickly into an angry mob. Again, the film doesn't give you what you expect. Having come out to Wyoming with the promise of fertile land, and having dragged their sheep with them, they, too, are soon in a fight for their own survival. Instead of behaving rashly, they go through Orrie to seek a compromise with Lance for the use of his land (even though the law is on their side). These are decent men, willing to negotiate, but time is of the essence. This leads to the second violent action sequence, a particularly painful episode because the film has afforded sympathy to both sides. Where are the bad guys? Lance knows he must fight or

be trampled, and the homesteaders must have the land they've been promised *now*. (Coolan has provoked this confrontation but he's not present for it.) When the homesteaders make their move on Sweet Meadows, Lance leads a dynamite attack on their wagons and their sheep. After these harrowing explosions, and the resulting clouds of gray smoke, the warfare becomes more personal. The opposing forces ride at each other on horseback, colliding in a brutal combat of guns, knives, and more dynamite. Rifles are used like clubs. The carnage is a sobering reminder of what good men are capable of if pushed to the limit. You want it to end as soon as it begins.

Emboldened by fighting the good fight, Orrie won't give up. She's been the voice of reason in her attempt to seek change through petition, as mediator between Lance and the homesteaders and, finally, by telegraphing the U.S. cavalry in order to prevent a massacre. All she can really do is slow down what's inevitable. Now comes the final showdown, Lance's prolonged last stand. Mann's filmmaking prowess is on full display in a climax that not only puts Coolan and the homesteaders on Lance's property, ready to attack, but also includes the arrival of the cavalry and Orrie's last-ditch intervention. Coolan's gang makes thundering dynamite raids on Lance's house; the Indians silently engage in spooky, one-on-one attacks in the dead of night. Mann's westerns are marked by their urgency, the unstoppability of their impending violence, and the grief left behind.

Taylor, again surpassing expectations of his abilities, is keenly attuned to Lance's comprehension of the losses he's about to face, not just his life and his land, but the probable fatalities of others in his family, and confinement to a reservation for those who survive. Perhaps his grimmest realization is that the rituals on which he was raised, those by which his tribe has lived for centuries, may be erased from existence in a few moments. In one unbroken camera move, Taylor emerges from the house, walks into a close-up, and is followed by the camera as he walks to his right, revealing a full-blown battle. It's hard to believe "it's only a movie" when a camera seems to stumble spontaneously on such a large-scale, in-progress incident. *Devil's Doorway* has an unforgettable ending that packs a real wallop. Taylor is given a devastating final line, and the picture ends abruptly following an equally devastating final image of Lance.

Mann captures the placid, nourishing paradise of Sweet Meadows, a serene contrast to the violence engendered on its behalf. The black-and-

white cinematography is by John Alton, a favorite of Mann's (they did excellent work together in film noir in the 1940s, and *Devil's Doorway*, their last collaboration, was their only western). Alton incorporates a film noir look, notably in his use of shafts of light in dark places and in his low-angle perspectives. Exemplifying the film's ability to tell its story through pictures is the physical transformation of Lance. In the early scenes, fresh from the war, he dresses like a white man: first in his military uniform and then as a cowboy. His hair is short. As the film progresses, and as Lance's identification with the white man diminishes, he dresses increasingly like an Indian, and his hair lengthens. He slowly returns to his roots as the divide between him and the "Americans" widens. This is a purely visual way to convey what is happening to Lance without drawing attention to it.

Mann's westerns are strong in period feel yet his characters have a contemporary immediacy. In *Devil's Doorway*, you feel the losses as if they were something you could almost prevent, not as something that happened in olden days. Guy Trosper's screenplay is first and foremost a moving, humane portrait of the destiny of the American Indian. It also expresses some unpleasant things about the United States: its ingratitude to its "undesirable" war heroes; the heartless opportunism (represented by Coolan) that forged a nation; and the assertion that sometimes our laws are bad. None of this was typical for 1950 Hollywood. It's an exemplary piece of screenwriting that never feels didactic, and it's studded with memorable lines (and that's never hurt any movie). Trosper later cowrote *One-Eyed Jacks* (1961), a leisurely revenge-driven western directed by Marlon Brando.

Paula Raymond, who bears a striking resemblance to Gene Tierney, is more than a pretty face, and was a welcome addition to the MGM films of this period in which she appeared. There's also good support from Marshall Thompson (as a homesteader), Edgar Buchanan (as the marshal), and Spring Byington (as Orrie's mother), each lucky enough to play a character who makes discoveries through the course of the film rather than stagnate as a mere "type." In Buchanan's case, his character begins as a good friend of Lance's, but then he becomes marshal and must abide by the laws, however much it pains him. A true friendship is torn apart. *Devil's Doorway* never ceases to provide its cast and its director with material worth mining.

Anthony Mann was now at home in the genre that would demonstrate his immense skills as an astute director of text and actors, and a

visual artist who used the American landscape for its awesome beauty and threatening turbulence. Later Mann westerns include *The Man from Laramie* (1955), his final one with James Stewart, followed by *The Tin Star* (1957), with Henry Fonda, and *Man of the West* (1958), with Gary Cooper. Mann's propensity for exploring troubled psyches with probing depth and unshackled emotionality makes his film legacy look very modern. How fortunate for the western that it became his medium in which to examine the human condition.

The Lusty Men (1952)
Contemporary Cowboys

Most westerns are set in the years between the Civil War and the turn of the century, the period in which the West was Americanized. But there's a sub-genre of western—the contemporary western—which includes films like *Bad Day at Black Rock* (1955) and *Giant* (1956), that explores western values and character in light of changing times. Some of these pictures, notably *The Misfits* (1961) and *Lonely Are the Brave* (1962), are elegies to the past, with modern-day cowboy characters portrayed as outmoded men deemed obsolete by mid 20th century. The West of *Hud* (1963) and *The Last Picture Show* (1971) is a place from which anyone would want to escape because it seemed less vital and hopeful with every passing day. John Sayles' *Lone Star* (1996) offers a West suffering an identity crisis between a romanticized past and bald reality. These pictures share thematic material distinctly grayer than the blacks and whites that dominate the western genre.

With *The Lusty Men,* from RKO, director Nicholas Ray gave us a West in which the only way a cowhand can improve his lot is to bring his skills to the rodeo circuit, risking life and limb but possibly hitting the jackpot. The story could apply to race-car drivers or test pilots or any profession in which there's a quest for highs outside the realm of usual experience. The West in *The Lusty Men* is a drab and dusty black-and-white expanse, not a place of colorful vistas or storybook ranches. The rodeo world has a tawdry showbiz aura, with the heightening drama of its potential for bodily harm. Like the booze, guns, and dance-hall gals of saloon westerns, the rodeo in *The Lusty Men* is an addiction. The main character, Robert Mitchum's Jeff, says, "Some things you do just for the buzz you get out of it." Here it's awfully hard to turn one's back on that buzz. But what makes this movie unusually adult is its three central characters, whose cross-purpose yearnings create a psychologically rich triptych of intense, festering desires and fears, both conscious

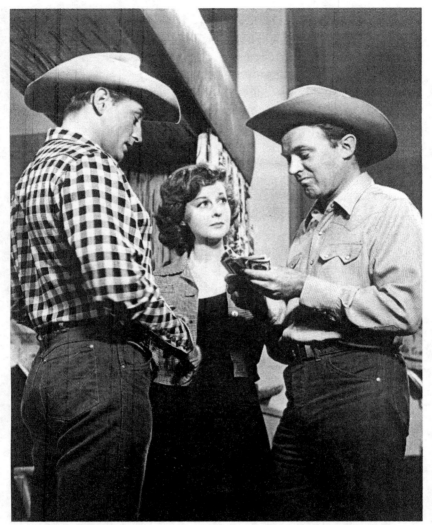

THE LUSTY MEN. Susan Hayward between available Robert Mitchum and her husband Arthur Kennedy.

and unconscious. Ray had already made *They Live By Night* (1949) and *In a Lonely Place* (1950), two overrated films held in higher esteem today than *The Lusty Men*; the former is marred by the malt-shop casting of its bruised leads and the latter is undermined by its weak second half. Flavorful *Lusty Men* easily bests them both.

After a leg injury, rodeo champ Jeff McCloud (Mitchum) returns to his Texas roots with thoughts of settling down. He befriends cowhand

Wes Merritt (Arthur Kennedy) and Wes' wife of two years, Louise (Susan Hayward), who are saving up to buy a place of their own. Wes harbors dreams of the life that Jeff led, but Louise is dead against it. Jeff agrees to coach Wes on the rodeo circuit, in exchange for half of any prize money won. Louise goes with them, fortified by Wes' promise to quit right after he makes enough money to buy a homestead. Wes does well quickly, and he's so seduced by the attention and the cash that he doesn't want to stop. As Jeff falls in love with Louise, she continues her struggle to hang on to Wes and their onetime plans.

The Lusty Men certainly delivers action. It's not an expensive production, but the rodeo sequences are an expert mix of actual rodeo footage with the film's scenes: Mitchum and Kennedy on horseback or in contact with bulls and calves; the stunts of their rodeo doubles; cast members and extras atop soundstage bleachers. The seamless editing of these elements creates an overwhelming feeling of being swept inside this rugged, sweaty world. Mitchum has a sensational entrance. A bull ambles down a chute and into an extreme close-up, and the camera looks up to discover Mitchum about to straddle the animal for the bull-riding event (though it's a double who will suffer Jeff's injury). There's something heartless about the way the rodeo continues matter-of-factly following serious accidents; lingering on the sport's broken bones (or worse) isn't good for business. All the rodeo scenes are properly rousing and visceral, but they serve best as the grubby, gritty background for the triangular story from which *The Lusty Men* derives its zesty humanity. Jeff's eighteen-year career is over soon after the film begins, but Mitchum is firmly believable as "one of the all-time greats" of rodeo, a man who has lived this battering life without regret. A shot of a multitude of patrons exiting the rodeo dissolves into one of Mitchum leaving the empty arena amid dust and litter hazily blowing in the wind. As he limps along in eerie silence, carrying just a knapsack, it's a haunting image of utter isolation. (The cinematographer is the great Lee Garmes, Oscar winner for 1932's *Shanghai Express*.)

Underneath the Texas home of his youth—a three-room shack now owned by an old codger—Jeff locates his hidden boyhood treasures amid cobwebs. Like his exit from the rodeo, the sequence at his birthplace has a dreamlike, time-standing-still quality, with Mitchum something of a hulking ghost. With his no-fuss approach to building fully realized characterizations without self-indulgence or self-admiration, Mitchum always made it easy to overlook his deceptive command of screen act-

ing. The wistful emotion and quiet pleasure he conveys at seeing this ramshackle place and its contents, a place Jeff hasn't seen in twenty years, feels so intimate that you wouldn't dream of interrupting him. With unvarnished simplicity, he tells the current owner, "I was born in this room," and, as he looks around, it appears that his long-ago past is flashing before him. This bittersweet contact with his roots deepens his current need to belong to something and somebody. With his broad physique and elemental masculinity, Mitchum has always personified the man's man, but with a presence so secure and confident that he never shied away from on-screen gentleness or sensitivity. (Think *Heaven Knows, Mr. Allison* or *The Sundowners*.) It's his capacity for simultaneous strength and delicacy that made him a great star. His Jeff is an easy guy to look up to, and it's no surprise that the rodeo people admire Jeff the man as much as Jeff the rodeo cowboy.

The arrival of Jeff into the lives of the Merritts sparks strong feelings: Wes' childlike awe and hero worship, and Louise's wariness and worry over his influence on Wes. Jeff becomes an unintentional catalyst, the detour off the couple's slow but stable course. Arthur Kennedy may seem miscast as a guy in the kind of physical shape to throw animals around, but he taps into Wes' cunning from our first sight of him, when he recognizes Jeff and pursues their friendship. Kennedy's smoothly crafty performance of an impatient, determined fellow (who is not always bright or likable) is a savvy portrayal of the kind of person who says whatever he thinks he must to get what he wants, without thinking too far ahead. He offers a fan's flattery to Jeff and enthusiastic (yet untrustworthy) husbandly assurances to Louise, yet he's using both of them to assist in the realization of his ambitions. Kennedy's Wes, with his killer smile and relentless drive, stands in stark relief to Mitchum's Jeff and Hayward's Louise, two characters marked by their honest, nononsense approach to life. Jeff may once have been thrill-seeking like Wes, but now he's like Louise, ready for commitments and responsibilities. Jeff and Wes want what the other has (or had).

Susan Hayward was her era's Barbara Stanwyck. By the time Stanwyck reached forty in 1947, Hayward was emerging as the new generation's Stanwyck, another spunky Brooklyn-born gal with Irish blood who drew on her disadvantaged upbringing to play dames you believed had been hit by life's hard knocks. Like Stanwyck, Hayward was dandy with zingers, comfortable in prison, equally at home in westerns and soap operas, looked swell with a drink and a smoke, and made a half-dozen

stinkers for every good film she made. Glamorous, yes, but not the girl next door. Louise is one of Hayward's Stanwyck-style roles, noted for its sass and smarts, even though all Louise wants is to be a wife and mother out in the middle of nowhere. Yes, Hayward is too fashionably attractive for Louise, a woman of limited means and experience (and a hash-house past), but the role gives us Hayward at her brassy best. In the 1950s, Hayward was queen of the biopics, with all manner of melodramatic calamities flung her way. As Jane Froman in *With a Song in My Heart* (1952), she survived a disabling plane crash and resumed her singing career. Then came Hayward's uncompromising portrait of Lillian Roth's alcoholism (and the pain and loneliness that got her there) in *I'll Cry Tomorrow* (1955), and from there Hayward went to the gas chamber (and won an Oscar) as Barbara Graham in the raw, jazzy *I Want to Live!* (1958). Sometimes—certainly as Graham—Hayward's vocal limitations brought strident strain to her "big" scenes, but as Louise, in the relatively mundane settings of trailer parks and lamb-chop dinners, she never pushes her gutsy alto or loses control of her performance. Her Louise isn't as showy a turn as her blood-letting biographical roles, yet she's nonetheless a powerhouse.

It's not *what* Louise wants that strikes you—domestic bliss with Wes—it's the fierceness with which she sustains and protects her dream. Louise has a very clear objective, and Hayward maintains the character's deep-seated longing, plus the stamina to stand up to whatever gets in the way of her vision. Wes is the man in whom she has invested her hopes, and Jeff is seen as the threat to those hopes, but Louise is too single-minded to notice that the men have been cast in the wrong roles: Jeff wants a settled post-rodeo life whereas Wes is a wild-oats sower. Her anger at Wes for changing their course is projected onto Jeff, the stranger whom she blames. The trio of *The Lusty Men* not only has to examine what it is they want but also how entangled they wish to be with the other two characters. Hayward is flexible in her scenes with Kennedy, indulging Wes' whims because Louise still believes they share a view of the future. One of her best scenes is her straight-talking, unro-manticized explanation of why she picked him from among her suitors; she loves him, yes, but she's also a practical girl. Hayward is decidedly tenser opposite Mitchum, seeing Jeff as a home wrecker.

Once the three characters are firmly established, they begin to show interesting contradictions, prompting questions of who is really using whom. For all Louise's anti-rodeo protestations, Hayward lights up

around the money being won. Wes may depend on Jeff and Louise at the outset but, as he grows more successful, Kennedy struts with the cockiness of one who has done it all on his own. Jeff may have found something to do by coaching Wes, but Mitchum makes it increasingly evident that, though he likes the cash too, it's Jeff need for Louise that keeps him on board. As Wes savors his big-deal status, Jeff and Louise grow closer. All along they've been fighting about Wes, questioning each other's motives, not quite seeing that Wes has been calling the shots from the start. Hayward and Mitchum start treating Kennedy as the spoiled, unruly child that Wes has become. Kennedy never makes the mistake of turning his flawed character into some kind of villain; Wes' failings are all-too recognizable.

Hayward and Mitchum are an ideal match in terms of their shared balance of tough and tender; their streetwise intelligence, likability, and decency; their unforced sexiness; and their directness, with its accompanying look of experience. Mitchum was an ace teammate to many leading ladies, notably Deborah Kerr and Jean Simmons, but Hayward (who carried most of her major pictures solo) never had a match-up like this one. Even though she's married to Kennedy, you're aching for the script to find a way to bring her and Mitchum together—where they belong. (Divorce was a dicey issue for 1952 Hollywood, on-screen anyway.) It's bliss to watch Hayward toss her one-liners his way because Mitchum is a partner who can appreciate her delivery. In response to his watchful eye on Kennedy, she snorts, "There are still a few things he can do by himself," grazing the line's sexual connotation. There's an erotically amusing scene in which Hayward jumps at a chance to take a luxurious shower in a woman's fancy trailer. Mitchum shows up unexpectedly, in time to help her with the shower knobs: "Anytime your plumbing don't work, just call McCloud." Mitchum is humorous and flirty, but Hayward holds tight to Louise's defenses. Their verbal sparring ends when she finally turns on the water, and there's a sexy moment when you can see him take pleasure in imagining her naked body, just a curtain and a shower door away. Their disappointing follow-up film, *White Witch Doctor* (1953), is a phony, primitive African jungle melodrama unworthy of their chemistry.

Eventually, Louise's guard comes down, and she and Jeff become allies, trying to control the excesses of Wes' spending, boozing, and womanizing. It's soon obvious that their supportive bond is truer and better-functioning than her marriage. As Louise absorbs Wes' bad be-

havior and is increasingly worn out by it, you can feel Hayward tighten in the pit of her stomach; you can almost hear an ulcer forming. And it's touching to observe Mitchum's Jeff, the loner, feel his need for Louise grow deeper and discover that she's the reason he can't leave this set-up. Once Louise has saved enough money to buy a home (Jeff's birthplace), there's a showdown between her and Wes. Louise still loves him, and Hayward plays this as a given; it may not be wise or no longer good for her, but it's so ingrained in her vision of her future that she cannot let it go. But that doesn't mean she can't get really mad.

In perhaps the film's most enjoyable scene, Louise confronts Wes' tootsie, Babs (Eleanor Todd). Earlier, Hayward had given her a swift kick in the pants ("That's *my* brand, sugar") at a bar. She vents her frustrations to Jeff, readying herself for this confrontation, while he tries to enjoy her pot roast. This is the hard-boiled Hayward her fans loved, referring to Babs as "that blonde with her dress cut down to her kneecaps" and, about Wes, "He ain't two years old and I ain't his mother." She furiously slips into a low-cut black dress; the good little wife is a knockout ready to start punching. She arrives at the hotel-room party all smiles, with Jeff, her handsome escort, knowing full well what's coming. She sees Wes with his lipstick-smeared cheek, then saunters over to him and Babs. About her rival's skimpy dress, she says, "I can't tell whether she's outside trying to get in or inside trying to get out," still all smiles and dazzlingly confident. But, finally, it's time to teach a lesson. She pours a drink over the girl's head, gives her a hard push, then clobbers her with a full ice bucket and sends her crashing to the floor. After declaring it a lovely party, she makes a triumphant exit with Jeff following. Hayward had already engaged in a memorable catfight, a powder-room assault on Marsha Hunt in *Smash Up: The Story of a Woman* (1947), and still to come was another ladies' room altercation in *Valley of the Dolls* (1967), but neither scene delivers the vicarious satisfaction of watching the ice bucket-wielding Hayward render sweet justice.

The tricky aspect of triangular plots is in resolving them satisfyingly. (As in *Rachel and the Stranger,* Mitchum has fallen for a married woman.) Jeff, in the film's most heartfelt scene, confesses his feelings to Louise in a hallway, moments after her hotel-room skirmish. Director Ray employs a series of alternating close-ups, intensely large and revealing, between Mitchum and Hayward, contrasting his bare feelings with her surprise and confusion; the stars' restraint is affecting and the tension palpable. Wes interrupts and this scene comes to blows

too, but, characteristic of this film, the emotions expressed aren't one-dimensional. The movie isn't over yet—the characters need to let things sink in and make adjustments. The climax will take place at the rodeo. Though I like that Jeff and Wes make peace with each other before the finale, I don't care for the actual ending. It's similar in that regard to the enchanting *Scaramouche* (1952), another film that botches its love-triangle plot in its final minutes. Whatever you think of the outcome of *The Lusty Men*'s story, there's no question that it happens too quickly, easily, and abruptly to be credible, and with a callously upbeat lilt to boot. A dramatic case can be made for this resolution—in terms of the characters' functions, specifically Jeff's role in the Merritts' lives—but it should have been executed with the careful attention applied everywhere else in the movie. For a film of such density and nuance to rush its final moments isn't disastrous but it is unfortunate.

Nicholas Ray brought out mature shadings in this multi-textured story and its simmering central relationships. It's an assured, tonally varied work and a damn fine entertainment. The screenplay, by David Dortort and Horace McCoy, suggested by a *Life* magazine story by Claude Stanush, has pungent, quotable dialogue and characters of surprise, depth, and yearning. Though the leads have significant individuality, the supporting characters are a collection of types, thinly drawn figures who serve their obvious function, mostly to show the punishing toll that a life in rodeo will extract.

Ray went on to make *Johnny Guitar* (1954), another off-the-mark western, one that accommodated psychosexuality, witch-hunt allegory, female empowerment, obsessive emotion, and a no-subtext Joan Crawford in one movie, and later the seminal teen picture *Rebel Without a Cause* (1955). Mitchum continued to beef up his résumé with acting triumphs in *The Night of the Hunter* (1955) and *Home from the Hill* (1960), but Hayward, after her Oscar win for *I Want to Live!* (1958), was soon mired in bad melodramas that deserved to star Lana Turner, true (meaning false) "women's pictures." In *Ada* (1961), as a hooker turned governor's wife, Hayward uttered a great camp line, "I never thought I'd be a lady, let alone a First Lady." Well, Hayward was a legitimate first lady of the screen who is insufficiently remembered today, primarily because she isn't in any all-time classics, movies that would guarantee eternal visibility. If more people saw her in *The Lusty Men*, probably the best movie she ever made, that wrong could be righted.

The Big Country (1958)
The Issue of Manliness

Director William Wyler's reputation isn't what it ought to be, meaning that it isn't what it *used* to be. He isn't ranked in the company of Howard Hawks or John Ford or Alfred Hitchcock because, supposedly, his filmmaking isn't *personal,* lacking the kind of thematic stamp that would identify his films as being the output of —heaven help us—an auteur. What could be more of a "stamp" than a body of work that provided the American cinema with as many classic movies as any individual has ever made? Wyler's hand is often invisible, but his presence is undeniably felt in his ingenious instinct for camera placement, thereby heightening drama and clarifying stories pointedly, without self-consciousness or showiness. He mined his material with both tact and rigor, and he had phenomenal success with actors, most of whom did their best work under his guidance, often finding themselves sitting expectantly at Oscar ceremonies. Since Wyler moved from genre to genre, he never became associated with one the way Cecil B. DeMille or Douglas Sirk did. His talent for bringing out the depths in screen-plays, and in performers, often led to his putting acclaimed plays onto the screen, resulting in some of the finest adaptations ever, including *These Three* (1936), a persuasive reworking of Lillian Hellman's contro-versial play *The Children's Hour,* minus the lesbian content; *Dodsworth* (1936), still one of the great films about marriage; *The Little Foxes* (1941), improving upon Hellman's biggest success; and *The Heiress* (1949), re-markable for its utter lack of staginess without significant "opening up." (Count 1951's *Detective Story* as one of his rare stage-to-screen misses.) Wyler's films often received their due, such as his justly revered and multi-Oscared post-war drama *The Best Years of Our Lives* (1946), yet his rich and haunting *Carrie* (1952) was unfairly discarded. Somewhere in between, with regard to attention and neglect, is *The Big Country,* a sprawling, popular western that has been ignored lately and is never cited among Wyler's best, a ridiculous assessment because it's a superior

150

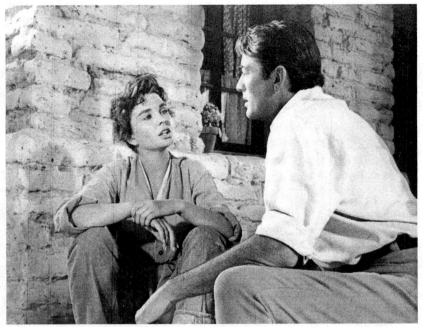

THE BIG COUNTRY. Jean Simmons and Gregory Peck appear to be made for each other.

entertainment, the kind of large-scale, star-studded, grown-up movie that went out of fashion but now looks pretty sensational.

Ex-sea captain Jim McKay (Gregory Peck) arrives out West from Baltimore to join his fiancée, Pat Terrill (Carroll Baker), on the vast cattle ranch owned by her father, Major Henry Terrill (Charles Bickford). The couple's unseen whirlwind romance, on Pat's recent visit east, no longer has a context, and their impetuous match-up soon seems like pure *mis*match. Pat is displeased and embarrassed by Jim's lack of interest in proving how manly he is whenever he's challenged by the locals, including Steve Leech (Charlton Heston), the Terrill foreman who wants Pat for himself. And Jim's faith in Pat is shaken by her lack of confidence and trust in him. Jim also becomes embroiled in the turf warfare between Mr. Terrill and Rufus Hannassey (Burl Ives), a mangier brand of cattleman, as both try to get hold of the Big Muddy, a water-abundant piece of land owned by Julie Maragon (Jean Simmons), Pat's schoolteacher friend. Julie maintains the peace by allowing both men to use her water, but there's no stopping the violence that's brewing, nor the fact that it's Jim and Julie who are made for each other.

The Big Country is best remembered for Jerome Moross' instantly identifiable musical score, one of the greatest (and most hummable) ever written for a western. It's also a score of surprising variety and texture, enhancing the visuals and the emotions so much so that it becomes an integral element of the film's overall impact, in much the same way that Hitchcock's later classics, such as *Vertigo* (1958), are unimaginable without Bernard Herrmann's music. And, as with Herrmann's work, you're never unaware of Moross' Oscar-nominated score, but it's so *right* that I never tire of it. Moross' rousing music connects stirringly with the rapturously beautiful images of Franz Planer's color cinematography, embellishing the film's sensory pleasures to ecstatic proportions. Obviously, this movie has to be big, and it has to be big *often*. It's no surprise that the camerawork is gorgeous, or that the natural scenery astonishes, but the film's look is uniquely memorable for its array of compositions that serve as constant reminders of just how big the big country is. These vistas aren't employed merely to showcase wide-screen visions of American beauty for their own sake, but rather to highlight, through the camera's distant perspective, how small humanity is within these unfathomable spaces. The film features breathtaking, panoramic shots in which the human figures (or the houses or towns they inhabit) are tiny, isolated specks in a world they mean to conquer and control. Whether on horseback or in carriages or on foot, the characters are matted against an endless nothingness that, to our eyes, overwhelms them, but it actually invigorates them with possibility. Since "big" is the unifying force behind every aspect of Wyler's vision, it's extraordinary that the production never swallows up its cast. In his pursuit of grandeur, Wyler never sacrifices the small, telling details of character.

Gregory Peck (who coproduced the film with Wyler) is ideally cast as Jim. The role calls for the assured, unforced masculinity and humane, penetrating wisdom that came so easily to Peck. In his capable hands, it's very satisfying to watch his Eastern gentleman stun those around him, first with his refusal to buy into their rites of on-demand machismo, then in his prowess at showing them up. It may be in the film's overt exploration of masculinity that the screenplay resonates most. Certainly, testosterone is key to any western, but rarely is the subject addressed as explicitly as it is here. Jim is unwilling to participate in constant challenges to his manhood, tests that speak more to issues of insecurity than virility (and just happen to be a turn-on for Pat). Notions of masculinity are the deciding factor in the future of their relationship, a

clash between Jim's ego, unthreatened by rowdies, and Pat's insecurity, which requires public displays of Jim's courage. Peck plays Jim with a steady, not-easily-riled demeanor that's confidence-inspiring and unassailably admirable; Jim will not overreact, nor will he cave in to what others expect of him. Peck's absorbing intelligence pervades the movie; it's most enjoyable watching him size up situations and figure everybody out. He's also a low-key delight in the highly entertaining, extended scene in which he attempts to ride "Old Thunder," the horse that won't be broken. It's good for a character like Jim, of such honor and moral fiber, to be brought down a peg, so as not to be deemed insufferably superior—and this scene lands him on his rear end, with hay in his hair and mouth. Peck had recently played another sea captain, Ahab, in *Moby Dick* (1956), and had given a terrific performance in *The Gunfighter* (1950), his best film in the western genre.

Pat is a juicy role, and Carroll Baker, who had recently appeared in another western epic, *Giant* (1956), doesn't shy away from the character's less attractive traits. She and Peck are a physically demonstrative couple, underscoring the fact that it was lust that brought the characters together, in spite of their basic incompatibility. The first crisis comes in their wildly divergent reactions to the attack on their wagon by the Hannassey boys; Jim takes it in stride as harmless hazing, whereas Pat calls for blood. Each time Jim disappoints her—whenever he refuses to be baited into some kind of violent proof of his bravery—Baker reveals the petulant, bratty rich girl that Pat is. That his actions might be interpreted as cowardly is more than she can bear. Kittenish when she chooses to be—Baker was, after all, the star of *Baby Doll* (1956)—she can turn on a dime; the blond, wholesomely pretty nymphet is suddenly a hard, unpleasant person. Baker is unafraid to make an audience dislike her; there's unsightly anger in her anytime her pride is beaten. Her Pat is willful and demanding, pampered by a daddy with whom she shares a creepily flirty relationship. She's incapable of loving Jim as anything more than her idealization of who he is and how he should behave. Watch her eyes when it looks as though Jim and Steve are going to fight over her; she cannot conceal her titillation. But when Pat discovers that she's underestimated Jim, Baker turns into a needy child and her vulnerability spills out. Even when she exposes the lost little girl who aches for Jim's love, Baker makes it just another of Pat's mercurial swings. In fact, over the course of the film, Baker is either throwing herself in his arms or being haughtily reproachful, but she's

rarely ever balanced. The character is shallow, and doomed to be as harsh and close-minded as her beloved daddy, and Baker intensifies Pat's flaws by playing her as oblivious to her true failings.

The Big Country is something of a romantic quadrangle, with the other two sides provided by Charlton Heston's Steve and Jean Simmons' Julie. This is the kind of movie in which the right match-ups are immediately clear to the audience but not to the characters. Heston, sullen and sly, allows Steve's immediate dislike of Jim to seep out of his every sweaty pore. But you have to hand it to Steve for knowing that Jim and Pat make a terrible pair, and that the volatile Pat is better suited to him. The key scene between Heston and Baker is the one in which she strikes him with a riding crop after he makes a sarcastic crack about Jim. He then grabs and kisses her roughly; she tries to fight him off, biting and bloodying his lip. They're both turned on by this kind of ferocious display, which makes contempt and desire look interchangeable. Pat may fancy herself with Jim, but Steve is the sort of brawny brute that's more her style. Released from the dull virtuousness of leading-man assignments, Heston feels unbound by this role, and his performance is the loosest, sexiest he ever gave. He makes a neat, snide baddie, unhampered by the nobility of his heroic and Biblical roles. And Steve isn't just a swaggering torso; Heston shows some new colors with the role's late-arriving conscience. He made this film after *The Ten Commandments* (1956), so his essentially supporting role (he's billed fourth) is unexpected at this point in his career. I'm sure glad he took it, though, and Wyler must have been pleased, too, because he rewarded Heston with the title role in *Ben-Hur* (1959), which led to Oscars (undeserved) for both men.

In Julie, Jim finds the woman whose maturity and thoughtfulness match his own, which isn't to say that they aren't any fun. In the scenes in which they get to know one another, Peck and Simmons interact with the kind of humorous playfulness that makes audiences grin; they seem to be discovering how irresistible they are at about the same time we are. And the actors' easygoing playing styles fit together as precisely as the characters' personalities. The scene in which they try to out-shock each other with gruesome tales (his from the sea; hers from the West) exhibits a freedom and prankishness that the characters share with no one else. Peck had already displayed a light comic flair for Wyler in 1953's *Roman Holiday*. (The Jim-Pat-Julie triangle reminds me of the one in *Holiday* (1938), in which Cary Grant, seemingly happily engaged,

figures out that he has nothing in common with his snotty bride-to-be and really belongs with free-spirited Katharine Hepburn.)

Now, one can't just slip by the fact that ladylike, English Jean Simmons is here in, of all things, a western. Against the odds, she's quite at home, and such a vibrant, feisty presence that the issue is ultimately a non-issue. Her beauty, frankness, and spine bring even more verve to a film well stocked with personality. The role of Julie isn't as flashy as that of Pat, though it does have a delicate arc, as she fights within herself not to fall in love with her friend's fiancé. But, then, Simmons always had a way of making any role seem better for her having played it.

The broader canvas around which the romantic complications swell is the thirty-year hatred between the Terrills and the Hannasseys. The leaders of the clans are roles of Shakespearean fury and patriarchal grandiosity. Charles Bickford, as Henry Terrill, hadn't worked with Wyler since the early talkie *Hell's Heroes* (1929), another western and probably the best film version of *The Three Godfathers* tale. Henry is one of those apparently respectable tycoons who turn out to be men of shocking cruelty and selfishness. Bickford starts off fairly benign, without a hint of Henry's ruthlessness until he speaks of the Hannasseys to Jim over breakfast. His demonization of the enemy is all the scarier for the self-righteous stance Bickford assumes; ridding the area of this "trash" is a noble, just cause (or so he claims). Peck's reaction is a realization of the ugliness that Jim has entered into. His presence becomes increasingly less welcome to Henry because of Jim's ability to detect darker motivations. Bickford's Henry is protected by a wall of power, wealth, and manners, a perfect cover for his sadistic brutality and crafty manipulations. It's a shrewd, frightening portrait of a villainy that hides its true intentions behind a do-gooding sense of community. (Politics, anyone?) In a climactic moment, after his men forsake him, he goes off to battle alone, knowing full well that Steve and the others will soon weaken and follow him. It's a spectacular sequence, shot in a single take: Bickford rides slowly inside the canyon, and then, in the far-off distance, Heston appears around the bend, racing to catch up to him, and then, a few beats later, the others follow, all to the thrilling accompaniment of Moross' score. Bickford's confidence is terrifying; wearing a self-satisfied smile, he barely glances backward, never making eye contact or even acknowledging his men's return. It's a major performance by one of Hollywood's top character men (*The Farmer's Daughter, A Star Is Born, Days of Wine and Roses,* among so many).

As Bickford's opponent in this dynastic war, Burl Ives won the Oscar for best supporting actor. Ives has the showier role, and his Oscar victory was aided by the fact that he recreated his stage role of Big Daddy in the film version of *Cat on a Hot Tin Roof* that same year. He plays men disappointed in his sons in both movies. Ives seems shorter and stouter as Rufus Hannassey than he did as Big Daddy, but the electricity in his energy is the same. Even when absolutely still, Ives is a theatrical presence, and he devours the role handily. His work is tense and deliberate; he never throws away a line or makes a casual gesture. He has quite an entrance, silencing a party at the Terrill place with his formidable, motionless appearance, rifle in hand. He looks especially scruffy in this setting, nowhere near as refined or well off as the Terrills. His speech, in which he tells off Henry for having attacked the Hannassey homestead (while Rufus was away), is delivered without movement, though his blue eyes positively blaze and his concentration is mesmerizing. Bickford's work may be subtler, but Ives has the advantage of playing a role that becomes more likable as the picture progresses. In response to events involving his slimy, worthless son Buck (Chuck Connors), and in his dealings with Julie and Jim, the character affords Ives unexpected moments of warmth, charm, honor, and pain. He has also got some of the movie's best lines. When Buck enters and asks him if he wants him, Rufus replies, "Before you was born I did." Rufus' succinct advice on courting a lady is, "Take a bath sometime." And when Burl Ives spits on you, you know you've been spat on.

The Big Country has more than its share of set pieces, sequences designed to wow you. Peck and Heston finally have their fistfight, and it's the fistfight to end all fistfights. At dawn—strictly between them and without any witnesses—the two men go at each other against the limitless expanse of land behind them and the faded blue of almost-morning light. Shot from various vantage points, it's superbly pieced together, alternately faraway and in-your-face. The brawl begins slowly, then becomes quite punishing. It's a brilliant touch that, in a film surging with music, this scene has no music at all (till the very last part), with the only sounds being the pounding of flesh and the accompanying grunts. Because the men are well matched and resilient, it's a four-minute pummeling, ending with Peck's line, "What did we prove? Huh?" Another splendid moment is the perfectly timed single take in which Simmons enters her house (screen left) and Peck walks off (screen right), both having exited the foreground when, a second

later, way off in the distance and from over a hill come three men on horses, on their way to kidnap her. Then there's the final shootout but, for a change, this showdown is between two old-timers rather than young hotshots and valiant lawmen. Ives and Bickford move toward each other, through the narrow, curving path of a startlingly white canyon, in a dizzyingly high overhead shot. Yep, the movie ends with one last look at the title character.

Based on a fast-reading novel by Donald Hamilton, *The Big Country*'s screenplay was written by James R. Webb, Sy Bartlett, and Robert Wilder. The script is very skillful at telling both the intimate love stories and the grander tale of the family feud. It delivers a half-dozen full-bodied characters, etched with fascinating, subtextual turbulence. There's surprise and growth in these people, and some interesting gradations of villainy on hand. To its credit, the movie makes several jokes about this being a "big country," references that both amuse and annoy Peck's character. It's something of a running gag. The movie is also big in length at 166 minutes. (Is it possible, for once, that it takes less time to read the book than see the movie?) Most of it flies by, but it bogs down in an elaborate pistol duel, which is one climax too many, and too formal considering the violence about to erupt elsewhere at any moment. But Wyler did an exemplary job of delivering western fodder in a fresh, unusually smart fashion (and, of course, it's better acted than most oaters). His visual acuity, his adult sensibility, and his storytelling sense are in prime form here. His direction is flashier than usual, proving that he could be a bit of a dazzler when he chose to be. *The Big Country* has been dismissed in recent years, just as Wyler is no longer as famous and touted as he once was, but let's hope that the tide turns in both their favors before too long.

Comanche Station (1960)
"B" As in Budd Boetticher

In Mel Brooks' famously flatulent comedy *Blazing Saddles* (1974), sheriff Cleavon Little has trouble convincing the evacuating citizens of Rock Ridge to give him twenty-four hours to save their town from destruction. Finally, he tells them, "You'd do it for Randolph Scott." The crowd repeats Scott's name reverently, and men stand and remove their hats as a heavenly choir repeats Scott's name. The people change their mind because, yes, they *would* do it for Randolph Scott. Scott had been retired a dozen years when Brooks made his typically anachronistic joke, proof that Scott was still a western icon. He may have had a small acting talent, yet something special happened when he brought his tall, light, and handsome looks and uncomplicated presence to westerns. His effortless embodiment of decency made him one of the genre's quintessential good guys. In the 1930s and early 1940s, Scott worked in all genres, lending his amiability and lean beauty to such diverse pictures as two Astaire-Rogers musicals (1935's *Roberta* and 1936's *Follow the Fleet*), the supernatural camp classic *She* (1935), the Mae West comedy *Go West, Young Man* (1936), two Shirley Temple vehicles (1938's *Rebecca of Sunnybrook Farm* and 1939's *Susannah of the Mounties*), the screwball favorite *My Favorite Wife* (1940), and war pictures such as *Bombardier* (1943) and *Corvette K-225* (1943). By the late 1930s, he was making his mark in westerns, appearing as Wyatt Earp in *Frontier Marshal* (1939), supporting Tyrone Power in *Jesse James* (1939) and Errol Flynn in *Virginia City* (1940), starring in *Western Union* (1941) and *The Desperadoes* (1943), and forming a zesty threesome with Marlene Dietrich and John Wayne in *The Spoilers* (1942). Like Joel McCrea, Scott concentrated on westerns after World War II, though his were distinctly second-rate. That all changed in 1956.

Like John Ford and John Wayne on *Stagecoach* (1939), and Anthony Mann and James Stewart on *Winchester '73* (1950), something rare clicked when Budd Boetticher directed Scott for the first time in *Seven*

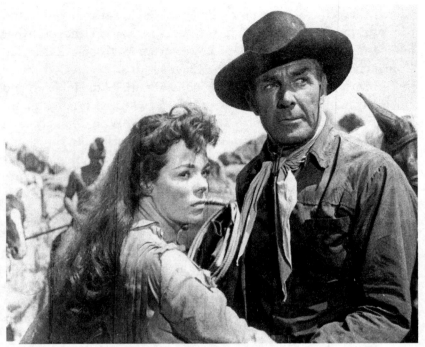

COMANCHE STATION. Nancy Gates under the protection of stoic Randolph Scott.

Men from Now (1956). With a superior script and a director with gifts for visual expressiveness, dramatic fire, and unvarnished truth-telling, Scott, by now in his late fifties, excelled as never before. The movie established the Scott persona that dominated the series of seven Boetticher-Scott westerns (1956-60): a loner mourning the loss of a wife and seeking revenge and/or closure. This septet of color films is often regarded as a great B-movie series. They may be B in their unpretentiousness and brief running times (not one reaches eighty minutes), but certainly not thematically or visually. The deceptive simplicity of Boetticher's artistry was ideally matched to Scott's plain acting. Scott never could have played the psychologically bristling roles that James Stewart mastered in his Anthony Mann westerns, but he's just right for Boetticher's private stoics. My favorite picture, and arguably the best, in the series is *Comanche Station,* the final one and the purest distillation of the Boetticher-Scott style. If it's a B, then few westerns rate an A.

By trading goods, Jefferson Cody (Scott) rescues Mrs. Lowe (Nancy Gates) from the Comanches who abducted her last month. Cody is a fixture in this territory, ever since his own wife was captured by

Comanches ten years ago, prompting his relentless search for her and the resulting rescues of women such as Mrs. Lowe. Headed for her home in Lordsburg, he and Mrs. Lowe encounter trouble at deserted Comanche Station when Ben Lane (Claude Akins), whom Cody knew in the army, and Lane's two "young guns," Frank (Skip Homeier) and Dobie (Richard Rust), arrive. Ben wants the $5,000 dead-or-alive reward for Mrs. Lowe, and he'll kill her and Cody to get it. With Comanches on the warpath, all five uneasily travel together on horseback to Lordsburg, with Cody awaiting Lane's treachery. Along the way, affection develops between Cody and Mrs. Lowe, and Dobie begins moving his allegiance from Lane to Cody.

At just seventy-four minutes, *Comanche Station* plays like a perfect short story of a movie. As credits play, there appears in the distance a man on horseback and a mule following. They are riding over and through a rocky, gnarled landscape, a favorite backdrop in the series. The setting looks like an uninhabited, faraway planet and serves as a starkly dramatic metaphor for Cody's isolation. The craggy, misshapen landscapes in these films sometimes augment the unsettling tensions in the plots but, even more eloquently, mangled rock formations suggest ruins and reflect the broken lives of Scott's characters. *Comanche Station* plays without a single interior scene. It's an all-natural western, reminiscent of Anthony Mann's gem *The Naked Spur* (1953), which also features a five-principal cast in a deadly drama on challenging terrain. *Comanche Station*'s power derives not only from the reality of its physical world, but also from its time-taking rhythm. The film is brief yet unhurried. With transporting long takes, Boetticher gives the film a leisurely pace, allowing the story and the characters' transitions to soak in. The film is, essentially, a journey, and Boetticher doesn't stint on showing what that entails. What at first may seem like filler—much footage of the five characters traveling across pretty scenery—provides a genuine feel for what it is to ride for days, on changing topography, at varying speeds, in rumination or in conversation. Though the wide-screen beauty is consistently rapturous, the effect is never showy or superfluous. Westerns belong outdoors, and rarely has a movie made an odyssey like this one feel and look so unstintingly authentic.

Characteristic of the series, the plot is basic but the characters' backstories are rich. Cody isn't a man prone to opening up or sharing his pain, but he's conscious of others' needs. Mrs. Lowe, who does not yet know Cody's story, asks him, hypothetically, how he would feel about

his woman after learning she'd been raped by Comanches. If he loved her, he answers, "It wouldn't matter at all." This is the first clue as to who the private Cody really is. He carries his sadness inwardly, is loath to explain his actions, and doesn't seek attention. Reserve was perhaps Scott's finest attribute as a film actor, assisting in his personification of unshakable honor and suggesting hidden depths. Here, as so often, Scott represents all that is good, without being a righteous pain about it. What he lacked in acting chops, he made up for with the comfort and grace with which he carried innate goodness. Cody's black hat and black shirt, usually reserved for villains, serve as mourning attire for the life snatched from him. Scott, attractively weathered and still trim, was past sixty when he played Cody, and his signs of age add further poignancy to the punishing futility of his unfaltering quest to find his wife.

Lane is as intrinsically bad as Cody is good. Cody knows Lane to be a killer and a liar, and he's ready for anything from him. Their battle is elemental, and they prove equally resolute in their missions. As Lane, Claude Akins is a human-sized villain, cool and smart and confident but refreshingly not larger than life. (He had just played another bad guy in 1959's *Rio Bravo*.) Akins makes Lane a frightening figure because of his nonchalant willingness to murder. His laid-back, regular-guy manner only makes his ruthless greed more disturbing. Akins is especially fine in the scenes in which Lane slyly tries to foment trouble merely with words, hoping to instigate dissension between Cody and Mrs. Lowe. Akins' unctuous ease is a distraction from how alert Lane is; he doesn't miss a beat. Boetticher stages a subtly impressive two-minute tracking shot in which Cody and Lane, leading the pack, talk easily. The dialogue points up further differences in the men, such as Lane's womanizing versus Cody's faithfulness. When Lane threatens to steal Mrs. Lowe from Cody's protection, it puts the plot's central danger out in the open. As the camera follows the riders on their trail, the technical expertise of this single, extended take is a marvel of shape-shifting perspective. The camera is sometimes in front of the men, sometimes at their side, sometimes takes in the other three players, sometimes closes in on the action and sometimes pulls away. The scene—its trickiness invisible—feels, like all of *Comanche Station*, simply captured rather than staged.

The scene that made me fall in love with this movie (the first time I saw it) is a nighttime chat between Dobie and Frank, bedded down around a tree. When these characters are first introduced, you expect them to be nothing more than mere adjuncts of Lane. The fact that the

actors playing them look alike only confirms their probable function as interchangeable sidekicks. What a surprise then that Dobie becomes the most interesting and complex character of all. You're not prepared for self-examination in an uneducated gunslinger, but Dobie is a fellow with a budding conscience, a contrast to Frank who follows Lane unquestioningly. Dobie genuinely wonders, "Are we bad?" As Dobie, Richard Rust gives the kind of performance that makes you wonder why he didn't have a major career. The guilelessness in Rust's acting is so honest that he nearly breaks your heart. Beautifully written by scenarist Burt Kennedy, the scene is a thoughtful conversation between a boy looking for answers and a boy who never thinks ahead. Dobie is a lost and lonely soul who, in banding with Lane and Frank, found a sense of belonging. He yearns to turn his life around, haunted by his father's words about the importance of "amounting to something." He's an initially dumb-seeming kid who isn't dumb, and he sees in Cody the kind of man he'd like to be. The scene awakens in Frank thoughts that never occurred to him, though he's incapable of Dobie's level of self-awareness. Rust's searching performance is winningly innocent, unforced in its humor, and touching in its cleansing growth. Kennedy's dialogue feels ahead of its time in its introspective probing. Suspense builds as to whether or not Dobie will amount to anything before the picture ends.

Talking with Cody about the inevitable doom of an outlaw's life, Dobie speaks of life on "the wild side." Cody responds, "Man can cross over anytime he's a mind." Cody is an old-school western hero, firm and sure, whereas Dobie is more modern, a man uncertain. (Dobie is a western character for the 1960s.) Cody encourages Dobie and invites him to ride with him after they get to Lordsburg. When Scott says, "Man gets tired being all-the-time alone," it's a hopeful moment for both men. With Scott confronting and revealing Cody's loneliness and Rust exhibiting Dobie's awe at his new idol's interest in him, this is an affecting high point in a deeply felt western. This strain of the plot would resurface in Scott's next and final film, *Ride the High Country* (1962), in which another hotshot must choose between two older role models (but Scott is the surprising "bad" choice there). Despite the baggage and heartache of Cody and Dobie (and Mrs. Lowe), there's potential for happier days. The film alternates evenly between optimism and pessimism, right up to its finish. When Lane says that Dobie "runs on the gentle side," he means it as an insult, but you see Dobie's burgeoning sensitiv-

ity expand in his warm scene with Mrs. Lowe. He tells her the details of Cody's loss of his wife and the resulting, unending search. When he says, "Sure must've been a love between them two," Rust conveys that love is something else Dobie pines for. The scene ends with Dobie a bit desperately telling her to stick closely to Cody, fearing for her life. Dobie has, inside anyway, already changed sides, and Rust makes his transition equal parts rejuvenating and agonizing.

As Lordsburg draws near, so does the inevitable Cody-Lane showdown. In response to offensive remarks, Scott, usually so contained, hits Akins hard with a lightning-fast punch that flattens him, a reminder that the subdued Cody is also tough as they come. Larger-scale action comes in a Comanche assault on Cody as he rides across an open clearing, another sequence of wide-screen glories, mobile camerawork, and visceral action. Off his horse, Cody bests an Indian by throwing his saddle at him, which bashes the Indian to the ground; they then fight in the dust. The leg injury Cody incurs leads to Scott's one comic moment, when liniment is poured on his wound and he cuts loose with a sustained "Whoo!" till the pain subsides. (Nice to see the stoic let go.)

A restrained amatory feeling brews between Cody and Mrs. Lowe. We don't know if her husband will declare her damaged goods—the film saves for the end the reason why Mr. Lowe hasn't been looking for his wife himself—and no one knows if Mrs. Cody is alive, so there's a feeling of possible availability between Cody and Mrs. Lowe. In her he sees his own wife, both women having suffered the same fate. He and Mrs. Lowe seem grateful for time spent with substitutes for spouses they may never have again. The film's weakest performance is Nancy Gates' as Mrs. Lowe. She's serviceable, but she's the only aspect of the film reminding you that you're watching a movie. It isn't all her fault, since she's subjected to gratuitous moments that drench her tight clothes or eye her cleavage, but she's just not as unerringly convincing as the other four principals.

After one of the sadder deaths in the genre, there's an exciting, superbly executed climax set within a maze of those gnarly rocks. The ending offers a catharsis of sorts for one character, a visualization of all this character dreams of. The final moments constitute an ending without an ending, with Boetticher repeating the opening shot in reverse for a quietly haunting fade-out.

The other Boetticher-Scott westerns are *The Tall T* (1957), *Decision at Sundown* (1957), *Buchanan Rides Alone* (1958), *Ride Lonesome* (1959),

and *Westbound* (1959), and they're all good! *Seven Men from Now* and *Westbound* were made for Warner Brothers, while the other five were made for Columbia. *Comanche Station* (a pedestrian title) was a production of Ranown, the company formed by Scott and producer Harry Joe Brown. Rand Brooks, solely remembered as Charles Hamilton in *Gone With the Wind* (1939), has a bit role as the fatally wounded station man, spewing out a few expository lines before expiring. Skip Homeier, who plays Frank and was also in *The Tall T*, is best known as the child actor ("Skippy") who played the Nazi youth in *Tomorrow, the World!* (1944), a laughable performance that terrorized wartime audiences.

On *Comanche Station,* Boetticher used a cinematographer and writer both of whom had been previous participants in the series. Cinematographer Charles Lawton, Jr., (no relation) shot *The Tall T* and *Ride Lonesome.* His ravishing open-air work on *Comanche Station* takes thrilling advantage of the expressive potential of CinemaScope with compositions of staggering depth and range. Writer Burt Kennedy also wrote *Seven Men from Now, The Tall T,* and *Ride Lonesome,* which means he wrote the four best in the series. Kennedy's *Comanche Station* screenplay has penetrating western dialogue, marked by unusual introspection and intimacy. The script is clean and compact, with well-delineated characters and precise plotting.

Boetticher's refined technique—masterful long takes; filling the wide-screen with information as well as beauty; using locations as thematic enhancement; savoring the natural wonders vital to the genre; rupturing tranquility with jolting blasts of violence—is always in unassuming service to the material. Add to this his delicacy for the painful emotions in the script and you have a major director unfairly unknown beyond cult status. He made another fine, modest western, *The Man from the Alamo* (1953), starring Glenn Ford and worth the attention of every western aficionado.

It's astonishing that Scott, in a career of roughly 100 films, saved his two best for last. Effective as he is in the penultimate *Comanche Station,* he had apparently been hoarding all his acting talent for *Ride the High Country,* his sublime farewell. Let's cue up *Blazing Saddles* for one more fervent chant of "Randolph Scott."

Hour of the Gun (1967)
Deconstructing Wyatt Earp

One of the western genre's essential characters is real-life lawman Wyatt Earp. His name immediately evokes Doc Holliday (his friend), the Clantons (his enemies), and the legendary shootout at the O.K. Corral, a landmark of western history. Movies about Earp, be they fact or fiction, are almost a genre in themselves, so familiar is the mythology surrounding the man. Naturally, western regulars Randolph Scott and Joel McCrea played Earp: Scott in *Frontier Marshal* (1939) and McCrea in *Wichita* (1955). Sometimes Earp wasn't the main character but would show up to lend some veracity, as in Will Geer's appearance in Anthony Mann's *Winchester '73* (1950) and James Stewart's guest shot in John Ford's *Cheyenne Autumn* (1964). There were even dueling Earp pictures as recently as the 1990s: the equally prosaic *Tombstone* (1993), starring Kurt Russell, and *Wyatt Earp* (1994), starring Kevin Costner. Few would refute that the best Wyatt Earp movie is Ford's *My Darling Clementine* (1946), with Henry Fonda as Earp and Victor Mature as Holliday. It may not be a factual account of these men, but it's a masterwork, the best western of the 1940s. Pictorially and dramatically rich, it's a poetic work anchored by Fonda's deceptively inventive (and surprisingly funny) performance and Ford's haunting black-and-white compositions.

In 1957, director John Sturges made a slick, Technicolor version of the story baldly titled *Gunfight at the O.K. Corral,* starring Burt Lancaster as Wyatt and Kirk Douglas as Doc. Lacking the artistry and textures of Ford's film, it's nonetheless a satisfying commercial entertainment, vitalized by its star power. With this muscular hit behind him, Sturges went on to make two of the most devoutly revered "guy flicks" of all time: *The Magnificent Seven* (1960) and *The Great Escape* (1963). (If he, instead of Robert Aldrich, had directed *The Dirty Dozen* [1967], then he would have made all three of the 1960s' triumvirate of mega-macho movies.) It seemed logical when Sturges signed on to direct *Hour of*

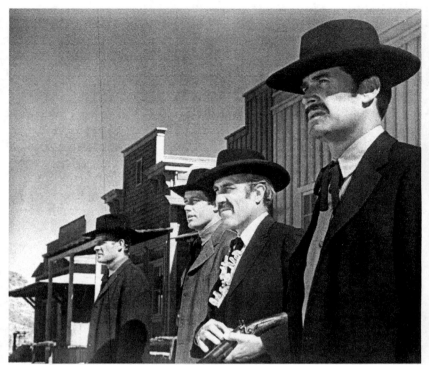

HOUR OF THE GUN. Sam Melville, Frank Converse, Jason Robards, and James Garner approach the O.K. Corral.

the Gun, his second picture about Wyatt and Doc, and another opportunity to provide the action, gunplay, and heroics he had delivered so successfully before. Well, two very unexpected things happened. Instead of a straightforwardly rousing, profit-minded epic, Sturges made a demanding, elegiac meditation on violence and its lingering residue. The film was also a surprise in that it begins where most Wyatt Earp movies finish: at the O.K. Corral. The shootout *opens* the picture rather than serve as its cathartic peak. An unofficial sequel to Sturges' 1957 crowd pleaser, the movie takes its renowned characters past the central event of their lives and probes the dark aftermath. Its tone of low-key introspection didn't appeal to audiences or critics of 1967, but the result now looks mightily impressive and far superior to *Gunfight at the O.K. Corral*. It's hard to accept that the same man directed both movies. *Hour of the Gun* is one of the relatively few fine westerns of the '60s. It's a transitory work that connects the '50s-style thinking man's westerns, like *The Gunfighter* (1950) and *High Noon* (1952), with the

166

new Hollywood's genre-busters, such as *The Wild Bunch* (1969) and *McCabe and Mrs. Miller* (1971).

Nothing is resolved between the Earps and the Clantons after the O.K. Corral incident. Ike Clanton (Robert Ryan) and his allies continue to fight marshal Wyatt Earp (James Garner) and Earp's two law-enforcing brothers, first in court and then by gunfire. After the crippling of one brother and the murder of the other, Wyatt gets federal authorization to form a posse. His gunfighting pal, ex-dentist Doc Holliday (Jason Robards), is the first to sign on, and they (and three others) go after Ike and his four henchmen, which eventually brings Wyatt and Doc to Mexico. As the consumptive, alcoholic Doc faces the deterioration of his health, Wyatt grapples with the realization that his lawful mission is tainted by his appetite for avenging violence.

The film begins with a wide-screen long shot of Garner, at the left of the frame, as he puts on his black hat. He then walks front and center, accompanied by the ominous strains of Jerry Goldsmith's overemphatic (and repeatedly intrusive) score. After the credits, up comes, "This picture is based on fact. This is the way it happened." That certainly intimidates me enough not to question what follows, the implication being that truth has rarely been applied when enacting this story. As Wyatt, Doc, and the Earp brothers, Virgil (Frank Converse) and Morgan (Sam Melville), line up across the screen, Sturges sets a formal, solemn mood. The men slowly start walking to the corral, and the screen reads, "Tombstone, Territory of Arizona. October 26, 1881." In the gunfight, there's no clever camera movement, no stylistic beauty, and no prolonged suspense. The fight is short-lived, lasting about fifteen seconds (which is, apparently, closer to fact than the elaborate showdowns of Ford's film and Sturges' earlier one). Three of Clanton's men are dead, and Virgil and Morgan are wounded. Sturges has instantly deconstructed a famed clash into a rather ordinary skirmish, making it clear that this film isn't going to be a rehash of standard material.

The role of Wyatt Earp is the occasion for one of James Garner's best, and most offbeat, performances. Even though he became a star as a western character, in the title role on television's *Maverick* (1957-60), his Wyatt is entirely without the bright charm and humor for which he is known. By 1967, Garner was a premier light comedian who had played opposite Lee Remick, Kim Novak, and romantic comedy's reigning queen Doris Day. His finest work is alongside Julie Andrews in *The Americanization of Emily* (1964), a comedy-drama set in WWII London;

both he and Andrews are marvelous (and talk about chemistry!). As Wyatt, not only is Garner's customary affability absent, but he rarely even smiles. Dressed in black and sporting a mustache, he may at first appear to be spoofing a western tough. The riveting intelligence he emits quickly dissipates that notion; so does his ability to make plain the core of strength beneath Wyatt's guarded feelings. He's quiet, but he's observant. Garner burrows within, and his steeliness never seems a put-on. When the witness to Virgil's shooting refuses to reveal the killer, Wyatt threatens him, "You've got just as much to fear from me as you have from Clanton." His cause may be just, but he's no uncomplicated hero. He's a good man willing to go as far as he must to get the results he wants. This is a Wyatt Earp for the late 1960s, a hero operating in the gray areas.

The only person who can see inside of Wyatt is Doc. Victor Mature made a sad-eyed Doc in 1946, and Kirk Douglas a charismatic one in 1957, but I've never seen a Doc Holliday that approaches that of Jason Robards. Sharply lucid, ironically funny, and unlike anyone else in the picture, Robards is not your typical cowboy, yet he's equally credible as gunfighter, card shark, and drunk. He had already given one of the screen's great alcoholic performances, repeating his stage role in *Long Day's Journey into Night* (1962), so it's no surprise how sincere and unquenchable Doc's thirst is. In addition to the stinging authenticity he brings to Doc's physical decline, Robards embodies the confirmed outsider and rakish cynic. He delivers his lines in a loose, fast style; his rhythm is unique here. Seemingly extroverted—boozing and gambling—he doesn't think very much of people ("I can't stand pillars of society when I'm not taking their money"). Look closely enough and you'll see an utterly isolated individual. He has a detachment that allows him to figure out anyone, and he can be a mercilessly smooth manipulator. Robards dons a selfish, wryly superior, hypocrisy-hating stance, immune to notions of goodness or sentiment. Doc is unto himself, or is he?

In Wyatt, Doc sees qualities to look up to, and he's devoted to his friend, a man he views as decidedly unlike himself. He admires Wyatt's belief in the law (belief in *something*), envying his idealism. Doc isn't the scoundrel he thinks he is, and the scenes between Robards and Garner are played with a bedrock of loyalty and shared history running beneath them. The actors, two of the smartest and subtlest, portray a very affecting friendship; they appear able to read each other's thoughts. (I'm

sorry this duo never worked together again.) The characters come to function as consciences for one another, and with no one else do they share such an honest, intuitive bond. Doc's the one to bear witness to Wyatt's cloudy transition from enforcer to executioner. (Garner is increasingly ruffled by Robards' discerning eyes.) If Doc recognizes Wyatt's moral ambiguity, Wyatt calls attention to the severity of Doc's failing health. Neither man can readily accept the truth of what the other sees so distinctly.

The movie never makes explicit the backstory of the feud between the Clantons and the Earps, so their profound hatred is merely a given. Robert Ryan's Ike Clanton is Garner's equal in coolness, firmness, and control. He's a man who wants to grab as much power and influence as he possibly can. Both Ike and Wyatt use the court; both get warrants issued against the other; and both form posses. The citizens of Tombstone want to take arms against Ike's men (one of whom is a boyish, yellow-haired Jon Voight, making his screen debut), but Wyatt discourages it, still holding faithfully in the law, or so it seems. It's interesting that Garner, whose character's vengeance becomes an obsession, keeps his performance contained. He plays Wyatt as a man alert and willful enough to withhold his thoughts from others (except Doc), perhaps even from himself. His is a well-concealed obsession: no fury, no eyes bulging, no overt emotion. Garner's private, levelheaded approach— focused and committed— feels truer than a display of passions.

Sturges maximizes the film's bursts of violence by having them arise out of quiet; the resulting disruptions are jangling. He embellishes the startling impact with unusually loud gunfire. As Morgan Earp plays pool with Wyatt and Doc, he leans over the table to make a move just as a gunshot crashes through a window, hitting him in the back and hurling him flat onto the table. In one continuous move, his game-playing lunge turns, eerily, into a leap of death. The reward of $20,000 for Ike's four gunslingers stipulates "arrest and conviction" rather than "dead or alive." In a blackly comic running gag, the reward diminishes each time Wyatt finds it impossible to avoid killing one of the men he is after. These eliminations become more calculated, not to mention more dramatic, as the picture proceeds. Wyatt and his men come upon one of their prey, Warshaw (Steve Ihnat), on a ranch. Taking impressive advantage of the wide screen, Sturges places Warshaw at the far left of the screen, his holstered gun visible to the camera but not to Wyatt, who speaks on horseback from the far right of the screen. The tension derived

from that gun's potential, as Warshaw explains to Wyatt that he was a lookout only (not a murderer), is palpable. Garner quietly seethes his way through this scene, then steps down from his horse. Challenging Warshaw to a draw, he says he'll allow him the advantage of shooting on *two,* with Wyatt waiting till *three.* Garner counts quickly and, in a display not seen since Bette Davis unflappably fired six shots into her lover in *The Letter* (1940), he, too, shoots six times, more than enough to accomplish the task. Garner doesn't lose Wyatt's composure, though he looks inwardly shaken by this extreme, uncharacteristic behavior.

At this point, both men are in bad shape (Wyatt, morally; Doc, physically), and their relationship reaches a crisis when Doc challenges Wyatt's pretense of lawfulness, labeling it a cover for a blood-soaked agenda. He calls Wyatt's warrants "hunting licenses." In this scene Robards releases Doc's stewing anger and disappointment at the man he's held in such high esteem, who is actually no better than he is. (Instead of the "good" guy rubbing off on the "bad," it seems to have worked in reverse.) When Garner finally punches him, Robards slowly, achingly crumples to his knees, coughing. Doc's pitiable health can no longer be ignored, and he takes a temporary stay at a sanatorium. Wyatt visits, despite their blowout. The ties between these characters, acted with such comfortable ease, feel too deep to allow for any grudges. Besides, Robards is the only one who can make Garner laugh here. Their final scene together is a moving, perfectly tempered few minutes, thanks to their understated acting.

In *Hour of the Gun,* violence is an empty, soul-shattering business. This is no upbeat story of vindication, nor does it resolve with a feeling of restored security. The bad guys are vanquished, but the good guys are left trying to make sense of what happened. The screenplay, written by two-time Oscar winner Edward Anhalt, turns familiar fare on its ear, providing two central characters of rare fullness and a complex array of disturbing actions and reactions. (Unlike the popular 1946 and 1957 Earp-Holliday pictures, in which both men have love interests, women barely figure here.) Lucien Ballard, the man who filmed *Ride the High Country* (1962) and *The Wild Bunch* (1969), both for director Sam Peckinpah, was the director of photography on this movie. The wide screen is used to striking effect. That's no surprise because John Sturges was one of the first directors to make artistic sense of the initially confounding CinemaScope rectangle when he made the potent *Bad Day at Black Rock* (1955), in which he devised dramatic composi-

tions of stylized beauty in a stark desert setting. (He received his only Oscar nomination for it.)

Each of *Hour of the Gun*'s three stars had worked with Sturges once before: Garner on *The Great Escape,* Ryan on *Bad Day at Black Rock,* and Robards on *By Love Possessed* (1961), a Lana Turner turkey. Garner would again star as Earp, in Blake Edwards' comedy-mystery fiasco *Sunset* (1988), set in 1929 Hollywood. The only saving grace in that muddle is Garner, who, in a flashback, appears in another variation of the O.K. Corral gunfight. After his first go-round as Earp, Garner went the comic western route with the lame, TV-style *Support Your Local Sheriff!* (1969) and it was a box-office success. The unprofitable *Hour of the Gun* is a film for those who like their westerns off the beaten trail; maybe its hour is finally at hand.

V. Fantasy and Horror

Like *Frankenstein* (1931), *E.T.—The Extra-Terrestrial* (1982), and other fantasy-horror classics, the next five films put their emphasis on humanity over special effects. (Frankenstein's Monster may not be human, but what could be more achingly human than his lonely yearning to connect?) These emotion-driven films—whether motivated by love, friendship, survival, or guilt—are propelled by character rather than plot mechanics. However otherworldly they may appear, these movies are really about the world in which we actually live. Why else would they affect so deeply?

The Man Who Laughs (1928)
Move Over, Lon Chaney

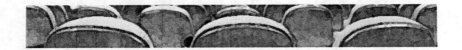

Not many would dispute that Hollywood horror movies had their heyday at Universal in the 1930s, the location and period that produced, among others, *Dracula* (1931), *Frankenstein* (1931), *The Mummy* (1932), and *The Invisible Man* (1933). But Universal's prowess in the genre had already been well established before the sound era immortalized Bela Lugosi's accent and Boris Karloff's grunts. The studio had made *The Hunchback of Notre Dame* (1923) and *The Phantom of the Opera* (1925), the two films for which the incredible Lon Chaney is most revered. Universal produced another horror milestone in the silent era, after Chaney had moved over to MGM. *The Man Who Laughs* is not nearly as well known as the two Chaney classics, nor was it famously remade, but it's the most terrifying of the three, all of which found horror in the human rather than the supernatural. Since it was made during Hollywood's transition to sound, *The Man Who Laughs* is one of those silents with a soundtrack of music and aural effects but no spoken dialogue. Because it marked silent film's last hurrah, some would argue that 1928—move over, 1939—was Hollywood's greatest year. That year's roster, boasting *The Crowd, Street Angel, The Wind, A Woman of Affairs, The Circus, Show People,* and *The Last Command,* proved that visual storytelling had reached an apex of sophistication and mobility. A year later, cameras would be playing second-fiddle to microphones, resulting in a blessedly short-lived era of hopelessly stagnant movies. *The Man Who Laughs* is one of 1928's best films, a macabre marvel whose biggest claim to fame is that it was *Batman* creator Bob Kane's acknowledged inspiration for the look of the Joker, Batman's flamboyant nemesis.

Like *The Hunchback of Notre Dame, The Man Who Laughs* is based on a dense Victor Hugo novel. The film begins in 1690, at the English court of James II. The king informs the captured Lord Clancharlie that, as punishment for his being a rebel, the face of his ten-year-old

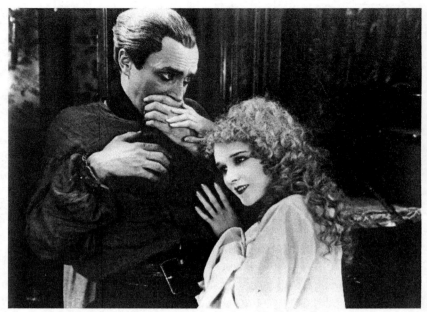

THE MAN WHO LAUGHS. Conrad Veidt conceals his laugh from blind Mary Philbin.

son, Gwynplaine, has been surgically mutilated into a permanently laughing expression (so that the boy "might laugh forever at his fool of a father"). Clancharlie is executed, and Gwynplaine is abandoned by the cutthroats who maimed him. After rescuing a blind baby girl, Dea, from frosty death, he finds refuge with Ursus (Cesare Gravina), an old strolling player. The adult Gwynplaine (Conrad Veidt) becomes a star—billed as "The Laughing Man"—touring the provinces with Ursus and lovely Dea (Mary Philbin). Though he and Dea are in love, Gwynplaine feels unworthy of her because of his hideous face (even though she can't see it).

Carl Laemmle, Universal's German-born studio head, assigned two fellow countrymen to this film, director Paul Leni and star Conrad Veidt. Both were esteemed artists of the celebrated Expressionist movement in German cinema, with Veidt having become an international symbol of ghoulishness as the somnambulist in *The Cabinet of Dr. Caligari* (1919). Veidt and Leni had made four German films together, including the world-renowned *Waxworks* (1924), in which Veidt's Ivan the Terrible stole the show. It was Laemmle's hope that their talents would flourish in Hollywood. Leni had a major success with his first

American effort, *The Cat and the Canary* (1927), a highly enjoyable spooky-mansion movie that set a standard for all subsequent pictures of its kind. Leni soared higher with *The Man Who Laughs,* a film whose influence on Universal's later horror classics is substantial: one of its art directors, Charles D. Hall, went on to design the sets for *Dracula* and *Frankenstein,* and its makeup artist, Jack P. Pierce, was the man who devised Boris Karloff's legendary look as Frankenstein's Monster.

The Man Who Laughs is ideal material for a silent film, a form in which acting is essentially the art of facial expression; this is, after all, a pantomime *about* facial expression. In Gwynplaine, you have a character who cannot alter his madly intense smile, a challenging limitation for any actor. Wearing dentures that give him a blinding, piano-key set of choppers (framed by a lipsticked mouth), added to his prominent nose, heavy eyebrows, and nest of hair, Veidt is an unforgettable sight. (Metal hooks on the dentures pulled the actor's lips into a laughing rictus.) Acting primarily with his eyes and lyrical hands, he comes through with a heart-stopping performance. Aided by accentuating eye shadow, Veidt's eyes are piercingly sad. Within the obvious confines of the role, Veidt finds considerable variety, poetically enacting Gywnplaine's crippling fears, aching self-pity, loving tenderness, and vivifying courage. This is stylized acting simultaneously marked by bold, operatic strokes and subtle gradations of feeling, resulting in a Chaney-worthy turn of significant pathos. It is especially chilling to watch him cry; the upper half of his face in torment and tears, while the lower half frozen in maniacal glee. The disconnect is devastating. Veidt's command is such that, when Gywnplaine is happy, his chiseled smile combines with his invigorated eyes to produce a face that seems oddly whole. It's no surprise when Gwynplaine covers his mouth with a scarf or a hand or a book, negating the laugh from his face and from people's perception of him. How else can he come near to feeling normal?

When Ursus first meets the boy Gwynplaine, he tells him to stop laughing. Of course, the boy isn't really laughing, which makes for a queasy joke. The movie must sustain a serious, frightening tone, despite having a central figure who can't stop "laughing," and it does so because the circumstances of Gwynplaine's ongoing misfortune can't be shaken off. Even when the movie enters its mad-dash finale, the image of Veidt—which you do not get used to—is never less than heartbreaking; the more out of place his expression is, the more pain it evokes. You will blanch at the casual insensitivity of a fellow performer who tells him,

"What a lucky clown you are—you don't have to rub off *your* laugh!" Despite such an instance, the film captures a romanticized feeling for showfolk, people with little to call their own who are nonetheless devoted to bringing thrills to dreary places. The onstage magic, combined with the story's extreme cruelty and scandal-mongering court, is part of the film's unabashed theatricality. Larger than life, yes, and you wouldn't want to see this daring, unusual story played for naturalism. Still, a troubling subtext emerges, dealing with our inability to read people. Gwynplaine's face is an unchanging mask, but most of the other characters wear masks of different kinds. Barkilphedro (Brandon Hurst), the king's treacherous and ambitious jester (and the film's main villain), looks eerily like Gwynplaine, with his large nose and perennially exaggerated smile. Gwynplaine's smile may not tell you anything about his true feelings, yet neither does Barkilphedro's.

The film opens in King James' bedroom, a set lined with two rows of imposing religious statues that provoke more terror than comfort, and a secret passage accessible behind one of the cold, saintly figures. (This set looks like something that might have inspired Josef von Sternberg's baroque look for his outrageous 1934 *Scarlet Empress*.) The king is led by Barkilphedro to the manacled Lord Clancharlie (also Veidt), Gwynplaine's father. In this role, too, Veidt's suffering eyes are emphasized, against his dirty face. Having returned from exile in search of his son, he is sent to his death in "The Iron Lady," a torturous contraption that director Leni floats dreamily into the foreground, against a black background. The film moves to the coast and our first sight of the boy, though his mouth is concealed. Having been banished, the Comprachicos—people who, for profit, carve the faces of children into those of monstrous clowns—are piling onto a ship as a snowstorm rages. This is one of the eerier scenes, as Leni gives close-ups to the men's faces, each one more piratical than the next, while helpless Gwynplaine is deserted on shore. This is not a movie for children, so harsh and disturbing is the boy's fate. Gwynplaine wanders aimlessly, through cinematographer Gilbert Warrenton's shadowy image of a series of gallows with skeletoned men swinging in the wind. (For nightmarish gruesomeness, this visual is hard to top.) It's relieving that Dea and Ursus quickly come into the boy's life; the happiness in Gwynplaine's story derives from the mutual love between him and Dea, with Ursus their devoted father figure. As Dea, Mary Philbin has cascades of blond curls, looking every inch a storybook waif, which heightens the disparity

between the film's ingénue (photographed as if she glowed in the dark) and the demonic-looking man she adores (but cannot see). The gentle scenes in which the two characters express their feelings are unsettling. Though the scenes' content is warming and gratifying—this "beauty" isn't horrified by her "beast"—it's akin to watching Lillian Gish wooed by Mr. Hyde. Top-billed Philbin, Christine in Chaney's *Phantom of the Opera,* isn't asked to be anything more than sweet and pretty, neither of which is a problem for her. She would sensibly retire from Hollywood once the talkies arrived.

The film's more interesting female, unsurprisingly, is its naughty lady. Duchess Josiana (Olga Baclanova) resides in the estate that would have rightly come to Gwynplaine. Engaged to a lord, she's a lusty blond vamp—more Roaring Twenties than Olde England—with an astonishing (and appropriate) physical resemblance to Madonna. Photographed through a keyhole, she makes a bare-assed emergence from her bath, then plays her first scene scarcely covering her nakedness with a furred wrap. She has a pet monkey and enjoys bawdy slumming with loutish peasants more than court activities; her breasts are often threatening to spill out of her clothes. At Gwynplaine's performance, she, unlike everyone else (including Gwynplaine, who works the crowd into a frenzy), doesn't laugh. Affected by the sight of him, she invites him to her home for a midnight rendezvous. If a sighted woman can be interested in him, then he may be able to believe that he has the right to marry Dea. Arriving in her boudoir (with his mouth covered), he finds Josiana strewn across her bed, head dangling off it, and her thighs generously exposed. This may make you giggle, but you'll still be fascinated by what this vixen is up to, though it's not really a surprise that she would be kinky enough to be turned on by his face. She wraps herself around him and erotically rubs her lips against his scarred mouth, before pulling the scarf down. But how far is he willing to go, faithful as he is to Dea? Veidt malleably mixes gratitude, pleasure, and arousal with confusion, guilt, and alarm, as the luscious Baclanova puts her moves on him. The scene climaxes with the arrival of news that sends Josiana into spasms of ironic laughter. Veidt reacts with pitiable fragility, feeling like a beast once more and shielding his mouth with his hand, then backing away agonized and running from the room.

The emotional peak of the film is the moment when Gwynplaine finds the courage to clasp Dea's hands to his mouth, allowing her to feel, for the first time, his disfigurement. Despite the momentary shock, it's a

scene of ultimately ecstatic happiness, exemplified by Veidt's moistening eyes and raised arms. Bizarre and creepy as the story is, here is a joyously cathartic release from the misery. It may sound hackneyed, yet its impact is overwhelming. From this point, the plot gets overstuffed with too much action, all generated by vicious court intrigues that might restore an unwilling Gwynplaine to his father's rightful place. The best scene to come out of all this takes place back with the strolling players. Believing that Gwynplaine is dead, Ursus conceals the news from Dea. That evening's performance is canceled, but Ursus hopes to fool the blind Dea into thinking that the show, and Gwynplaine, will go on. With fellow troupers pretending to be loudly enthusiastic patrons in the audience, Ursus is able to take his ruse pretty far. The sequence's effect is surefire, both a rousing tribute to good-hearted showfolk and a touchingly desperate and naïve attempt to protect innocence from unavoidable reality.

The film is capped by a hair-raising suspense sequence—a chase from land to sea, which includes swordplay—of D.W. Griffith proportions. Though impressively staged and edited, it's too elaborate, extended, and generic for a film of such striking intimacy and strangeness. The movie may feature a cast of hundreds on beautifully wrought period sets, but what you remember is the primal power of the story and the exquisite visuals that ponder what constitutes beauty and ugliness. Leni's intoxicating flair for the grotesque and the theatrical and his visceral empathy for Gwynplaine make *The Man Who Laughs* one of the more spellbinding works of the horror genre. It was a financial success, so there's no acceptable reason why Gwynplaine never joined Quasimodo and the Phantom of the Opera as household names in our cinematic chamber of horrors.

The Man Who Laughs might have seemed absurd as a talkie—what kind of voice and speech should emerge from that mangled mouth?—yet its sound effects (horns, bells, applause, crowd noises, and music) are mostly welcome. The twice-used vocal—a woman singing "When Love Comes Stealing"—is pure sap and entirely unnecessary. This movie belongs to the sub-genre of horror films set amid circuses, carnivals, and freak shows, such as *The Unknown* (1927) and *Freaks* (1932), the latter starring Ms. Baclanova. The memorable canine in *The Man Who Laughs* is Zimbo, who plays a wolf called "Homo." Though he's called by name only a handful of times, it's hard not to gasp every time his moniker appears on a title card, as in "Be quiet, Homo!"

Paul Leni died of blood poisoning at age forty-four in 1929, the year Conrad Veidt returned to Germany because of the talkie boom. Veidt came back to Hollywood a decade later, becoming the industry's resident portrayer of Nazis, most notably as Major Strasser in *Casablanca* (1942), which was released not too long before his death from a heart attack at age fifty in 1943. The Bogart classic may have secured Veidt's immortality but it doesn't offer a sense of the inventiveness of his talent. Veidt's Gwynplaine proves that he was a match for the two giants of American horror—Lon Chaney, who preceded him, and Boris Karloff, who followed him—when it came to haunting people's dreams.

Isle of the Dead (1945)
The Psychological Horror Film

In 1942, RKO put Val Lewton in charge of a new production unit that would specialize in low-budget horror movies, resulting in nine films released over the next four years. Lewton, who had written novels, non-fiction, and poetry, was a Russian-born immigrant (and nephew of actress Alla Nazimova) who had been working in the movies, notably as an editorial assistant to David O. Selznick, for a decade when this opportunity came along. Producing cheap scare-inducers hardly sounds like "making it" in pictures, but Lewton turned his assignment into an artistic challenge. Imagination would have to make up for the lack of special effects and elaborate sets; Lewton made frugality a virtue. The thrills would come from the anticipation and suggestion of evil rather than lurking monsters, and virtually total darkness would prove a scarier background than any constructed set. Praised for the literacy of their screenplays, Lewton's horror movies are psychologically motivated, driven and sustained by their characters' fears and desires. *Cat People* (1942) was the first, and it remains the best known and most venerated. It stars Simone Simon as a Serbian girl with, shall we say, an unusual problem.

Lewton used three directors for the series: Jacques Tourneur, Mark Robson, and Robert Wise. Each of these men had worked as film editors, with Wise editing *Citizen Kane* (1941) and Robson on board as the associate editor. After directing *Cat People*, Tourneur directed the next two: *I Walked with a Zombie* (1943), a voodoo reworking of *Jane Eyre,* and *The Leopard Man* (1943). Robson, who was the editor on the three helmed by Tourneur, graduated to director with *The Seventh Victim* (1943), all about a satanic cult in Greenwich Village, and *The Ghost Ship* (1943). Wise, replacing Gunther V. Fritsch and sharing screen credit, took over the directing chores on *The Curse of the Cat People* (1944), a sequel only in a loose sense, and then made *The Body Snatcher* (1945), the film that brought Boris Karloff into the Lewton fold. Lewton's final two, both starring Karloff and directed by Robson, were *Isle of*

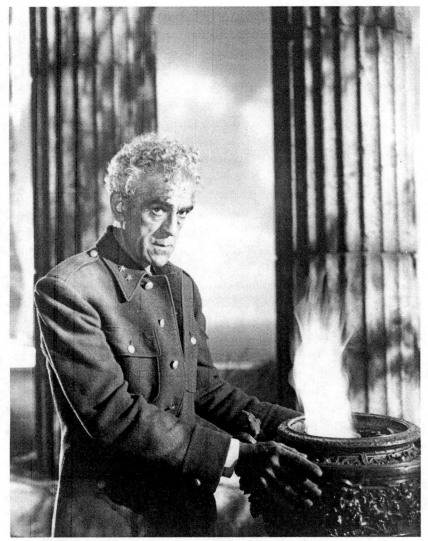

ISLE OF THE DEAD. Boris Karloff in a Greek nightmare.

the Dead (1945) and *Bedlam* (1946). (The cheesy titles of all these films continue to do them a disservice.) All three directors took what they learned here—how to do a lot with a little—and brought it to film noir, a genre whose emergence certainly owed a debt to the fatalistic mood and shadowy style of Lewton's work. Tourneur directed *Out of the Past* (1947), Wise made *Born to Kill* (1947), and Robson gave us the noir-ish boxing classic *Champion* (1949). Tourneur's career never rose to the A

list, but he continued to do fine work, such as *Stars in My Crown* (1950) and *Wichita* (1955), two exceptional Joel McCrea vehicles. Wise and Robson became big-time Hollywood players, with Wise winning Oscars for *West Side Story* (1961) and *The Sound of Music* (1965), and Robson bringing *Peyton Place* (1957) and *The Inn of the Sixth Happiness* (1958) to box-office glory. (Wise returned to his "horror" roots with 1951's memorable sci-fi drama *The Day the Earth Stood Still*.)

Why choose *Isle of the Dead* as the Lewton picture to write about? Well, for one thing, it's not as well known as most of the others, but, more than that, it's the one that strikes me most deeply. There's nothing supernatural in the story; all of its so-called horrors can be rationally explained. It builds its scares and suspense through characters whose superstitions and fears reach the point of hysteria. There are some frightening people but no real villains. The movie is character-driven in the sense that, once the situation is in place, the drama is derived from the characters' attempts to make sense of the terror in their midst, and some of their explanations put others in harm's way. *Isle of the Dead* is psychological in the purest sense: it's all in their heads.

Greece is at war in 1912, and General Pherides (Karloff), known as "the watchdog," is a cold, unyielding leader fighting not only a war but also the threat of plague. One night, he and an American correspondent, Oliver Davis (Marc Kramer), take a boat to a nearby cemetery island to visit the grave of Pherides' wife. Once there, they discover a group of people in a house, most of them seeking refuge from the battles: Mr. Albrecht (Jason Robards, Sr.), a Swiss archaeologist who owns the house; Madame Kyra (Helene Thimig), his Greek housekeeper; Mr. St. Aubyn (Alan Napier), a British consul, and his sickly wife, Mary (Katherine Emery); Thea (Ellen Drew), the beautiful Greek girl employed to tend to Mrs. St. Aubyn; and Mr. Robbins (Skelton Knaggs), an Englishman in the tin business. Pherides and Davis spend the night, and in the morning it's discovered that Robbins has died from the plague. Summoned by Pherides, Dr. Drossos (Ernst Dorian) arrives and quarantines the island. As the plague spreads within the house, Madame Kyra is convinced that among them is a Vorvolaka—a vampiric spirit that takes human form and drains people of their vitality to the point of death—and she believes it to be Thea, the healthy servant to a noticeably weakening mistress. Kyra's suspicions are not taken seriously until Pherides, a man used to controlling any given situation, becomes susceptible to her ravings when no other explanation seems viable.

What a great set-up! A plague-infested island cut off from the mainland becomes the equivalent of a haunted house in the middle of nowhere on a rainy night. There are nine people on the island, but their number decreases as the story moves forward (call it *Nine Little Indians*). And, most compelling of all, there's the question of whether a Vorvolaka is the evil force at work. As more people become ill, and the hope for survival diminishes, this irrational explanation starts to seem less outrageous to some. Will the hot winds from the south that can kill the plague-carrying fleas arrive before everyone is dead? The story has the pull of a juicy yarn, but the movie is richer for the unexpected questions it raises. When the world becomes inexplicable, is it surprising that people resort, and cling, to old-world superstitions? If people keep telling you that you are evil, will you start to believe them? Will a man of action, one who lives by the rules, go to pieces when all his sound attempts to solve a problem fail? The movie's exploration of humanity's varied responses to encroaching death gives it a depth that makes it more than just an enjoyable chiller.

Boris Karloff's presence enlivens the film; he gives it heft, both physically and emotionally. His portrayal of human frailty is that much more effective because Pherides seems impenetrably strong and hard at the outset. As a general, he's pitiless and unforgiving, but he makes the same demands on himself that he does on others. Having always managed to make sense of the world, Pherides lives by the law and doles out punishment without qualms. He is never less than a general. Beneath the righteousness, Karloff carries a sadistic streak, slyly flaunting the character's enjoyment at wielding his authoritative weight. Pherides surprises Thea in the hallway, late that first night, for the purpose of intimidating her. Her blatant animosity rankles him; she puts the first chink in his armor. Once it's decided that they will all stay on the island until the crisis is over, thereby protecting the lives of Pherides' troops on the mainland, Pherides proclaims, "No one may leave the island." He says this several times, in response to pleas from those who *need* to leave, but there's no use arguing with him. Karloff's delivery is so commanding, so threatening, that no one could possibly defy him. As the self-appointed "general" of the situation, Pherides believes that he can fight the plague as he would any other enemy.

He's a man who puts his faith in what he can see or feel, but he's increasingly shaken as their plight worsens. In a rare instance, he allows himself to be seen as less than towering when he engages Davis,

the American, in a heart-to-heart. Pherides is suddenly a man seeking answers instead of someone who assumes he already knows them. Karloff prevents the character from ever being dismissed as sinister because of the probing self-awareness he brings to the role; he isn't likable or compassionate, but he's certainly not stupid. The quietly menacing Kyra (yet another Mrs. Danvers clone) needs an ally with force, and Pherides fits the bill. Even as the character is losing his grip, Karloff's performance doesn't degenerate into a display of histrionics. In a credible transition, the actor unhinges his character gradually and with absolute clarity. Pherides corners Thea once again and tells her that "every human remedy" has failed him, and he insists that she stay away from those that remain. He's not convinced that she's a Vorvolaka, but that explanation is starting to look like the best one. And all of this must be *explained*. He's not taking any chances, even threatening Thea with murder if she disobeys. Karloff's intensity is smartly controlled; Pherides is hanging on to his sanity but just barely. The code by which Pherides has lived has been turned upside down. Karloff makes his confrontation with reality, and his resulting susceptibility to unreality, unnerving but always identifiably human. Pherides, and the rest, are doing their utmost in a horrible situation, and the cruelties they inflict upon one another can only be pitied. At its most piercing, the movie is about our quest for answers when there are none.

Earlier, Pherides made a rather macabre wager with Albrecht that Dr. Drossos, representing the scientific approach to battling the disease, will outlive Albrecht, who will be making prayers to Hermes as his way to fight the illness. Albrecht doesn't believe in Hermes but can't help noting that Kyra's belief that the plague is divine retribution sounds no sillier to him than the idea of waiting for hot winds to come and kill fleas! Here the film implicitly brings religion into the discussion, allowing actual discourse on the subject, a rare occurrence in films of the 1940s. Albrecht later concludes that perhaps it's best to believe in *something* because it provides comfort. Kyra, obsessed with the notion that Thea is a Vorvolaka, is caught in the place where religion, legends, superstition, and culture collide. The movie is clear-eyed enough to consider both the positive and negative impact that religion has on its characters.

It's unusual in a horror movie for the lovely young ingénue to be the figure most feared. Admittedly, she does always seem to be in the wrong place at the wrong time (near a newly sick or dead person). Thea

is played by a colorless Ellen Drew, the low-rent version of Paulette Goddard, who was barely Grade A herself. Unsurprisingly, Drew makes an exceedingly glamorous Greek peasant girl. The character as written is far more interesting than anything the limited Drew does with it, and the strength of the writing (screenplay by Ardel Wray) comes through despite her. Thea begins to doubt herself, wondering if in fact she could be a Vorvolaka by night. Can she control her spirit when she sleeps? If Pherides and Kyra keep telling her that she's evil, is it possible that she is? If Drew were more of an actress, the strain of all this would be visible, and fascinating. It doesn't help that Marc Kramer, as her American love interest, is even duller. They're both far too unperturbed considering the nightmarish setting in which they're placed. His character, Davis, has a recurring, inadvertent knack for suggesting that Thea leave a room, ostensibly for her safety, and go to a far more dangerous place—where she'll be *alone*. But that's part of the fun, isn't it?

In addition to Pherides, the other character that assumes three-dimensional proportions is Mary St. Aubyn. Katherine Emery (who starred with Anne Revere in the original 1934 Broadway production of *The Children's Hour*) is both poignant and strong-willed as the fragile Mary, who is very protective of Thea. There's already more than enough in play for a top-notch frightfest, but Mary adds her own brand of creepiness to the proceedings. Prone to cataleptic trances that can last more than a day (with almost complete suspension of respiration and heartbeat), she lives in fear of someday being mistaken for dead, which would lead to her greatest fear of all: being buried alive. Now, you know a horror movie doesn't introduce a tidbit like that for nothing. Every scary movie needs a dilly of a climax, and Mary is the centerpiece of this film's extraordinary final section. In a brilliantly compiled sequence, cinematography (ravishingly dark black-and-white), sound (the steady drip on a wooden coffin; a woman's echoing voice), and editing (startling flashes of a ghostly figure) come together hypnotically.

Isle of the Dead is a beauty, despite a less than first-rate cast. Jason Robards, Sr., is adequate as Albrecht but is hardly an actor in the same league as his gifted son. Alan Napier (Mr. St. Aubyn) will be familiar to many as Alfred on the 1960s television series *Batman*. Photographed by Jack Mackenzie, this is a very black black-and-white movie, one with a tangible feeling for the unknown terrors in the dark. (Much of it is set at night.) Of course, B films often used darkness to conceal budgetary constraints, but in Lewton's oeuvre the blackness is always used to dra-

matic advantage. Director Mark Robson puts the plot in motion with precision, then lets it build to a slow boil, and, finally, boil over into a crescendo of heart-racing action, all in only seventy-two minutes.

Lewton also made two non-horror pictures during this period, *Mademoiselle Fifi* and *Youth Runs Wild*, both released in 1944. After the financial failure of *Bedlam* in 1946, his unit at RKO folded. Lewton produced only three more movies: *My Own True Love* (1948), starring Melvyn Douglas; *Please Believe Me* (1950), starring Deborah Kerr; and *Apache Drums* (1951), starring Stephen McNally. None of these were horror movies, or what you would describe as successes. Lewton died in 1951 at age forty-six from a heart attack. But he found immortality in a most surprising place: a looked-down-upon genre at a less than major studio, elevating both with the consistency of quality that he brought to the series. Rarely has the name following "Produced by..." seemed to matter so much.

Portrait of Jennie (1948)
A Love Beyond Time

The post-war years of Hollywood are usually thought of as the
period in which the industry grew up, addressing adult sub-
jects such as alcoholism *(The Lost Weekend)*, anti-Semitism
(Gentleman's Agreement), mental illness *(The Snake Pit)*, and racism
(Pinky), with groundbreaking candor. As this new maturity was reshap-
ing American movies, and as film noir (with its cynicism and fatal-
ism) was becoming the fastest-growing genre, a batch of fantasy films
arrived as an antidote to this wave of social realism. (*It's a Wonderful
Life* [1946] is the most enduring of the pack, but it took decades for
it to attain its current beloved status.) This blast of magical escapism
peaked in 1947, with *Miracle on 34th Street* (featuring a real-life Santa
Claus played by Oscar-winning Edmund Gwenn), *The Ghost and Mrs.
Muir* (a love story between widow Gene Tierney and Rex Harrison's
ghost of a sea captain), and *The Bishop's Wife* (with visiting angel Cary
Grant untangling the lives of mortals Loretta Young and David Niven).
To a lesser extent, there was *Down to Earth*, a meager musical sequel
to *Here Comes Mr. Jordan* (1941), starring Rita Hayworth as the god-
dess Terpsichore and, in 1948, *The Luck of the Irish*, which cast Cecil
Kellaway as an actual leprechaun, and *One Touch of Venus*, presenting
Ava Gardner in the title role. What these movies have in common
is comedy. (Even considering the darker aspects of *It's a Wonderful
Life* and *The Ghost and Mrs. Muir*, both films are essentially comic.)
Fantasy was an acceptable format if its intention was laughter. At the
same time, these pictures reassured audiences, encouraging them to
recognize what's really important (and appreciate what they already
had), and promoting faith that all will work out in the end. With their
use of humor, romance, and easy-to-follow plots, most of these films
continue to delight viewers (particularly on holidays).

In late 1948, producer David O. Selznick released *Portrait of Jennie*, a
romantic fantasy that defied the conventions and, not surprisingly, died

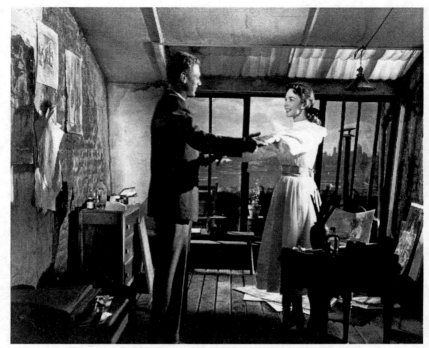

PORTRAIT OF JENNIE. Bliss in a garret for Joseph Cotten and Jennifer Jones.

at the box-office. Audiences were asked to accept a "serious" romance between a man and a female ghost in a time-curving story in which the past and the present come together. It's easy to see why ticket buyers resisted its ahead-of-its-time metaphysics: there's nothing comic about the way its fairy-tale elements intermingle with its reality; the film retains an aura of mystery, choosing not to go out of its way to explain its necessarily inexplicable plot, including its ending. Nowadays, we're overly familiar with all manner of time-travel stories and nothing in *Portrait of Jennie* should confuse a modern moviegoer. Call it a mood piece, a film that communicates with an emphasis on visual inventiveness, the key to its enthralling power. (How many other Hollywood films of the era could conceivably be described as mood pieces?) It's an exquisite, meticulously wrought production, a haunting, cosmic tale of the quests for true love and artistic inspiration beyond the boundaries of time.

In the winter of 1934, struggling painter Eben Adams (Joseph Cotten) meets a strange and enchanting child, Jennie Appleton (Jennifer Jones), in Manhattan's Central Park. During their enjoyable conversation, Jennie wishes aloud for Eben to wait for her to grow up so that they

can always be together. Jennie thereafter appears to Eben periodically, and almost always unexpectedly, over the next few months. Each time she is noticeably older, rapidly maturing into a beautiful young woman. Eben doesn't have to "wait" for Jennie because she's obviously catching up. Although she revivifies Eben's art, it becomes clear to him that Jennie comes from an earlier time. He's puzzled by the curious things she says, including her references to a New York that no longer exists. Through some detective work of his own, he learns that Jennie died in a 1920s tidal wave off Cape Cod. (In an unsettling coincidence, Eben painted the exact site before ever meeting Jennie.) After finishing her portrait, he heads to Cape Cod on the anniversary of Jennie's death to see if she'll appear to him there, affording him a chance to correct time and save her life.

There are gorgeous opening shots of soft, swirling clouds that eventually reveal New York City way down below. Unfortunately, a quote from Euripides appears, then one by Keats, then some fussy narration about our story "the truth of which lies not on our screen but in your heart." Ouch! Couldn't anyone see that such pretentious overkill was pointless in the presence of those sublime images of sunstreaked New York emerging from the heavens? Don't run away because the picture rarely succumbs to this kind of high-toned claptrap again (an occasional too-flowery line, a bit of angels' chorus). It's too restrained to generate much in the way of unwarranted giggles.

Watching an actor with canvas, easel, and brush, doesn't usually convince me that I'm watching an artist at work. Artistic inspiration in movies usually looks like a lot of overacting. Luckily for Joseph Cotten, he has few moments that require him to be in the throes of creation, so he must make us believe he's an artist in scenes outside his garret. Perhaps Cotten, past forty, is too old to personify the struggling artist, but with his inherent intelligence and effortless underplaying he's credible as an ordinary man committed to seeking the extraordinary. Eben is not a success, and Cotten's sad-sack physicality and air of lonely solitude embody the isolation of a life devoted to art. (Jennie may be a ghost, but Eben is an invisible man.) Cotten's Eben is uncomfortable in the world, preoccupied with his art but lacking the confidence and passion that would augur great things. There are none of the overdramatic clichés of an artistic temperament on display; the most effective component of Cotten's performance is the gentleness that informs everything he does. In his acting, simplicity and sensitivity never come across as un-

interesting. Eben is the center of the story, and Cotten's grace allows us to enter the film with him as our trusted guide.

Some of Jennie's entrances and exits are among the more rapturous of black-and-white screen images, featuring shafts of light (from the sun or streetlamps) just before she appears. Emerging from shadow and soon all aglow, Jennie glides, often runs, into Eben's life. Perhaps the most dazzling example is her second appearance, her arrival at the park's ice-skating pond. The sun is blindingly bright, but at the bottom of the screen a tiny dark figure rises into the frame, skating into view: it's the teenage Jennie in a fur-trimmed skating costume. *Portrait of Jennie* is a visual feast not only in its breathtaking contrasts of light and shadow, but also in its loving close-ups, its textured establishing shots (which appear to be stitched onto the screen), its evocative use of not-to-be-duplicated New York locations, its green-tinted storm at sea, and its final, brief burst of Technicolor. The contribution of cinematographer Joseph August (who died before the picture was completed), cannot be overestimated. He received a posthumous Oscar nomination but lost the award to William Daniels for his documentary-like vision of New York (the opposite of August's dreamlike conception) in *The Naked City.*

Eben's spiritual and emotional transformation is the core of the movie. Jennie gives him the idea to paint people rather than landscapes, and she becomes his subject. While revived by a new enthusiasm in his work and his growing affection for the child-woman, he's also disturbed by the mystery surrounding her, wondering if he's bordering on madness. No one but Eben ever sees Jennie, yet she becomes so vital to him, and his art, that he cannot doubt the fact that she's *real*. He becomes demoralized by the seemingly endless stretches between her visits. (Is Jennie pulling the strings, or is she as much a victim of supernatural doings as Eben is?) In a glorious sequence, Eben dejectedly returns to his apartment after futilely seeking Jennie, only to find his door ajar. He instantly knows that she's inside and his pace quickens. From the outer room, all he can see is her hands going through his pictures, but then he moves closer and gets a full view of her, radiantly lit, in a white dress. She's come to pose for her portrait. It's a mesmerizing flow of images that changes the somber mood in a flash. The portrait is finished after a second sitting, and Eben and Jennie (who is no longer a girl) are now a couple. His need for her will eventually lead him to Cape Cod for an attempt at altering the past. He *knows* she'll show up where the tidal wave hit, and he'll be there to save her.

With the first lightning crash, the movie takes on a green tint. In the whirling storm, Eben reaches his destination when his small boat smashes into the rocks. Inside the lighthouse, there are stunning overhead shots of Eben, climbing a spiral staircase, that will immediately remind you of James Stewart in *Vertigo* (1958). If most of *Portrait of Jennie* is a fever dream, here it reaches spectacular proportions. Ominous dark clouds pad the sky, water crashes in all directions, and then the Oscar-winning tidal wave (Best Special Effects) arrives. The actual effects, including slow motion, aren't astonishing, but the impact is considerable because the rush of danger and excitement (and all that water!) is such a contrast to the quiet and intimacy of everything that has gone before it. In their final scene together, Jennie talks to Eben about eternity, faith, time's errors, and life without love. The film offers the usual platitudes about true love, but they are superfluous. In *Portrait of Jennie*, the visuals always trump the dialogue. Anytime anyone tries to spell out something, the movie automatically diffuses its hold.

Jennifer Jones is consistently a vision of otherworldly loveliness, and she loses none of her ability to induce wonder with each subsequent appearance. She's ideal in the role. I often find something essential missing in Jones' performances, a depth that would allow for greater connection to her characters. That's not a problem here because Jennie is a question mark, an apparition, a character who is never quite the same from scene to scene. Psychological complexity is not an issue. Jones, nearing thirty, still has the girlishness to pull off the precocious, pre-adolescent Jennie (this *after* playing slutty Pearl Chavez in *Duel in the Sun* in 1946), and also the dark beauty to convey a woman of mystery. Her fragility, which resulted in a Best Actress Oscar for *The Song of Bernadette* (1943), is perfect for Jennie of the "big sad eyes." I can't think of another female star of the 1940s that had both the childlike vulnerability and womanly sensuality to bring Jennie Appleton to life. In addition, the lushness of her beauty and the innate gentlemanliness of Cotten make for a complementary combination.

A touching counterpoint to the story of Eben and Jennie is the relationship between Eben and Miss Spinney (Ethel Barrymore), the elderly art dealer who befriends him. They meet when Eben drops by Spinney's shop to offer his work to her and her partner (Cecil Kellaway). She tells him there's no love in his work ("I'm an old maid, and nobody knows more about love than an old maid."), then buys one of his paintings. As he's leaving, a grateful Eben tells Spinney that she has beauti-

ful eyes. In that moment, Barrymore establishes her character in one stunned look, a quietly startled reaction that goes to her solar plexus. His comment takes Spinney out of herself; decades of loneliness and invisibility evaporate. Love comes to her even though she knows that all she can be to Eben is a kindly aunt or a guiding force in his career. So, we have another time-twisted relationship, but Spinney can't wait for him the way he can wait for Jennie. She's an "old maid" because she missed Eben by a few decades, and time won't be correcting its error in her case. Deep love radiates from Barrymore's wise eyes. Spinney is happy in Eben's company yet he would never suspect the degree to which she cares for him. She can never be his inspiration, stuck in time as she is, but at least she becomes a central figure in his life. (Barrymore and Cotten had recently appeared together as mother and son in the 1947 confection *The Farmer's Daughter*.) This is one of the formidable lady's finest screen performances. She's carefully understated yet, in the manner of celebrated theatre stars of her day, you couldn't possibly miss anything she's doing; she won't allow it. Every nuance is visible on that face that seems to know all the answers. It's a part that's worthy of her, and she imbues it with the strength and heart that one expects from a legend.

Portrait of Jennie is top-heavy with distinguished supporting-cast members, including the great Lillian Gish, though she's wasted as the nun who reveals the facts of Jennie's death to Eben. (I wonder if Gish was miffed that it was Barrymore who got the plum older-woman role.) David Wayne, in his screen debut, is likable in the thankless role of Eben's pal, an Irish cabbie. Wayne and Albert Sharpe, as a pub owner, filmed their scenes by day, while appearing in *Finian's Rainbow* on Broadway by night. Their scenes are the film's most disposable, through no fault of theirs. Then there's Florence Bates, the matron you love to hate, who has one scene as Eben's hard-nosed landlady.

For all the sumptuous care given this film, it seems positively teensy after Selznick's previous picture with Jones, Cotten, and Gish: the overproduced, hysterically erotic western epic *Duel in the Sun* (1946). Selznick, the man who produced *Gone With the Wind* (1939), was known as the maker of long, plot-driven entertainments, so the eighty-six minute, atmosphere-driven *Portrait of Jennie* is an oddity in the showman's career. (It's also the rare film of its time to place its credits at the end, in sepia no less.) Based on the 1939 novella by Robert Nathan, the screenplay, written by playwright Paul Osborn and Peter Berneis,

improves upon its source in terms of clarity and emotional satisfaction. (My reaction after reading Nathan's final page was, "Huh?") In the book, Jennie interacts not only with Eben but also with his landlady and the cabbie (who made the conversion from Jewish to Irish for the screen). For the film's lovely score, Dimitri Tiomkin adapted themes by Claude Debussy.

Portrait of Jennie was directed by William Dieterle, who had already worked with Cotten and Jones on the hit *Love Letters* (1945), a pleasurably absurd amnesia-related love story. The two stars had first appeared together in Selznick's manipulative 1944 home front saga *Since You Went Away,* wherein high-school senior Jones has a crush on Cotten, her father's best pal. It was something of a prelude to their relationship in *Portrait of Jennie,* their fourth and final film together. Dieterle is best known for his Paul Muni biopics, *The Story of Louis Pasteur* (1936) and *The Life of Emile Zola* (1937), and the Charles Laughton *Hunchback of Notre Dame* (1939), but *Portrait of Jennie* is his best film. It's masterfully put together, has an unerring sense of detail, is bathed in warm nostalgia and the resulting sense of loss, and has a pervasive tenderness.

When *Jennie* was released, it lost a great deal of money and Selznick's career never recovered. In less than a decade, the maker of *GWTW,* the hit of the ages, was a man whose studio was in financial ruin. Looking at *Jennie* today, it was worth the attention that Selznick lavished upon it; it's much more original and intrepid than most of the movies that trampled over it in 1948. Even though it's never had much of a reputation, it did have one illustrious admirer. In 1952, when a Belgian survey asked international film people to select the ten best movies ever made, the esteemed Spanish filmmaker Luis Buñuel placed *Portrait of Jennie* on his list. I hope somebody told Selznick.

Time after Time (1979)
Jack the Ripper in the Disco Era

The time travel in *Portrait of Jennie* is of a spiritual variety, an inexplicable colliding of past and present in the name of a transcendent love that would otherwise never be. In *Time after Time*, traveling through time is accomplished by the nuts and bolts of science, specifically a helicopter-like machine that converts sun rays into electricity. This is time travel as inspired by H. G. Wells in his novel *The Time Machine* (1895), and that's no coincidence: *Time after Time* is an ingenious, grown-up fantasy thriller that puts Wells himself inside the machine of his imagination and sends him hurtling into the future. That's a fresh, clever concept of make-believe, but the film's creators go a step further by adding another historical figure to their magical revisionism: Jack the Ripper. Written and directed by Nicholas Meyer (with a story by Karl Alexander and Steve Hayes), *Time after Time* is smart and inventive, an accomplished amalgam of social satire, serial-killer horrors, offbeat romance, fish-out-of-water comedy, and historical conjecture. These ambitious elements congeal so sensibly, and *plausibly,* that *Time after Time* whizzes by, a witty entertainment made of equal parts charm, scares, and laughs. And it does all this with a minimum of special effects.

In 1893 London, writer Herbert George Wells (Malcolm McDowell) introduces his friends, including Dr. John Leslie Stevenson (David Warner), to his secret invention: a contraption that Wells insists can race through time at two years per minute (in either direction). Before Wells can try it himself, Stevenson (alias Jack the Ripper) uses the machine to escape the police. After the shocking discovery that his friend is the notorious murderer, Wells decides to go after "Jack." He is able to do so because the machine automatically returns to its point of origin (unless a special key in Wells' possession directs it not to). It also reveals where it has been: Jack got off in November, 1979. Wells follows, surprised to find himself in 1979 San Francisco rather than

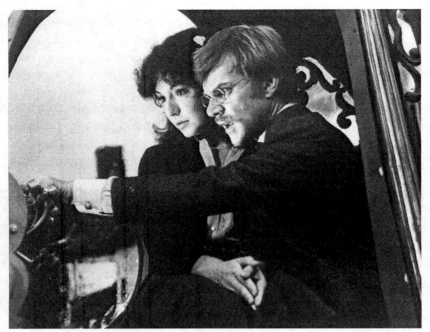

TIME AFTER TIME. Mary Steenburgen and Malcolm McDowell inside his time machine.

London, inside a museum exhibit about himself that includes the time machine from which he has emerged. Befriending (and then romancing) Amy Robbins (Mary Steenburgen), a foreign-currency bank employee, Wells is aided by her in his mission to protect the future from Jack who, continuing his killing spree, feels very much at home in the sex and violence of modern times.

For all the originality and flash in the story, perhaps the film's best coup was the casting of Malcolm McDowell as the kind, gentle Wells. McDowell was best known for terrorizing audiences in *A Clockwork Orange* (1971); he would have been logically cast here as Jack the Ripper. It's a great comfort to see *Clockwork Orange*'s marauding delinquent transformed into a brilliant humanist, fervently attached to the belief that the 20th century will be Utopian. Wells is a man in a hurry for that future, to which he imagines he belongs, a world in which his controversial ideas—free love, socialism, equality of the sexes—will be implemented and result in a world without war, crime, poverty, and disease. As the film begins, Wells is a man of passion and daring but limited experience, too nervous even to test his time machine.

Jack's escape provides the impetus to turn the cerebral Wells into a man of action, compounded by the guilt at having unleashed Jack on "Utopia." McDowell's Wells, complete with mustache and spectacles, is an endearing comic turn, a lightly funny portrait of a brainy, tweedy Englishman suddenly confronted with the neverending challenges of 1979. The demon of *Clockwork Orange* is unexpectedly snug in David Niven territory. Chasing a madman through time tests Wells' deductive powers to their limit, yet he also must process the sad truth that the 20th century fell far short of his expectations. McDowell touchingly, yet unsentimentally, colors his performance with Wells' ongoing transition from naïve optimism to sobering maturity. If thoughts of McDowell's *Clockwork* brute still infest your dreams, his warm and compassionate Wells is likely to vanquish them forever.

The movie opens in Victorian London, first on the foggy scene of one of Jack's back-alley murders, and then in the after-meal repose of Wells' intimate all-male dinner party. The movie will leave behind 1893 England quickly, but it's important for it to be established as a tangible time and place so that the contrast between it and 1979 America will be truly jolting. Having spent some time with Wells in his plush, cozy home, we are more able to enjoy the humor of his clash with automatic doors, telephones, escalators, cars and taxis, an electric toothbrush, a trip to the movies, a garbage disposal, even a meal at McDonald's ("that Scottish place"). Most of these moments are indeed funny, but the film doesn't resort to slapstick silliness to italicize its laughs. Even in the climactic scene in which Wells must drive a car, the comic aspect is aptly incidental to the narrative thrust (and suspense) of the situation. Alongside Wells' befuddlement is his fascination with these technological advances. For all his disappointment in a century that could hardly pass for Utopian—news of the world wars is particularly troubling to him, as is the improved efficiency of killing—there are the wonders of what minds as forward-looking as his have accomplished.

David Warner's Jack the Ripper is one of the screen's great villains but not for the reasons you might expect. His is no flamboyantly theatrical scenery-chewing turn, the kind of over-the-top beast who is so much larger than life that he works as a buffer, keeping audiences safely aware that it's only a movie. Warner is mostly calm and cool, a man of obvious and immense intellect yet soulless. His ugliness festers unemotionally; he personifies the lucidity of evil. With this unblinking look into darkness, Warner manages to suggest unfathomable isolation

from the world, without any hint of a plea for understanding. The actor's chilly deadpan conveys Jack's inhumanity as simply a given. There's no explanation for why Jack, a chief of surgery, does what he does, though he once mentions that his mother "was rather an atrocious woman" with "many failings." Before his first on-screen murder, he opens his pocket watch and sets it down; its lullaby melody serves as twisted accompaniment to his brutality. Opposite the watch face is a portrait of a woman, presumably his mother, a witness to his heinous act. The pocket watch is always part of his killing ritual, perhaps his necessary thread to mother. The film doesn't shy away from, or in any way soften, Jack's cruelty and violence. In one instance a drop of spattered blood drips down his cheek like a devil's tear. Though he's not without black humor, Warner is consistent in presenting Jack as an all-too-real, remorseless fiend who sees the world as "a cosmic charnel house." Essentially, the film is a battle of wits and ideologies between two men who, despite being friends, are opposites in every way. Late in the film, Wells says, "The first man to raise a fist is the man who's run out of ideas." His idealism and Jack's depravity will fight to the finish.

Audiences of today will be stunned by how cheap and minimal the special effects in *Time after Time* are. Nowadays, most of this film's budget would have been lavished on effects deemed necessary for the film's success. The actual effects employed are minor, but with a screenplay this fine and strong they don't need to be anything more. When the time machine is activated, the screen is filled with twinkles and streaks of colored light and not much else. As Wells travels through the 20th century, we see clocks and clouds moving rapidly, but the sequence is not the centerpiece of the film in the way director George Pal made Rod Taylor's journey forward the highlight of *The Time Machine* (1960), resulting in the win of the special-effects Oscar that year. *Time after Time* is utterly *un*-dependent on effects. McDowell does get a show of colored shapes streaming by (in the mode of the last section of *2001: A Space Odyssey*) and a soundtrack peppered with key moments of our war-torn "future." You certainly notice what a no-frills passage this is, but there's no reason to feel cheated; the machine just has to get us where we need to go. Why clog the screen unnecessarily?

Wells' eyeglasses break during the trip but, because the museum exhibit into which he arrives ("H. G. Wells: A Man Before His Time") includes his old desk, he can reach into one of its drawers and find his spare pair. That's a good example of the movie's light touch and casual

wit. With his outmoded suit and Sherlock Holmes cap, Wells attracts notice, even in a city as loose as San Francisco. The modernist of 1893 is suddenly a relic. He exchanges some pounds for dollars and realizes that Jack must have done the same. So, Wells goes bank to bank hoping to find someone who will remember Jack's transaction. That someone turns out to be Amy.

Mary Steenburgen's Amy is instantly smitten with this helpless gentleman, thus instigating the film's delightfully odd coupling. Amy is a career-minded "women's libber" with a pro-active approach to men but also a little girl's voice and a bit of Annie Hall quirkiness; Wells is shy, disoriented, and preoccupied with Jack. After their first encounter, Amy tells a co-worker, "That was a very cute man," not having any idea that this "Herbert" is H. G. Wells. On their first date, a lunch, he's at a loss as she talks about what "turns me on" and that she's not a "dyke." He tries valiantly to keep up with her as she rambles nervously. It's a charming scene because, though they're rather baffled by each other, they're clearly on their way to falling in love, forging a bond that transcends the specificities of time and custom. As their lunch becomes a whole day (and night) together, their similarities emerge: they're both divorced because neither wanted to be made "routine" to satisfy their spouses. Steenburgen is altogether winning—funny, vulnerable, and spirited—as Amy. She and McDowell open up in their scenes together and develop a heartfelt, appealing romance. (Steenburgen and McDowell married in 1980 and it lasted a decade.)

Amy tells Wells which hotel she recommended to Jack, which leads to the first showdown between the two men. In his hotel room, Jack declares Wells "literally" the last person he expected to see, then states his satisfaction in finding a time that suits him perfectly. To make his point, he provides Wells with a channel-surfing medley of violent acts on his television screen and then, in perhaps the most chilling moment in the film, says, "I belong here completely and utterly. I'm home." He continues, "The future isn't what you thought…it's what I *am*." This is a harsh, devastating assessment of 1979 America, a time and place in which Jack the Ripper, roaming streets lined with sex shops and porn theatres and prostitutes, could label himself an "amateur." The movie is not a reactionary celebration of Victorian values; it's more a wake-up call with regard to the casualness and pervasiveness of violence in our society, a notion that hasn't exactly become quaint in the quarter century since the film was released. Jack wants the key that will prevent Wells

from following him wherever he may go (without the key, the machine will keep returning to its point of origin, thereby allowing Wells to keep track of Jack). Jack dresses in '70s garb—at one point he's decked out in a *Saturday Night Fever*-style white suit—while Wells sticks with his retro outfit, emphasizing Jack's fit into this new world and Wells' sustained displacement. The bitter irony is that it was Wells, "a man before his time," who was supposed to be at home in the future, instead of the homicidal maniac.

Jack figures out Amy's connection to Wells and threatens her at the bank. After exiting, he suddenly returns, thrusting into the frame beside her and whispering threateningly into her ear. This image, with Steenburgen facing front, frozen in fear, is one of the film's scariest. Wells eventually goes to the cops, disastrously identifying himself as Sherlock Holmes, not having any sense that that name means anything in 1979. He fares no better with Amy in his confession of who he really is and why he's here. She's convinced, at the museum exhibit, by a brief time-machine trip forward, but it only leads to more anxiety because a newspaper from a few days in the future reveals Amy as a murder victim. This device was used in Rene Clair's comic fantasy *It Happened Tomorrow* (1944), also set in the 1890s, in which Dick Powell—a reporter with access to tomorrow's headlines—reads about his own death and then tries to prevent it. *Time after Time* follows the same arc, as Wells and Amy try to avoid the circumstances of her would-be death, at the same time using their knowledge of the days ahead to ensnare Jack. Wells and Amy are by now deeply close and undeniably in love, and the strength of their relationship imbues the film's last section with considerable emotional investment. The film becomes unbearably suspenseful once Wells is picked up by the police as a suspect, leaving Amy on her own against Jack. McDowell is intensely affecting in his desperate pleas to the police for Amy's protection, and it becomes an excruciating race to save her and destroy Jack. Wells conclusively says, "Every age is the same. It's only love that makes any of them bearable," taking some of the heavy burden off the 1970s and discovering a truth both grim and uplifting.

First-time director Nicholas Meyer—author of such novels as *The Seven-Per-Cent Solution* (1974), which he adapted into an Oscar-nominated screenplay for the 1976 film version—did an impeccable job of maneuvering the tone shifts in his own script, making them complement each other rather than appear disjointed. The humor makes the

scares more pronounced; the romance heightens our involvement in the suspense. His screenplay's intermingling of fact, fiction, and fantasy—logically sewn together—is to be lauded. You do have to suspend your disbelief forcibly anytime the functions of the key and the machine's "vaporizing equalizer" are explained, but that's not too much to ask. Meyer went on to direct *Star Trek: The Wrath of Khan* (1982), generally considered the best of the *Star Trek* features, but nothing he has done has fulfilled the promise of *Time after Time*, a film ignored when Oscar time rolled around. Finally, mention must be made of old-timer Miklós Rózsa's sweeping, yearning score. Rózsa's music is expansive and melodic, yet never invasive because, like everything else about *Time after Time*, it's just right.

The Iron Giant (1999)
Animating the Cold War

I didn't plan to include an animated feature in this book, but when the notion struck me I thought, "Why not?" After all, full-length animated movies have been a part of American film culture ever since Walt Disney made the leap with *Snow White and the Seven Dwarfs* (1937), a critics' darling and a box-office bonanza. Disney was pretty much a one-man genre for decades, with a burst of creative fervor in the early 1940s, resulting in his masterwork, *Pinocchio* (1940), then another healthy spurt in the early fifties with *Cinderella* (1950) and *Peter Pan* (1953). Beginning with *Sleeping Beauty* (1959), the quality of Disney animation became noticeably inferior, and his artistic decline continued until his death in 1966. You couldn't immerse yourself in the textures and hues of a movie like *101 Dalmatians* (1961) the way you could in, say, *Fantasia* (1940) or *Bambi* (1942). If, like me, you were a kid in the 1960s, you undoubtedly feel more affection for Disney's live-action *Mary Poppins* (1964) than you do for his thinly drawn *Jungle Book* (1967). Long after Disney's animated features had become extinct (rendering the studio's library a finite group of re-releasable classics), the company took a chance on *The Little Mermaid* (1989), and, in one big splash, two genres were resurrected: the full-length cartoon and the movie musical. However, the onslaught of subsequent projects, which include the overrated *Beauty and the Beast* (1991) and the worthy-of-Walt *Aladdin* (1992), was too much too fast, and by the time of *Hercules* (1997) and *Mulan* (1998), the formula, no matter where the films were set, was wearing thin (even to the kiddies, I suspect).

With the animated feature on the wane *again,* along came something new: computer animation. Leaving behind the soft, painterly imagery of the hand-drawn standard, computer images made possible a more three-dimensional feel and a seemingly limitless flexibility. With an instant classic in Pixar's *Toy Story* (1995), the new form was solidified. With *Toy Story 2* (1999), *Shrek* (2001), *Finding Nemo* (2003), and *Cars*

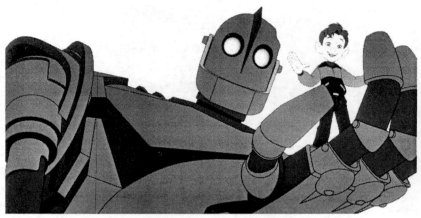

THE IRON GIANT. Hogarth in the palm of his new best pal.

(2006), we're in a golden age of computer-generated animation, and Snow White must really be feeling her senior-citizen status. Bucking the trend, Warner Brothers' *Iron Giant,* based on the children's book *The Iron Man* by Englishman (and onetime husband of Sylvia Plath) Ted Hughes, is a major work of traditional animation. It's a cartoon, crafted with the painstaking detail of Disney's fairy-tale classics yet, unlike them, it's not a musical: no ballads of yearning, no production numbers performed by inanimate objects or animals. Eschewing Disney's long-standing show-tune format, *The Iron Giant* is, fittingly, more akin to Warners' legendary animated past of witty, vibrant storytelling and unforgettable characters (like Bugs Bunny). And, like those Looney Tunes, *The Iron Giant* passes the supreme test for any kids' movie: adults find it as entertaining as the youngsters do.

Set in 1957, on the coast of Maine, *The Iron Giant* is the story of a bright, lonely boy, Hogarth Hughes (voiced by Eli Marienthal), who is being raised by his single mother, Annie (voiced by Jennifer Aniston). When an iron giant (voiced by Vin Diesel) falls from the sky, Hogarth rescues him, befriends him, and tries to protect him. For all his hulking metal, the giant is a gentle soul. Kent Mansley (voiced by Christopher MacDonald), of Washington's Bureau of Unexplained Phenomena, arrives on the scene, paranoid about national security and maniacally bent on the alien's annihilation. Beyond colossal strength, the giant soon reveals other capabilities: he can reassemble himself if broken; he can fly; and, if provoked, he automatically turns into a multi-gunned killing machine.

It's rare for an animated film to have such a strong social context in recent history. *The Iron Giant* is a children's film about the Cold War, and it deals explicitly with the fear of *other,* yet it does so without becoming a didactic finger-wagger. With humor and the emotional bonding between boy and giant, the points are made in the right way, through dramatic action and character development. It's a comic-book style entertainment rooted to a very real, and nervous, time and sensibility. The movie has some satiric fun with the period by including two black-and-white sequences that scream the 1950s: scenes from a stiffly acted, science-fiction movie about a square-jawed scientist, his curvy nurse, and a hungry brain, that Hogarth watches on television; and a schoolroom educational short about how to survive "atomic holocaust." Both scenes induce smiles for their innocent quaintness. Just because Rockwell, Maine is an idyllic America, with a sun-baked wharf and autumnal colors brightening the landscape, doesn't mean that its citizens aren't expecting invaders from Mars, or at least Russia.

The Iron Giant celebrates outsiders, beginning with spunky Hogarth. He's too brainy to be popular, and he's alone much of the time because his mother has to wait tables to keep her small family afloat, which means his imagination is always on high alert. Animated protagonists are often young, lonely, and "different" (Pinocchio, Cinderella, Dumbo, etc.). It's in the grown-up characters that *The Iron Giant*'s outsider sympathies are more pronounced and unusual. Dean McCoppin (Harry Connick, Jr.) is as close to a beatnik as Rockwell has. He's a vision in black: hair, sunglasses, turtleneck, jacket, boots, even his five o'clock shadow and thumbprint of a beard below his mouth. Dean (as in *James* Dean) rides a motorcycle and creates sculpture out of the scrap metal in his junkyard. (His sign reads "McCoppin Scrap. Where Art and Junk Meet!") Dean becomes Hogarth's most trusted human friend, and later a love interest for his mother. In hipster Dean, the movie offers a fresh idea of a father figure. Then there's government hawk Kent Mansley, a blue-eyed, redheaded, pipe-smoking fellow with a pointy jaw who looks like an animated version of the ideal sitcom dad. Actually, he's a high-strung, violence-instigating man with a bomb-happy agenda. He likes to end sentences with an ominous "and all that that implies." Kent wants to destroy what he doesn't understand ("foreign" is synonymous with evil), before it *might* destroy him. By making the dark "freak" the good guy, and the all-American lawman the villain, the movie plays refreshingly with the physical stereotypes of good and evil.

The good-and-evil twist is also there in the kind, loving nature of the enormous, outer-space *monster*. The giant is part of the tradition of misunderstood creatures who can't understand why they're feared and hated, and who resort to violence in response to attack. Frankenstein's Monster, helplessly naïve and more emotional than we first assume, is an obvious kindred spirit. But the giant is pieces of many movie characters, which doesn't mean he's unoriginal. He's part of the brotherhood of other "aliens" with good-hearted instincts: his intense bond with the boy is reminiscent of the ties between E.T. and Elliott, and the giant also shares E.T.'s ability to fly (in a pinch); his rescue of children is right out of Mighty Joe Young's playbook; his size recalls Gulliver in Lilliput and King Kong in New York; his body parts make him an overgrown Tin Man; and, on a rampage, he clomps through town like Godzilla. Part of the plot involves the giant's fascination with Superman and his desire to emulate him. Noting their non-earthling similarities, Hogarth astutely tells him, "He started off just like you." The giant may resemble Atomo, "The Metal Menace" comic-book star but, inside, he *is* the Superman type. (The sight of the giant and the boy sharing comic books in a barn, as if at a slumber party, with the giant on his stomach, resting his head in his hands, is a gently amusing image.) Just because you look like Atomo doesn't mean you can't be Superman. First spoken by Dean, the film's mantra is "You are who you choose to be." When the giant pulls a large *S* off a junked *Seafood* sign and attaches it to his chest, he's on his way.

The giant may be a sweet lug, but he's also a skyscraper of shiny metal whose walk quakes the earth. His biceps and thighs are thin, but his forearms and calves are bulky. His standout features are his headlight eyes. (Following the giant's exciting crash landing, a boatman mistakes him for a lighthouse until the giant turns; the one mighty light beam becomes *two*.) It's apt that this gargantuan innocent, who seems to know nothing of his past, should come under the protection of a boy desperate to own and care for a pet. They first encounter each other when Hogarth tracks the giant to the power station in the woods. The giant chomps on the electrical towers (he eats metal to live), and he gets a shock that flings him backward into live wires that send lightning flashes of electricity coursing through him. It's Hogarth who sympathetically turns the power off; the giant loses consciousness. At their next meeting, again in the woods, it's clear that Hogarth has nothing to fear. The giant sets down the on/off power switch as a way of saying that he knows the boy rescued him. With Hogarth as teacher, the giant

imitates human behavior and learns to speak English. The boy not only has a friend, but essentially a whole amusement park at his disposal. The film's enveloping appeal derives from the warming satisfaction of watching a tower of steel acclimate himself to Earth eagerly, and of a boy finding happiness with an unlikely best pal.

Is the giant immortal? There's a memorable scene just after a train smashes into him. His scattered parts, blinking with blue lights, march back dutifully and reattach themselves to his bulk. Hogarth explains death to him after a pastoral scene with a deer who sniffs the giant's finger, prances off, and is instantly shot dead by hunters. (Shades of *Bambi*, clearly.) The giant is devastated by this, but he's far more disturbed when, later, he discovers *he's* a weapon. Hogarth aims his toy gun at him and the giant's eyes turn red; he appears possessed by a dark force beyond his control and deadly rays issue from his eyes. The giant is, as Dean notes, "a piece of hardware." This revelation horrifies the giant, who runs away in shame. He's programmed to respond defensively, so, if a gun is pointed at him, he will attack. His wish to transcend his built-in purpose—his internal struggle to overcome what may be insurmountable—is a poignant and potent display of sheer will. After he saves two boys from the certain death of a fall off a tall building, he touchingly tells Hogarth, "I am not a gun." He may have his "instincts" under control, but the army is soon firing on him, as are fighter jets and battleships. The action mounts, but the story's force comes from the emotional toll of watching the giant painfully resist his violent inclinations. He shields his eyes to stop them from turning red, the cue that gets his guns blazing. The assault on the giant is steady, and the film goes ballistic with his conversion into an all-out killing machine. Guns arise from varied places on him, and three snakelike coils emerge from his head (looking like those *things* from the 1953 *War of the Worlds*) and start firing. Against a sky turned red, made more threatening by gray clouds, the giant, as we knew him, is gone.

The movie peaks with a key character's moving display of responsibility and unselfishness, and there's a beautiful coda, one that's set up earlier in the story and that manages to be uplifting without goopy sentimentality. The sweeping, fast-moving final shot brings a rush of emotion and pleasure, promising the sequel that might have come if the picture had been a box-office smash.

With its winking references to other movies—primarily amusing for the adults—*The Iron Giant* has an unpretentious self-consciousness, a

touch of irony worthy of Bugs Bunny. (Most of the storytelling in the current age of animation has a "Bugs" spirit.) It's also sophisticated in its "camera angles." The points of view from which scenes are drawn often have the cinematic flair of live-action camera set-ups. And to watch a scene lit from behind by headlights makes you forget you're watching a cartoon! The editing, too, has the speed and panache of "real-life" movies. There's a very funny sequence, following Kent's renting a room in Annie's house. Suspicious of Hogarth's knowledge of the giant, Kent stalks the boy. There's a quick-cut montage of moments in which he surprises Hogarth—at the bottom of the stairs, from behind the refrigerator door, in the bathroom mirror, etc.—in his persistent, intimidating pursuit of information. It's an accelerating flow of pictures, punctuated by Kent's unctuous chumminess, referring to the boy as "buckaroo," "slugger," "ranger," etc.

For all the movie's dealings with violence, close-mindedness, and irrational fear, it's still very funny. At Dean's, Hogarth, wanting to seem cool, has some coffee (it turns out to be espresso, or "coffee-zilla" as Dean calls it), and the next scene has the already sprightly Hogarth on a caffeine high, hilariously spewing a mile-a-minute monologue in which he rails on about his life. A deadpan laugh is delivered after Hogarth, the giant, and Dean go to the lake, and the boy demonstrates his cannonball dive. The giant wanders off, but he's actually getting a running start for his own cannonball, a seismic event. There's an ingenious visual of Dean, from behind, in his beach chair and holding a newspaper, as the resulting wall of water rears up before him. It sends him so far that he lands, stunned and still in his chair, in the middle of a road. Another key laugh comes when Dean camouflages the giant as a gigantic art project of his. The few slapstick scenes, like the one in which a squirrel wreaks havoc on the diner, are the film's least successful, lacking the refined comic ingenuity of the rest of the picture.

The Iron Giant has a lush palette, both in the reds and yellows of fall and the whites and blues of winter, and some showstopping visual set pieces: the raging storm at sea when the giant crash lands; the electrical spectacle at the power station; the moment he takes flight, firing up from the bottoms of his feet and then soaring through blue sky and clouds; and his snowy, barn-crushing, tree-demolishing impact after being shot down. There are also some impressive visual grace notes, like the subtlety of a flashlight's decreasing power as it extends beyond

its reach, or the fleetingly seen bedside photograph of a military pilot, presumably Hogarth's father (a Korean War casualty?).

The Iron Giant was the first film directed by Brad Bird, who would go over to Pixar to make the computer-animated smash hits *The Incredibles* (2004), for which he won the animated-feature Oscar, and *Ratatouille* (2007), neither coming close to his initial film's excellence. Written by Mr. Bird and Tim McCanlies, *The Iron Giant* is a loose adaptation of Ted Hughes' book, deepening the attachment between Hogarth and the giant. The movie, which turned Hughes' giant into a gun, is thoughtful without being smug or self-admiring with regard to its Cold War setting and its anti-violence stance. The only line I would remove is Hogarth's "I love you" to the giant because it goes without saying and because it sticks out as an obvious heartstring-pulling moment, something the movie is otherwise good at sidestepping. All the voice-over performances are first-rate, with Connick, Jr.'s rebel Dean and MacDonald's certifiable Kent the standouts (neither character appears in the book). At one point, Hogarth tells the giant, "People just aren't ready for you." Not true.

VI. War

The mention of war movies conjures images of gung-ho scenarios with the ubiquitous John Wayne perhaps tossing a grenade. The genre, however, has often been as devoted to anti-war sentiment as it has been to the notion of glory (though rarely in wartime). The quintet of this chapter, though not specifically anti-war, all share the weight of intensified moral dilemmas. Internal conflicts are the focus here, as are unexpected vantage points on staggering events. The main characters are outsiders (be they good guys or bad guys), caught in the thick of national or international upheaval. Whether ultimately hopeful or bleak, these films thrust us into their respective wars in ways we never could have anticipated.

The Seventh Cross (1944)
Germany vs. Germany in WWII

The World War II years spawned a period in American movies unlike any other. The films that directly addressed the war (and were released between the bombing of Pearl Harbor and V-J Day) didn't take their responsibilities lightly. Never before had the industry been called upon to use its enormous influence for so vital a cause. The studios made morale and patriotism the order of the day, turning out hundreds of movies designed to make the nation feel unified, proud, and optimistic. The steadfast surety, the lack of ambiguity or doubt, is what made Hollywood's impact so strong (and is what makes these films so immediately recognizable today when channel surfing). By the late forties, enough time had passed so that movies could address stories of the war with more openness and depth, notably in *Twelve O'Clock High* (1949), which dealt with the psychological toll of military command. But while the war was raging in Europe and the Pacific, Hollywood's function was clear: help win the war by making pictures about Allied bravery and sacrifice amid acts of German and Japanese treachery. Most of these films have dated badly because of their shameless lack of nuance, but subtlety was never their intention. (Their casual and frequent use of "Jap" and "Kraut" is now rather startling.) What hasn't dimmed is the urgency with which these movies were made, resulting in an invaluable time capsule of national, social, and cultural history.

Hollywood's war-movie output had several sub-genres. Combat films often dramatized actual battles *(Wake Island, Guadalcanal Diary, Bataan)*, bringing the headlines to audiences as quickly as possible (and invariably featuring a character nicknamed "Brooklyn"). The warfare wasn't very graphic but the point was unmistakable: America's fighting men and women, in victories or defeats, were always valorous. *Mrs. Miniver* (1942), with its spectacular box-office success and six Academy Awards, kicked off the home front drama. Its depiction of unshakable British fortitude was erected as a model for Americans,

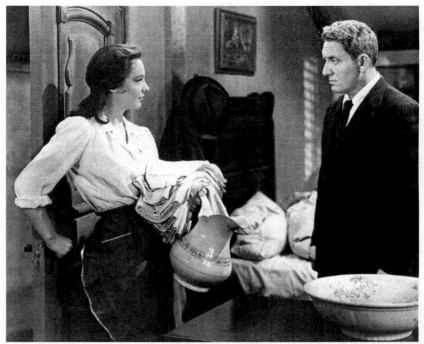

THE SEVENTH CROSS. Can Signe Hasso be trusted by Spencer Tracy?

who were apparently struck by Greer Garson's ability to move grace-
fully through the blitz. The stateside variety of home front drama *(The
Human Comedy, Since You Went Away)* paid tribute to the solidity of
the American family. Sometimes domesticity came into direct contact
with Nazi sympathizers *(Watch on the Rhine, Tomorrow the World),* and
other times regular Joes found themselves uncovering Nazis in their
midst *(Dangerously They Live, Saboteur).* Silly? Sometimes. Implausible?
Often. Obvious? Always. Even so, many of these films remain compul-
sively watchable. More than sixty years later, it's still comforting and
reassuring to watch a world in which right and wrong, good and bad,
are so easily distinguished.

Then there were the films that depicted the Germans' record of
European atrocities. Be they set in France *(The Pied Piper),* Poland *(In
Our Time),* Norway *(Edge of Darkness),* Czechoslovakia *(Hangmen Also
Die!),* Russia *(The North Star),* or Germany itself *(Hitler's Children),*
the formula most often used pitted commoners' ingenuity against
the heartless drive of Nazi menace. Viewers marveled at the gallantry
of our friends, and imagined themselves sporting the same kind of

grit and guts if confronted with a German invasion here at home. But all of these films, whether they were set in Anytown, U.S.A., the jungles of the Philippines, or Occupied Paris, were meant to inspire Americans to follow the lead of ordinary characters who behaved in extraordinary ways. Lastly, there were the all-star, entertain-the-troops musicals (Warners' *Thank Your Lucky Stars*, MGM's *Thousands Cheer*, Paramount's *Star Spangled Rhythm*) which climaxed their nonsensical story lines with star-heavy variety shows, providing not only escapism but the bolstering sight of superstars showing their confidence in our inevitable victory.

In July of 1944, MGM released *The Seventh Cross*, a film that departs from the period's war movies in ways that make it one of the more penetrating and stirring made at that time. Set in Germany in 1936, this unusual film has a compassionate message about innate human decency in an indecent world, an especially surprising theme because all of the film's characters are German *and* because the war in Europe still hadn't been won when it came out. Using ordinary German citizens as heroes yields a complexity of content just about unheard of in 1944. The film reminded audiences that there were good Germans living among the Nazis. *The Seventh Cross* doesn't stint on Nazi horrors, but its main goal wasn't to inflame audiences on that score. The movie's uplifting message, about the cumulative power of many small acts of goodness, may sound simplistic and sentimental, but *The Seventh Cross* is far more restrained than the typical war picture of those years. While many of those movies became instantly disposable with the war's end, the strength of the humanistic content in this film did not expire with Hitler's demise.

Before moving beyond Germany's borders, the Nazis are purging the nation of "undesirables." Seven prisoners escape from the Westhofen concentration camp, including Ernst Wallau (Ray Collins), the group's leader and the first one to be caught. Returned to the camp, he's beaten and tortured, then tied to a cross on a tree. Six more crosses are prepared for those still at large. One of the six fugitives is George Heisler (Spencer Tracy), a political dissident, whose faith in humankind has all but eroded inside the camp. George heads for Mainz, relying on both friends and strangers, risk-taking people who will do their best to help him get out of Germany. Unbeknownst to George, a faction of the underground has made his getaway their primary goal, but the underground cannot find him to help him.

The film opens with a dreamlike calm as the seven men quietly make their escape during a foggy dawn. Wallau, our narrator, identifies each man as, one by one, they approach the camera before disappearing into the gloom. The set-up is clear: this is a suspense movie in which the Nazis will relentlessly seek the apprehension of each man. That's compelling on its own, but it is only parallel to the film's main objective, that of rebuilding the faith of George Heisler. As George, Spencer Tracy's features exude a dark, sunken-in quality that sometimes recalls his Mr. Hyde from *Dr. Jekyll and Mr. Hyde* (1941). He will wear his expression, a sleep-deprived scowl, for much of the movie. Numb to everything but a basic will to survive, he makes his way to Mainz, with "46 Morgenstrasse," an address he's been given by Wallau as a place where he will find someone to help him, as a mantra to keep him going.

After his capture, Wallau is interrogated but reveals nothing, vowing "I shall not speak from this moment on." An echo of Iago's final words in *Othello,* this is an interesting line for an important character to utter at the beginning of a movie. After Wallau is left to die as he hangs from his cross, we never see him again, but actor Ray Collins continues to narrate the story. Not only has our narrator gone from living to dead, but he will thereafter engage in a one-sided conversation with George (who cannot hear him), making it his afterlife mission to restore George's belief in people. This is a tricky device to sustain, but only rarely does it feel intrusive or heavy-handed. Wallau hovers over the story, his narrative presence integral rather than merely expository.

George injures his hand climbing over a wall topped with broken glass, he steals a leather jacket to hide his prison jacket, and he witnesses the capture of one of his comrades. But his isolation ends when he arrives in Mainz and must seek the aid of others. The film now moves episodically, enacting each of the events that bring George closer to safety. Most of the characters involved have one or two scenes, fulfilling their part in George's story, then returning to their normal lives. (You can't help wondering what's to become of them once the war begins.) Among them are Leni (Karen Verne), the girl George loved before his imprisonment, the theatrical costumer Madame Marelli (the great Agnes Moorehead, overdoing it here as she was sometimes wont to do), and Dr. Loewenstein (Steven Geray), who is required by law to inform patients that he's a Jew before treating them. (Is this Dr. Loewenstein related to the one later played by Barbra Streisand in *The Prince of Tides*?) There's an ever-present tension regarding how each new character will

react to George. The guarded nature of these interactions is a necessity in such a fearful atmosphere.

Trust is a terrifying prospect in this movie, which is why it is so gratifying when George turns to his old friend Paul Roeder (Hume Cronyn). Cronyn's boyish exuberance, a startling contrast to Tracy's somber demeanor, enlivens the film with a jolt of positive energy. Cronyn's warmth, humor, and openheartedness make Paul probably the most likable German character in any movie of the era. Mostly oblivious to politics, he and his family, wife Liesel (Jessica Tandy, of course) and their three children, are enjoying the benefits of Germany's economic boom without asking any questions. Paul works in a factory that used to make sewing machines but now makes machine guns. He is awakened by his involvement in efforts to protect George, and it's rather touching to watch this sweet little guy put himself in jeopardy without question. It turns out to be Cronyn's film, and his supporting performance was honored with the film's only Oscar nomination. Tandy, who married Cronyn in 1942, would soon have her Broadway triumph as Blanche DuBois in *A Streetcar Named Desire* (1947). She never really registered in her films from this period—*Driving Miss Daisy* was a mere forty-five years away.

When Paul visits the home of architect Bruno Sauer (George Macready) to ask him to help their mutual friend, we are given a glimpse of another Germany, one of wealth and glamour. Would someone so well-off be willing to fight the Nazis and imperil the privileged life he's made for himself and his family? It's not only the abused who want change; through Bruno, the film shows that even those prospering under Nazi rule have the capacity to put everything on the line. Finally, there's Toni (Signe Hasso), the barmaid and housekeeper at the inn where George hides out. Here the film becomes a ships-that-pass-in-the-night love story, which may feel a bit unnecessary but, then again, it's a delicate depiction of people grabbing at what happiness they can find in volatile times. And Hasso's understated performance matches Tracy's economical acting style. George receives a great deal from those brave enough to come to his aid, yet the picture deepens with its awareness of what these good people get from helping George, be it political awareness, refocused commitment to ideals, love, or the basic satisfaction at having done something worthwhile.

Helen Deutsch's screenplay, based on the novel by Anna Seghers, is schematic in a good way; it efficiently lays the groundwork for the par-

allel story lines—the fast-paced hunt for George and his slow spiritual reawakening—then follows through on both in a well-built, clearly charted fashion. The script has more drive and thematic clarity than the book which, after a rocky start, juggles far too many characters (including a wife for George). Deutsch impressively pruned Seghers' work, shedding the extraneous plot strands and zeroing in on its strengths, distilling it for heightened impact. The screenplay is occasionally too talky, and some of the "underground" scenes are drab, but the film's brand of uplift is certainly no cause for embarrassment, unlike the variety of accents that abound in a film in which all the characters are German. If the rest of the cast were as American as Tracy, it would be easier to accept them as all having the same nationality. But with German accents thrown in (and not just by those playing evil Nazis), it becomes something of a free-for-all. It's also hard to suspend one's disbelief in the chase scene when George is mistaken for a pickpocket; it's so obvious that Tracy has a stunt double for his running that you may actually wonder who it is that they're chasing. When Karen Verne, here cast as George's old girlfriend, played Robert Cummings' love interest in *Kings Row* (1942) she was billed as Kaaren Verne. She needn't have bothered removing the continental extra "a" from her first name because clearly she wasn't going to be a star however she spelled it.

Even with Spencer Tracy on board, *The Seventh Cross* is not an expensive production. Is Germany really as foggy as London, or is all that moisture concealing budgetary frugality? Karl Freund, the man who photographed everything from *Metropolis* to *I Love Lucy*, uses the fog and shadows to create a lurking unease in backlot Germany. This was director Fred Zinnemann's first major Hollywood film after many shorts and two B pictures. Zinnemann's work shows an undeniable visual sense and a talent for storytelling, but he wasn't yet the refined artist who was capable of making films as rich and beautiful as *The Nun's Story* (1959) and *The Sundowners* (1960). However, *The Seventh Cross* holds up better than *The Search* (1948), the affecting but uneven and clumsy film set in post-war Germany that put Zinnemann on the A list of directors.

The hope that *The Seventh Cross* was meant to instill in audiences is to be derived from George's gradual emergence from his bitter stupor, his acknowledgment of the impact that so many lives have had on his. (And George isn't always privy to the kindnesses done on his behalf.) George Heisler is a dramatic device, a resourceful figure on whom the

film's theme is hung. He's not especially interesting as an individual; we don't really learn much about him. Because he's something of a blank slate, an Everyman on the run, it was imperative to cast a star whose very presence would make George seem whole. The role may not be very talkative, but Tracy anchors it with his steady low-key intelligence. While far from a great part, it stands as the solid center around which the more colorful characters revolve. Even with its limitations, this was Tracy's best dramatic vehicle of the 1940s, though not as well-remembered as his other war-themed pictures, *A Guy Named Joe* (1943) and *Thirty Seconds Over Tokyo* (1944). Overall, the forties were not a great artistic period for Tracy: his biggest dramatic dud was *The Sea of Grass* (1947), his fourth film with Katharine Hepburn, which features his dullest, most lifeless performance (and lots of talk about grass); his biggest comic dud was *Tortilla Flat* (1942), with his condescendingly false performance as a paisano. With the possible exception of *Adam's Rib* (1949), a comic winner co-starring Hepburn, *The Seventh Cross* is his best film of the decade.

The Raid (1954)
The Civil War Comes to Vermont

Put aside images from *Gone With the Wind* (1939) for the moment because one of the most powerful, unsettling, and resonating films made about the war between the states is set a world apart from Miss Scarlett, magnolia blossoms, and mint juleps. *The Raid* is a Civil War movie that takes place in upstate New York, Canada, and Vermont. That's one of the many surprising things about this Twentieth Century-Fox picture, a film that has rarely been heard of since the time of its release. Based on true events, *The Raid* is situated one thousand miles from the front and near enough to the war's end to provide a false sense of security to the Vermont town in which the story unfolds. There are no villains in this piece; nothing is made convenient for us as to whom we should be rooting for. The main characters, Union and Confederate, are sympathetic and afforded multi-dimensional treatment as they face up to the ravages of war. *The Raid* builds to a climax that could hardly be termed commercial in that it finishes without a comfortably resolved ending; it raises questions but it doesn't have the presumption to supply facile answers. Without letting romance or notions of victory seep into its final moments, *The Raid* uncompromisingly dramatizes this incendiary piece of our history. Coincidentally, the film begins in much the same way that *The Seventh Cross* does.

In September of 1864, seven Confederate officers, led by Major Neal Benton (Van Heflin), escape from a Union prison in Plattsburg, New York. The surviving six make their way into nearby Canada. A few days later, Benton arrives by train in St. Albans, Vermont, passing himself off to the small town as a Canadian businessman interested in buying property. He rents a room at the boardinghouse of the Bishops, war widow Katy (Anne Bancroft) and her nine-year-old son Larry (Tommy Rettig). As Sherman marches through Georgia, Benton is heading a secret mission that will empty St. Albans' banks, then burn the thriving, if quaint, town to the ground. He and his team have lost everything

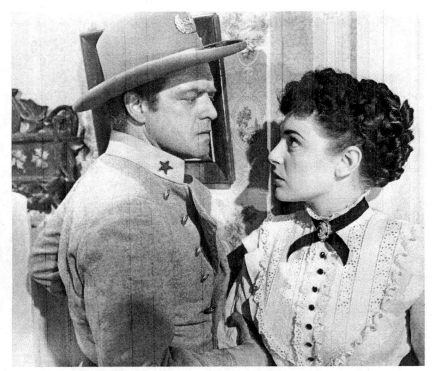

THE RAID. Confederate Van Heflin and Yankee Anne Bancroft.

in this war, but now it's payback time, with St. Albans only the first target in a series of proposed Northern raids. Benton must deal with a loose cannon (Lee Marvin) in his squad, the unexpected arrival of two platoons of Yankee cavalry and, most unforeseen of all, his growing attachment not only to Katy and Larry but to the entire St. Albans community. Are these people really the enemy?

The potency of the film's moral issues—its conscience—derives from the character of Benton, played excellently by Heflin. First seen in charge of the exciting prison break, Benton is a commanding leader, but he's a man who *feels* the impact of his actions, not necessarily an asset in war. At odds with his inherent humanity is his desire for revenge on those who burned his house and cotton fields. That bitterness is seldom expressed openly, but when it emerges Heflin positively seethes, fueling Benton's resolve. (He nearly loses his composure at the town bazaar, finding it hard to suppress his disgust when a captured Confederate flag comes up for auction as a war "souvenir.") Heflin plays Benton with his customary intelligence (smart guys were his specialty), which allows

for a level of awareness that believably leads to considerable emotional strain. It's a struggle between his fixed ideas and the simple, positive forces that start to weaken his determination. When Heflin first steps off the train and enters the town, he moves like an alien who can't quite believe that his true nature has gone undetected. He soon sees that there's no difference between him and these people; these generic Northerners are now individualized persons. Even so, he never expected to feel affection for Mrs. Bishop and her boy or to be worried about their safety. Benton's internal war, the one pitting his soldierly will power against his own sensitivity, results in a good deal of the film's suspense. Can he engage in vindictive destruction and retain his humanity? Is it an impersonal war action if the victims are no longer strangers? There are now faces on those he "hates," but there's no turning back. Heflin's soul-searching and his tilts in one emotional direction or another are psychologically astute and consistently up to the gravity of the moral questions at hand. The doubt on his face—and his inability to shake it off—is an emblem for the film's unease with violence, whatever the cause. Benton's popularity in St. Albans widens after an incident that's misinterpreted as an act of heroism, which only adds to his discomfort. He bristles at kind words because he knows he doesn't deserve them. His fortitude is corroding, and guilt is now always present in Heflin's eyes (though no one looks closely enough to see it). Is Benton more humane for feeling guilty, or less so for feeling that way but choosing not to alter his course? He can't have it both ways. If his compassionate impulses must be held in check, then the best he can now hope for is that it will all soon be *over*.

Benton and Katy Bishop are definitely attracted to each other and clearly enjoy each other's company. There's the potential for a future together. If the film had turned this story line—a relationship that forms in a week's time—into more of a clear-cut love story it would have seemed false, a melodramatic exaggeration. The same is true of Benton's attachment to Larry, Katy's boy. Missing his deceased father, Larry quickly latches on to Benton as a paternal figure, and Benton enjoys the attention. Dramatically, there's enough there to create a sense of betrayal in Benton without the screenplay forcing their bond to be implausibly close. Also staying in the house is Captain Lionel Foster (the hulking Richard Boone), a one-handed veteran who is now the district's recruiting commander. It's obvious that Lionel pines for Katy, but he's in the story for far more interesting reasons than the

obvious makings of a love triangle. The revelations of his character add to those elements that keep *The Raid* from being predictable or formulaic. And the eye-opening poignancy in Boone's performance is not to be undervalued.

Even Lee Marvin's troublesome character, the volatile Lieutenant Keating, is given a fair shake. His angry thirst for revenge comes from deep within; it seems to be all that sustains him. It's ugly but it's also genuinely painful. Witness Marvin's great moment kneeling in a church pew: as a reverend chillingly quotes from the Bible to justify the North's killing of the "rebels," a drunk Keating, with his hands over his face, peeks through his fingers as he listens, and it's only a matter of seconds before his mounting rage is unleashed. For all Keating's combustibility, Marvin shrewdly turns him docile whenever he wants something, as in the Montreal scene where he tries to convince Benton to take him to Vermont. Never merely a dumb brute, Keating is the first to notice Benton's wavering conviction. He suspects that the major's unwillingness to turn this military operation into a massacre is due to his newfound intimacy with the enemy. Marvin seems able to look deep inside Heflin, and Heflin reacts as if he's aware of this. The uncontrollability of Keating is another source of ongoing stress for Benton, and it reaches a boiling point in one of the movie's best and most emotionally intricate scenes. Keating joins other Marvin characters of this period, such as those from *The Big Heat* (1953), *Bad Day at Black Rock* (1955), and *Seven Men from Now* (1956), in his gallery of scary, capable-of-anything fellows.

Sydney Boehm's compact screenplay, based on the story "Affair at St. Albans" by Herbert Ravenal Sass, packs an enormous amount of dramatic heft into eighty-two minutes. It explores an unfortunately unstoppable chain of brutality (of the eye-for-an-eye variety), and the issue of loyalty (to causes, to people, to principles). Disillusionment is addressed too, certainly for the folks of St. Albans, but also for Benton as his black-and-white objective turns as gray as his uniform. These themes are articulated simply and without pretension, strengthened by the film's guts in sticking to its guns. And the empathy expressed for each of the characters is remarkable in the kind of film where you expect to be able to identify the good guys and the bad guys. There are none of either here. The climax, an impressively staged action sequence, intentionally provides no vicarious thrills. When violence erupts from the peace of St. Albans, it's shocking and disturbing. There's no cathar-

sis. The script puts an unusual story before us without interpreting it on our behalf, without resorting to speechifying. Using commendable restraint, it packs a wallop.

The Raid was directed by Hugo Fregonese, an Argentinean who never quite clicked in Hollywood. This film should have brought him the notice he would never receive in America. His style is lean and unadorned, which allows you to sit back and believe in the authenticity of what you're watching. There's not a wasted or unnecessary frame. Fittingly, blue and gray (and not just in the uniforms) dominate the muted Technicolor tones that establish the rusticity of the period and the locales. (The movie was photographed by Lucien Ballard.) Fregonese keeps the action out of doors as much as possible, staging scenes against picturesque yet unprettified landscapes.

You would never guess from her work here that Anne Bancroft had a big career ahead of her. She's perfectly adequate but whispers too many of her lines in the tentative manner of Hollywood starlets. She would wisely leave Hollywood for the stage, taking Broadway by storm in *Two for the Seesaw* (1958) and *The Miracle Worker* (1959), returning to the movies for the latter's screen version, which won her the 1962 Best Actress Oscar. *The Raid* has its share of familiar television faces: Peter Graves *(Mission: Impossible)*, Richard Boone *(Have Gun Will Travel)*, and Tommy Rettig *(Lassie)*. For Graves, who plays one of the Southern officers, this film fell between two memorable roles in *Stalag 17* (1953) and *The Night of the Hunter* (1955). Rettig had already starred in the cult classic *The 5,000 Fingers of Dr. T* (1953), and in the same year he appeared in *The Raid* he also went down the rapids with Marilyn Monroe in *River of No Return*. Also on board as one of Heflin's raiders is the seriously handsome James Best, known to many as one of the cast members of the screwy *Shock Corridor* (1963).

The Raid bears resemblance to *Shane* (1953) in the bonding between Benton, an intriguing stranger, and little Larry, an impressionable boy. Of course, the boy in *Shane,* played by Brandon de Wilde, has a father, and he's played by none other than Van Heflin. Though Heflin's ordinary-guy decency in *Shane* is often overlooked in favor of Alan Ladd's blond stoicism, Jean Arthur's romantic subtext, Jack Palance's black-hatted treachery, and de Wilde's wide-eyed adoration, it's Heflin who gives that classic its best, fullest performance. His abilities had been recognized a decade earlier when he nabbed the Best Supporting Actor Oscar for stealing *Johnny Eager* (1942), admittedly not a film

worth stealing but it solidified Heflin's reputation as an actor's actor. Other career highlights for him include being shot by Joan Crawford in *Possessed* (1947), chased by Robert Ryan in *Act of Violence* (1948), and abused by Jennifer Jones in *Madame Bovary* (1949). A later generation would know him as the pitiable bomber in *Airport* (1970). But he was never better than he is in *The Raid*, brimming with smarts, scruples, and shame, and helping to make the Civil War live on-screen in a unique and unforgettable way.

They Came to Cordura (1959)
Heroic Icon Plays a Coward

"What is courage? What is cowardice?" These lines appear on-screen before *They Came to Cordura* begins. The nature of bravery is an essential component of any war film but rarely has it been examined as directly, or as penetratingly, as it is here. Directed by Robert Rossen, Columbia's *They Came to Cordura* was disliked by critics and ignored by audiences in 1959, but its contemplative, relentless burrowing into its themes should find more appreciative audiences today since moviegoers are now more accustomed to characters consumed with self-examination (and interested in analyzing others). As war movies go, this one is talky, but in its verbiage it offers an unusually probing look at human behavior under inhuman circumstances, specifically combat and its ever-after repercussions. *They Came to Cordura* has a massive, superbly executed battle sequence, yet the film stands out more for its willingness to tackle uncommon psychological issues than for its action. It's a cerebral war movie without clear-cut heroes or cowards, and it emphasizes introspection, ambiguity, and conscience over victory and glory.

Gary Cooper had been a superstar, and one of Hollywood's two or three most enduring leading men, for three solid decades when he made *They Came to Cordura*. The role of Major Thomas Thorn brought him little attention, but it's a fascinating part for him to have played, and it resulted in one of his riskier performances. Thorn is the film's "coward," and to have it acted by Cooper, the man who won Oscars for two of the most famous heroic roles in screen history—the title role in the biopic of World War I soldier *Sergeant York* (1941) and the fictional marshal of *High Noon* (1952)—is ingenious casting. Cooper was in his late fifties when he played Thorn, a quarter century past his reign as the most beautiful man in movies, and his age only makes him more vulnerable. Thorn's guilt and self-loathing are visible in the lines on Cooper's face and the limitations of his body. Rarely has this great star seemed so exposed.

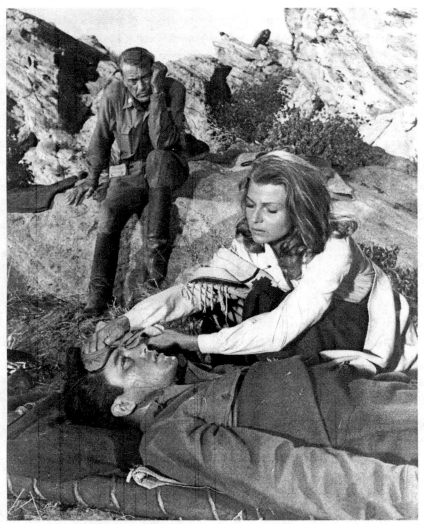

THEY CAME TO CORDURA. Gary Cooper observes Rita Hayworth tending Michael Callan.

They Came to Cordura is set in Mexico in 1916, yet it could be classified as a World War I movie because of the story's awareness of America's imminent entry into the European conflict. The military men in *Cordura* know that their cavalry-led fighting will soon be extinct, with the Great War decisively changing the tools of war. The notion of heroism takes on greater urgency for the military as our involvement in WWI looms: they're going to need heroes to inspire all the young men about to be

sent overseas. So, in this outmoded world of battle on horseback, a much bigger war provides a percolating subtext. Cooper's casting also has significance for his specific on-screen associations with WWI. His Sergeant Alvin York, the cinematic epitome of WWI heroism, provided a valorous ideal for young men on the eve of the attack on Pearl Harbor. Cooper had also appeared in, among others, the silent, Oscar-winning *Wings* (1927), which fought WWI in the skies, and *A Farewell to Arms* (1932), a poetically rendered WWI love story. As a WWI-era examination of courage, *They Came to Cordura* may sound like typical Cooper fodder, yet it offers little of what you expect: it's a war movie without an official war; its heroes can hardly be called role models; and, though it is purely, tenaciously war-themed, it has the landscape of a western.

After an attack on Columbus, New Mexico by Pancho Villa, the American army hunts for Villa and his rebels inside Mexico. Because of an act of cowardice during Villa's attack, Major Thorn is quietly demoted to awards officer, a position in which, ironically, he recommends brave soldiers for the Congressional Medal of Honor. In Mexico, Thorn selects five men to be decorated and makes arrangements to lead them back to the base in the U.S. (at Cordura), relieving them of active duty until their medals can be approved (and so that they will be alive to receive them). But Thorn has a much more personal mission: to probe the men's minds and figure out what it is they have that he lacks. In short, what is the secret ingredient of courage under fire? But as the journey becomes torturous, and the "heroes" prove to be inarticulate, ungrateful, and less than admirable, Thorn may never find the answers he seeks. Also on the trek to Cordura is Adelaide Geary (Rita Hayworth), an American with a Mexican ranch who is under arrest for allegedly aiding Villa's men.

Cordura has an interesting opening. Cooper emerges from the background of an outdoor shot, and you expect him to walk into the foreground. He stops to get some coffee, but the camera doesn't stay with him, moving instead to the military matters being discussed by an officer and the press. The subliminal message is clear: Cooper isn't playing an important guy. Thorn is a man stripped of his dignity, a man who cannot forgive his failure, and he hopes that the five men he deems heroic can teach him something about bravery. For all his celebrated underacting, and his ability to rely on leading-man charm if need be, Cooper doesn't shy away from Thorn's weaknesses, his masochism, or his obsessive need to accomplish his goal. Beneath the weight of his guilt is the mettle to see this thing through, and a searing desperation

to be enlightened and perhaps redeemed. With a transparently readable face, Cooper was a natural for movie acting. The moments I find most memorable are his point-blank interviews with the men about their heroic actions. "What made you do it?" he asks, ready to take notes in his little black book, followed by an earnest "Try to remember." He speaks of how important it is to him to know what they thought, what they felt, what it is that makes people go beyond "the limit of human conduct." Cooper has a focused commitment and fullness of purpose that makes these scenes among his best. The naiveté in Thorn's desire to intellectualize human impulses, and make conscious what was unconscious, and tangible what may remain abstract, only makes his quest more moving. That he's met with indifference, confusion, and lies—a total lack of revelation—is painful. Thorn is searching for profundity, but his subjects are anything but profound.

The "heroes" are a mixed lot: John Chawk (Van Heflin), a mangy sergeant; Milo Trubee (Richard Conte), a crafty corporal; William Fowler (Tab Hunter), a handsome lieutenant with a dark side; and two young privates, Hetherington (Michael Callan) and Renziehausen (Dick York). Hetherington's heroic act occurs before the film begins, but the other four distinguish themselves in the film's battle sequence, a real beauty of epic filmmaking. Director Rossen and his cinematographer Burnett Guffey compose stirring shots of cavalry formations as a huge number of men on horseback spread wide across the CinemaScope frame (long before they could be digitally faked). The rectangular shape is breathtakingly used as the soldiers race to their showdown with the Mexicans. The battle's mastermind is Colonel Rogers (Robert Keith), a four-decade veteran about to retire, who realizes that this may be the last cavalry charge *ever,* and it better be a great one. After the rousing visuals of the horses stampeding across a dusty landscape, against mountainous terrain, comes the warfare. Thorn observes with binoculars, studying the scene for acts of courage that warrant medals. Tab Hunter has already appeared in one scene, but Heflin, Conte, and York are introduced by their courageous feats.

Colonel Rogers is a small role, but Robert Keith makes the most of it, especially in his final scene, a confrontation with Cooper. This is the scene, a half hour into the movie, in which we learn that Thorn once acted with "cowardice in the face of the enemy." Rogers is the man who protected Thorn by demoting him rather than having him court-martialed (out of respect for Thorn's dead, and heroic, father).

With Thorn now an awards officer, Rogers hopes he will return the favor and suggest Rogers for a special citation. When Thorn refuses (because he believes such a citation to be undeserved), something else emerges in his character. For all his sense of defeat as a soldier, Thorn is still a by-the-rules military man. This explains why he's so hard on himself, and why he's steadfastly compelled to "put my hand on the bare heart of heroism." Here Cooper's age is not a plus: shouldn't a man this old be more familiar with reality? (Thorn is a man of forty in the novel on which the film is based.) In Keith's performance, ego trumps all else. His bitterness and anger at Thorn, for his refusal, are nakedly ugly. For Thorn, the man looking for ideals, this is a collision with blatant opportunism.

Thorn, his five heroes, and the under-arrest Geary woman set off for a two-day ride to Cordura, with only Hetherington aware of his medal candidacy. (The other four don't know why they've been assigned to this detail but find out soon enough.) There's quickly the expected tension between a group of six men and one beautiful woman. This marked the first and only time that Cooper and Rita Hayworth appeared together. She may never have reached his level of dramatic skill before the camera, but she managed to sustain her star presence even after her beauty became more earthbound than goddess-like. Dressed simply (in riding clothes), the fortyish Hayworth looks just fine here, better than she does in other films of this era in which she's more overtly glamorous. (*Cordura* happens to be one of those '50s films with the now eye-catching credit: "Hair Styles by Helen Hunt.") This film was made during Hayworth's *second* comeback of the 1950s: the first (1952-53), following her divorce from Aly Khan, consisted of *Affair in Trinidad*, *Salome*, and *Miss Sadie Thompson*; the second (begun in 1957), following her divorce from Dick Haymes, included *Pal Joey* and *Separate Tables* before *Cordura*. As Geary, Hayworth is best in her quieter moments, when revealing the details of her unhappy past (which includes a corrupt father, three marriages, and the custody loss of her two children) or reaching out to Thorn, and she works comfortably with Cooper. They will move closer together as the story proceeds, as the others move farther away from them. The expected romance between them never happens. Their strengthening bond is one of supportive friendship; it's not sexual or flirtatious. The director has enough on his mind without cluttering things with kisses. (Too bad he wasn't able to control Elie Siegmeister's overexcited score.)

With muted blues, yellows, and earthy reds, Guffey's color camera-work captures a starkly beautiful yet gnarled world (Utah and Nevada standing in for Mexico), an apt psychological backdrop for the characters' troubled minds. With no civilization in sight, the landscape becomes a metaphor for their internal isolation, their alienation from a world in which they are outcasts of one kind or another (to varying degrees). This is especially vivid once they sacrifice their horses to the rebels (to save their lives) and travel on foot. Moving closer to dealing with truths and fears they would rather not face, the psychological toll equals the arduous bodily strains, and the remoteness of their journey starts to feel existential. I've just made *Cordura* sound pretentious and heavy-handed, and detractors of the film would say it *is* those things, but the movie stays tautly focused on the character-driven story rather than wallow-ing in the weight of its themes and symbols. Rossen never misplaces the film's entertainment value: there's the mounting suspense of impending mutiny and outright violence against Thorn's leadership; the increas-ingly perilous hazards of their journey; the gorgeous images, including long shots of them trudging across the vastness, and a memorable shot of their ghostlike shadows moving alongside railroad tracks.

The movie never ceases to expand the story's ambiguity. As the men, specifically Heflin's Chawk and Conte's Trubee, behave poorly, and with, among other things, the murder of a pet bird, an attempted rape, and a blackmail proposition, Thorn is sickened by their actions but stays resolute in his awe for what they once did (and are capable of doing again). Their answers to his questions continue to disappoint him—Chawk speaks of wanting to kill (and of the pay raise his medal will bring); Trubee says whatever he thinks Thorn wants to hear. It's even more disheartening that most of the men don't want the medal. These aren't poster-boy heroes, but Thorn needs to protect what they have inside them even if they don't prize it, or even recognize it, them-selves. Things become hellish: Hetherington gets typhoid and has to be carried in a litter; Renziehausen has his ear shot off by the rebels; Trubee reveals to Thorn that he knows the truth about him. Watch Cooper's face go ashen when Conte first says he knows *something*. Trubee tells the others and loudly refers to Thorn as "a yellow guts." Cooper has a valiant stoicism that shields Thorn's humiliation and allows him to absorb such cruelty and continue to do what he must. Here Cooper puts me in mind of the emasculating indignities suffered by James Stewart in his Anthony Mann westerns, but whereas Stewart responded with

quaking emotion, Cooper mostly lets things just seep through his pores. In both cases, it's alarming to watch big, beloved movie stars receive such disrespectful treatment. Once the men know Thorn's secret, he's even more susceptible to their hostility and spite.

Finally, in a conversation with Geary, Thorn reveals the specifics of his cowardice, which occurred after many years of military service in which he saw no action. Cooper, characteristically, speaks quickly, scrupulously avoiding any self-indulgent emotion; his honesty and simplicity anchor the scene. To Thorn, all his prior life is negated by this new label of coward. It's interesting that Geary interviews him here in much the same way he questions the others, and he isn't any more expressive on the nature of cowardice than they are on courage. Rational thought doesn't apply here. Should one moment, either courageous or cowardly, define the rest of a life? Hayworth supplies solid, sympathetic support, and Cooper is remarkably open. He walks a delicate line between self-loathing and firmness of purpose, still speaking of the men as possessing "a miracle and a mystery" and of his need to save what is best in them, even though he no longer wields any authority over them except that afforded by his gun. Late in the film, Geary makes a sacrifice on Thorn's behalf that is startling (especially for a 1950s film).

The last section of the movie—hot, dry, and exhausting—has them reach the railroad tracks and ride a handcar in the direction of Cordura. The sleepless Thorn is implacably resolved to get to Cordura, and no one else exhibits his endurance. With Geary his Magdalene, Thorn's masochism reaches Christ-like proportions once he ties a rope around himself and drags the handcar along the tracks like his own cross. The path to Cordura is one in which the odyssey itself becomes more important than the destination. *They Came to Cordura* is about addressing the past rather than continuing to suffer its wounds. The last moments are marred by Tab Hunter's limitations as an actor, so the ending appears more forced, more movie-ish than it should. Throughout, Hunter is not up to the demands of his mercurial role.

Hunter's work may be undernourished, but the film's effectiveness is bolstered by old reliables Heflin and Conte. Heflin, so good at playing intelligent, humane men, relishes being cast against type as a grubby, vicious lout. Conte, one of Hollywood's most underrated actors, is cast exactly *to* type, making Trubee another of his smoothly calculating, expertly slimy characters. How could anyone ever trust him again after he brandished his flair for sadism on Susan Hayward in *I'll Cry*

Tomorrow (1955)? He's also slickly "rotten" in the polished noirs *Cry of the City* (1948) and *The Big Combo* (1955), the one in which he says, "First is first and second is nobody." And he certainly adds to the overall verisimilitude of *The Godfather* (1972). Conte also excelled as good guys, as in the hardy *Thieves' Highway* (1949); his streetwise savvy made him the Italian John Garfield. As for the other two "heroes," Michael Callan had just come off playing Riff in the original 1957 Broadway production of *West Side Story,* and Dick York would find fame as the original Darrin on the sitcom *Bewitched,* beginning in 1964.

Based on the novel by Glendon Swarthout, *They Came to Cordura* is something of a middle-aged *Red Badge of Courage,* so focused is its search for answers with regard to the inexplicability of wartime instincts. Director Rossen cowrote the screenplay with Ivan Moffat, and they clearly felt a passion for the themes expressed. The script is meticulously faithful to the book until the finish, altering how things end for Thorn. Rossen's direction is intelligent and thoughtful, and he maintains a balance between absorbing talk and action blasts, though it's widely documented that he wasn't happy with Columbia's final edit of the film. Rossen had made *Body and Soul* (1947), the quintessential boxing movie, and *All the King's Men* (1949), a highly overrated, Oscar-winning Best Picture, before being blacklisted for his Communist-party past. His career resumed, after he named names, with the turgid *Alexander the Great* (1956), in which Richard Burton, wearing a blond wig that appears to have been styled for June Allyson, makes you wonder what was so "great" about him. After *Cordura,* Rossen made *The Hustler* (1961), his best movie.

Cooper had started looking considerably older on-screen once WWII ended, but he continued not only to be a star but to make worthwhile movies. There were interesting parts in *The Court-Martial of Billy Mitchell* (1955), *Friendly Persuasion* (1956), *Ten North Frederick* (1958), *Man of the West* (1958), and *The Wreck of the Mary Deare* (1959), some ignoring his noticeable aging and others acknowledging it, yet they all made use of the low-key skills of which he was now a long-standing master. The boyish comic glint he irresistibly flashed in *Mr. Deeds Goes to Town* (1936) was no longer evident, but in its place was the life experience that allowed Cooper to tackle issues of responsibility and conscience with a persona of integrity that few stars could match. He died at age 60 in 1961 from cancer. Though his life was relatively short, his career had density and scope. In terms of portraying the male ex-

perience, from *The Virginian* (1929) and *Morocco* (1930) in his youth, to *The Pride of the Yankees* (1942) and *For Whom the Bell Tolls* (1943) at his peak, to *High Noon* and *They Came to Cordura* in his maturity, was there really anything left for Cooper to say?

The Train (1965)
The Art of War

World War II has to be the most dramatized war in screen history. With villains bent on world domination, multi-continental settings, and a population valiantly resisting (or sometimes collaborating with) the enemy, WWII will never lose its film potential or appeal. Hollywood had done its duty triumphantly during the war, churning out its steady flow of films designed to keep America undaunted. But after victory in 1945, would interest in war stories be sustained, or did audiences want to put the war behind them? Would the cathartic, moving coming-home drama *The Best Years of Our Lives* (1946), which swept the Oscars and grossed a fortune, be a fitting last word? There were no major WWII films released in 1947, but after a short breather, Hollywood began to examine the war with a complexity that would not have been possible, or patriotic *enough*, during wartime. Be they stories of leadership pressures (*Command Decision* [1948] and *Twelve O'Clock High* [1949]), combat (*Battleground* [1949] and *To Hell and Back* [1955]) espionage (*Decision Before Dawn* [1951] and *5 Fingers* [1952]), or more personal dramas set against the conflict (*Heaven Knows, Mr. Allison* [1957] and *The Diary of Anne Frank* [1959]), tales of WWII became an inexhaustible source for stirring screen drama. From small, confined movies, such as *Stalag 17* (1953), to ambitious blockbusters, such as *The Bridge on the River Kwai* (1957), the subject of WWII was a fertile, ideal context in which to explore humanity at its best and worst.

In the 1960s, WWII continued to thrive on-screen with the colossal success of commercial-minded, star-driven nail-biters like *The Guns of Navarone* (1961) and *The Great Escape* (1963). But there were also more offbeat WWII films: *36 Hours* (1964), with its wild plot involving a Nazi attempt to learn about the upcoming D-Day invasion by convincing a drugged, kidnapped American major that the war has been over for years; *The Americanization of Emily* (1964), a stinging romantic-comic look at American-English relations on the eve of D-Day; *The Hill* (1965),

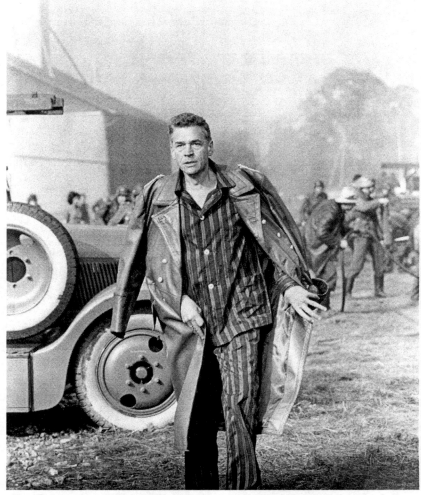

THE TRAIN. Nazi colonel Paul Scofield having a tougher time with the French than expected.

a brutal, desert-set exposé of Britain's treatment of its own military prisoners. One of the most unusual and thought-provoking WWII films to emerge was *The Train*, a film that succeeds as both large-scale, on-location epic and intellectually provocative drama. Superbly made by John Frankenheimer, *The Train* also happens to be a crackerjack suspense thriller that combines sooty realism with fantastic adventure. More challenging than *The Guns of Navarone* or *The Great Escape*, *The*

Train is smart, tricky, funny and sad, and consistently exciting. Like *The Bridge on the River Kwai,* it's a massive, visually sweeping film that asks complicated questions while delivering movie-movie entertainment.

In August of 1944, with the Allied liberation of Paris imminent, Nazi Colonel Von Waldheim (Paul Scofield) has his men steal dozens of priceless paintings from the city's Jeu de Paume museum. Because of the art's cash value, he convinces a superior to provide him with a train for the pictures' transport to Germany, but the colonel's true motive is his love for this "degenerate art" and his will to possess it. French resistance fighters, led by railway official Paul Labiche (Burt Lancaster), thwart the colonel's plans at every turn, determined not to lose this piece of their culture. Labiche is troubled by forfeiting lives to save canvases but can't ignore the nationalistic pride of his compatriots.

The Train tells a humane, disturbing story, yet it leaves the viewer to decide what to make of what transpires. Can inanimate objects, however irreplaceable and valuable and beautiful, bear the cost of human life? How do you ask people to sacrifice their lives for pretty pictures? The French characters in *The Train* aren't interested in the paintings' financial or artistic worth but, rather, in the art's representation of "the glory of France." How does one distinguish between French masterpieces and France itself? Don't, say, Manet and Matisse, define France to its populace and the world? The paintings are symbols of what the French are fighting for: to retain their national identity—their past, their pride, their very soul—from those who would pilfer it. *The Train* grapples with these issues without dispensing pat answers.

This film was made in black and white on French locations, coming remarkably close to looking like a WWII documentary. It primarily features French actors in French roles and German actors in German roles (notable exceptions are the two stars), yet, typical for '60s screen epics with international casts, no one speaks anything but English. In the center of this substantial veracity is Burt Lancaster as a French freedom fighter, looking and sounding all-American. I'm not leading up to a pan of Lancaster's performance. On the contrary, *The Train* is one of many worthy films he lent his name to, offering the clout, budget, and box-office potential that came with it. Certainly he's miscast here, but the pros of his appearance outweigh the cons. Since he has a predominantly action-oriented role, one requiring authority and virility, is it really fair to complain that he isn't French enough? Previously, he hadn't been old enough for *Come Back, Little Sheba* (1952) or Italian enough

for *The Rose Tattoo* (1955), but his "name" value made it feasible for his co-stars, Hollywood newcomers Shirley Booth and Anna Magnani, respectively, to be cast in the roles that won them Oscars. Sometimes, as with *Separate Tables* (1958) and *The Devil's Disciple* (1959), Lancaster's own production company was involved, but in all these cases the actor used his stature to get risky movies *made*. In none of these is he at his best, yet you have to admire the enthusiasm with which he tackled roles that didn't suit him. Billed solo above the title, Lancaster is aboard *The Train* for his movie-star skills, rather than the Oscar-winning dramatic heft he had recently flashed so dazzlingly in *Elmer Gantry* (1960). At age fifty, he has a ball incorporating his acrobatic past into several mightily impressive stunts, sliding down ladders, scaling walls, leaping onto (and off of) moving trains. Watching Lancaster display his he-man prowess is pure pleasure because he's such an eager, graceful showman. Yes, he's playing Burt Lancaster *playing* a brawny humanitarian, but he's a force to be reckoned with. And he surely knows how to carry a big movie.

The prologue begins at night, with the colonel's arrival at the museum. Alone with the masterworks he covets, he's a man at odds with his position. Nazis are not supposed to respond favorably to these works, but the colonel considers himself a superior person. He engages in a conversation with the museum's curator, Mlle. Villard (Suzanne Flon), and they communicate as mutual art lovers. She knows how much he adores the paintings and thanks him for protecting them over these four years of occupation. This quiet, ruminative atmosphere is ruptured when Nazi soldiers enter. The colonel turns to Villard and dispassionately says, "We're removing the paintings." It's a startling tone shift and, as the credits fill the screen, we watch the Nazis pack the art treasures into crates that are then stenciled with names like Degas and Cezanne. By the time we get to "Directed by John Frankenheimer," Villard is alone with emptied walls. *The Train* has swiftly declared that it is not going to be just another WWII picture.

Lancaster may have all the derring-do, but Englishman Scofield has the best part (though his German accent is untraceably strange). His colonel may remind you of another WWII colonel, the British one played by Alec Guinness in *The Bridge on the River Kwai*. Both characters develop an obsession—in Guinness' case it's the building of a bridge, even though it benefits the enemy—that puts their personal pursuits above the war effort. Guinness' colonel is guilty of losing perspective but Scofield's colonel grows more arrogant and selfish as his story proceeds,

carried by some unreasonable vision of himself and these artworks com-mingling. Never mind Aryan superiority, Scofield plays the colonel as superior to everyone, astutely making him as detached from his fellow Nazis as he is from the French. Amid a flurry of evacuation activity in a Nazi-occupied building, the camera discovers him standing utterly still, a self-possessed figure removed from the hysteria and confusion gripping those around him. It's the colonel's love of art that separates him from the usual screen Nazis. He sees something in these paintings that he cannot see in living souls and finds nothing unjust with the art going to the person who can most appreciate it. His only concern in these catastrophic times is the art's safe arrival in Germany. As the train's problems mount, thanks to Labiche and his team, Scofield ampli-fies the colonel's steely determination, sometimes losing his clenched composure with the irrationality of a spoiled child.

Mlle. Villard meets with Labiche and other rail-working freedom fighters inside a barge. She describes the paintings as "the national heri-tage" and France's "special vision" and asks the men to stop the train rather than destroy it (and endanger the art). In this scene, Lancaster introduces the cynicism with which Labiche will treat the paintings throughout the film. He's not convinced that art is important enough to warrant risking his remaining men and he refuses, but as the story continues Labiche witnesses multiple examples of people willing to make the ultimate sacrifice to keep the paintings inside France. This does not lead to a movie-ish conversion on his part but it does make him marvel inwardly at his countrymen's selflessness. Papa Boule, played robustly by Michel Simon (of such '30s French film classics as *L'Atalante*) is one such fellow. A burly, grizzled engineer, Boule is assigned the art train, and he's the first to take action against it by sabotaging its oil line with coins. Simon plays Boule as a man too old and fed up to be frightened by Nazi thugs, and he spits at the colonel after being found out. It's a touching detail that he had pocketed the incriminating oil-stained coins; times are too tough to throw away money, even if it's life-threatening evidence. In light of Boule's defiance, Labiche's two closest allies com-mit to the mission and make the necessary contacts for an elaborate plan, though Labiche is still conflicted.

I'm in awe of Frankenheimer's expertise at handling the logistics of scenes dependent on the machinery of planes and trains and explosives, all the while providing tiny details within these scenes, such as the time on a Nazi's wristwatch or split-second track switches, that ratchet up the

suspense and our overall immersion in the intricate plotting. The action scenes are so impeccably worked out, timed, and edited, that you cannot believe they are anything but historic events miraculously captured on film. *The Train* confidently covers enormous spaces, without any worry that "1965" might intrude upon it; the movie places you securely inside a credible 1944 France. The length of some of the director's takes also adds significantly to the verisimilitude. Without frequent cuts, 1944 just keeps rolling along. There's a long take of Scofield, being driven in a sidecar to a train wreck caused by the Resistance, amid much noise and commotion. When he arrives at the scene, barking orders, the camera moves in to capture his seething rage. A large scene has evolved into one of singular intensity.

There's a highly charged sequence in which Labiche and his men, at the colonel's orders, drive the repaired engine car (the one Boule had sabotaged) to Rive-Reine to join the cars containing the art, when an Allied plane swoops down and fires on them. The tension is augmented by the fact that in war you can be as vulnerable to your friends as you are to your enemies. This attack peaks with the engine's breathless race to the safety of a tunnel as bullets rain down. Once they deliver the engine, the colonel, fearing more sabotage, insists that Labiche himself drive the train into Germany, prompting another gem of an action sequence. Labiche—sent to a hotel room to sleep until the train is ready to depart that evening—must escape from his room just long enough to make the phone call that will put the final piece of the plan into play. The scene, in which Lancaster climbs down from his second-story window, leaps over a wall and makes his way to the station master's office, is riveting. Aided by a diversionary truck fire started by a comrade, he fatally stabs a Nazi, completes his call (which we cannot hear), and races back to the hotel.

To deliver the most impact, the movie deliberately avoids telling us too much about the plan to stop the train, letting us witness it as it plays out, and affording us the worthwhile surprises that result. The Resistance characters don't stop the movie to explain the plan to each other (and thereby us), and so we can never get ahead of the story. But we do learn the truth of what they're doing before the Nazis do. It's a very pleasurable position for an audience to be in, not completely privy to what the heroes are up to, yet delighted to be in on the scheme early enough to feel smugly superior to the villains. The resistance fighters' biggest coup (which I'll not reveal), a brilliantly executed way to keep

the train inside France without arousing the on-board Germans' suspicions, culminates in a rail-busting crescendo. This whole sequence—the film's centerpiece—is wickedly funny and perhaps improbable, but vicariously satisfying. The perfection of their plan is made believable by Frankenheimer's storytelling clarity and his crew's technical proficiency. There's not a single gratuitous crash or explosion in *The Train;* each has the kick of the Resistance's work paying off, besting their better-armed foes, and the satisfaction of Allied might vanquishing evil.

A welcome addition to the film is the internationally prized Jeanne Moreau. As Christine, a war widow running a hotel near the Rive-Reine train station, she is no-nonsense, hardened by the endless war and tired of it all. Will she be sympathetic to the dangerous Labiche when he needs help? When he, back from his phone-call mission, is discovered by the Nazis eating in her kitchen, there's the uncertainty of whether or not she will lie for him. The tension is heightened by her pause, but naturally this proud French woman will do what she can for the cause. The role of Christine is small, but Moreau is the kind of talent who provides instant gravity to any part she plays: her presence is grounded; her face mesmerizingly honest. Despite the losses she has incurred, she allows herself to care about Labiche. Later, in yet another exquisite long take, Moreau looks out her front door for him, and the camera then follows her, still looking, to her back door. The second she steps out of the frame there he is in the distance, climbing over her wall and limping (he's been shot) to her door. After hiding him in her basement, Moreau releases the exhausting strain of Christine's clamped emotions to him, mostly the pain of mourning so many war-related deaths. When she and Lancaster embrace, it isn't romantic; it's a fleeting, warming expression of human contact.

As casualties mount, including close friends of his, Labiche continues to weigh the mission's worth, especially with Paris' liberation so near. In his most animated scene, set in a farmhouse hideout, Lancaster puts a little Elmer Gantry fervor into his performance as he rails against the delays of the Allies and his superiors' sustained orders to save the train. Even though Lancaster doesn't really bother to tap its potential, Labiche is a good role. He's continually amazed at the number of Frenchmen who feel that the art is worth the risks, and this aspect of the role could have been more affecting if Lancaster had given it his full attention.

The climax of *The Train* comes close to the German border, with Labiche a one-man guerrilla operation, doing all he can to disable the train,

if only for all those who died on its behalf. There are spectacular shots of Lancaster racing across the hills above the tracks, eluding watchful Nazis and preparing his next moves. The terrific build-up to the final showdown between Labiche and the colonel features more trouble keeping the train on the tracks, a phalanx of retreating German soldiers in trucks, more dead Frenchmen, and, finally, just Labiche, the colonel, and the paintings. Scofield has a near-mad scene, unable to process the possibility of defeat and having lost any sense of the war itself. He shouts threats, makes crazed orders; Scofield is striking in his deranged self-absorption.

Writers Franklin Coen and Frank Davis received the film's sole Oscar nomination for their story and screenplay "written directly for the screen," even though the film credits Rose Valland's book *Le Front de L'Art* as source material. The screenplay has considerable breadth, fusing adventure, history, and morality, while the gritty photography of Jean Tournier and Walter Wottitz is exhilaratingly fluid. Not a moment in *The Train* looks anything but authentic. This was stage actor Scofield's third movie, but his next, the stately and unchallenging *A Man for All Seasons* (1966), won him the Oscar for repeating his theatre role of Thomas More. (Nowadays that film feels like a 1960s version of Paul Muni's too highly regarded prestige pictures of the 1930s.) Despite this success, Scofield continued to work primarily on London stages.

John Frankenheimer replaced Arthur Penn on this movie shortly after filming began, following Penn's creative differences with Lancaster. Frankenheimer, who had come out of television, began his big-screen career directing *The Young Stranger* (1957), a good post-*Rebel Without a Cause* misunderstood-teen drama. He will be forever revered for making *The Manchurian Candidate* (1962), one of the great American films of the 1960s. Frankenheimer and Lancaster made five films together in the '60s, beginning with *The Young Savages* (1961), which is basically *West Side Story* minus music and romance, and then *Birdman of Alcatraz* (1962), with its fine, subdued (and Oscar-nominated) Lancaster performance. Next came *Seven Days in May* (1964), an effective cautionary thriller fueled, like *Manchurian Candidate*, by Cold War paranoia. After *The Train* came *The Gypsy Moths* (1969), a deserved flop. Frankenheimer's other noted '60s film is the grim sci-fi picture *Seconds* (1966), a movie that fails to deliver on its stunning first half-hour. Frankenheimer's reign as a major director didn't extend beyond the decade. *The Train* shows his capabilities at their fearless, visionary best, and it's a must for those with an insatiable fascination with WWII movies.

Three Kings (1999)
What Did We Win in the Gulf War?

W hen *Three Kings,* a movie about the 1991 Gulf War, was re-
leased in 1999 no one knew that there would be a subsequent
war with Iraq, beginning in 2003. Yet the film is certainly
prescient about what was to come. In defending America's decision to
leave the region, one character asks another if he would like, instead,
to occupy Iraq and have another Vietnam. Topicality isn't why *Three
Kings* is so good, though it remains a fascinating marker of the times.
The movie is blatantly critical of the first President Bush, by name,
which probably precludes Bush-family fans from seeing it as anything
more than a scolding from liberal Hollywood. Yet its points are made
on human terms and with humor that is dark and idiosyncratic but not
smug. *Three Kings,* a good candidate for the best American film of its
year, was well received by critics, though less so by the public, and its
reputation has been steadily on the rise. Politics aside, it's a bold, inven-
tive genre-bender, a war film that combines ironic comedy, heist thriller,
action-star antics, and farcical situations, set against a surreal landscape
and a gravely serious situation. *Three Kings* is quite a ride because it takes
U-turns, detours, and maneuvers dead ends, colliding with bald reality
in a way it never could have if its central characters had behaved like
conventional soldiers. It's similar to *Gunga Din* (1939), another dizzily
comic war film in which three soldiers are swept inside the chaos of war.
But *Gunga Din* and other Rudyard Kipling-based adventure films (like
John Ford's 1937 *Wee Willie Winkie*) were paeans to British imperialism,
whereas *Three Kings* is no hymn to American foreign policy.

 Three Kings was written and directed by David O. Russell, the writer-
director of *Spanking the Monkey* (1994), an unkind, relentlessly mas-
ochistic film featuring mother-son incest (with a title referring to mas-
turbation), and *Flirting with Disaster* (1996), a sure-footed modern-day
screwball comedy with Ben Stiller and a stellar supporting cast that
includes Lily Tomlin and Alan Alda. These pictures hardly anticipated

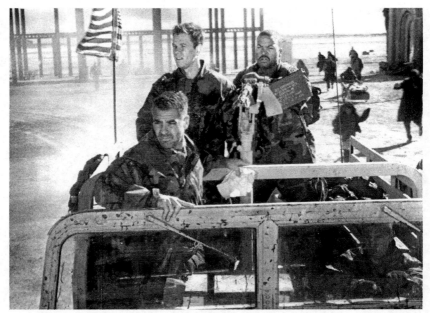

THREE KINGS. George Clooney, Mark Wahlberg, and Ice Cube getting more than they bargained for.

Russell's producing a work like *Three Kings.* Though it shares the comic edginess of his previous films, *Three Kings* has a visual grandeur and thematic ambition you don't expect from a director known for small, quirky movies. The film's breathless editing and brash visual effects (including an unusual color palette) make for an intensely sensory experience.

As the film opens, it is March 1991, and "Operation Desert Storm" has just ended. When a map revealing Saddam Hussein's bunkers is pulled from an Iraqi prisoner's anus, three American soldiers plot a secret mission to retrieve the stolen Kuwaiti bullion hidden in the bunkers, keeping it for themselves: Major Archie Gates (George Clooney), who takes charge, Chief Elgin (Ice Cube), a serious-minded, religious fellow, and Troy Barlow (Mark Wahlberg), a husband and father. Along with them is Conrad Vig (Spike Jonze), a goofy sidekick. Their operation should last a few hours, but, instead, embroils them in the civil unrest between Saddam's soldiers and the anti-Saddam rebels. Gates spells it out: "Bush told the people to rise up against Saddam. They thought they'd have our support. They don't. Now they're getting slaughtered." The "kings" find the gold, aided by the rebels, and promise in return to help these refugees flee Iraq. It's not a promise they're in a position to make.

The war's over, but it has ended so quickly that many of the soldiers haven't had a chance to participate. When, in the opening moments of the movie, Barlow, wandering across an expanse of gray desert with a handful of other soldiers, sees an Iraqi waving a gun in the distance, he asks seriously, "Are we shooting?" Barlow pulls the trigger, killing the man, who, in addition to the gun, had been waving a white rag from his other hand. The tone is set: mixed signals lead to utter confusion. The scene swiftly shifts from combat to partying, as the soldiers drunkenly celebrate victory frat-house style. There's talk of this war exorcising the "ghost of Vietnam, with a clear moral imperative," but most of the soldiers seem unconnected to what it was they were fighting for, or what it is that they've *won*. The next day, one soldier wears his night-vision goggles in blazing sunlight simply because otherwise he will never get a chance to wear them.

The movie amusingly introduces its main characters by freezing the frame on them, then typing out their names and revealing one salient fact about them, like "Conrad Vig, wants to be Troy Barlow." Set to retire from the military in two weeks, Clooney's Gates is first seen having sex with a newswoman, even though he's a Special Forces "escort" to Adriana Cruz (Nora Dunn), a rival reporter. As an escort, he's supposed to push the stories that are favorable to the military. Clooney gives the character a renegade streak that makes it impossible for Gates to be anything but his own man (which can't be easy in the military). It's demeaning to play media liaison, especially when you're a cynic. The role is in the classic tradition of charming, smooth-talking rogues with selfish agendas who find unexpected redemption; Clark Gable played it countless times. Clooney is likably wry and crafty, and he makes vivid Gates' individualism. He bristles when he tells a superior that he doesn't "know what we did here." The movie can't commend American policy, but it does commend American ingenuity, and that's embodied in Clooney's shrewdness. Gates' plot to outsmart the military, the media, and the Iraqis is naïve only in its not considering the possibility of his becoming emotionally involved. Clooney is part of the ensemble here; this is no star vehicle. Gates is a fine part, if not a showy one, and Clooney gives it the relaxed confidence it merits.

The power of *Three Kings* comes from its characters' unplanned foray into the heart of a national horror. The war may technically be over, yet it's about to begin for Gates and his crew. What was, for them, a pretend war now becomes the real thing. The men come in contact

with the strife within Iraq and can't ignore it, even with images of gold dancing in their brains. The succinct comic flashbacks of the guys' jobs back home, ending with the jobless Vig shooting stuffed animals off an abandoned car, illuminate their gold fever. *Three Kings* isn't about good soldiers doing good; it's about opportunists who choose to do good because to do otherwise would be unconscionable. The casual attitude with which they begin their mission, talking sports and firing off their guns as they ride to the bunkers (with a tiny Bart Simpson attached to the front of their Humvee), is schoolboy stuff. They ride across the desert to the Beach Boys' "I Get Around," which seems both apt (irresponsible hedonism) and loony (a "beach" song in the desert?). But all the action they have missed is about to be theirs. At first, Gates imagines they will sail along on the "blinding power of American sunshine," but it's soon clear that that won't be the case. They find themselves immersed in an Iraq that is no longer an abstraction. These anti-heroes become heroes, but the film doesn't make too much "drama" out of their transitions. Without heavy-handedness, it just happens. It wasn't supposed to get personal, but it does. They also become a real unit, a force with a purpose. If they didn't know why they were there, they soon will. Like their Biblical namesakes, the three kings wander the desert, carry precious items, and bear gifts for something in which they believe.

The movie's comic audacity heightens the alien nature of the stark location, a setting that becomes host to a series of bizarre events, alternately funny and shocking, sometimes both. When a cow is blown to bits by a cluster bomb, spattering blood and body parts on the men, Vig says that it's "like a cartoon." It surely is. Anything can happen in *Three Kings*, yet its strangeness never seems unreal. This outlandishness— parallel threads of funky comedy and wrenching pain—establishes how war removes normalcy from the mix. With varying doses of absurdity and lucidity, the film has a jolting believability, much more persuasive than if it were unwaveringly serious. Before they uncover the gold, they find a bunker filled with *stuff*, from computers to blue jeans to jewelry, all of it incongruously housed below a dust-filled wasteland. They tell the Iraqis that they're here to confiscate Saddam's booty, including the Kuwaiti bullion—it is, after all, spoils of war—and pack the gold bricks in, of all things, Louis Vuitton bags.

Later, after Barlow is first captured he finds a stash of cell phones and calls his wife in Detroit. She has no idea what his situation is and talks from her kitchen (with their baby in her arms) about job opportunities

on his return. He tells her to call the reserve center with a message on his whereabouts. Wait, isn't the war over? "It is and it isn't," he tells her. The contrast between his life-and-death urgency and her humdrum domesticity is wickedly funny. It's a moment emblematic of the movie's simultaneously matter-of-fact and off-the-wall viewpoints. Another such moment occurs when Gates and company arrive at a rebel outpost that houses a showroom of expensive cars—in the middle of *nowhere.* The rebels won't part with these Kuwaiti, Saddam-stolen cars, so Gates decides to sway the situation by rousing them into a unified brother-hood against Saddam. The room becomes a fired-up revival meeting, yet the head guy still won't part with the cars. Clooney deflates his energy instantly: Gates gives in and *buys* the cars. (Even Gates can't win them all.) Headed for a showdown to save Barlow, a caravan of fancy cars rolls across the desert.

You don't forget the bullets in *Three Kings.* In a violent confronta-tion between the Americans and Saddam's soldiers, director Russell makes sure that we hear the air-searing force of each bullet fired, and his camera appears to move *with* the bullets (at their speed), blurring the image until each reaches its target. This technique isn't realistic, but it allows you to experience warfare in a way that breaks down its specific, detailed components. The sounds, the impacts, and the inju-ries have a charge that is startling in an age anesthetized by too many action movies. Clooney's narration of what a bullet does to our insides is accompanied by an internal anatomical visualization, gooey and brightly colored.

The film's big, exciting incidents are occasions for spellbinding visual and dramatic fireworks. After investigating one of the bunkers, the guys emerge to see Saddam's soldiers attack a tanker carrying milk, blowing a hole in its side and flooding the area in a high tide of white. It takes a moment for this unearthly image to settle. The starving people rush to scoop up the liquid, with the guys, ankle-deep in it, removed from the desperation of those around them. Once the Americans co-opt a truck and leave with the gold, taking along Saddam's prisoners in the Humvee, the enemy fires gas bombs, resulting in huge bursts of white clouds. Though everyone survives, the Humvee is blown to bits by a mine, and the truck tips over on its side and skids across the dirt, just missing a mine. The action is thrillingly timed and staged, and the suspense escalates unnervingly. In the bomb-induced white fog, an eerily calm scene follows in which they are silently rescued by gas-masked figures

who behave like robotic Martians in a sci-fi thriller. (They are rebels who have emerged from an underground shelter.) Again, the film has found an otherworldly, though convincing, reality in opting for visuals and plot turns that seem anything but real. Gates becomes something of a pied piper as the number of refugees in his charge increases, passing fifty, as they traipse across the desert. (These Iraqis are helping to carry the bullion, too.) The final major action sequence occurs when Saddam's men man a helicopter and start shooting at everyone in their path. Russell's directorial craftsmanship is phenomenal here. Technically, his effects are impeccably achieved, and his work is consistent in its pictorial imagination and visceral stimulation.

Even if the Iraqi characters don't have very defined roles here, the film nonetheless puts faces on the war, for the "kings" and for the audience. Unforeseen pangs of guilt and responsibility are aroused in Gates and the others. After Barlow is captured, the refugee leader (Cliff Curtis) agrees to help Gates rescue him on two conditions: a portion of the loot, and his people being safely escorted to the Iranian border. This character represents good, Saddam-defying Iraqis, but even Saddam's soldiers are granted humanity. Captain Said (Said Taghmaoui), the young man who interrogates and then tortures Barlow (with electric shocks), has much in common with his captive. The men talk of being husbands and fathers, though the Iraqi's wife has been maimed and his son killed by a bomb. Barlow, who shot that Iraqi in the opening scene, here confronts the face of his "enemy," a man for whom he feels sympathy even after he's been tortured by him. Barlow explains that the war was important to "stabilize the region." In response, the Iraqi pours crude oil into Barlow's mouth. It's a revolting image, and the point is made resoundingly. Early on, they discuss Michael Jackson. The Iraqi wants to know why America made the King of Pop hate himself so much that he chose to disfigure his face. The Iraqi's comments make perfect sense, questioning what he perceives as America's "the-whiter-the-better" brand of racism, but they're also—uttered in, of all places, a torture chamber—completely unexpected and, therefore, funny.

Mark Wahlberg was coming off his breakthrough work in the outstanding *Boogie Nights* (1997) when he played Barlow. He's good here, teetering on the edge after his torture, feeling the losses incurred by this war, and desperate to get back to his family. Ice Cube is solid and stoic as Elgin, and Spike Jonze makes an appealing hick as Vig. (Jonze is better known for directing two of the best, and more daring, of re-

cent comedies, 1999's *Being John Malkovich* and 2002's *Adaptation*.) Special mention must be made of Nora Dunn's difficult "star" reporter ("five-time Emmy runner-up"). An alumnus of *Saturday Night Live*, Dunn creates a ferociously funny, tough, impatient character, driven by ambition, ego, and the merciless pressures of competition. It's not a large role, but she makes every moment crackle. Clooney, who reteamed with Wahlberg on *The Perfect Storm* (2000), a much bigger hit than *Three Kings*, had already secured his transition from television's *ER* to the big screen with a stylish crime picture, Steven Soderbergh's *Out of Sight* (1998). *Three Kings* proved it was no fluke.

David O. Russell conceived *Three Kings* with the size and scope of an old-style Hollywood epic (albeit one with decided political attitudes). The cinematography by Newton Thomas Sigel offers a fresh imagining of the region, replacing the intoxicating dreaminess and golden hues of a *Lawrence of Arabia* (1962) with an often washed-out glare, as if *Three Kings* were set on another planet. (It was filmed in Arizona, California, and Mexico.) The blues, whites, and greens, the haziness and the vast gloom, are enhanced by breathtaking wide-screen compositions and the use of different film stocks. Russell's supple direction of his canny, tone-shifting screenplay (story by John Ridley) maintains an edgy, hip style, without feeling gimmicky or smart-alecky. Take a moment like this one, in which comedy, danger, and irony fuse: in the Infiniti Vig is driving, he's got Chicago's slushy "If You Leave Me Now" blaring from the tape deck (a pertinent comment on the U.S./Iraq situation); after the shooting begins, he realizes his gun is locked in the car, and when a bullet shatters the glass he's able to retrieve it, allowing the Chicago tune to emerge as a truly weird, easy-listening soundtrack to warfare.

Russell seduces you into his slick buddy-movie plot, then absorbs you, via tumultuous action and wild comedy, in the moral questions the fellows must wrestle with as reality impinges on their caper. The movie stands as a reverberating capper to the Gulf War and an alarming prelude to the disastrous Iraq War. *Three Kings* is anything but a mindless action movie.

VII. Vintage Comedies

If the screen's Golden Age of Comedy was the silent era, where does that put those early, valiant filmmakers who tried to get laughs with *sound,* braving the new technology? They didn't get much help from the two greatest silent clowns, Charlie Chaplin and Buster Keaton, with the former daring to continue working without dialogue in *City Lights* (1931), and the latter sadly misused, and ultimately fired, by MGM. Logically, the joining of screen comedy and spoken dialogue included a spate of talk-filled adaptations of hit plays, resulting in some very stagy and claustrophobic films like *The Last of Mrs. Cheyney* (1929). The better of these stage-to-screeners, such as *Holiday* (1930) and *Private Lives* (1931), were able to transmit to moviegoers the exuberant spirits of their source material. With George Cukor's elegant *Dinner at Eight* (1933), the filmed Broadway play was solidified as a valued staple of literate screen comedy. Also emerging as a mainstay of the sound era were the European-set high comedies, typified by Ernst Lubitsch's divine *Trouble in Paradise* (1932), a form that flourished until World War II ended Europe's reign as the most chic place to set a sophisticated comedy. The early thirties also saw Frank Capra fine-tuning his brand of big-hearted, all-American comedy, which reached flawless fruition with his *It Happened One Night* (1934), the model romantic comedy from which hundreds of others stole freely. Spanning the first quarter-century of the sound era, the talking comedies included here celebrate the talented people, both directors and performers, who were among the most proficient in the art of getting laughs with dialogue. Some are legends—Spencer Tracy and Katharine Hepburn, directors Cukor, Capra, and Preston Sturges—but all of the following key artists—including those great character people, such as Frank Morgan, Guy Kibbee, and Franklin Pangborn—did their part in making those wondrous first twenty-five years of verbal comedy truly hilarious.

The Half Naked Truth (1932)
Lee Tracy and the Fast-Talking Talkie

One kind of 1930s comedy didn't last very long or become a source of ongoing imitation. I'll call it the comedy of merry insanity, which is different from the screwball comedies that dominated the second half of the decade and the first half of the 1940s. However nutty, screwball comedies revolve around reasonably recognizable issues of love, class, and bank accounts, while the merry-insanity comedies are far more anarchic, audacious, and eccentric, refusing to allow "real life" to rein them in. The two best, and most famous, of these would be *Million Dollar Legs* (1932) and *Duck Soup* (1933). Bordering on the surreal, each is set in a fictional country: the first in Klopstokia; the second in Freedonia. *Million Dollar Legs,* which revolves around the Olympics and features W.C. Fields and Jack Oakie, and *Duck Soup,* with all four Marx Brothers immersed in politics and war, are among the funniest movies ever made, partly because of their unwillingness to contain themselves. (The earliest Marx Brothers films, *The Cocoanuts* [1929] and *Animal Crackers* [1930], belong, instead, with the aforementioned stagebound adaptations.) *The Half Naked Truth* isn't as well known as these two classics, and it isn't set in a mythical land, but it does share their wackiness, nose-thumbing, and anything-goes surprises: it's adorable *and* ruthless. It's a comedy that can accommodate, among its pleasures, a hotel-room lion, a mock nudist colony, and a sham princess (complete with eunuch). It has the unbound visual freedom of a silent comedy, combined with the verbal dexterity and quickness of the new era, depending equally on these traits to get its laughs. And it really builds, consistently accelerating its zaniness and risk-taking, swooping the viewer along on its brassy, outrageous ride.

The Half Naked Truth was directed by Gregory La Cava, a major comic force of the 1930s, the man who would make *My Man Godfrey* (1936) and *Stage Door* (1937). His best films share a freewheeling looseness, a quality that goes a long way in preventing them from looking dated. His

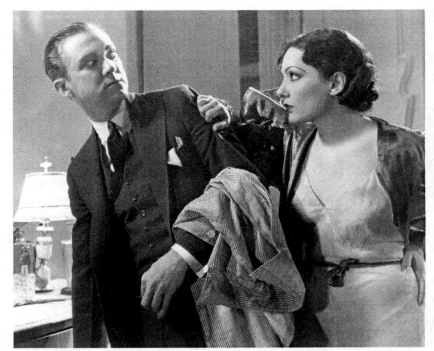

THE HALF NAKED TRUTH. Battling lovers Lee Tracy and Lupe Velez.

direction is so buoyant that his actors often appear to be making up their roles as they are carried along. *The Half Naked Truth,* his first terrific comedy, doesn't have legends like Fields or the Marxes at its center, but it does have a mini-legend in Lee Tracy, a barely remembered figure of early '30s comedy who is as quintessential a period type as Mae West. In 1928, Tracy made a commotion as one of the stars of the original New York production of *The Front Page,* the granddaddy of all the newspaper comedies—another soon-to-be prevailing type of "talking" comedy— that followed. (It was filmed in 1931, with Pat O'Brien in Tracy's role, but turned out better as *His Girl Friday* [1940], with Rosalind Russell giving the role a gender change.) The blond Tracy, slight and slender as a matchstick, may have looked insignificant but his barking nasality (often placed high) and snarling delivery made him formidable. Add to this his physical panache and the lightning-speed of his graceful, magician-like gestures. Tracy, as you would expect, usually played agents, columnists, and reporters, any cocky bamboozler with rapid speech and deadly powers of persuasion. Tracy's bag of tricks wasn't bottomless and sometimes, if given too much to do (as in *The Nuisance* [1933]), he could be tiresome;

a little Tracy goes a long way. In a vehicle as wonderful as this one, he may be the star but he isn't a one-man band. His fellow players are also swell, and he shines even brighter bouncing off their talents. With all of the main cast members assigned funny material of their own, the result is a super, balanced ensemble.

Carny man Jimmy Bates (Tracy), his hooch-dancer girlfriend, Teresita (Lupe Velez), and his sidekick, Achilles (Eugene Pallette), bolt from a small-town carnival (after one of their stunts brings in the police) and make their way to New York, or, as Jimmy calls it, "sap town." Jimmy is determined to make Teresita a star in one week, and his publicity-minded brain goes into overdrive. He declares her the Princess Exotica of Turkey, moves them into a luxurious hotel suite, and begins his assault on Merle Farrell (Frank Morgan), a Ziegfeld-like producer. The "princess" does become a star, but when she acts as if she doesn't need Jimmy anymore, he decides to destroy her and create another new star just as fast. (Careers rise and fall so quickly here; the movie's clock ticks to its own rhythm.)

The plot doesn't sound anywhere near as cracked as *Duck Soup,* does it? One of the many joys of this film is that it begins in a deceptively "normal" manner but gets screwier with each successive scene. And, of course, a key creative component of this film (and the few like it) was the permissiveness of a pre-Production Code Hollywood. (This is another reason why the "merry insanity" films didn't have much effect on the course of screen comedy; their sexual friskiness, so crucial to their frivolous abandon, would soon be exiled from the movies.) *The Half Naked Truth*—its title alone is a badge of pre-Code honor—is studded with sexual jokes, and without the Code's *taming* it lives on with every bit of the chutzpah with which it was imagined. The Code authorities would certainly have cut the priceless running gag in which Jimmy mischievously—and without ever saying the word—causes people to think that Achilles is an actual eunuch. This detail has nothing to do with the plan's success, but it amuses Jimmy, not to mention current viewers delighted to discover that such naughty wit once reigned in old movies.

Jimmy is always thinking ahead, always imagining the next stunt. He's one of those awful-behaving characters who is hard to dislike because he's so unstoppably good at what he does. With the carnival suffering—the fat girl is down to 112 lbs.—Jimmy knows that what's needed is "excitement, sensation, baloney." You could also say that

those are the things by which Jimmy lives and thrives. It's a sustained joyride to watch Tracy perform Jimmy's pitches because he's just about the most confident confidence man you're likely to come across, and victory is invariably his. These are "arias" of comic manipulation, full of flash and spit, neighs and whinnies. Nothing gets him more aroused than a crowd forming—a group of people to badger and cajole—and his biggest high is in knowing that he has put something over. There may have been a sucker born every minute, but Jimmy says, "The day I was born the clocks weren't running." When he, Teresita, and Achilles escape the carnival, amid an all-out riot, he steals a car and announces, "The next stop is Broadway!" (Theatrical flair he clearly possesses.) He relies equally on cagey machinations and impulsive intuitions, but the goal remains constant: "We're on our way to page one!" When the press descends upon their New York hotel room, he feigns woe, then resignation, very grandly. Not since Jolson had anyone gestured so flamboyantly to make a point. Perhaps it's no surprise that Tracy's screen heyday was brief; how long could a guy keep this up?

Mexican-born beauty Lupe Velez, who is now best remembered for being married to Johnny Weissmuller and for having committed suicide at thirty-six, is a real comic find here. The role is a cliché of a fiery Latina, but Velez *gets* laughs rather than being the victim of them. She's almost never called by her character name, but, rather, by stage names (La Belle Sultana in the carnival; Princess Exotica on Broadway), or, by Jimmy, as "the tamale." (Not only pre-Code, but pre-p.c., too.) You expect her merely to be the film's scantily clad window dressing, and, yes, she's often exposing flesh, but she turns out to be a genuine sparring partner for Tracy, verbally as well as physically. Since his rat-a-tat delivery and flying hands could intimidate anyone, it's gratifying to see an actress give as good as she gets. The characters' on-again/off-again romance, marked by screaming matches and spiteful acts, makes for combustible fun. Velez is a game sport, a short-fused firecracker, and one helluva hooch dancer. The highlights of her performance are her several renditions of a lewd, lowdown song about a carpenter. Velez isn't much of a singer or dancer, but she has got the moxie and the razzmatazz to put over a cheerfully suggestive number. The first time occurs in producer Farrell's office. As she sings to the imaginary carpenter to "bring your tools up here and begin, turn the knob and walk in," or tells him, "I have a big job for you," she jiggles around, swiveling her hips and smiling broadly. There's no doubt what she's singing about, but her good-hearted anima-

tion has a daffy innocence. This number wows them on Broadway, with Velez shaking her fringed hips while singing of her "*chiseling* carpenter." The movie stops to enjoy and celebrate this infectious, uninhibited burst of youthful freedom and racy desire, and the on-screen audience and Velez's spear-carrying extras are rightly carried away by it.

Frank Morgan, known to all as Oz's wizard, was one of the best things to happen to screen comedy in the 1930s, and his Merle Farrell is among his first great screen opportunities. Morgan had a knack for making characters lovable, not in *spite* of their flaws but *because* of them. He exposed their foolish foibles and humiliating humanity, but, however hopeless, these characters were trying hard. Farrell may be a big deal on Broadway, but, in Morgan's hands, he's endearingly befuddled, even when angrily taking out his insecurities on his underlings. Farrell is a high-maintenance "artist," usually overreacting, overdramatizing, and working himself into a frazzled state. In his first scene, a dance rehearsal, he rises from his seat, waving his cigarette holder and grouchily whining to his yes men about requiring a "yellow mood" for this number. But for all his orders, he's a pretty ineffectual guy, and Morgan is deft at making Farrell's big-deal grandeur and unsure demeanor one and the same. Morgan's dithery hysteria is a perfect foil for Tracy's steamrolling calculations.

Jimmy is ticked off when Teresita, now a success, makes it clear that she doesn't need him anymore; Farrell will handle her career (and romance her). Oh, Jimmy can accept her falling for another guy, but not her seeking "more refined publicity." ("I can hit myself on the chin and knock ten stars like you out of my beard!") He sets his sights on Ella (Shirley Chambers), a shapely, blond hotel maid with no talent. He stops dead when the notion strikes him, points to Ella accusingly, and then stalks her like prey. The film is now a vindictive *Pygmalion*. Jimmy's nudist-colony brainstorm, another surefire attention-getter, results in a deliriously kooky outdoor scene featuring extras that Jimmy has paid to dress like cave people and frolic like wood nymphs. The dim-witted Ella, with Lady Godiva tresses, meets the press, who obey Jimmy by averting their eyes. When, as "leader of the cult," she mistakenly gives her real name (rather than "Eve"), Jimmy chimes in to say that it's a "nickname meaning mother of a new race."

Jimmy secretly snaps a photograph at a moment when the married Farrell feeds an olive, from a toothpick in his mouth, to Teresita during a room-service dinner. This leads to the funniest scene in the movie,

set in Farrell's office after Jimmy has been fired. When Farrell picks up his phone, he notices, to his astonishment and horror, a tiny, circular print of Jimmy's snapshot fitted into the phone's mouthpiece. (He didn't even know that such an incriminating photograph existed.) Increasingly larger prints of the picture, most of them framed, continue to appear in unexpected places, spooking Farrell, who is eventually joined by Teresita. The scene is a model of pacing and restraint, with each revelation of yet another photograph perfectly timed and artfully rendered. Then Jimmy arrives, smilingly faking ignorance of this blackmail. As a token of friendship, he brings a gift: a very large, wrapped piece of artwork, and it's obvious what it must be. Just before he exits, Jimmy goes to the window and waves his handkerchief, cueing what will be the sequence's crowning laugh. It's the rare scene that can be described as both subtly refined and off-the-wall hilarious.

There's another gem of a comic sequence later, one that's utterly unlike the taunting photograph scene. Although both scenes deal with unpleasant confrontations with the truth, the subsequent scene is all in the mind. After Jimmy opens his own successful agency, he starts to miss Teresita and Achilles and their days of scrounging. The scene that follows, even though it's set in a typical city office, is one of fairy-tale imagination. Jimmy hears the noise of a power tool outside his window, and, suddenly, it seems to be vibrating the melody of Teresita's carpenter song. He closes the window. Then his secretary's typing appears to be pounding out the tune in a clicking staccato. He stops her. He sits down, rocking back and forth, and the squeak in his chair croaks out the song like a dying violin. He bolts from it. Finally, he can hear it in an office boy's light footsteps. He just can't get it (meaning *her*) out of his head. This sequence is very simple, yet transportingly magical and essential to the film's daft charm.

The Half Naked Truth, with a story by Ben Markson and H.N. Swanson, was written by La Cava and Corey Ford. The screenplay is a frenzy of comic inspiration, providing Tracy with a wealth of choice under-his-breath wisecracks. Feisty Lupe Velez would soon be relegated to the Bs, where she starred in a seven-picture series of *Mexican Spitfire* titles from 1939-43. Eugene Pallette, the "eunuch" Achilles, was Hollywood's foremost grumbling character man, and he would reunite famously with La Cava on *My Man Godfrey.* Pallette is also fondly recalled for two other ageless movies, *The Adventures of Robin Hood* (1938) and *The Lady Eve* (1941).

As for Frank Morgan, my enthusiasm for his work is ever increasing. Yes, he's a marvelous "character," but his range is often overlooked. His Farrell is a forerunner to his riotous work as another hapless philanderer in *The Good Fairy* (1935). And don't forget his heartfelt work as the mayor in *Hallelujah, I'm a Bum* (1933), his superb final scene (with a delivery boy) as the lonely shop owner in *The Shop Around the Corner* (1940), his "non-Aryan" professor, the anchoring force of *The Mortal Storm* (1940), his profoundly moving, full-bearded "Pirate" in the otherwise unbearable *Tortilla Flat* (1942), his deeply affecting, broken-down telegrapher in *The Human Comedy* (1943), and two 1949 film-stealing performances as gamblers, in *The Great Sinner* and *Any Number Can Play*. While a fixture of support in MGM's A releases, Morgan also starred in many B pictures for them, the best one probably the forgotten fantasy *The Cockeyed Miracle* (1946). He worked again with La Cava on *The Affairs of Cellini* (1934), which showcases one of his funniest performances (one that got him a Best Actor Oscar nomination) and also happens to be one of La Cava's happiest films.

Soon after his benchmark work in *The Half Naked Truth,* made for RKO, Tracy would move over to MGM where he appeared in five films, among them *Bombshell, Dinner at Eight,* and an interesting precursor of *Back to the Future* titled *Turn Back the Clock.* (All three came out in 1933.) It would be thirty years before Tracy repeated this kind of success when he got an Oscar nomination for his supporting role in *The Best Man* (1964), repeating his Broadway role of a former U.S. president and stealing the movie from a big-name cast led by Henry Fonda. When Tracy, near the end of *The Half Naked Truth,* takes a handful of sawdust and says, "Can you imagine that stuff going through your veins?" the picture seems to embrace every incurable participant in the lunatic business of "show."

Lady for a Day (1933)
In Defense of Capra Corn

When the peerless romantic comedy *It Happened One Night* swept the 1934 Academy Awards, its director, Frank Capra, had truly arrived. He would become one of the few directors of Hollywood's Golden Age—Cecil B. DeMille was another—that moviegoers were aware of, and his name on a picture actually meant something to them. Capra had been on the rise since the talkies began, and he was instrumental in making newcomer Barbara Stanwyck a star in his drama *Ladies of Leisure* (1930). The first real Capraesque comedy was the fetching *Platinum Blonde* (1931), something of a warm-up for the classic Capra comedies that followed. It's a movie that celebrates the values of ordinary folks, brands the wealthy as useless, and features a romance between a reporter and an heiress, three elements that would resurface in *It Happened One Night.* Its lead character, played by Robert Williams, is labeled a "Cinderella Man," and there's a scene in which he and a servant playfully echo their voices through a mansion's grand front hallway, two items repeated in Capra's sublime *Mr. Deeds Goes to Town* (1936). Not to mention the fact that the lead character's name in *Platinum Blonde* is "Mr. Smith," eight years before another Capra-directed Mr. Smith would go to Washington. Capra was honing his skills, discovering his strengths, and devising a technique all his own that resulted in some of the most charming, romantic, and affecting comedies ever made. He single-handedly turned his studio, Columbia, from "Poverty Row" to a major force in Hollywood.

Capra had actually hit it big the year before *It Happened One Night* with a comedy called *Lady for a Day.* Not only was it a huge hit, but it was also the first Capra film to be nominated in the Best Picture and Best Director Oscar categories. It's not as well remembered as the Capra comedies that followed it, primarily because it wasn't widely seen after it was remade, by Capra himself, as *Pocketful of Miracles* (1961), which turned out to be the director's final film. If you know the remake, then

LADY FOR A DAY. Skeptical Ned Sparks and superstitious Warren William consider May Robson's apples.

you know the plot. The chief difference is between that of a work by a director on his way up, full of energy and freshness, and a work by a director trying effortfully to recapture his former glory. *Pocketful of Miracles* weighs a ton, and it was miscast, too, with Glenn Ford and Bette Davis exhibiting noticeable strain in the leads. (Another crucial defect of the remake is that it's about forty-five minutes longer than the original film!) *Lady for a Day* is very much of its time (something else *Pocketful of Miracles* isn't), with its Depression-era flavor and its yearning for better days. It finds heart in a supposedly heartless city; it finds a fairy tale amid squalor. It's a consistently delightful movie, peopled by one of those casts abundantly blessed with great character people on hand to do their specialties.

Lady for a Day is based on Damon Runyon's short story *Madame La Gimp*. Capra and Runyon are an ideal match with their knack for balancing sentiment with humor and in their affection for underdogs. Runyon's surefire tale is prime fodder for Capra, and the meeting of material and director produces a disarming work full of feel-good

schmaltz and well-tossed wisecracks. It's unquestionably the best film ever made from a Runyon piece. Call it Capra-corn if you like, but it was made long before the uplift in the director's movies became mechanically obvious and more than a little smug (as in his *State of the Union* of 1948). *Lady for a Day*'s plot is a reworking of *Pygmalion,* that is if Eliza were a decrepit geriatric *and* a drunk. It's a "makeover" movie, made long before that concept became a cultural staple.

Apple Annie (May Robson), a broken-down old lady who makes her living peddling apples on the streets of New York, has a faithful friend in Dave the Dude (Warren William), a superstitious gambler-mobster who depends on Annie's apples as his good-luck charms. Annie's got a secret. About eighteen years ago, she had an illegitimate daughter and sent the baby (Louise) to Spain to be raised in a convent. Mother and daughter keep in touch, and Annie sends money, but she also lies to Louise about being Mrs. E. Worthington Manville, a made-up high-society matron. Annie receives a letter from the now-grown-up Louise (Jean Parker), informing her that she is coming to New York with a prospective fiancé and his father, Count Romero (Walter Connolly). Annie's terrified that her daughter's happiness will be destroyed when the truth about Annie is revealed. Dude and his gang come to the rescue, providing Annie with a swanky hotel apartment, fancy clothes, even a husband, in an attempt to put her over as a lady and be all that Louise is expecting. Technically, the picture should be called *Lady for a Week.*

Annie is a plum role, and May Robson plays it for all it's worth. Robson, like Lucile Watson, May Whitty, Ethel Barrymore, and many others, had been a stage actress for decades but will forever be suspended in time as an old woman thanks to the enduring work she did in the movies. (At seventy-five, Robson was too old to play the mother of an eighteen-year-old, but that's nitpicking.) According to his autobiography, Capra wanted Marie Dressler for the role. Sexagenarian Dressler was one of the biggest, and most unlikely, box-office stars of the day, so of course her studio, MGM, was keeping her for itself. As enjoyable as Dressler could be, she would have hurt this movie. Because she loved to mug for comic effect (and usually had one eye on the audience), she wouldn't have been as honest or believable in the role as Robson. Dressler also had a tendency to indulge in masochism and would therefore have overplayed Annie's more dramatic scenes to the point of *Madame X*-style melodrama. Robson is able to pull off both Annies, the pitiable hag *and* the great lady, with equal dexterity. There's an urgency in Robson's acting

whenever Annie is nervous or frightened; she never really lets go of the panic that her whole world might topple at any moment.

Annie is a feisty street figure, known to all and very well liked. Dressed like an unmade bed and with a rats' nest of gray hair, she may look like a witch, but she's more the fairy godmother type. Alone in her one-room dump, away from her panhandling cronies, Annie is a fragile, alcoholic wreck. She settles down to write her cherished Louise a letter (with stationery swiped for her from a ritzy hotel), setting the mood with elegant music spinning on her record player and a framed 8 X 10 of Louise set before her. Several belts of gin give her the courage to write (lie) about her whirlwind social season. It's a scene of stark loneliness, and though the situation is far-fetched, Robson locates the ongoing pain in Annie's life, temporarily eased by the haze of booze. When her hotel contact loses his job for trying to pocket a letter (Louise's to Annie), Annie goes into a tailspin. She dashes into the hotel lobby and makes her way to the front desk, determined to get her letter. A shock to the snooty staff and clientele, Annie asks for the letter addressed to "Mrs. E. Worthington Manville." This may be Robson's best scene, as Annie resorts to any tactic she can think of to get her letter: polite pleading, impatient indignation, heartbreaking begging. Then there's her sheer terror when she's told that the letter was sent back. When she sees the mail boy, she knocks the outgoing mail out of his hands and scrounges on the floor until she finds it. Annie gets her letter.

The news that Louise is coming—so that her proposed father-in-law can meet Annie before he gives his final consent—is a shock. In a cleanly directed scene, Capra has Robson read the letter while walking on a busy New York street, oblivious to the crowd. As the startling facts sink in, she slows to a dead stop, in contrast to the New Yorkers racing by her in both directions, a neat visual that emphasizes just how alone and power-less Annie is. She then rereads the unbelievable lines about Louise's visit and faints. Passersby do stop to help her up, and she quickly resumes her dread and returns to the hotel to beg the manager to inform the soon-arriving Louise that her mother is dead. Robson acts with unguarded desperation, completely immersed in Annie's plight. Later, when Dude comes to her flat, Annie's drunk. Robson plays the scene, in which Annie tells Dude the whole story, with a poignant, and sloshy, mix of laughter and tears. By helping Annie, Dude is insuring his future of lucky apples. A new fear grips Annie when a phalanx of make-up artists descend upon her after Dude has set her up in an enormous hotel apartment.

There's a gay reference when one of the make-up crew, a Frenchman, enters Annie's bedroom with all the women. Dude shouts, "He can't go in there." Missouri (Glenda Farrell), Dude's nightclub-owning tootsie, replies knowingly, "It's all right, Dude, it's all right." Haughtily, the man proceeds. Then Dude says, "Oh...*Pierre.*" (It's not what you'd call friendly, but at least movies of the loose pre-Code early 1930s acknowledged that gays existed.) The artists emerge hours later, exhausted by their task. In her new hairdo and stately, fur-trimmed gown, Annie has been transformed, and Robson makes it apparent that the change is interior as well. Being treated like a queen gives her a newfound grace and dignity. It's lovely when she approaches Dude and quietly says, "I'll never forget you for this, Dude. God bless you."

A source of nonstop pleasure is funnyman Ned Sparks as Dude's deadpan sidekick with the ironic moniker of "Happy." Sparks, who has bags under the bags under his eyes, is a real scene-stealer, rattling off choice wisecracks throughout the picture with a nasality not to be heard again until Walter Matthau hit the big screen. Happy is the voice of reason and the voice of doom, the character who wants Dude to get back to the business of making money and away from this do-gooding escapade. The movie would be too cheerful and much too nice without Sparks' snarky contribution. He often looks like he wants to gag on the whole prospect of putting friendship before finances and luck before reality. Fortunately, no one pays much attention to him. (Peter Falk received an Oscar nomination for this role in the remake. There were no supporting categories in 1933.) Conversely, "Judge" Blake, another of Dude's associates, becomes totally absorbed in Annie's venture. Blake is a pool hustler, but with a touch of class, so he's Dude's choice to impersonate Annie's "second" husband, Louise's stepfather, the illustrious E. Worthington Manville. As played by Guy Kibbee, Blake is a cunning scamp, an irredeemable rascal. Since he's a master con artist, he's a natural for this line of work. The surprising bonus is that he becomes an unfailing source of calming support and encouragement to Annie. The glee that Kibbee exhibits adds immensely to the fun, particularly in the scene where he craftily winds up playing billiards with the Count (the loser will pick up the tab for Louise's dowry). Kibbee is so affable that, by the end, you can't help hoping that Annie and Blake will make a stab at being a real couple (as they do in Runyon's story).

The arrival of Louise yields an unexpected depth of tenderness to the picture. As played by the unspoiled Jean Parker (who was unforgettable

as Beth in the same year's *Little Women*), Louise is no paper-cutout ingénue. Not only is the love that mother and daughter feel for each other plainly transparent, but their physical intimacy—hugging, kissing, fondling—highlights their awareness of all the years together of which they've been deprived. Even in their first moments (the reunion at the pier), their tears of joy feel earned; the actresses are radiant in each other's company. When Louise expresses worry over the Count's final decision on the marriage, Annie responds twice with, "Nothing's going to happen." Robson says this reassuringly but she also reads the lines as if they were a prayer aimed heavenward. Nothing must interfere with her girl's happiness. Toward the end, Annie speaks seriously to the Count. Wise, candid, self-possessed, and gently regal, Annie has truly become all the things that she has been pretending to be.

As Dave the Dude, spiffy-looking Warren William is adequate in a role in which Clark Gable would have been terrific. William was a bargain-basement version of John Barrymore, best remembered for his Julius Caesar in DeMille's *Cleopatra* (1934), the one starring Claudette Colbert. By protecting Annie, Dude is safeguarding his luck, but he, too, gives in to the fun of the make-believe situation, the con that keeps getting more elaborate. (He kidnaps three reporters who get nosy about the unknown Mrs. Manville.) He's introduced to Louise as her "Uncle David." A high point of William's performance is the scene in which he coaches his mugs and Missouri's chorines on how to play society folks for the reception in the Count's honor. (Blake asks, "Now, is there any reason why Louie the Lug couldn't be the ambassador to Turkey?") In this "rehearsal," William gets to satirize a harried stage director, like Warner Baxter in *42ⁿᵈ Street* or James Cagney in *Footlight Parade,* with his tie loosened and his impatience mounting. His "cast" is never going to be able to deliver the performance he needs from them. They may be lousy, but they, too, get into the spirit of it. Teamwork is the overriding principle driving *Lady for a Day.* With the cops getting wise, it doesn't look like the crew will be able to get to Annie's reception without being tailed. If no one shows, the jig may be up. The clock is ticking, with the count, his son, and Louise set to sail back to Spain at midnight. (The "midnight" factor heightens the film's fairy-tale quotient.) *Lady for a Day* builds steadily into a very suspenseful comedy.

Another treasure of the supporting cast is Halliwell Hobbes as Annie's butler. One of Hollywood's supreme players of English butlers, Hobbes had already played one for Capra in, you guessed it, *Platinum*

Blonde. Hobbes is dry perfection when he renders Ned Sparks speechless with, "If I had choice of weapons with you, Sir, I'd choose grammar." Walter Connolly is decidedly un-Continental as the Spanish count, but Capra rewarded his valiant effort with the much better role of Claudette Colbert's father in *It Happened One Night.* (As Carlos, the Count's son, Barry Norton rates a zero.) Also on hand is Samuel S. Hinds, as the mayor, thirteen years before he played James Stewart's dad in Capra's *It's a Wonderful Life.* And Glenda Farrell, the good-hearted floozie of many a Warner Brothers programmer, is indeed welcome as Missouri, the been-around glamour-puss. (Hope Lange was no competition in the remake.)

Lady for a Day also got Oscar nominations for May Robson as Best Actress and for Robert Riskin's gangbusters screenplay. (Riskin and Capra were frequent collaborators.) Robson, who, incidentally, played the Matron in the 1927 silent version of *Chicago,* is best remembered for her supporting roles in *A Star Is Born* (1937), *Bringing Up Baby* (1938), and *Four Daughters* (1938). *Lady for a Day* was defeated in the Academy's picture and director categories by *Cavalcade* and its director Frank Lloyd. (There were ten Best Picture Oscar nominees that year and, wouldn't you know it, *Cavalcade* is by far the worst of them.) Joseph Walker, Capra's favorite cameraman, was the cinematographer on *Lady for a Day.* Walker repeated an effect he had used on *Platinum Blonde:* Louise and Carlos are filmed kissing behind a fountain—essentially a flower-framed sheet of glass with water cascading down—as if they were underwater. It's a dreamy, vibrating distortion of the lovers, and it's as extraordinarily beautiful as it had been two years before.

In Runyon's story, Madame La Gimp (the "Annie" character) is Spanish, which explains the Spanish connection retained for the film. La Gimp, who sells newspapers and flowers, has nothing to do with apples, lucky or otherwise. There's a reception in the story, but the climax of *Lady for a Day* is pure Capra, a blissful, magically right finale, perfectly timed and most satisfying. At the fade-out, you may be thinking, "Now what?" but for the moment all is right with the world.

It Started with Eve (1941)
When Quasimodo Met Cinderella

The comedy classics of the second half of the 1930s, screwball gems like *Nothing Sacred* (1937), romantic beguilers like *Ninotchka* (1939), and a humanistic heart-warmer like *Mr. Deeds Goes to Town* (1936), belong to an extraordinarily laugh-abundant heyday for the genre that continued into the new decade with masterworks like *His Girl Friday* (1940) and *The Philadelphia Story* (1940). Alongside these highs are many other comedies that, though they never attained classic status or enduring popularity, are delightful additions to the era's output and deserve mention when this shining period is evoked: *The Good Fairy* (1935), a Preston Sturges-scripted charmer starring a radiant Margaret Sullavan; *Theodora Goes Wild* (1936), a madcap riot that turned drama queen Irene Dunne into a comedy sensation; *Libeled Lady* (1936), a brash newspaper comedy featuring not only William Powell and Myrna Loy, but also Spencer Tracy and Jean Harlow; *Midnight* (1939), a Continental romp in which Claudette Colbert and John Barrymore join forces; *Bachelor Mother* (1939), a Cinderella tale pairing working-girl Ginger Rogers and rich-boy David Niven; *The Talk of the Town* (1942), a Capra-influenced social comedy with the solid-gold triumvirate of Cary Grant, Jean Arthur, and Ronald Colman.

One of the least regarded of these peripheral comic winners is Universal's *It Started with Eve,* a box-office hit given little respect. Best known for *Dracula* (1931) and *Frankenstein* (1931), Universal was rescued from its financial woes of the mid 1930s when producer Joe Pasternak, director Henry Koster, and plucky teen soprano Deanna Durbin collaborated on *Three Smart Girls* (1936), thus beginning this trio's well-attended series of frothy musicals. Not only a smash hit, *Three Smart Girls* was a Best Picture Oscar nominee. It helped that Durbin—whose singing voice was clear and mature rather than shrill—was girl-next-door pretty and had a nonchalant flair for comedy. *It Started with Eve* was the sixth and final (and best) picture for the Pasternak-Koster-

IT STARTED WITH EVE. Charles Laughton being charmed by Deanna Durbin.

Durbin combo and, though it features three songs, it's not a musical. Durbin was by now a young woman of nineteen, and the studio was hoping that the adult Durbin could sell as many tickets as the pubescent Durbin. *It Started with Eve* brought smiles and made money, surely, but it turned out to be a real sleeper. Aided immensely by the casting of esteemed Charles Laughton, it's a smartly scripted, flawlessly cast, and enchantingly played comedy that continues to deliver enormous pleasure to those who discover it.

As elderly tycoon Jonathan Reynolds (Laughton) lays dying, his son, Johnny (Robert Cummings), tries to fulfill the old man's final wish: to meet Johnny's brand-new fiancée, Gloria (Margaret Tallichet, the real-life Mrs. William Wyler). With Gloria unavailable, and the clock ticking, Johnny grabs the first girl he sees, Anne Terry (Durbin), a coat-check girl and aspiring singer, and pleads with her to play his fiancée for an hour. The pretense is a success, and Johnny pays Anne fifty dollars, but there's a slight hitch: Jonathan doesn't die. In fact, he wakes the next morning invigorated and wants nothing more than to spend time with "Gloria." Dr. Harvey (Walter Catlett) tells Johnny that the truth

of Anne's identity could cause a fatal shock for Jonathan. So, Johnny must track down Anne, who is using her fifty dollars for train fare out of New York and away from her failed vocal career. The hoax must be sustained until Jonathan is well enough to handle the truth.

With an original story by Hans Kraly (who adapted *The Student Prince* for the screen in 1927), *It Started with Eve* was written by Norman Krasna and Leo Townsend. Krasna may never have become a household name yet he had considerable impact on American comedy of the last seven decades. A master at mistaken-identity plots, Krasna's influence is still on view today in the better situation comedies. With hit plays like *Dear Ruth* (1944) and *Sunday in New York* (1961), and screenplays for *Bachelor Mother, The Devil and Miss Jones* (1941), and his Oscar-winning *Princess O'Rourke* (1943), Krasna proved himself a consummate craftsman of comic structure and logic. The plot of *It Started with Eve* is meticulously fashioned; it may sound silly and absurd yet everything that happens in it has a moment-to-moment believability. The characters make the soundest choices within the options open to them; the script never pushes them to make stupid "funny" choices. Yes, we ask comedies to take us on a ride, but if a script violates the truth inside its premise, however outlandish, an audience will resist (and stop laughing). Even in the glory days of the '30s and '40s, there were dozens of labored comedies, movies that copied winning formulas but resulted in forced, witless, and irritating affairs, fundamentally misunderstanding and sidestepping the vital, inherent plausibility of the movies being pilfered. Just because *The Bride Came C.O.D.* (1941) had a spoiled heiress, that didn't make it another *It Happened One Night* (1934), nor did the marital shenanigans of *The Feminine Touch* (1941) guarantee merriment to equal *The Awful Truth* (1937). The plot of *It Started with Eve* is certainly improbable, but Krasna and Townsend crafted it so expertly that we can accept everything that happens in it and gladly be whisked away.

As Anne, Durbin is comfortably cast—it is, after all, a vehicle for her. The movie doesn't strain to put her over as an adult; Anne is a capable young woman supporting herself in the big city while pursuing her dream. The only reminder of Durbin's schoolgirl persona is her disgusted reaction to a sip of alcohol, late in the film. *It Started with Eve* came at the tail end of pre-war Hollywood's fondness for a zany and helpless privileged class. Naturally, what the wealthy Jonathan and Johnny want (and need) in their lives is the enlivening presence of a

hearty, hardworking poor girl. The film offered viewers the vicarious satisfaction of watching a have-not ingénue find her rightful place in a world of splendor. Durbin's fresh, easily confident screen presence benefited the film immeasurably, and she wisely didn't try to compete with the more energized antics of Cummings and Laughton.

This was the third pairing of Durbin and Cummings (after 1939's *Three Smart Girls Grow Up* and 1940's *Spring Parade*). Her grounded nature was nicely complemented by his flightier on-screen tendencies. Though never Cary Grant, or even Ray Milland or Fred MacMurray, Cummings was a skilled light comedian. His weakness was his lack of sex appeal—a real detriment in romantic comedy—which meant that he fared better with girl-women like Durbin than he did with more mature ladies like Jean Arthur and Olivia de Havilland. Perennially a juvenile, Cummings had a genial, animated spirit and—when his Johnny is stammering and flustered—he reminds me of the young Bob Hope. Cummings gets all his laughs here; his work is polished and thoroughly professional.

The surprise is the casting of the great Charles Laughton in a Deanna Durbin movie, especially when you consider that his most recent movie roles had been Quasimodo in *The Hunchback of Notre Dame* (1939) and Italian-accented Tony in *They Knew What They Wanted* (1940). To his credit, Laughton didn't treat Jonathan as a take-the-money-and-run gig. Instead of playing down to the movie's light-comic sweetness, he brought all his resources to the party and appears to be having a grand time. Though audiences knew him best for his Oscar-winning title role in *The Private Life of Henry VIII* (1933) and his Captain Bligh in *Mutiny on the Bounty* (1935), they were also familiar with his inventive comic abilities thanks to *Ruggles of Red Gap* (1935) and the British-made beauty *The Beachcomber* (1938). Still, his participation in a comedy as sprightly as *It Started with Eve* must have looked to many like slumming. It may in fact be slumming, but that doesn't lessen the pleasures of his performance.

As Jonathan, Laughton is playing considerably older than the forty-one he was at the time. With whitened hair, eyebrows, and mustache, a doddering gait, and hopelessly ill-fitting costumes that stress the sixty pounds the character lost during his illness, Laughton's Jonathan is a fine addition to the actor's gallery of chameleon makeovers. As a sickly man who gets sprier with each successive scene, Laughton exhibits his joy of performing. He revels in big gestures, exaggerated facial reac-

tions, and speech inflected with gasps, sputters, and bellows. Yet he's equally in command of subtler strokes, with under-the-breath line readings, warmth emanating from his eyes, and a foxy capacity for manipulation. With Laughton you get theatricality but also the refined technique to wield that showmanship to optimum effect. (On that score, his Jonathan is not dissimilar to his Henry VIII, Bligh, or Quasimodo.) Occasionally, his effects pander—his climactic Conga on a nightclub dance floor, featuring high kicks, raised arms, and excited squeals, courts cheap laughs. Even so, I'm a sucker for Laughton's prankishness, the wink in his performance. Once Jonathan learns the truth about Anne's identity—and doesn't let anyone know that he knows—the film shifts its point of view. Up to now, son Johnny was running the show, sustaining the charade and keeping the real Gloria out of sight, but hereafter it's Jonathan pulling the strings, doing whatever he must to ensure that Johnny ends up with Anne, which requires his role as fragile senior citizen. The affection that Laughton displays for Durbin anchors the movie and is the sturdy underlying constant beneath the farce. The surprising, affectionate chemistry between the shameless Laughton and the unaffected Durbin, who by all accounts got along famously, resulted in their being reteamed in the lesser *Because of Him* (1946).

Johnny meets Anne in a hotel lobby. He's frantically searching for Gloria when Anne asks him if she can check his coat. Preoccupied, he moves on. Instead of following him and the main action, the camera stays on Anne at work, establishing her as someone feeling the crunch of hard times. When she and Johnny meet again soon after—outside the hotel in pouring rain—she's not the stranger to us that she still is to him. He pleads so rapidly that before she knows it she's accepted his offer of fifty dollars to be Gloria for the next hour. It's a refreshing touch that when Johnny remembers to pay Anne the fifty dollars for a job well done, she takes it. She can't afford not to.

The Jonathan who wakes the next morning is not the gentle grand-fatherly type of last night's deathbed. Has he been given new life by the warming presence of his daughter-to-be? After expressing gladness at seeing him alive, Cummings registers the confounding fix Johnny's in after Laughton casually utters, "Where's Gloria?" In truth, she's headed for a train that will return her to Ohio. Johnny's thoughtful, humane gesture, securing his father a happy death, has backfired. Laughton emerges a bit like the title character in *The Man Who Came to Dinner*, irascible and impatient with those who won't give him his own way, with

a special contempt for nurses (one of whom is played by Clara Blandick, *The Wizard of Oz*'s Auntie Em). Such trouble with dedicated nurses predates his memorable sparring with real-life wife Elsa Lanchester in *Witness for the Prosecution* (1957). It's Jonathan's flaky doctor (Walter Catlett, an alarming dead ringer for Dick Cheney) who insists that the truth might kill the old man, which allows the ruse to continue with sensible justification. This permits the romantic leads to satisfy their subconscious desire to be near each other. The Laughton-Durbin bond is cemented quickly; we have to wait for the Cummings-Durbin bond to catch up.

Similarly to the way the Veronica Lake character in *Sullivan's Travels* (1941) wants to meet Ernst Lubitsch so she can become a star, Durbin's Anne wants to sing for Leopold Stokowski, who just happens to be a friend of Jonathan. This leads to the three vocal selections sung by Durbin, all of which are performed seated at a piano. The filmmakers gave Durbin's fans the expected vocalizing without having to turn a comedy into a musical. In "When I Sing" (bland lyrics assigned to a familiar Tchaikovsky waltz), she trills for Jonathan, proving the necessary plot point that she has talent enough to be seen by Stokowski. (Stokowski doesn't materialize, but he did appear with Durbin in *One Hundred Men and a Girl,* a 1937 Best Picture Oscar nominee.) Her song is also responsible for healing Jonathan further, raising him from his sickbed once and for all.

After Jonathan plans a party in which Anne can sing for Stokowski, Johnny decides he can end this make-believe by telling his father that she has broken up with him, a scheme to which Anne seemingly agrees. Here's another challenge for the writers to find a plausible way to continue the Anne-as-Gloria complication. Following the dinner scene in which Cummings explains the break-up, barely containing his glee, in walks Durbin dramatically begging to be forgiven. No insipid ingénue, she knows that the party is her big chance and she's too ambitious to sacrifice it. The exuberant fight between Cummings and Durbin that ensues—pinching, biting, tickling, chasing—makes plain their characters' attraction for each other. (This is the scene in which Jonathan overhears the truth but decides not to let anyone know he has.) She eventually sits at the piano and sings "Clavelitos," an upbeat Spanish ditty, and as she sings Cummings' smile reveals that Johnny is seeing her for the first time. His silent ardor gives this musical interlude a subtext—the moment in which he falls in love—and it's amplified by

Laughton's astute awareness of what's happening, strengthening his character's resolve to unite Johnny and Anne. No mere diversion, the song is a backdrop for a scene in which the two male characters make important discoveries.

Anne feels guilty over her selfish behavior and tries to tell Jonathan the truth. Again, we have a legitimate reason to end the mix-up but it's too soon to end the movie, so what's a screenwriter to do? Well, now it's Jonathan who wants the lie maintained so that Anne and Johnny can spend more time together. Feigning fragility, he prevents her from speaking, stressing the fact that the least excitement could be fatal. So, writers Krasna and Townsend keep the plot credibly airborne. Later, Anne and Johnny, sharing concern for Jonathan, have their first real, relaxed conversation sitting on the steps of one of the curved twin grand staircases on the film's elaborate mansion interior. They talk of "him" liking her and her liking "him," then realize that "him" means Johnny as well as Jonathan. Johnny moves to sit at the bottom of the other grand staircase, but they're still distracted by each other; they turn their faces to avoid eye contact. Their attraction is charmingly unavoidable. Durbin's third song, Dvorak's "Going Home," appears in what could be the final scene between Anne and Jonathan, set in her modest apartment. She sings at his request. He knows the song will affect her—she wants to stay with Johnny rather than return to Ohio—and it also allows him time to mastermind his final moves. Frail as a freight train, he unstoppably forges his way toward the happy fade-out.

It Started with Eve is a brisk fairy tale, and director Henry Koster afforded it his breezy touch. The cinematographer was the first-class Rudolph Maté, who would soon turn to directing films (a high spot being his 1950 Alan Ladd western *Branded*). It's unfortunate that this bright picture is saddled with one of those dumb, meaningless titles so often attached to romantic comedies. Perhaps the film would be better known if Ginger Rogers and Cary Grant had played the young couple, yet the youth and naiveté of Durbin and Cummings are just right. Universal would soon try to glamorize Durbin in inappropriate vehicles like *Christmas Holiday* (1944) and *Lady on a Train* (1945), and she made her last film in 1948. She married director Charles David and retired to France, where she lives to this day. Cummings' asexual screen presence made him an increasingly featherweight leading man, as in his two Hitchcock thrillers, *Saboteur* (1942) and *Dial M for Murder* (1954). Even in his best film, the dark melodrama *Kings Row* (1942), he can't

quite subdue the gee-whiz of his acting style. Laughton would take on other showy comic roles in, among others, *The Canterville Ghost* (1944) and *Hobson's Choice* (1954).

Koster directed other feel-good charmers, such as *The Bishop's Wife* (1947) and *Come to the Stable* (1949), then later made *The Robe* (1953), the film whose only claim to fame is that it introduced CinemaScope. He also directed Laughton in another comically grand performance in "The Cop and the Anthem," the winning opener of the five-episode anthology *O. Henry's Full House* (1952), overall a very mixed bag, in which Laughton, as a homeless man bent on getting arrested and jailed for the winter months, is the incontestable standout of an all-star cast. Pasternak moved to MGM and made mostly musicals, among them quite a few starring either Kathryn Grayson, Jane Powell, or Ann Blyth, three young sopranos whose careers were indebted to the Deanna Durbin prototype. *It Started with Eve* was miserably remade in 1964 with Maurice Chevalier in Laughton's role and, in a case of gender reversal, Sandra Dee in Cummings' role and Robert Goulet in Durbin's role. It was titled *I'd Rather Be Rich,* but you'd rather be sedated than endure it.

Hail the Conquering Hero (1944)
Screwball Comedy's Last Triumphant Gasp

With the end of the Depression and the start of World War II, gone were most of the Hollywood comedies about frivolously extravagant Park Avenue dwellers. Modesty became the order of the day. Despite occasional first-rate pictures like *The Major and the Minor* (1942) and *The More the Merrier* (1943), in which you were more likely to find leading men in uniform rather than tuxedoes, screen comedy seemed headed for a decline in quality, a decline decisively averted by the emergence at Paramount of writer-director Preston Sturges, the genre's leading force from 1941-1944. His reign was brief, but he left behind five indisputable comic treasures.

Sturges was a busy screenwriter throughout the 1930s, and his credits include such winsome winners as *Thirty-Day Princess* (1934), *Easy Living* (1937), and the exquisite *Good Fairy* (1935). Then came *Remember the Night* (1940), the best of Sturges' scripts to be directed by someone (the estimable Mitchell Leisen) other than himself. It blended comedy and drama deftly and is one of the best American films to be perennially overlooked. The chance for Sturges to direct his own work came with *The Great McGinty* (1940), for which he won his only Oscar (Best Original Screenplay), and *Christmas in July* (1940). Both are minor works that now look like warm-ups for the major works to follow. If folks presumed that screwball comedy was dead, Sturges silenced the doomsayers with *The Lady Eve* (1941) and *The Palm Beach Story* (1942), two films that pitted have-not women in pursuit of rich guys' dough, only to be undone by the nagging inconvenience of true love. Barbara Stanwyck, in the former (opposite Henry Fonda), and Claudette Colbert, in the latter (opposite Joel McCrea), are not only gloriously funny and witty but neither has ever been sexier. The Stanwyck-Fonda and Colbert-McCrea teamings rank among the more tinglingly erotic couplings of the era, seemingly unconstrained by the watchful eye of the Production Code. The slapstick pratfalls, the knowing cynicism,

HAIL THE CONQUERING HERO. Sad sack Eddie Bracken with relentless guardian angel William Demarest.

and the sexual longing reinvigorated screwball comedy, and rarely had it sparkled as brightly in the past. In between these two beauties, Sturges made the comedy-drama *Sullivan's Travels* (1941), his foray into Capra territory, which starred McCrea as a big-shot comedy director determined to go "serious" but who gets more than he bargained for. Anchored by McCrea's superb underplaying, *Sullivan's Travels* is arguably Sturges' greatest film.

As the war continued, screen content was increasingly informed by it. Sturges, forgoing the glamorous trappings of the rich and would-be rich, brought his screwball sensibility to small-town America and made two farces that dealt directly with the home front. *The Miracle of Morgan's Creek* (1944) is about a young woman (Betty Hutton) who goes to a soldiers' send-off party only to find herself married and pregnant with no memory of who her husband is. Instead of hunks Fonda or McCrea, Sturges' new leading man was nerdy Eddie Bracken, playing a stuttering milquetoast who sees spots every time he attempts a war physical and, therefore, remains miserably stateside. Even better is

Sturges' *Hail the Conquering Hero,* again starring Bracken, who gives the best, most rounded performance of his career. It would be the final triumph of Sturges' too-hot-not-to-cool-down career, and it's the least known and revered of his big five. (Is it because sex doesn't figure into it very much?) It's short on physical slapstick, though its plot is every bit as deliriously convoluted and anarchic as anything Sturges ever concocted. *Hail the Conquering Hero* both celebrates and good-naturedly pokes fun at American conventions, ideals, and values.

Woodrow Lafayette Pershing Truesmith (Bracken), the son of a decorated WWI hero who died on the day of Woodrow's birth, has been working in a San Francisco shipyard for a year because he's too ashamed to reveal the truth—that he was discharged from the marines (after just one month) because of chronic hay fever—to his mother (Georgia Caine) and hometown of Oakridge, CA. In a nightclub, he meets six marines who have just begun a five-day leave that has been hampered by the loss of all their money in a crap game. Led by Sgt. Julius Heffelfinger (William Demarest), the marines take Woodrow under their wing, pronounce him "wounded and honorably discharged," and drag him home to Oakridge. Woodrow is overwhelmed by the elaborate hero's welcome that meets his train, which sets the stage for snowballing lies about his overseas exploits, lies that are perpetuated by Heffelfinger and the other marines, who enjoy giving the people the "hero" they seem to crave. But Woodrow fumes, expecting at any moment to be found out. Instead, he's soon asked to run for mayor! Even if it means the humiliation he has taken such pains to avoid, Woodrow is determined to put an end to this travesty.

The movie begins at an atmospheric nightspot with a live band. A pretty girl performs a tap routine in a satiny sailor costume. There's a good turnout of servicemen and civilians who have the business-as-usual look of regulars. But way off, isolated at the end of the bar, sits Woodrow, firmly established by Sturges as an odd man out. Boyish Eddie Bracken, best remembered for broad physical comedy and an animated presence (as in *Morgan's Creek*), was Paramount's answer to MGM's Mickey Rooney, though decidedly less "cute." There's nothing sprightly about Bracken here. His Woodrow is instantly sympathetic as he wallows in heartbreaking shame; he's a sad sack with an unexpected introspective nature. Woodrow's plight is never merely a comic situation, thanks to the smarts and feeling driving Bracken's performance. Despite his crushing disappointment, Woodrow feels nothing but awe

for the marines; he even sends over beer and sandwiches to the marine sextet when he overhears their order of a single beer. They join him at the bar to say thanks, and off we go. It turns out that Heffelfinger knew Woodrow's father in France, and so he feels a fatherly attachment to the young man. The specter of the senior Truesmith, including his Congressional Medal of Honor, has shaped Woodrow's dreams since childhood. His love for the marines is expressed in a monologue, a recitation of all the battles fought by the corps since 1775. Sturges conveys Woodrow's yearning to be part of his father's legacy, and the devastation of his own failure, simply by having Bracken ardently rattle off battle sites in chronological order. (It sounds corny but it makes plain the extent of Woodrow's obsession with following in daddy's footsteps.) Bugsy (Freddie Steele), the orphaned marine with a mother fixation, hears that Woodrow has lied to his mother by pretending to be overseas. Bugsy telephones her, without permission, and announces her son's safe return. Before he knows it, Woodrow is in uniform and on an Oakridge-bound train with his new pals.

Bracken plays Woodrow in a foul, snappish mood for most of the rest of the movie. Whether literally kicking and screaming, or just seething with fear and anger, Bracken doesn't play for easy laughs, informing his work with Woodrow's sustained inability to tolerate all of the deceit that accompanies his return. Home is the place he wants to avoid, the place where his failure is most pronounced. The six marines, who have nothing better to do (and no money to do it with), operate as his personal band of fairy godfathers, even though Woodrow can't see any good in their mission. There's also the Libby (Ella Raines) situation. She's Woodrow's girl, the one he dumped by mail in order to protect her from his disgrace. She still loves him, even though she's now engaged to Forrest Noble (Bill Edwards), the mayor's son, a tall, good-looking but dullish young man, another victim of chronic hay fever.

The scene of Woodrow's arrival in Oakridge is a chance for Sturges to lampoon the various types involved in producing such a spectacle of supposed communal spirit: the self-absorbed mayor; the wretched Shirley Temple clone; a foreign-accented diva with attitude; and assorted members of competing marching bands. Best of all is the overdramatizing chairman of the reception committee, played by none other than Franklin Pangborn, the key portrayer of prissily effeminate, highly strung fellows in films of the '30s and '40s. The stress of directing this extravaganza soon has him operatically reaching for his handkerchief

and patting his perspiring forehead. He blows his whistle to no avail, and nearly has a breakdown because of the incompetence and apathy surrounding him. Pangborn was often cast as a sissy stereotype, but he was nonetheless very funny, and a worthwhile reminder that every community has its "artistic" men.

Oakridge is revived by their new hero, feeling good about itself and proud to show it. Woodrow feels the burden on his conscience, but it seems that the truth would only get in the way of everybody's good time. *Hail the Conquering Hero* addresses the need for heroes, whether or not the hero wants any part of it, even if he isn't a hero at all. (Remember the Iraq War's Jessica Lynch?) The town can't wait to fall over itself honoring Woodrow: they burn up his mother's mortgage; they plan a monument featuring both Woodrow and his father; they decide to place Woodrow on the ballot for mayor. Each of these actions leaves Woodrow aghast, but his negative reactions are dismissed as remnants of his jungle fever, and his self-deprecation is interpreted as modesty.

In their desire to show their appreciation to Woodrow, Oakridge gets considerable help from Heppelfinger. As played by William Demarest, the master of growling sarcasm, Heffelfinger propels the movie. Demarest appears in all five of Sturges' classics, making him one of the intrinsic components of a Sturges comedy, and Heffelfinger is the best part he ever got. (Demarest appeared in *The Jazz Singer, Mr. Smith Goes to Washington*, got an Oscar nomination for *The Jolson Story*, but nothing he ever did comes close to his association with Sturges.) Yes, Demarest was terrific as the irascible Mr. Kockenlocker in *Morgan's Creek*, but Heffelfinger is an even better part, a fast-talking, faster-thinking character tailor-made for an actor incapable of missing a beat. Demarest and Bracken argue through most of the movie, providing some head-spinning exchanges in which Heffelfinger makes light of the ever-expanding lies that Woodrow will eventually have to answer for. Underlying all the shenanigans is the sense that Heffelfinger knows that Woodrow deserves all the good that he is getting because he's capable of being a hero at home (even if he can't quite see it yet). Heffelfinger wants to see this kid in a position where he can truly be his father's son. He's making it all up as he goes along, but Demarest never shows signs of strain. Everything rolls off of him, and there's no such thing as backing him into a corner. The rapid-fire delivery, the used-car-salesman hucksterism, and the cranky charm with which Demarest attacks his role inspires boundless confidence. It's a crash-

course in comic steamrolling. Whenever he's on-screen, get out of his way or be trampled.

Mayor Noble (Raymond Walburn), representing the cynical, ambitious side of Oakridge, is the one with the most to lose as Woodrow's popularity balloons. Returning heroes threaten his set-up as the town's big shot. Raspy-voiced Walburn (who stole Sturges' *Christmas in July*) is an exasperated delight; Noble doesn't get along with, or seem to like, anyone. He's either all riled up (arguing with his son) or snidely snippy (putting down his wife). He bumblingly refers to "Guadalcanal" as "Guadalupe," and "foxholes" as "wolfholes." He's the butt of sarcasm from his political aide (Al Bridge), who is always telling him to save his voice (meaning "shut up"). A highlight of Walburn's wily performance is the scene in which he's told, first by his son and then by Libby, that he can't say "both humility, satisfaction, and gratitude" in a speech he's preparing. It's not easy to tell this self-centered, pompous man anything he doesn't want to hear.

Libby has been putting off telling Woodrow of her impending marriage, even though there's no reason to believe it will bother him. It's nice to watch an on-screen romance between Eddie Bracken, who is decidedly offbeat, and Ella Raines, quite believable as the prettiest girl in town. It's a sweet, surprising pairing. Libby doesn't know that Woodrow still loves her and wants only to spare her his humiliation. His relief at her romance with Forrest breaks her heart. Raines may personify the girl to come home to, but she was a distinctly limited actress. Sturges uses her very effectively, though; her comely woodenness works as a playing style. She establishes a rhythm—rapid but low-key—and her callow quality is ultimately winning. The film has plenty of huge comic talents, so Raines' lack of polish is welcome. Bill Edwards, as her fiancé, is even less skillful, and Sturges gives him and Raines a long scene, shot in one unbroken take, of nonstop dialogue as they walk several streets discussing their relationship. By picking up their cues, and avoiding pauses, they bring the scene off rather well, a nice break from the mayhem. (It shows that with dialogue this snappy, sometimes all you really have to do is get the words out.) Sturges' penchant for long takes makes sense because that way nothing can interfere with the timing of the dialogue.

It's not just Heffelfinger that Woodrow is up against. Bugsy becomes very attached to Mrs. Truesmith, and he can't understand how Woodrow could have stayed away from her and allowed her to worry about him

when he was safely in Frisco. Bugsy can only see Woodrow as unappreciative of his good fortune. On the train, he asks, "Does your mother put up preserves?" Of course, she does, which only feeds Bugsy's fantasy of mothers. This big tough marine is mush in her maternal presence. Mrs. Truesmith is devoted to the memory of her late husband—the living-room shrine she has erected is shockingly elaborate—and rarely is she far from her pancake griddle. The film wrings amusement from Bugsy's obsessive idealization of every aspect of Woodrow's mother and the home she has created.

Woodrow's mood lightens when he thinks he has figured a way out, one in which he can leave without the truth being exposed. He still can't see that he's needed at home, that he can do good from right there in Oakridge, and that his marine buddies want to see that what they're fighting for really exists. From here to the end, Bracken gives a straightforward, heartfelt performance as Woodrow finds his courage and becomes an adult. The film moves toward its heady ending, similar in spirit to the end of *Sullivan's Travels* because it's touching, and the rightness of it supersedes the sentimentality, meaning that the lump in the throat feels earned. The picture is gentle and frenzied, tender and boisterous, innocent and savvy, and it revels in home, family, patriotism, and romance while tweaking them, too. It's an optimistic movie that embraces small-town America without feeling old-fashioned or stale. The 1940s seem very much alive, suspended in time, in Preston Sturges' movies.

With *Morgan's Creek* and this movie, Sturges tapped into the national mood and created two wacky what-ifs for the people at home. They're both so canny and resonant that they feel like films that were made with the hindsight of the post-war era, so clear-eyed is Sturges' vision. He caught what was happening *as* it was happening, and was able to make rowdy, provocative comedies without being disrespectful or glib. In *Hail the Conquering Hero,* the marines are heroes on the war front *and* the home front.

The Sturges stock company—Raymond Walburn, Al Bridge, Franklin Pangborn, Esther Howard (the mayor's wife), Harry Hayden (the mayor's chief opponent), Jimmy Conlin (the judge)—does not consist of household names but each and every one is familiar on sight to those who love old movies. Two more—Georgia Caine and Elizabeth Patterson (as Libby's aunt)—had been seen to advantage in the Sturges-scripted *Remember the Night.* Another incidental joy here is Paul Porcasi, the

nightclub manager of the opening scene. His monologue, in which he recounts all the crap pawned off on him as valuable war mementoes (in lieu of money) by short-of-cash soldiers, all the while pulling said items from his assorted pockets (as if performing a magic act), is just one of the elements that gets this wonderful movie off to a grand start.

Hail the Conquering Hero came in second for the New York Film Critics' citation for the year's best film (losing to *Going My Way*). Sturges received Oscar nominations in the Best Original Screenplay category for both of his 1944 comedies, but he cancelled himself out, allowing the long-winded *Wilson* (featuring a different Woodrow) to take the prize. I find it easy to hail this movie and its writer-director as unabashedly as Oakridge hailed the returning Woodrow.

Pat and Mike (1952)
Tracy and Hepburn and Gender Equality

I n recalling the unparalleled chemistry that ignited the on-screen
partnership of Spencer Tracy and Katharine Hepburn, it's easy to
overlook the fact that their nine films together are a very mixed
bunch. The same is true of other legendary teams, such as Fred Astaire
and Ginger Rogers, William Powell and Myrna Loy, and Alan Ladd and
Veronica Lake. Their reputations are built on the best of their work, with
their lesser output (which outnumbers the good) conveniently blocked
out. Admittedly, the pleasure of a great team's company can withstand
below-par vehicles. In Tracy and Hepburn's case, only two of their nine
pictures are worthy of their skill and charisma: *Adam's Rib* (1949) and
Pat and Mike, both produced by Lawrence Weingarten for MGM, both
directed by George Cukor, and both written by Garson Kanin and Ruth
Gordon. Clearly, this was the group to assemble to bring out the best in
the stars' collaboration; the other seven pictures didn't find comparable
associates. Tracy and Hepburn were first paired in *Woman of the Year*
(1942), a critical and commercial success directed by George Stevens,
in which the duo's spark is immediate and irrefutable (and was never
so sexy again). It's heaven to watch Tracy's "regular" sportswriter and
Hepburn's renowned journalist flirt and fall in love, but far less fun
after they wed because of the movie's disapproval of women who put
careers ahead of domesticity. As the script turns against Hepburn's
character, the movie starts to curdle, replacing its funny bone with an
indictment of her emotional deficiencies (before her climactic attempt
at making her husband a waffle breakfast, a classic sequence that I've
never found remotely funny). *Woman of the Year*—the title is ironic—
belongs to a sub-genre of boss-lady comedies (often starring Rosalind
Russell), the kind of finger-wagging flick in which the heroine must
diminish herself to land a man. *Pat and Mike*, made ten years later, is
a refreshing reversal: instead of Tracy's Mike trying to put Hepburn's
Pat in her place, he helps her to fulfill her potential and become a top

PAT AND MIKE. Teamwork doesn't get any better than Spencer Tracy and Katharine Hepburn.

professional athlete. The film celebrates Pat's accomplishments, and, blessedly, Mike never tries to *tame* her. This isn't to imply that *Pat and Mike* is a winner because of political correctness, but its point of view does set it apart from most films of its era.

The outstanding George Cukor-directed screen comedies can be categorized into two groups: his sophisticated and snazzy theatre-based

romps of the 1930s and early '40s, such as *Dinner at Eight* (1933), *Holiday* (1938), *The Women* (1939), *The Philadelphia Story* (1940), and an occasional misfire like *Susan and God* (1940); and his visually modest, middle-class charmers of the late '40s and early '50s, such as *Adam's Rib, Born Yesterday* (1950), *The Model and the Marriage Broker* (1951), *Pat and Mike,* and *It Should Happen to You* (1954). Tales of the rich had been supplanted by those of more ordinary folks, though the later characters could be just as scintillatingly smart as their predecessors. Cukor's attention to the details and facets of comic characters made him a great director of comic performances, and he guided quite a few ingeniously funny, career-transforming turns, among them Jean Harlow in *Dinner at Eight,* Rosalind Russell in *The Women,* and Judy Holliday in *Adam's Rib.* For Tracy and Hepburn, he kept things very simple, getting out of their way and allowing their own rhythms to shape their scenes. With his actors free to be subtle and spontaneous, Cukor seems to sit back in awed satisfaction.

Pat and Mike has an unusually modern premise for a 1950s romantic comedy, examining the psychological barriers that prevent people from achieving their goals. (*Adam's Rib,* better known than *Pat and Mike,* covers more conventional turf: it's a classic battle-of-the-sexes comedy.) *Pat and Mike* is every bit as good-spirited and timeless as *Woman of the Year* is unfair and old-fashioned. Made with an all-pervasive air of effortlessness, and clearly an inexpensive production, *Pat and Mike* can unjustly be dismissed as slight or minor. It has no scenes of sidesplitting hilarity and its pace isn't rapid-fire. It's the kind of comedy that provokes a long, sustained smile because everything about it is so right. No garden-variety romantic comedy, in either plot or character, it's about hooking up with the person who helps you be your best self.

Hepburn's four pictures with Cary Grant, beginning with Cukor's *Sylvia Scarlett* (1936), had already made her part of a glorious team at a youthful stage of her career. She and Grant related in an energized, impetuous way, but, with Tracy, Hepburn found the ideal match for her maturity. (Once she co-starred with Tracy she never worked with Grant again.) In place of the Grant-accompanied heiresses of *Bringing Up Baby* (1938), *Holiday,* and *The Philadelphia Story,* came the more focused, serious-minded women of the Tracy films. Like Powell and Loy, Tracy and Hepburn connected in a way that allowed for every bit of their smarts to come into play, finding a teammate who appreciated (and deserved) what each had to offer. They could maneuver a scene by

interrupting each other or talking at the same time, but their intuitive timing made certain that their counterpoint duets were always uncannily synchronized. In the time in which Tracy and Hepburn were both at MGM (1940-1952), Hepburn's non-Tracy films for the studio, aside from the career-resurrecting *Philadelphia Story*, are terrible and her casting atrocious: a Chinese peasant in *Dragon Seed* (1944); an unconvincing "victim" in *Undercurrent* (1946); and self-sacrificing Clara Schumann in *Song of Love* (1947), which put her stiffly in Greer Garson biopic-weeper territory. Tracy's non-Hepburn vehicles of this period, especially *The Seventh Cross* (1944) and *Father of the Bride* (1950), fared much better.

Pat Pemberton, a physical-education teacher at California's Pacific Technical College, is engaged to Collier Weld (William Ching), a school administrator. Pat is a gifted athlete, but she's unable to perform well if Collier is present because of his confidence-shattering lack of belief in her. At the Women's National golf championship, Pat meets Mike Conovan, a shady manager-promoter who asks her to take a dive (for profit); she's appalled. Mike respects her integrity (and talent) and gives her his card. Under Collier's debilitating gaze, Pat loses the match. She bolts from California and shows up at Mike's New York office. With his guidance, she's a success in nationwide competitions, particularly on tennis courts. As elegant Pat and lowbrow Mike start to fall for each other, Pat moves closer to severing her jinxing relationship with Collier.

The movie offers many splendid glimpses of the lithe Hepburn in physical action, sending golf balls soaring and back-handing tennis balls, but it's in capturing Pat's confounding insecurity and her pretense of romantic happiness that Hepburn really scores. It's obvious that Collier is a creep when he tells her that he doesn't want her to wear pants. ("Slacks," she corrects him.) Anyone that doesn't want to see our Kate—fashion plate that she is—in her trend-setting attire obviously can't appreciate her. It's appropriately disconcerting to watch Hepburn behave so accommodatingly. Pat is miserable; she's sort of a decade-later peek at those beaten-down independent women of '40s comedies and how they may have ended up. Since Hepburn's persona was that of a fearless woman, it's excruciating to watch Pat choke under pressure. Collier's doubts in her give rise to her own doubts about her capabilities. It's an unhealthy relationship, particularly since Collier seems to take unacknowledged pleasure in keeping Pat in a humbled

position. Hepburn is very sympathetic in playing Pat's powerlessness to do anything about her predicament, even though Pat is unquestionably fed up with Collier. The actress locates the baffling frustration of being able to identify a problem without having the slightest notion of how to fix it, credibly fusing anger, self-pity, and weariness. (When asked what her golf handicap is, she replies, "My fella.") But her Pat is never a limp noodle because she has the inner resolve to overcome her demons. After her humiliating loss at the Women's National, she boards a train with Collier, feeling very much a loser. Hepburn acts this key scene with her trademark interweaving of laughter and tears, but also with the firm spine of someone who will not run from her troubles. Even with the sporadic wobblings of confusion in Pat, Hepburn plays her with a through-line of underlying determination. It's that wavering between low self-esteem and nervy pluck that makes Pat vividly three-dimensional. Just as the train starts to move, and after an insensitive comment by Collier, she impulsively slides her suitcases out the window. As Hepburn boldly voices Pat's need to prove her worth, she, without missing a beat, asks Collier to lend her some money, then immediately resumes her declaration of independence and climbs off the back of the train. The combination of strength and vulnerability is irresistible.

Hepburn plays straight man to Tracy, who, it must be said, owns this movie. Even more so than in *Woman of the Year,* the distance their characters have to travel to come together is indeed vast. Again, she's a well-bred, accomplished woman, but he's not exactly an ordinary Joe here. Mike is a real "character," something out of Damon Runyon, almost an anachronistic spoof of crooked yet good-hearted Broadway types. The role is unlike anything Tracy ever did, and he appears to be having a hoot of a time. (It's a major triumph for his low-key comic genius.) The king of underplayers, Tracy gives one of his broader performances yet he's still every bit as sharp and sly as you would expect when it comes to getting laughs. It's a wonderful transformation because he filters the usual Tracy charm and savvy through a New York wiseguy accent, bad grammar ("can't even speak left-handed English"), a fast-talking off-the-cuff line delivery, and a small-time mobster's shrewdness. Decked out in suits with dark shirts and light ties, he seems one step away from *Guys and Dolls.* The Kanin-Gordon dialogue affords him a distinctive verbal expressiveness, and Tracy wittily makes the most of this lowbrow poetry. After his first encounter with Hepburn, in which he tries to talk her into deliberately coming in second at the final, he says of her,

"A real honest face…only disgusting thing about her." Speaking to her of Davie Hucko (Aldo Ray), his boxing client, he says, "Heavyweight champeen of the world…in a couple of years." Memorably, he says of Pat, "Not much meat on her, but what's there is cherce."

Cukor's camera unobtrusively observes the major Tracy-Hepburn scenes; he'll not allow anything to disturb or distract his stars. When Hepburn—Pat is now Mike's client—attempts to light her cigarette in Lindy's restaurant, Tracy looks at her as if she sprouted two heads. This prompts a discussion of how Mike will, to Pat's horror, be watching her every move. At this point the characters still seem to be from different galaxies, though the seeds of his belief in her have been planted, and she is markedly more relaxed since leaving California. Much later, on their travels, the first amorous rumblings surface, though by now they are certainly good friends. Mike stalls saying good night, but Pat humorously deflects him by bringing up her strict manager's warning against her fraternizing with men. As they talk about manager Mike as if he were a third person, Tracy and Hepburn turn this little one-take scene into one of peerless charm, discreet sexiness, and playful ease; they seem to be making it up as they go along. It makes you wonder if Tracy and Hepburn worked everything out meticulously, down to every "uh" and every smile, or if they winged it and trusted themselves to make it happen "in the moment." Either way, it's miraculous. The affection between them deepens with each successive scene, and their facial expressions increasingly register that friendship is blossoming into love. After a romance is at last triggered between them, Tracy says, "The whole gizmo, it's hard to believe." I know what he means: on the surface, neither Pat and Mike nor Spence and Kate appear to be ideal matches, yet the resulting "gizmo" is flat-out extraordinary.

Pat has her most public faltering when she and Mike return to California for a tennis match. She plays beautifully until Collier's late arrival in the stands. It's agonizing to watch Hepburn become klutzy and flustered; Collier's appearance sends Pat back to square one. (Every time he re-enters the picture you will cringe.) For a film this unostentatious, this sequence is something of a showstopper. As her playing becomes more labored and desperate, the scene turns into Pat's waking nightmare: the net rises when Pat hits the ball; every face she sees is Collier's, and he's always laughing at her; her racket becomes tiny while her opponent's becomes huge; she moves in slow-motion while her opponent maintains normal speed. This is a cleverly amusing yet

heartbreaking expression of exactly what Pat is experiencing as the game gets away from her.

The non-athletic climax of the picture comes when two of Mike's crooked cronies, Hank (Charles Bronson, then still Charles *Buchinski*) and Spec (George Mathews), are displeased that Pat won't promise to *lose* her second Women's National golf match. Outside a restaurant, Hank and Spec corner Mike and start getting rough. Pat intervenes. Quite easily—by pulling Hank's pant legs out from under him, karate-chopping Spec and removing his glasses, snatching Hank's blackjack and bopping him on the head with it—Pat beats them up. Mike is mortified. Hepburn is at her most nonchalant and matter of fact, a breezy terminator. In the subsequent jail scene (with Chuck Connors making his screen debut as the police captain), Hepburn is delectable, employing her most ladylike Bryn Mawr manners to explain and display how she "disengaged" the attackers (who remain fearful of her), graciously apologizing to them, yet her demonstration inflicts more pain. Tracy is equally funny as Mike tries to save face and lessen his embarrassment, though a casual push from Hepburn sends him crashing into a stool. The lovely offshoot of the scene is that Mike's seriously bruised ego isn't *permanently* bruised. (This is the moment where it could turn into *Woman of the Year*.) Mike is angry, but, hey, he gets over it. Pat doesn't have to pay for protecting him from bodily harm, though she tries to give him a boost by screaming for his help—even though she doesn't need it—in a later scene. It makes him feel good, even though he proves to be useless. Tracy valiantly tries to imitate Hepburn's previous brute-force moves to no avail. Mike is no he-man, but he's heroic in helping Pat find her confidence. And Pat gives Mike faith in his managerial abilities, enough so that he can cut out the "fixes."

Kanin and Gordon tailored their script astutely to their stars' strengths, but they also nudged them into fresh places, providing Tracy with a stretch of a role that resulted in one of his funnier (and more off-beat) performances, and showcasing Hepburn's physical agility (though she does have an athletic double in long shots). The dialogue is first-rate, but the screenplay, centered as it is on an honest psychological block, transcends the mere (though wondrous) volleying of snappy sentences by two seasoned pros and becomes the occasion for an unpretentiously thoughtful comedy. The writing duo received an Oscar nomination for Best Story and Screenplay (they also got one for *Adam's Rib*). Adding to the story's verisimilitude are the appearances of a host of real-life

athletes playing themselves, most notably Babe Didrikson Zaharias. Another priceless ingredient is Aldo Ray, whose performance as the sweet, dopey boxer Davie is lovably childlike and goofily comical. He's especially ingratiating when he's feeling discarded by Mike, who is suddenly favoring Pat. Then Davie and Pat bond, and, in a way, she does for Davie's confidence what Mike does for hers. This pleasing scene is somewhat marred by advice to "lick yourself" and "lick myself," phrases that no longer play as innocently as they once did. The movie features a background score by the estimable David Raksin, who wrote scores for *The Bad and the Beautiful* and *Carrie* that same year. Is it just me, or do these three scores, complementing wildly dissimilar movies, sound oddly alike?

This was Tracy's fourth of five movies with Cukor, the last being *The Actress* (1953), an overlooked comedy-drama in which a radiant Jean Simmons plays the young Ruth Gordon, and Tracy plays her irascible but loving dad (superbly). For Hepburn, this was her eighth and final Cukor feature; she made her film debut under his tutelage in *A Bill of Divorcement* (1932) and attained a resounding triumph as Jo in his *Little Women* (1933).

Now to the other Tracy-Hepburn films: *Keeper of the Flame* (1942) is a deadly, unconvincing mystery (directed by Cukor) posing as a war-themed prestige picture; *Without Love* (1945), the least of their comedies, is a tepid, dismissible affair; *The Sea of Grass* (1947), inarguably their worst picture, is a dreary, driveling melodrama, and never have the stars seemed so drained of life; Frank Capra's *State of the Union* (1948) is smug, patriotic hokum disguised as serious drama; *Desk Set* (1957) gave the team a few good opportunities for comic sparring, but the movie is only mildly pleasant and rather stagy; *Guess Who's Coming to Dinner* (1967) operates, without apology, on the audience's accumulated affection for twenty-five comfy years of "Tracy and Hepburn," which trumps the movie's hot-button (and self-congratulatory) story line. (Co-star Sidney Poitier is awkwardly billed *between* them.)

I never believed that Tracy and Hepburn's off-screen relationship was the great romance that Hollywood mythmakers, including Hepburn herself, touted it as being. Their personal lives are beside the point. Anything you really need to know about their special connection is right there in *Pat and Mike,* "cherce" as ever.

VIII. Life and Times in America

T he films included here tell personal, sometimes intimate, stories set against the larger backgrounds of noted times in our nation's history and growth, dramatizing the following: the chaos surrounding young men trying to steer clear of the distant Civil War; post-Civil War America finding its way, exemplified by the fortitude of a typical small town; post-WWI disillusionment from a war hero; a Depression-era tale of the Deep South; and more disillusionment, this time post-WWII, from a visionary inventor. Be they problem pictures or message pictures or prestige pictures, each constructs a very specific America, without which their stories could not live on-screen as fully realized as they so painstakingly are.

I Am a Fugitive from a Chain Gang (1932)
Warner Brothers and Social Concern

A t the dawn of the talkies, Warner Brothers quickly established itself as the studio with a social conscience, specializing in uncompromising, realistic films about contemporary ills. The success of Edward G. Robinson in *Little Caesar* (1930) and James Cagney in *The Public Enemy* (1931) not only created iconic stars but made the gangster genre essential to the studio's signature. Since the strictures of the Production Code were not yet being enforced, Warners' early '30s crime output retains a ruthlessness that can still stun us, especially people who think of old movies as merely escapist merriment. The studio took their interest in national conditions beyond the realm of mobsters, tackling tabloid journalism (*Five Star Final* [1931]), homeless youth (*Wild Boys of the Road* [1933]), and labor (*Black Fury* [1935]). Warners' *I Am a Fugitive from a Chain Gang* is a blistering exposé of the brutality of chain-gang punishment and a pointed criticism of America's forgetful treatment of its war veterans. Enormously profitable and highly praised in its day, *I Am a Fugitive* is still a sensational, startlingly powerful movie, directed by Mervyn LeRoy (who made *Little Caesar*) and anchored by a performance from nearly forgotten Paul Muni that gives credence to his once-hallowed reputation.

Muni was among the Broadway actors wooed by Hollywood when talkies arrived. He got an Oscar nomination for his first film, *The Valiant* (1929), and had his first major hit with Howard Hawks' *Scarface* (1932), the Muni film most highly regarded today. Hawks' fictionalized account of Al Capone is a merciless gangster classic (even though it was released by United Artists rather than Warners), but a feral, exciting Muni goes well over the top, complete with forced mamma-mia accent. Muni began his association with Warners on *I Am a Fugitive,* though he would become best known as king of their biopics, following in the tradition of George Arliss, another stage star who became a popular Warners screen star. Often billed with "Mr." preceding his name, Arliss

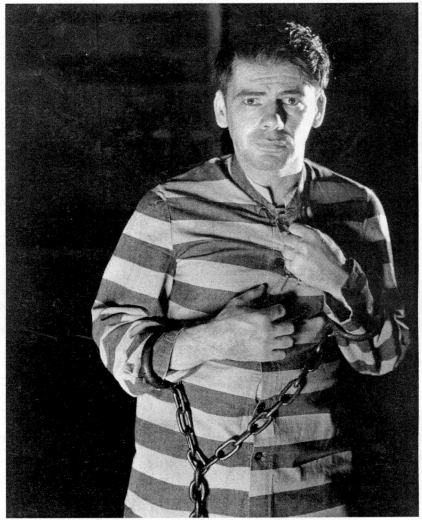

I Am A Fugitive From A Chain Gang. Paul Muni is a man trapped.

was always Arliss—arch, self-conscious, and sly—whether he was play-ing Disraeli, Voltaire, or Alexander Hamilton. Muni inherited Arliss' mantle as the studio's most prestigious commodity, with three biopics that shrewdly distilled weighty subjects into commercial fare by adding dollops of romance, melodrama, and sentiment. Beginning with his Oscar-winning title role in *The Story of Louis Pasteur* (1936)—a film that seems aimed at adolescents with science homework—Muni enacted historical figures to wide acclaim and surprising box-office receipts.

Next came title roles in *The Life of Emile Zola,* 1937's Best Picture Oscar winner, and *Juarez* (1939), in which he looks like a squat Frankenstein's Monster (and is just about as dead).

With his penchant for accents, wigs, beards, and age makeup, Muni exemplified "great acting" in the 1930s, always trying to disappear inside his characters. But who today wouldn't rather watch his more effortless-seeming contemporaries, ageless personality-driven actors like Clark Gable and Cary Grant? Muni's career is cautionary: times change, and one era's celebrated acting can later look as phony and overemphatic as much of Muni's now does. His commitment resonates through his movies, yet you can too often see the machinery behind his effects. The only Muni performance that can still stake a claim to greatness is to be found in *I Am a Fugitive.* Without any gimmicks or disguises, Muni gave one of the more stinging and moving screen performances of the decade, as close to naturalism as he ever got. He's every bit as good as he was always touted as being: Mr. Paul Muni, indeed.

James Allen (Muni), a decorated World War I soldier, returns home eager to do big things, specifically begin a career in construction. Traveling the nation, he finds opportunities hard to come by. After accidentally getting mixed up in a holdup, James is sent to a chain gang with a ten-year sentence. He manages to escape the misery within his first year and soon rises in the construction business. Despite his marriage to Marie (Glenda Farrell), a blackmailing tart who knows his secret, James becomes a prominent Chicago citizen. When Marie reveals his identity to the cops, James accepts an offer to return to the chain gang with the assurance of a pardon after ninety days. All he wants is to get back to his work and his new love, Helen (Helen Vinson), as quickly as possible.

Similarly to *The Best Years of Our Lives* (1946), *I Am a Fugitive* addresses the practical and emotional difficulties facing soldiers on their return to civilian life. Stateside Americans can't know what the servicemen have been through and are impatient with them to get back to being their old selves. Muni begins the film with uncontainable optimism and eagerness, free from the restrictions of the military and raring to build a new life, literally, in construction. His mother and brother can't see why he isn't grateful that his old boss has saved his shoe-factory job for him, but James resists a routine life, bolting from a desk job complete with a window whose panes look like jail bars. Muni plays James as a man with an aching yearning for his time in the war to have meant

something, informing how he lives the rest of his life. Muni's restlessness drives the film, and his sense of isolation from post-war America is saddening. He just wants to fulfill his potential—he's smart, brave, and hardworking—yet a scarcity of employment leads to his doom. The film's cruelest irony is that James, who has already "been through hell," will wind up on a chain gang, a roundabout result of his conviction to *avoid* a stifling existence. He's a post-war Everyman, and this film bemoans the squandering of America's precious resources, relegating someone as vital as James to oblivion. Also, on a purely dramatic level, the story is a frightening warning about the possibly calamitous uncertainties attached to a life that defies conformity.

As James scours the country for work, there's a scene in which he tries to pawn his war medal, only to have it refused; the pawnbroker has dozens of WWI medals. This is a simple, eloquent way to make a devastating comment on our country's short memories regarding its gratitude to war heroes. Yet Muni still suggests a man who prefers a hand-to-mouth freedom to the numbing stability he left behind. By now in the South, he and a flophouse mate, Pete (Preston Foster), go to a diner for a handout. It's not just the sight of burgers topped with onions that lights up Muni's face, it's also the seductive sizzle of meat on the grill. Pete pulls out a gun and forces James to take the money (a measly five dollars) from the cash register. This pivotal sequence, which includes the arrival of the cops and James' arrest, is set to the sound of that sizzling beef, a symbol of the gratification and pleasure within James' reach that is not to be his. A judge's pounding gavel dissolves into a hammer securing the shackles on James' ankles. In just seventeen minutes of screen time, we have seen James, the buoyant doughboy, sent back to hell.

The details of life on a chain gang are depicted unsparingly. James is pushed off his cot by a guard, who then throws a chain in his face. In stunned amazement, Muni covers his face with his hand, shudders his head and body, then peeks above his hand almost in disbelief. It's a shockingly effective moment for James to realize the extent of the sadistic brutality to which he will be subjected, which includes his being punched by another guard for wiping the sweat off his brow without permission. After he's overheard calling the warden a skunk, two guards whip off his shirt and walk him from his bed to be lashed. Like the accompaniment of that frying burger, this time the dominant sounds are the clinking of Muni's chains and the screams of the man

being beaten ahead of him. James' flogging happens off-screen, but the snaps of the strap making contact with his skin are audible. Muni doesn't make a sound, having steeled himself in the preceding moments, while the camera tracks the assorted reactions—admiration, concern, enjoyment, sleep—of the other inmates. And who can forget Muni's disgusted reaction to the chow? Rarely has a reaction been as convincingly nauseating as Muni's expression at the taste of his meal of grease, fried dough, pig fat, and sorghum. And it isn't just James that we see abused; an unidentified prisoner is seen chained to a cross, an image all the more upsetting for not even being referred to by anyone, implying just how commonplace a sight it must be.

"Hang it on the limb" is the jargon for escape. After six months, James has a plan, employing all the ingenuity and determination that the post-war James was saving up for his career. Muni's James cannot live cooped up, shielded from all he was meant for, and he *will* find a way out. He asks Sebastian (Everett Brown), a massive prisoner, to bang and bend his shackles with a sledgehammer so he can slip his feet out of them. The scene makes you wince with unimagined pain, another of the film's visuals that singes into your brain. (Brown later played Big Sam in *Gone With the Wind*.) Mervyn LeRoy directs the escape superbly, building slowly then exploding into a series of chain reactions and a breathless chase. The tension is immediate: James takes a bathroom break in the bushes yet can't slip one of his feet out of its shackle (even though he has already had a practice run in bed), finally doing so by spitting on his heel. With his shoes back on, he bolts into the woods. Again, sound plays a significant part in the sequence's overall impact: the rustling of leaves and branches as Muni races by; gunshots fired and an alarm blaring; the percussive yapping of frantic bloodhounds. There's also the lushness of Sol Polito's masterful black-and-white photography, as sunlight dapples the darkness of this forest chase, flashing shards of brightness onto Muni and his hunters. The scene climaxes once Muni gets to water. He breaks off a reed, blows air through it, and then uses it as a breathing device once he submerges himself. The underwater shots of Muni, inhaling through his ingenious tube and sitting on the muddy floor, are mesmerizingly languid, a dreamy contrast to the fraught suspense, especially when a guard is unknowingly a few feet away from him.

After he buys a cheap suit, James goes to a barbershop, resulting in a quiet time-bomb of a scene. As James is being shaved, a cop enters and

talks about the convict on the loose. For Muni, it's a prime opportunity to act solely with his eyes, which register varying degrees of fear as he listens intently to the cop's description of him. A hot towel makes his face disappear temporarily. When the barber removes the towel, swivels the chair around and lifts James up, LeRoy films the moment as a big fat close-up, springing Muni into the camera and presumably into recognition by the cop. The cop takes no notice, and the barber then asks, "How was it? Close enough?" When Muni replies, "Plenty," it's a welcome bit of leavening humor. The next morning he's at the train station, eating hamburgers (the long-awaited fulfillment of that fateful day) at a stand when the cops show. About to board his train, he hears, "There he is!" and jumps on as the cops pass him in pursuit of a vagrant. The tautness in LeRoy's direction and Muni's acting never lags; uncertainty and paranoia are a permanent part of James' subsequent life. He makes it to Chicago and begins his ascent, changing his name none too cleverly from James Allen to Allen James, studying hard, and rising from laborer to field superintendent. Ironically, he accomplishes all he set out to when he returned from the war. What isn't ironic is that he builds roads and bridges "for people to use when they want to get away from things."

Three women figure in James' post-escape life, beginning with Linda (Noel Francis), a slinky, available blonde he meets on his first night of freedom. Muni at first seems too distracted for dames, but then relaxes enough to take in her slim body (the camera travels down from her face to her shoes) and it's as though James is remembering what it is to feel desire. The screen soon fades to black. Then there's Marie, the flirty blonde from whom he rents a room and begins a casual affair. With her hands affixed to her hips, Glenda Farrell is awfully good as Marie, a bad girl intent on getting all she can out of him. Though Muni carries a sense of achievement in James' success, he's mired in a deep-seated melancholy, having married Marie to keep her quiet about his past. His gloom isn't lifted until he meets ladylike Helen and falls in love. Though the relationship isn't portrayed with any depth—actress Helen Vinson was better at playing elegant bitches than perfect mates—it provokes James to call Marie's bluff.

Among the film's moments of Muni being confronted with stupefying twists of fate, none is stronger than the one in which James faces two detectives who arrive at his large office to arrest him. Thus begins negotiations between Illinois and the unnamed state that wants him

back despite his having made good. If he returns voluntarily, and serves ninety days in a clerical job, the state will pardon him. His ache for a clean slate for his future with Helen has him agree to their terms. To see him back on the chain gang, back in the filth, is especially jolting *after* the scenes of his big-business status. As new difficulties emerge, Muni seethes with an intensity bordering on madness, with line readings fired from deep in his guts. There's a thrilling, climactic action sequence, featuring a dynamited bridge, followed by an epilogue of whispered force and fathomless blackness. The film ends suddenly with a memorable last line, hands down one of the more unshakably haunting finishes of any Hollywood movie.

Based on Robert E. Burns' autobiographical *I Am a Fugitive from a Georgia Chain Gang!* the film diplomatically chose only to indicate that its chain gang was somewhere in the South. Burns, who was a consultant on the movie, had made his post-escape success in magazine publishing rather than construction. With a script by Howard J. Green and Brown Holmes, the film caused enough of a sensation that it was said to have been instrumental in effecting real-life reforms. Much of the film's anxiety derives from James' innocence, and one wonders if an indictment of the system as scathing as this one could have aroused the same feelings if it were about a guilty man instead of a victim. The movie would be more challenging if the down-and-out James had been the one to pull the gun at the diner. His innocence augments our need to see him freed, to see wrongs righted, and it also scares us into believing that such a thing could happen to us. If it had been made after the Production Code went into effect, the movie would have probably made placating assurances about the overall fairness and goodness of America's judicial and penal systems. As it stands, LeRoy's film operates without concessions to sentimentality, optimism, or blind patriotism. Times had surely changed when LeRoy was back at Warners to make the child-murderess melodrama *The Bad Seed* (1956), a film so fearful of disturbing its audience that it was ruinously compromised (though it is an all-time camp classic).

I Am a Fugitive from a Chain Gang won Oscar nominations for picture, actor, and sound. Muni and LeRoy made two more films together, *The World Changes* (1933), a facile, underdrawn epic that stampedes from 1856 to the Depression, with Muni unlikely starting off as a fair-haired farm boy with a hick accent, and *Hi, Nellie!* (1934), a mildly amusing newspaper comedy-mystery with Muni lighter-spirited than

usual but still no Cagney. After the Code became watchdog, Warners' social-concern series declined, the last two major examples being the white-supremacist drama *Black Legion* (1937) and LeRoy's own *They Won't Forget* (1937), which attacked the press, politics, and mob mentality. The studio's gangster pictures became more clichéd and romanticized. Though smashing entertainments, *Angels with Dirty Faces* (1938) and *The Roaring Twenties* (1939) are unlikely to give you nightmares the way the ending of *The Public Enemy* still might. *I Am a Fugitive,* too, with its downbeat grit, still strikes a blow. If you want to see Paul Muni at his relentlessly hammy worst, seek out *A Song to Remember* (1945), but if you want him to send shivers down your spine, spend ninety-three minutes with James Allen.

Stars in My Crown (1950)
An Appreciation of Small-Town America

S ome exceptional movies are so gentle, and achieve their effects so delicately, that the mere act of recommending them almost feels like a disservice to their charms. Can such movies bear the weight of high expectations? I fear overpraising MGM's *Stars in My Crown* because of its simplicity and modesty, two elements that make it a convincing and winning piece of period Americana. After all, it doesn't have a big pay-off; it isn't ambitious; it's merely a series of lovely scenes strung together. Did I say *merely*? We must not overlook the effort, however invisible, that goes into the creation of beguiling films like *Stars in My Crown*—including *My Brother Talks to Horses* (1946), *Margie* (1946), and *Come Next Spring* (1956)—that gracefully bring the past to very specific and evocative life. It's no small feat to render a long-ago era onto the screen and have it just *be*. *Stars in My Crown* is a film that makes you want to go fishing or bake a chocolate cake, even if you've never wanted to do these things before. It's a heart-warmer without goo.

Jacques Tourneur would seem an unlikely choice to direct *Stars in My Crown*. Tourneur made his name with the horror classic *Cat People* (1942), a B picture whose shoestring production values gave him the opportunity to display how a small budget could be a springboard to a wealth of inventiveness. He continued his horror run at RKO with *I Walked with a Zombie* (1943) and *The Leopard Man* (1943). Tourneur's *Out of the Past* (1947), in which hunky Robert Mitchum gets entangled in luscious Jane Greer's web, is now widely regarded as the quintessential film noir, though it wasn't especially valued in its day. Continuing in this style-drenched vein, Tourneur made *Berlin Express* (1948), a twisty post-war thriller. So, for a man firmly entrenched in lurking danger, smoldering sexuality, and near-complete darkness, the easygoing uplift in *Stars in My Crown* would appear to be beyond him. True, he had made *Canyon Passage* (1946), an impressive Technicolor western that got him out of shadowy places, but it was an action-packed, viscerally

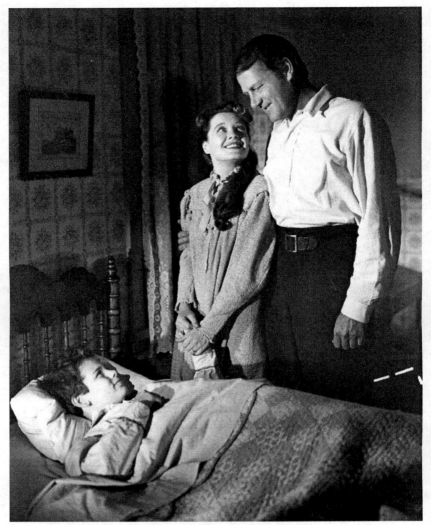

STARS IN MY CROWN. Ellen Drew and Joel McCrea look after nephew Dean Stockwell.

exciting movie that shared little with the ambling rhythms required of *Stars in My Crown*, a laid-back chronicle of a small-town parson and his family in the latter half of the nineteenth century. Of course, it isn't as showy as the aforementioned 1940s films for which Tourneur is best remembered, but it shares with those movies the director's meticulous attention to detail. It's impeccably worked out for the screen, yet the craftsmanship never calls attention to itself. Some of its visuals—a wife

at her apple peeler, two boys relaxing atop a slow-moving hay wagon, a nighttime group of teenagers sitting on the front steps and singing, a worn-out doctor asleep in his carriage as his horse takes him to his next patient—artlessly recall a world gone by. *Stars in My Crown* is a grown man's grateful look back at his childhood. Tourneur offers both a credible re-creation of the historical past and the narrator's memory-enhanced idealization of it.

It's a movie that is plotless in the way that *Meet Me in St. Louis* is; both films dramatize episodes—some significant, some everyday—in the lives of a family. *Stars in My Crown* makes its town, Walesburg, the true star of the film, with each individual character contributing to the overriding sense of community. It begins with the voice-over of the grown-up John Kenyon (spoken by Marshall Thompson) and lulling exterior images of small-town life. We are deliberately never told what state we are in so that it can appear to be *any* American town, but it seems to be, by turns, Western and Southern. Kenyon takes us back to the years following the Civil War, when Josiah Gray (Joel McCrea) came to Walesburg as the new parson. He soon had a church built and married a pretty girl named Harriet (Ellen Drew). Harriet's nephew, the pre-teen John Kenyon (Dean Stockwell), came to live with her and the preacher after he was orphaned. *Stars in My Crown* is a memory piece, a fond look back at the place and the incidents that shaped John. The title refers to the parson's favorite hymn.

You couldn't do better than Joel McCrea when casting an actor to play a plain-speaking parson, a character who is immensely likable and never smug. By this point in his career, McCrea had been a screen leading man for nearly two decades, unobtrusively building his durable body of work, in comedy (*The Palm Beach Story* [1942], *The More the Merrier* [1943]), drama (*These Three* [1936], *Dead End* [1937]), and comedy-drama (*Primrose Path* [1940], *Sullivan's Travels* [1941]). Here he's the head of an ensemble cast, and he serves the film splendidly; he's the picture's glue, its humanistic center. Embodying manly goodness, McCrea's parson has no pretensions whatsoever, and he also has a disarming sense of humor. Subdued and candid, and incapable of falseness, McCrea sets the film's tone. The parson arrives in Walesburg and, carrying his Bible, his first stop is the saloon. He introduces himself, announces that he's about to make his first sermon and, following the patrons' laughter, pulls out two guns and sets them on the bar. Walesburg is won over quickly; folks recognize not only

the parson's faith and commitment but also that he's a man of courage and action, someone on whom people can lean and depend. Who could blame them after one look at McCrea in his long black coat and cowboy hat? This tall, handsome fellow is comfortable in his skin, and his confidence is unthreatening.

Young John witnesses the parson's intervention on behalf of a man being whipped by a town bully. The parson grabs the whip, whips the bully on his behind, and lands the ruffian into a muddy puddle. Everyone ends up laughing, including the muddied man; even *he* can't dislike the parson. One of the parson's best friends is farmer Jed Isbell (Alan Hale). The two men, who seem to have nothing in common, fought side by side for the Confederacy in the Civil War and, consequently, are lifelong pals. The razzing they give each other is good-spirited, especially the stuff about churchgoing. The parson always manages to work in a "When you coming to church, Jed?" which amuses Jed no end. There's nothing insufferably pious about the parson. McCrea makes him a regular, decent guy.

The parson and Harriet have a very good marriage. Theirs is one of affectionate bickering and teasing, the kind that makes you believe not only that they really live together but that their bond is secure. And they are united in their dedication to raising young John. When John contracts typhoid fever, Harriet nurses him to the point of exhaustion and the parson insists that she get some sleep. Sitting on her bed, with her husband standing over her, she speaks of her regret at having spoken sharply to the boy in the past, fearing that the presumably dying child doesn't know how loved he is. Ellen Drew was hardly a first-rate screen actress (read my piece on *Isle of the Dead*), but she's very touching here. As she says her lines, she begins to pull the pins out of her hair. McCrea takes her lead, unpinning her hair and easing it down her back as she speaks. This is one of those exquisite details that enriches the film. It's already a moving scene, but when McCrea assists Drew with her hair, this intimate and tenderly consoling gesture says more about the parson's love and support of his wife than ten pages of dialogue could. He listens to her fears and puts her to bed. Throughout the picture, Drew exhibits a strength and warmth as undeniable as the loveliness of her face.

There's a captivating episode in young John's life when the medicine show comes to town. Professor Jones (Charles Kemper) and his wagon pull into Walesburg, and the sequence casts a wave of enchantment, making you feel what a show like this would have meant to people for

whom entertainment and magic were not easily come by. When the pro-
fessor pulls a watch out of John's ear or makes coins fall from the boy's
nose, little Dean Stockwell is properly awed and wide-eyed. At the show
that evening, John assists the professor's magician act and continues to
be quietly thunderstruck by the showman's every move. This is neatly
embellished by shots of other mesmerized children looking on.

Among the rest of the townsfolk, the most prominent is young Dr.
Harris (James Mitchell), son of old Dr. Harris (Lewis Stone). Following
his education, the young Harris has returned to Walesburg a citified
gentleman, out of step with the rhythm of the town and uncomfort-
able with its one-big-happy-family mentality. He's unfriendly and im-
patient. He's also a good doctor. His mood lightens when he becomes
entranced by Faith Samuels (Amanda Blake), the pretty schoolteacher.
Their first date, an idyllic picnic, comes to an unhappy close. In an-
other example of the kind of detailed moviemaking that reverberates
emotionally, Tourneur films the doctor and the teacher returning to
town in a horse-drawn carriage, coming to a stop when a departing
train blocks their way. They begin to sing as they wait for the train to
pass, spontaneously expressing their pleasure at newfound love. Time
almost stands still. Then the train goes by, revealing the doctor's house
and a group of people outside it. His father has died. The scene's care-
free spirits evaporate immediately, reality having put an end to a day
of wonderment, the memory of which can now only be bittersweet.
The doctor wears a black armband thereafter, a morbid accessory to
be seen on the man who has inherited the task of keeping Walesburg's
inhabitants in good health.

The central conflict in the movie becomes the head-butting between
Parson Gray and young Dr. Harris. It's the eternal clash between religion
and science. More than any politician, Gray and Harris are the leaders
of Walesburg, the two men most relied upon for the moral and physical
welfare of the town. Gray understands that he and Harris are both neces-
sary to Walesburg, but Harris doesn't quite see it that way. The situation
comes to a head when there's an outbreak of typhoid fever among the
children. Harris accuses Gray of spreading the disease because he tended
to John (the first case in town) while continuing to go about his other
duties. The thought that this might be true shakes Gray to his core, and
he holes himself up in his house, avoiding potentially deadly contact
with his parishioners. This crisis of helplessness and doubt *cannot* last
long. After two weeks, Gray emerges after learning something vital

about how the typhoid spread. It's such a relief to see McCrea instantly reinvigorated, back in the saddle as it were. Surprisingly, Harris, who has never shown any respect for Gray's position, summons him for one of his dying patients. Individually, neither man could handle all of the town's woes, but together they stand a fighting chance.

As Harris, James Mitchell, a dancer familiar to lovers of movie musicals as Cyd Charisse's mentor in *The Band Wagon* (1953), her partner for one ravishing dance ("One Alone") in the mostly embarrassing *Deep in My Heart* (1954), and as Dream Curly in *Oklahoma!* (1955), is remarkably good. His conversion from stuck-up outsider to committed community member is honestly drawn and believably timed. Mitchell also appeared in other dramatic films at this time, such as *Border Incident* (1949) and *Devil's Doorway* (1950), two laudable Anthony Mann-directed pictures included here.

Young John fishes with Uncle Famous (Juano Hernandez), a black farmer who lives alone and knows more about fishing than anyone else around. Famous' land is desired by local merchant Lon Backett (Ed Begley, who frequently, and expertly, played slime) for the vein of mica that runs beneath it. Famous won't sell, and this ignites the wrath of Backett and his miners. John has his innocent eyes opened when he witnesses an attack on Famous' property. Later, after men in Klan robes burn a cross in front of Famous' house, the parson confronts the attackers at Backett's store. McCrea gets a good tell-off scene, anchored by the integrity that he carries so easily. (And who speaks lines as naturally as McCrea?) Even away from his pulpit, the parson is the voice of the town's conscience. When the torch-carrying Klansmen return to Famous' for a lynching, the parson is there (so is John, hiding). In the speech that follows, the parson uses some astute psychology in his attempt to prevent a murder. He finds a way to individualize the members of the hooded mob, thereby defusing their power. Tourneur's concentrated direction allows the camera to detect—primarily through its focus on the men's body language—character transitions taking place within the hooded figures. McCrea's sustained conviction provides the stable presence around which the scene rises and falls. This sequence may remind you of a similar one in *To Kill a Mockingbird*, made twelve years later, though in that film the mob isn't hooded, and it's a child (Scout) who ingenuously prevents the crime.

An important component of the film's effectiveness is the genuine feeling of community portrayed. Because this is a small town, charac-

ters should be repeatedly visible throughout the story, even in scenes in which they are insignificant. So, the supporting players are sometimes in the background—at church service or at the medicine show—infusing the film with physical veracity. Community is also emphasized by the storytelling within the film. Characters pass on information or reveal themselves by telling stories of the past. This illuminates character but it's also emblematic of a time when oral storytelling was primary entertainment.

Based on the pleasing novel by Joe David Brown, *Stars in My Crown* has a screenplay by Margaret Fitts. Her script manages to give concise weight to each of the film's story threads, which are smartly rearranged from the order in which they appear in the book, allowing the film to build dramatic momentum. Each character registers; each episode is absorbing; each moment adds to the overall fabric. In Brown's novel, which feels more specifically Southern than the movie, John is being raised by his grandparents, not his aunt and uncle. This page-to-screen alteration was probably made so that attractive movie stars could be cast in the central roles. Tourneur's guiding hand establishes an unhurried pace, evoking a far-off time in American life. The black-and-white cinematography of Charles Schoenbaum suggests an old scrapbook stuffed with snapshots of bygone days. There's something *Our Town*-ish in the movie's ultimate effect: its mixture of joy and sadness; the way it's both real and nostalgia-enhanced; the dignity and respect with which it honors small-town America; and the way it revives an America that no longer exists. *Stars in My Crown* plays like a labor of love; no one makes this kind of picture imagining big box-office.

Dean Stockwell's unaffected performance is proof that he was one of the era's better child actors. He grew into a fine young actor *(Long Day's Journey Into Night)* and a fine older actor *(Married to the Mob)*. Juano Hernandez, who had been so good as the dignified and proud victim in the beautifully made *Intruder in the Dust* (1949), is similarly good here. Interestingly, this film features both Amanda Blake and James Arness (as Jed's oldest son). In 1955, the duo would be cast on television's *Gunsmoke* and settle in for a two-decade run.

McCrea and Tourneur reunited for two westerns, *Stranger on Horseback* and *Wichita,* both from 1955, but *Stars in My Crown* is the best of the three movies. I may be a little apprehensive about over-praising it, but I obviously have no problem hailing both McCrea and Tourneur as loudly as I can.

Bad Company (1972)
The 1860s with a Vietnam Subtext

Five years after receiving enormous acclaim for their screenplay of the groundbreaking, tone-swerving *Bonnie and Clyde* (1967), writers Robert Benton and David Newman were at it again. Their *Bad Company* is a worthy companion piece to their '67 classic, with its doses of comedy, unsettling blasts of violence, travels through a hard-times American heartland, and thieving main characters. However, the film caused little stir when it was released and was soon forgotten. Not only did Benton cowrite *Bad Company* but he also made his directorial debut with it. (Arthur Penn directed *Bonnie and Clyde*.) Set during the Civil War, it's a war film that never gets near the war. Because the lead characters head west, it's something of a western, though the "West" being sought never quite materializes, and is thus more an idea than a reality. With the war raging north, south, and east, and the West a question mark, *Bad Company* presents an America without a safe haven, a nation whose identity is in limbo. You might say that *Bad Company,* like *Easy Rider,* is "looking for America." It's a tale of displacement, a bit of historical fiction that illuminates an off-kilter time. Although it is set on the fringes of the big story (the war), the pain and loss of that conflict hovers over the film as the underlying cause of everything that takes place. Sometimes period films are marred by contemporary acting styles or forced modern sensibilities, but in *Bad Company*'s case the New Hollywood brashness of a cast led by a young Jeff Bridges results in an immediacy of identifiable feeling that makes effortless the potent connection between this tale of draft dodgers and a 1972 America in the thick of the Vietnam War.

In 1863, Drew Dixon (Barry Brown), a young Ohioan, escapes conscription in the Union army with the help of his parents (who have already lost one son to the cause). In Missouri, Drew encounters Jake Rumsey (Bridges), a deserter who now leads a band of ragtag thieves, which includes other army dodgers. Drew joins the group as an ex-

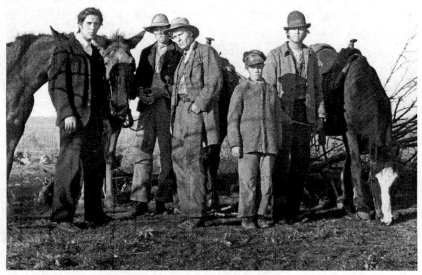

BAD COMPANY. Thieving youths Barry Brown, Damon Cofer, John Savage, Joshua Hill Lewis, and Jeff Bridges.

pedient way to get out of Union-controlled Missouri, though he vows privately never to commit any crime. Thus begins an adventure as unreliable, threatening, and violent as the war Drew has successfully avoided.

Bad Company has a brilliant prologue that sets up the film's historical and social context succinctly, startlingly, and without using any of the story's main characters. It begins with a sun-dappled shot of a lovely white house with a massive tree in front of it and clothing swaying breezily on the line. The camera stays fixed on this picture as a horse-drawn wagon, manned by Union soldiers, pulls into the frame. The soldiers make their way into and around the house, but the camera doesn't follow, waiting patiently with the horses, two remaining soldiers, and young men imprisoned behind the wagon's bars. The disconcerting silence is broken by a distant noise, then the sounds of a chase. The image then cuts to the front doorway as the soldiers carry a boy who is wearing a dress and struggling to be freed. He's dumped into the wagon, sharing the defeat and humiliation of those already there (another of whom is dressed as a woman). The boy's mother and little sister follow alongside the departing wagon. The everydayness of

the setting, the efficient soldiers, and the terrified boy and his numbed fellow passengers provide a shivering glimpse into a specific time, but it's rendered with a well of feeling that makes it timeless. The film doesn't glorify or condemn these boys; it accepts their fear and acts of self-preservation as human responses to impending horrors. The scene is a stirring episode that sets the tone for the story to follow. The credits come on the screen, during which we follow the wagon's journey, and they finish just as the soldiers arrive at their next stop, the home of Drew Dixon, another boy on their list of army evaders.

Despite the severity of the situation, Drew is introduced comically, as a disembodied voice. The soldiers have left but Drew remains concealed, speaking to his mother from under a table until the coast is clear. Then, with $100 in his boot and his dead brother's gold pocket watch, Drew rides off for Virginia City with dreams of hitting it rich in the silver mines. As played by Barry Brown, Drew is a good-hearted, well-brought-up, handsome lad, thoroughly unfit for what lies ahead. Brown narrates the film, reading from Drew's journal, and he provides the film with a durable center, alternately childish and grown-up, crafty and honorable, volatile and levelheaded.

One of the most impressive aspects of this film is Gordon Willis' burnished cinematography. He lights scenes hauntingly with lantern light or campfire light, such as a nighttime long shot that is no more than an orange dot at the center of a black screen. There are also staggeringly beautiful, sun-blazed expanses of golden prairies topped by azure skies. Willis' work is exceptional for both its compositional stillness and its intricate mobility. An example of the former is that exquisite opening scene, as is the transfixing shot of Bridges packing up his horse as a far-off stagecoach—a mere speck—moves barely perceptibly across the horizon, heading their way. These, and other scenes marked by long takes and little camera movement, are, of course, also a product of Benton's direction. He allows such scenes to build and be "lived in," making it easier for audiences to believe they are watching a pre-technology time period. *Bad Company* often resembles a series of sepia-tinted photographs come to life.

Long takes can also accommodate considerable movement, and the best example here occurs on Drew's arrival in Missouri. In more than three minutes of unbroken film, an upbeat Drew crosses the street from his hotel and is tracked by the camera until he reaches the end of a long line of folks awaiting the wagon train. This places him a

few feet from the entrance of a recruiting office and two alert soldiers. With Drew on the right of the screen and the soldiers at left and center, it's a deftly composed, highly tense scene; we cannot see Drew's face, which heightens the tension. (His perspiring discomfort can be felt in his self-conscious nonchalance.) The shot, still unbroken, continues as Drew leaves the line, whereupon Bridges' Jake steps out from an alleyway and starts a conversation. The camera follows them walking and talking until Jake, supposedly offering aid, leads Drew down another alley, knocks him out, robs him, and then slips out of the frame. The sequence is notable for its sustained technical skill, the period detail of everything the camera passes, and the ambience of spontaneity that a long take provides, but perhaps most striking is how much the story accomplishes in this three minutes of flawless film craft: Drew's high-flying optimism comes crashing to earth; he narrowly avoids the curiosity of the soldiers and possible capture; he meets and likes Jake, only to be betrayed by him; and Jake, our second major character, is introduced as both charmer and scoundrel. This is all very entertaining, dramatically astute, and purely cinematic. Benton's storytelling sense and directorial confidence, wedded to Willis' artistry and technique, display astounding ease.

Once Jake shows up, the film's inspiration appears to be *Oliver Twist*. He and his band of young thieves, whom Jake refers to as "hand picked for gumption" (and numbering six once Drew joins them), evoke the grimy, shrewd tricksters of Dickens' classic, though they are sorely in need of a Fagin as surrogate parent. They aren't all orphans but may as well be. Drew and all but one of the others are close to being men but not quite. Benton provides jolting reminders that these guys, for all their daring and autonomy, are inexperienced kids. When Drew and Jake meet for a second time, at a reverend's home where Drew sought aid, they engage in a nasty, funny, sloppy fight, complete with biting, hair pulling, and boot-swiping. Their brawl trashes the kitchen so badly that there's no recourse for Drew but to leave the scene of the crime with Jake. Like children, they don't see very far in front of them, indulging their emotions and tempers impulsively. Jake likes Drew's feistiness and convinces him that joining up with him is the safest way out of the Union. His first evening with them in the woods, feasting on a stolen fruit-pie dinner (a child's delight) and telling scary stories about Indian torture, climaxes with putting a live frog down each other's clothing. It's heartbreaking when they're seen as the playful boys they can't help

being. The lighter moments highlight how bleak the circumstances are, when kids run from untimely wartime death to the equally dangerous path of fending for themselves in a vicious landscape. And their skill with guns isn't encouraging; it takes all six of them shooting repeatedly to nab one rabbit, and then only Jake knows how to clean it. When he's done, even he has lost his appetite, and so he tosses it away as the others look off in varying directions.

The first two meetings of Drew and Jake—the robbery and the brawl—establish their relationship for the rest of the story. They genuinely like each other and truly get along, but there will be ongoing bouts of mistrust, betrayal, and the inevitable blows. Drew the gentleman and Jake the rascal are an opposites-attract pairing whose kinship appears to outweigh their perpetual gripes and wariness. (Drew is accepted by the group when he offers twelve dollars, from his own stash, as supposed criminal booty.) Barry Brown's Drew is a good boy trying to remain good, and Jeff Bridges' Jake is a bad boy reveling in his badness. But Bridges also allows something else to sneak in: that Jake feels inferior to Drew and doesn't like being shown up by such refined morality. Jake was one of the estimable Bridges' first roles, and he endows it with all the smooth roguery and cocksure magnetism that the role demands. He has a salesman's smile and the comic glint of a vagabond actor. Bridges' rakish appeal is similar to Paul Newman's when he first came on the scene. Jake is pleased that he and his gang will be "living off the land," even though they don't really have the skills for it. "We're boys in our prime; we take it as it comes," he says.

In a story in which the West is the place to put one's hope, it's chilling that no one coming from that direction has anything good to say about its prospects. There may be freedom—the kind that leaves you free to disappear and die—but it's a constant struggle to preserve it. The boys run into a couple on a wagon, heading back from failure out West, and the man offers his woman to the boys for eight dollars. (Only Drew, a Christian, and ten-year-old Boog decline.) Jake takes but a few seconds for his encounter; Bridges amusingly beams with pride over Jake's efficiency. The scene has a stinging, matter-of-fact unpleasantness, but its believability is marred by the woman's unfathomable eagerness to oblige. The boys also have several bad run-ins with mangy thugs led by Big Joe (David Huddleston channeling Burl Ives), who is also down on the West. It's particularly disheartening to watch adults rob youngsters; it's worse to watch them kill them. When the boys trade a gun for food

from a mean-looking farmer, the scene barely averts becoming a shotgun massacre. But when they steal chickens at another homestead, the scene does ends violently, with one of the boys getting shot through the head after swiping a sill-cooling pie. A boy's hunger (and partiality for dessert) leads to his demise. You can't accuse *Bad Company* of having a taste for blood because every one of its violent outbursts, including a very real hanging, sickens. In the film's most ironic acknowledgment that the young men we're watching are juveniles, a scene of betrayal erupts not in gunfire but in rock throwing. One of the boys (John Savage) throws rocks at Jake even while holding a gun in his other hand.

The relationship between Drew and Jake gets more intense as the picture proceeds. They have impassioned philosophical discussions, frequent physical tussles, and predilections for deception and vengeance. But they're more alike than they realize. After all, Drew isn't *so* good, and Jake isn't *so* bad. "You're the liar, I'm the crook," Jake tells him, but this proves less clear-cut as the film nears its conclusion. The boys make things up as they go along, and come to handle situations as risky as anything the war could have put before them. The film builds to its pessimistic, renegade, freeze-frame ending, which feels very 1970s without losing any of its punch.

The humorous grace notes deserve mention. One of the young thieves, played by *Summer of '42*'s Jerry Houser, departs the film in long shot, in one of the cleverest exits in any movie. Supposedly, he's the bait for a stagecoach robbery, but, instead, he uses this opportunity for his own ends. The scene is viewed from afar; we can't hear what he's saying and so we are wondering what's going on, as cut off from the action as the other boys. It's an unexpected, hilarious bit of outsmarting, and it makes perfect sense. Another bit that tickles me is when Big Joe, sitting at a campfire, is told that Drew and Jake are approaching. As if he were an ordinary storekeeper instead of an outlaw, Joe says, "Wait all day and nothing happens. Wouldn't you know we just sit down to supper and somebody comes by." Joe's gang, however, is too comically dumb, and the positions in which they are shot dead are too self-consciously "funny."

Bad Company mixes humor, violence, period evocation, episodic narrative, and Vietnam-era skepticism into the kind of genre-buster that a movie like *Bonnie and Clyde* made possible. With a fresh vantage point on the times, a persuasive environment, and a consistent knack for surprise, this is essentially a story of boys trying to become men,

exchanging one kind of misery for another, and fighting for their basic right to survive. The early '70s are now known as the second Golden Age of Hollywood though many of its classics, such as *The French Connection* and *A Clockwork Orange,* have not aged well. *Bad Company* is a film that was overlooked in its time that now looks better than many of the films that outshone it. It resonates not only with pain for Civil-War America, but also for the Vietnam War, the contemporary subtext gracefully informing the film. *Bad Company* paints a large, thematically rich, historical canvas, but it's also a small film about two young men. It succeeds, equally, as both.

Jeff Bridges, fresh from his attention-getting work in *The Last Picture Show* (1971), was well on his way to becoming one of American movies' acting treasures. He worked with Benton again on the minor comedy *Nadine* (1987). Barry Brown, whom you may remember from *Daisy Miller* (1974), committed suicide at age twenty-seven in 1978. He had a kind of Tony Perkins quirkiness—a handsome insecurity—and this film is a lasting tribute to his potential. Cinematographer Gordon Willis, who had filmed *The Godfather* right before *Bad Company,* went on to lens not only *The Godfather Part II,* but also, among others, *All the President's Men, Annie Hall,* and *Manhattan,* making him one of the premier men in his field in the 1970s. Benton has directed only ten other movies in the thirty-five years since *Bad Company,* the most celebrated being the overrated *Kramer vs. Kramer* (1979). That multi-Oscar winner is a "sensitive," annoyingly tasteful (in all its beige austerity), overwritten (right up to its false ending) weeper. (Why can't high-earning Daddy just hire a full-time nanny when Mommy walks?) Benton's best films are his first two, *Bad Company* and *The Late Show* (1977), a wondrous film-noir update featuring tremendous performances from Art Carney and Lily Tomlin. In both, Benton offers original perspectives—unique points of view from outcasts, from Bridges' homeless hotshot to Carney's broken-down gumshoe. Benton took audiences places they had never before been able to imagine inhabiting.

Tucker: The Man and His Dream (1988)
The Land of Opportunity?

Director Francis Ford Coppola was perhaps America's key film-
maker of the 1970s. He made just four movies during the de-
cade, all of them classics, each as powerful and revelatory today
as then. His peerless epics, *The Godfather* (1972) and *The Godfather Part
II* (1974), were not only Best Picture Oscar winners but became immortal
components of our film culture; both now constantly vie with *Citizen
Kane* (1941) for the top spot whenever groups rank America's greatest
films. Coppola's other two '70s works are *The Conversation* (1974), a
chilling, obsessively intense surveillance drama starring a peak-form
Gene Hackman, and *Apocalypse Now* (1979), a Vietnam War spec-
tacle which, for all its flaws and lapses—notably the lugubrious scenes
featuring a dead weight named Marlon Brando—is a visionary work,
a journey into hell both beautiful and horrifying, coherently mixing
realism with surreal, stylized visuals. Coppola obviously enjoyed this
experimentation because his career in the 1980s was dominated by
excursions into style and artifice.

Coppola had established the clout and bravado to take big chances,
but most of his films of the '80s proved to be ambitious creative failures,
notably *One from the Heart* (1982) and *The Cotton Club* (1984), leading
to the woefully misguided *Godfather Part III* (1990). His time-bending
Peggy Sue Got Married (1986), an instance of emotional whimsy, was
an exception—a good movie. Coppola's best film since the 1970s is
Paramount's *Tucker: The Man and His Dream,* a biopic that exhilarat-
ingly fuses content and stylization. After nearly a decade spent on mate-
rial with which his connection seemed impersonal, Coppola appears to
have felt considerable kinship with his title character, another trailblazing
maverick first praised then trashed. *Tucker* is the work of a flamboyantly
talented director; it's great fun watching Coppola give it his all.

With the end of World War II imminent, Preston Tucker (Jeff
Bridges), a successful designer and builder of gun turrets, plans to

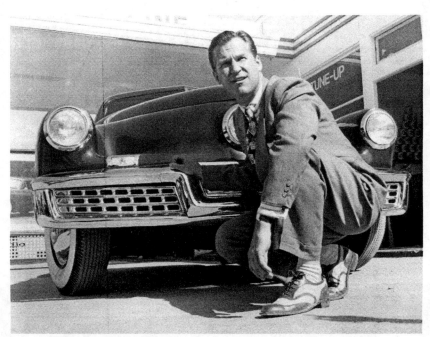

TUCKER: THE MAN AND HIS DREAM. Jeff Bridges in front of his creation.

give post-war America its dream car, named for himself. The Tucker will have a rear engine, pop-out safety windows, storage under the hood, sponge-rubber crash panels, and fenders and headlights that turn with the wheels. With his supportive wife, Vera (Joan Allen), his three sons and one daughter, a handful of devoted engineers, and Abe Karatz (Martin Landau), his new business partner, Tucker is ready to give Detroit's "Big Three" carmakers some real competition. Despite the car's excellence—because of it actually—there's no way the Big Three will be forced into spending billions to upgrade their cars to keep up with Tucker's innovations. The Tucker—whose slogan is "Don't let the future pass you by"—must be squelched.

As a rule, Hollywood—the dream factory—doesn't make movies about the American dream being a fraud, which is one reason why this film isn't easily forgotten. In *Tucker,* the better product is smothered and banished so that the continuing profits of fat corporations can be safeguarded. If Coppola had chosen to tell this true story as an earnest message picture, the results might have been unrelentingly depressing and disheartening. Instead of falling into this miring trap, he made a film that's informed by post-war enthusiasm and possibility, set to a

jitterbugging background score and photographed with all the saturated color and glamour associated with escapist movies of the period. *Tucker* the movie reflects Tucker the car: both are sleek, streamlined, impeccably crafted, and have real "drive." The troubling points about our free-enterprise system are not swallowed up by Coppola's dazzling technique, but, rather, emerge with clarity in a film whose buoyancy keeps audiences attuned to what it has to say. If the ending seems too determinedly upbeat, well, it isn't unjustified: Tucker does make his wonder car, and it's everything he said it would be. The film chooses to find optimism in the fact of the Tucker itself—the actualization of a dream—even though only fifty cars were produced. *Tucker* celebrates personal achievement and refuses to diminish its central character because he wasn't able to reap the benefits his invention merited. The losers are the American people, denied the best that's available to them so that Big Business can thrive unchallenged. It's a tricky balancing act for Coppola to deal honestly with downbeat themes while delivering a spiffy entertainment, but he succeeds. *Tucker* is gorgeous to look at, swiftly paced, and still strikes all the right nerves.

The role of Tucker required an actor who possessed the outward flash of a charismatic wonder boy but also the nuanced talent to make him a ticking human being. Aided by his all-American handsomeness, Jeff Bridges is a gleaming showman here, a sparkling personality enhanced by transfixing blue eyes and a dimpled smile. In one scene, he practices his devilish grin before a mirror, lowering his chin and squinting his eyes; it's an endearing private moment rather than one of calculating cynicism. Bridges infuses *Tucker* with as much snap and vitality as his director, gliding through the film with energized grace. When he's about to shake a hand, his fingers extend straight ahead, his thumb confidently erect. His Tucker is a man synchronized to the saxophone and drums on the soundtrack. Bridges carries the riveting passion of a man of new and newer ideas; Tucker is on a perennial high. Refusing to be quashed by negativity, and rarely exposing his disappointments, he naïvely thinks that it's really all about building a better mousetrap. Bridges' Tucker is joyous, impulsive, and innocent, also headstrong and big-mouthed; the actor completely fulfills the role of an infectiously inspiring, crackpot revolutionary. And with his nattily tailored '40s suits, Bridges is every inch the '40s-style film star, evoking Joel McCrea and Gary Cooper, two likely candidates to have played Tucker if his car had been adopted and his household-name status assured.

Tucker begins with a promotional featurette about the car (during the credits), enhanced by a sonorous voice-over that introduces Tucker and his family to potential buyers (and the movie audience). Bridges is first seen chatting on the phone, utterly at home in his man-of-industry office, an embodiment of American success. Here the film nods to *Citizen Kane,* which also begins with a mini-documentary about its title character, generalizing about things that will later be explored. The first glimpse of the "real" Tucker is when he arrives home (Ypsilanti, Michigan) in a convertible packed with a dozen Dalmatians. The Tuckers are the kind of family who takes everything in stride. I wouldn't call them screwballs, exactly, but they certainly go with the flow of things. It's refreshing that Joan Allen's Vera isn't on hand to nag and scold Tucker, and his kids never tell him that he isn't paying enough attention to them. They're all in this together. His son, Junior (Christian Slater), refuses his acceptance to Notre Dame just so he can work with Dad on the car. Bridges plays Tucker more as big brother than father, more as madcap boyfriend than pragmatic husband. And there's nothing "wifey" about Allen's Vera. She's a true partner, included in his decision-making and a defender of his worth. Allen (formerly of Coppola's *Peggy Sue Got Married* ensemble) gives Vera a Lois Lane, gal-Friday persona, not brassy but bright, attractive, and perceptive, and able to enjoy a good time. Allen and Bridges are a perfect match, creating a relationship in which they protect each other, boost each other, and read each other's thoughts. Blithely unconcerned with practicalities, the Tucker clan is a loving, tight-knit unit of like-minded free spirits. They can pile into Tucker's tank-like combat car and speed into town for ice cream as normally as if they were riding in a suburban station wagon.

Tucker finds a business sense in the form of Abe Karatz. With a mustache, gray temples, and dark coat and hat, world-worn Abe is an urbanite marooned in the heartland of Ypsilanti. The pleasure of this character and Martin Landau's performance is in watching this lonely man become attached to the Tuckers, who embrace him as part of the family. Landau's role is certainly sentimental, but the film profits by its warming humanity; Abe is a worthy emotional anchor in a perpetual-motion movie. He's the voice of reason (and worry), reining in Tucker when he sees fit. Abe sets up a Board of Directors and handles the acquisition of a factory in Chicago. He thinks the factory is too big, but, naturally, Tucker revels in its expanse, eager to fill it. Landau's most

memorable moment comes when Abe tells Tucker that his mother once warned him, "Don't get too close to people, you'll catch their dreams," then reports that he misheard "dreams" for "germs." He laughs, then admits that he has, in truth, caught Tucker's dreams. Abe is a loyal, avuncular fellow, and good as Landau is in the part, he might have been even better if he didn't seem so aware of what a swell opportunity this was for his sagging career. Landau earned a supporting Oscar nomination, but I'm glad the Academy saw fit to wait and award him the prize for his unforgettable Bela Lugosi in *Ed Wood* (1994).

In a showstopping sequence at the factory, the car is finally unveiled to the press and the public. Behind a red curtain, Tucker's engineers work feverishly to finish the car as the crowd grows restless. Bridges employs his ebullient charms to control the impatient attendees, with the aid of the Tuckerettes, a sextet of statuesque, pink-gowned lovelies. Meanwhile, the backstage mechanics deal with locked wheels, a leak, even a fire. This funny, suspenseful scene climaxes with the triumphant debut of a silken-red Tucker, spinning majestically on a revolving stage. (If the movie ended here, it really would be the fulfillment of the American dream and the triumph of American know-how.) When his teenage daughter smashes the car with a bottle of champagne, the splash soaks Tucker's suit. This is a good-humored, unexpected moment, a down-to-earth reality check during a time of exultation, a harbinger of the mess to come.

On the subsequent publicity tour, Tucker enjoys being feted and glorified; Bridges is all puffed-up and seemingly invincible. But while Tucker is being seduced by the hoopla, his board is quietly neutering his car, dismantling all the elements—deemed impractical and impossible— that make the Tucker the car of the future. After refusing to accept these modifications, Tucker winds up on trial, fighting not just for his car but for his freedom. The powerful political machine bent on his demise is led by a senator, played by none other than Lloyd Bridges, in the pocket of the Big Three. It's an amusing twist to have Jeff Bridges' nemesis played by his own father. The senior Bridges does very well as the coolly cunning villain of the piece. The all-out assault on Tucker's integrity, built on lies, leads to a courtroom finale in which Tucker makes the closing arguments of his defense. Like James Stewart in *Mr. Smith Goes to Washington* (1939), Bridges, another shining example of American manhood, pours his heart out to his listeners; he matches Stewart in focused exasperation and aching sincerity.

One of Coppola's most eye-catching devices is his use of adjoined sets for phone-call scenes. Tucker and Abe speak—Tucker on the factory floor and Abe in a diner—and normally this would be intercut between their two locations; instead, Bridges and Landau are clearly a few feet apart, separated by a wall. This dilutes the naturalism of the scene, reminding us it's a movie, one suffused with the studio-bound style of the period being recreated. In another telephone scene, Joan Allen's face appears in the right corner of the foreground while, not far away in the background, there's Bridges talking to her from a phone booth. Most striking of all is a breathtaking single shot following a business discussion, bathed in golden light, around the dining-room table. Bridges rises from the table, steps out of the sunny lighting, twirls his hat and snazzily places it atop his head, and is immediately striding inside his massive factory. It's a stunning trick—we obviously left the dining room before the shot began—that celebrates the illusory magic of the movies. All these scenes are reminders that undisguised artifice doesn't necessarily impugn an audience's ability to believe in a scene's reality, no surprise to old-movie lovers.

Oscar nominations deservedly went to production designer Dean Tavoularis (who designed all four of Coppola's '70s classics) and costume designer Milena Canonero, but left out was the sensational work of cinematographer Vittorio Storaro, whose use of light and color gives *Tucker* the vibrancy and mobility of a graphic novel come to life. With his dreamlike blue backgrounds, his flattering golden hues on the actors' faces, and his fetishizing adoration of the cars' sensual curves and glistening sheens, Storaro provides continual visual luster. The sight of the fifty completed Tuckers paraded through town—a rainbow of colors—is enough to rev your engine.

Tucker's screenplay was written by Arnold Schulman (who wrote 1959's *A Hole in the Head* and 1963's *Love with the Proper Stranger*) and David Seidler. Their script proves that zippy storytelling and essentially dispiriting subject matter can be a surprisingly effective combination. Howard Hughes (Dean Stockwell) has a cameo appearance, offering his help to Tucker, recognizing him as another targeted visionary. Stockwell makes a haunting impression as an unsmiling, mild-mannered Hughes, a man who is strange and isolated but gentle and kind.

As for Bridges, Preston Tucker was one of a series of roles, including those in *The Fabulous Baker Boys* (1989), *The Fisher King* (1991), *Fearless* (1993), and *The Big Lebowski* (1998), for which this superb

actor received insufficient attention. Bridges hasn't exactly received the Tucker treatment—so good that he must be stopped for showing up everyone else—but something isn't right when the best actor of his generation isn't being appreciated at full value. If you're looking for the model with the time-tested reliability and the luxury accessories, look no further than Bridges.

Rambling Rose (1991)
The Triple Threat of Dern, Duvall, and Ladd

Far rarer than films that rely on a sole significant performance, or those elevated by a scintillating team, are movies borne aloft by *three* equally tremendous performances at their centers. I don't mean films with ensemble casts, such as *All About Eve* (1950), *The Godfather Part II* (1974), or *Shakespeare in Love* (1998), in which it would be easy to pick out three, or more, outstanding performances. I'm talking about instances in which three performers take charge of a film, play off and inspire each other, and raise the bar of each scene's potential with their instinctive gifts and refined techniques. It's there in the Clark Gable-Myrna Loy-Spencer Tracy tragi-comic trio of *Test Pilot* (1938) and the glimmering Cary Grant-Katharine Hepburn-James Stewart threesome of *The Philadelphia Story* (1940). A quintessential example is *Lolita* (1962), a film in which James Mason, Shelley Winters, and Peter Sellers are each so extraordinary that I'm sure one of them is stealing the movie, but I keep changing my mind about who it is that's doing the stealing. This is a highly pleasurable predicament, and it also happens to me every time I see *Rambling Rose*. It stars Laura Dern, Robert Duvall, and Diane Ladd (Dern's real-life mother), and just one of their splendid performances would be enough for this, or any, movie. Thanks to their glorious three-ring show, the independent *Rambling Rose* is one of the best-acted movies of recent years, a patchwork quilt to wrap snugly around you. Calder Willingham wrote the screenplay, based on his 1972 novel.

In Depression-era Georgia, Rose (Dern), a vibrant young woman with a bruised past, comes to live with, and work for, the well-off Hillyer family, led by Daddy (Duvall), a hotel manager, and Mother (Ladd), a well-educated, liberal-minded matron. The Hillyers have three children, the oldest being thirteen-year-old Buddy (Lukas Haas), a good boy whose "evil streak" can be seen in his sprouting fascination with sex (and the enticing Rose). Innocently childlike and erotically aflame, Rose

322

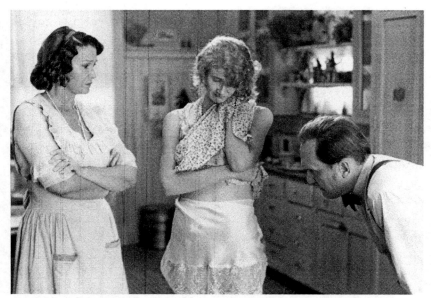

RAMBLING ROSE. Diane Ladd, Laura Dern, and Robert Duvall consider Dern's predicament.

proves to be both a blessing and a curse to the Hillyers, who, despite the ups and downs, come to think of Rose as family.

Rose is a character who is *all* feeling; there's nothing cerebral, or even logical, about her. No matter what mistakes or bad judgments she makes, she is unalterably guileless. Golden-girl Laura Dern has the tricky task of playing limited intelligence, but she never condescends to Rose, so the character doesn't become a backwoods bimbo. Dern's Rose is a lovable creation because everything she does, whether appropriate or inappropriate, she does full out. There's no monitoring or self-consciousness. Dern's ability to mix ripe sensuality, purity of heart, effortless comedy, exposed vulnerability, and a nifty twang is no mean feat, an achievement comparable only to what Marilyn Monroe brought off so memorably in *Bus Stop* (1956). I hate to label Dern's Rose as "a life force," but there's something truly affecting about a hard-knocks character incapable of cynicism, distrust, or spite. Rose lives in the moment, resulting in frequent repercussions for her impulsive actions. Dern is attentive to the passing nuances of feeling vibrating within Rose, and her performance is, therefore, resoundingly *alive*. She's a true child-woman, sweetly oblivious, which makes her both funny and pitiable. But for all her victimization, Rose is a survivor, and, through Dern,

her indomitable optimism, her unblemished capacity for joy, and her deepening attachment to the Hillyers radiate through the tougher times. Rose is a fresh-faced, gawky Blanche DuBois, another Southerner who has escaped a bad situation in hopes of a clean-slate rebirth.

You may expect, at first, to roll your eyes at Mother. Will she veer too close to being a dismissibly comic eccentric, a well-meaning scatterbrain? After all, though she's committed to the betterment of humankind, she sometimes seems as naïve as Rose regarding the world around her. Like Rose, she expects people to be good, but she's no ingenuous hick. Mother, who inherited money (and a hotel) when she was orphaned as a child, is a bighearted Southern lady who attended Columbia University (and is now finishing her master's thesis), devoted to forward-thinking causes such as human equality. (Rose will not be their "hired girl," but, rather, a friend, a guest.) As Diane Ladd inhabits her, Mother becomes a surprisingly uplifting, three-dimensional woman who puts herself on the line for those she loves and who acts on her words bravely. Ladd can emanate love and commitment without mush, and, when coming to the aid of a loved one, her Mother is every bit the "tiger" Daddy describes her as being. She wears a hearing aid, but it's richly satisfying that Mother never lets this impairment, or any other obstacle, diminish her guts or passion. Ladd's performance is built from a foundation of love that she has firmly, and generously, planted inside Mother.

Daddy is just as susceptible to caricature as dumb-blond Rose or bleeding-heart Mother. Robert Duvall enters the picture with a devilish grin, a charm-flashing Southern gentleman with a dexterous gift of gab: part poet, part preacher, part salesman. Duvall can bask in Daddy's good 'ol boy characteristics, but they're just one segment of a complex character. Daddy is revealed as a man who cares deeply, and, no matter how riled or frustrated he gets, he has an unusual capacity for self-reflection. Daddy may like discipline and order, but he's not a man of insecurities or inflated ego. Duvall has given many fine performances, but he's never been better than as Daddy, providing an often larger-than-life character with unforeseen depths. You never know how he's going to react to something, or what inventive rhythms or funny Southern inflections he'll bring to his line readings. Daddy is a 1930s husband who not merely indulges his wife's progressive nature but really listens to her thoughts. He may tease or mock her sometimes, yet it's clear that he has profound respect for her integrity and brains (from

which he knows he can benefit). He also knows that his more skeptical viewpoints provide a healthy balance in their household. Another man might feel henpecked by Mother's strength, but Duvall transmits that Daddy feels lucky to share his life with such an entertaining firebrand. As with Dern and Ladd, Duvall's work is infused with pure, unsentimentalized love that does its share in grounding the movie.

When Rose arrives at the Hillyers, she looks like a worn-out flapper all partied out. Dern, with her tall, slender figure, blond curls, and apologetic charm, is both an attractive young woman and a gangly, fidgety misfit, both an adult and a protracted adolescent. Rose inadvertently has an all-fired crush on Daddy after he calls her "Miss Rosebud" and tells her that she's "graceful as a capital letter *S.*" Enveloped by his rascally charisma, this simple country girl can't quash her feelings. It's amusing that the Hillyer children quickly pick up on Rose's infatuation and eagerly await the moment when she will pounce on their father, perhaps the funniest seduction in movie history. Mother is off at a meeting, and Buddy and his sister observe through a crack in the doorway. Dern is a delight when the helpless Rose, lust building up inside her, leaps onto Daddy's lap, professing her love. As he tries rationally to talk sense to her, she weeps (still on his lap), begging for one kiss. Duvall—why hasn't this mighty actor done more comedy?—takes Daddy's position as a devoted husband on a seesaw ride through the touch-and-go encounter that follows. He grants her request for a single kiss, in the name of putting an end to this, but then he's not quite able to detach himself from her, nor from the resulting titillation that lands them on the window seat. With his hand now on an exposed breast, he forces himself to pull away from this sure thing, annoyed that he let it go so far. The staunchness of his moral victory is in direct response to just how close he came to losing the battle. Dern's unbridled release of aching, palpable yearning and Duvall's hormonal warring make this a singularly funny scene, one that, unexpectedly, brings the characters closer together rather than placing them at a mutually embarrassed distance.

Actually, there is a funnier seduction scene in the movies, and it also happens to be in *Rambling Rose.* (And this one reaches climax.) Pubescent Buddy can't believe his good fortune in having his very own bombshell in his home. Rose, who thinks of Buddy as a child, arrives in his bedroom at night in her nightgown, needing to talk with someone after her failed attempt at loving Daddy. Like a big sister, she crawls into his bed. The beauty of this scene is that the characters are

at cross-purposes: Rose wants only to talk over her situation, while Buddy is trying to figure how to make this his first sexual experience. Rose, already guilty over one near sexual encounter with a Hillyer male (that same day), is no match for Buddy's single-mindedness. Dern and young Lukas Haas (formerly the child in 1985's *Witness*) connect so easily, in part because Dern has placed her Rose so comfortably at a thirteen-year-old level. As she gabs about Daddy's virtues, Buddy asks for certain liberties, satisfactions to his curiosity. Dern is hilarious in her rising shock at his increasingly bold requests, but Rose really can't come up with good enough reasons *not* to let him touch her, and her determination to be moral and adult grows less secure. Somewhere she's sure that this must be wrong, but Buddy's boyish persistence wins out. The scene augments its comic quotient as Buddy's hand, now under the covers and between Rose's legs, brings her to arousal; they're no longer at cross-purposes. As she writhes to orgasm, it's rather touching when a concerned, utterly naïve Buddy asks if she's "sick or something." After Rose rushes off, appalled that she has robbed the cradle, the scene ends with Buddy's smiling face. Rose returns, upset that Buddy might tell his parents what happened and that she will be asked to leave. As she cries and begs him not to tell, Dern is so breakable, exposing just how lost Rose is, how she knows that actions have consequences but can't seem to remember that beforehand. Dern speaks tenderly of how much Rose loves her new life and how desperate she is to hold onto it. Naturally, Buddy keeps their secret, tightening their bond.

Rose, determined to attract Mr. Right, unwittingly gussies herself up into looking like the whore she nearly became back in Alabama, clueless that a skin-tight, boob-bursting dress might be unseemly for a daytime stroll through a small town. Dern's saunter through the streets ranks with the screen walks of Sophia Loren and Jayne Mansfield; feeling beautiful, Rose delights in attracting notice (or, more accurately, commotion), and she flirts unabashedly. She's a sex kitten, all right, but, aglow with romantic fantasy, there's nothing tawdry about her. It may look like a neon-lighted display of availability, but it's a genuine search for love. The scene isn't embarrassing because Dern takes charge of it, owns it, allowing Rose to have her moment. Dern clearly loves this character and never steps out of her to snicker, or invite us to do so.

Rambling Rose is a major film about marriage. The conversations between Mother and Daddy rank among the richest and freshest ever spoken by on-screen spouses. Duvall and Ladd share a bed scene, a

late-night chat, and it may be the most believable depiction yet filmed of how a couple talks to each other when the lights are off. Through the highs and lows of this funny, hurtful, and romantic interaction, it's as though Ladd and Duvall have actually shared a bed for years. As they discuss Rose, and Mother says something metaphysical, Daddy tells her not to "go off into the fourth dimension," which wounds her. The dance of their relationship—the jabs, the laughs, the making up—is brought to life in all its complicated and reassuring wonder, making me feel like a fly on their wall. It's interesting that both characters see the *real* Rose; they just see different aspects of her. Daddy sees a well-meaning daughter who can't be disciplined; Mother sees the loving, victimized figure she will not give up on. The scene includes Duvall singing a few lines of "Beautiful Dreamer" and ends in a lovemaking clinch, a fitting end to a scene of stimulating give and take.

After Rose catches double pneumonia, a lecherous doctor (Kevin Conway) enters the story, representing the brutal forces that gobble up innocents like Rose. After her recovery, Daddy catches Rose (the girl who can't say no) with a sleepover boyfriend. The scene, comic in the moment when Rose is defending her actions while accidentally exposing a breast, becomes a heartbreaker when she tells Daddy that she's not perfect. When Dern simply says, "I am only a human girl person," it's a lovely moment, and as close to self-awareness as Rose ever gets.

Later, Rose needs an operation and the doctor suggests to the Hillyers that this would be an opportunity to perform a hysterectomy on the "neurotic" Rose to control her promiscuous sexual impulses. A mercy, he calls it. (Actually, it's his sexual impulses that can't be controlled, but he chooses to blame the object of his desire for provocation. The scene is a chilling display of male contempt for female sexuality.) The doctor finds a sympathetic listener in Daddy, at the end of his rope with Rose and her boyfriends. When Ladd rises, overflowing with compassion and a lioness' protectiveness, she stops the show with, "Over my dead body." In a scene that should have secured her an Oscar, Ladd challenges the men not just with pointed anger but an overwhelming sadness at having witnessed such casual, careless cruelty. She could have played it in a blast of rage, sounding a powerful single note, but, instead, Ladd's eye-opening heartbreak pulsates through the scene, especially in Mother's life-shaking crisis of faith in her husband. She sits and quietly addresses Daddy, hoping to see that he's still the man she thinks he is. The range and clarity of emotion—as Mother reaches out to him and

he finds his way back to her—make the scene close to miraculous. It's a huge moment in the characters' marriage, and, again, the scene scores its points through impassioned gentleness instead of yells. Duvall makes an astounding, moving transition from thoughtlessness to shame to redemption. When Ladd stands and threatens the doctor—should he dare act on his suggestion—her white-hot conviction is luminous. She says that "the creative power of life itself" has spoken through her, and you believe it. Something divine *is* at work indeed.

You could say that *Rambling Rose* is one of those movies, such as *Tea and Sympathy* (1956) or *Summer of '42* (1971), in which a young man learns about love from an older woman and will thereby be able to have good adult relationships with women. Rose is Buddy's first love, but that aspect of the film is just one of several kinds of loving attachments enacted here. This marvelous movie makes one major misstep, the framing story in which the adult Buddy (John Heard) returns home in 1971. At the beginning of the film, he delivers unnecessary narration, and at the end he drags out the story in a pointless tie-up. These bookends provide nothing worth including, and, considering the warmth of Haas' appealing, quirky performance, Heard's Buddy seems an impostor.

Director Martha Coolidge did a laudable job of getting abundant shadings of character and a variety of story tones (even within scenes) onto the screen. Her affection for her main characters is evident, and she allowed them to reverberate in all their offbeat glory. You can't catch anyone in her cast trying to get a laugh or looking as though they expect one. In both his novel and his screenplay, Calder Willingham offers original characters, some uniquely funny sex scenes, a penetrating portrait of a marriage, an honest look at puberty, and a flawed angel of a title character. The movie is positively European in its open, candid, and humorous look at sexuality. Not only is it an evocative re-creation of the Depression-era South, but it's an ingenious interweaving of comedy and drama. And isn't it refreshing that Willingham never puts Rose and Mother at odds with each other over the Hillyer males? This is true in the book, too, which includes a second attempt by Rose at snaring Daddy.

Johnny E. Jensen's cinematography is pretty, but its old-fashioned glow is sometimes so golden that the movie takes on a yellow haze, not just bathed in sunlight but drowning in it. And Elmer Bernstein's score is a little too slurpy to be poignant. His score for *To Kill a Mockingbird*

(1962), another Southern tale of 1930s family life (featuring Duvall, in his screen debut, as Boo Radley), has the stark beauty and textures lacking in his *Rose* score. *Rambling Rose* received mother-daughter Oscar nominations for lead actress Dern and supporting actress Ladd. Perhaps the Academy's glaring omission of Duvall can be blamed on "Daddy" falling somewhere between a lead and supporting role. Since *Rose,* Dern has given another great performance, as the defiantly drugged-out title character in the "abortion" comedy *Citizen Ruth* (1996), but, in a career that also includes the female lead in *Jurassic Park* (1993) and much-admired turns in *We Don't Live Here Anymore* (2004) and *Inland Empire* (2006), she's long overdue for another comparable opportunity.

Film Availability Guide

Bad Company — available on DVD (but don't confuse it with *two* more recent films with the same title).
Beautiful Thing — available on DVD.
Big Country, The — available on DVD.
Border Incident — available on DVD.
Comanche Station — once available on VHS, but see it letter-boxed on Turner Classic Movies (TCM).
Cover Girl — available on DVD.
Criss Cross — available on DVD.
Devil's Doorway — airs on TCM.
Hail the Conquering Hero — available on DVD.
Half Naked Truth, The — airs on TCM.
Harvey Girls, The — available on DVD.
Hour of the Gun — available on DVD.
I Am a Fugitive from a Chain Gang — available on DVD.
Iron Giant, The — available on DVD.
Isle of the Dead — available on DVD.
It Started with Eve — available on DVD.
Killing, The — available on DVD.
Lady for a Day — available on DVD.
Love Me Tonight — available on DVD.
Lusty Men, The — once available on VHS, also airs on TCM.
Man Who Laughs, The — available on DVD.
One Way Passage — airs on TCM.
Pat and Mike — available on DVD.
Portrait of Jennie — available on DVD.
Pretty Poison — available on DVD.
Rachel and the Stranger — once available on VHS, also airs on TCM.
Raid, The — airs on Fox Movie Channel.

Rambling Rose — available on DVD.

Seven Brides for Seven Brothers — available on DVD.

Seventh Cross, The — once available on VHS, also airs on TCM.

Stars in My Crown — once available on VHS, also airs on TCM.

Student Prince in Old Heidelberg, The — once available on VHS, also airs on TCM.

Tall Target, The — airs on TCM.

They Came to Cordura — available on DVD.

Three Kings — available on DVD.

Time after Time — available on DVD.

Train, The — available on DVD.

Two for the Road — available on DVD.

Tucker: The Man and His Dream — available on DVD.

Umbrellas of Cherbourg, The — available on DVD.

Index

333

Cabaret, 3, 42
Cabinet of Dr. Caligari, The, 176
Cagney, James, 14, 97, 265, 293, 300
Caine, Georgia, 277
Calhern, Louis, 136, 138
Callan, Michael, 227, 229, 233
Camelot, 42
Camille, 135
Can-Can, 42
Canonero, Milena, 320
Canterville Ghost, The, 274
Canyon Passage, 301
Capra, Frank, 107, 251, 260-263, 265, 266, 276, 290
Captain Blood, 133
Carey, Timothy, 79
Carney, Art, 314
Carousel, 11
Carrie, 150, 290
Cars, 203
Casablanca, 18, 89, 181
Cass, Mama, 125, 127-128
Castelnuovo, Nino, 43-48
Cat and the Canary, The, 177
Cat on a Hot Tin Roof, 156
Cat People, 182, 301
Catlett, Walter, 268, 272
Cavalcade, 266
Chakiris, George, 49
Chambers, Shirley, 257
Champion, 183
Champion, Marge and Gower, 34
Chandler, Jeff, 134
Chaney, Lon, 106, 175, 179, 181
Chaplin, Charlie, 251
Charade, 114, 120-121
Charisse, Cyd, 12, 17, 28, 30, 62, 306
Chevalier, Maurice, 5-12, 274
Cheyenne Autumn, 165
Chicago, 3, 266
Children's Hour, The, 114, 122, 150, 187
Ching, William, 286
Christmas Holiday, 273
Christmas in July, 69, 275, 280
Cinderella, 203, 205
Circus, The, 175
Citizen Kane, 77, 182, 315, 318
Citizen Ruth, 329
City Lights, 251
City Streets, 5
Clair, Rene, 69, 201
Clean Break, 81
Cleopatra, 265
Clock, The, 23

Clockwork Orange, A, 75, 197-198, 314
Clooney, George, 244-249
Cockeyed Miracle, The, 259
Cocoanuts, The, 253
Coen, Franklin, 242
Cofer, Damon, 309
Cohn, Art, 74
Colbert, Claudette, 265-267, 275
Collins, Ray, 215-216
Colman, Ronald, 267
Comanche Station, 158-164
Comden, Betty, 32
Come Back, Little Sheba, 237
Come Next Spring, 301
Come to the Stable, 108, 274
Command Decision, 235
Confession, 101
Conlin, Jimmy, 281
Connick, Jr., Harry, 205, 209
Connolly, Walter, 262, 266
Connors, Chuck, 156, 289
Conte, Richard, 229, 231-233
Conversation, The, 315
Converse, Frank, 166-167
Conway, Kevin, 327
Cook, Elisha, 76, 78-79
Coolidge, Martha, 328
Cooper, Gary, 98, 141, 226-234, 317
Coppola, Francis Ford, 315-318, 320
Corey, Wendell, 122
Cornered, 69
Corvette K-225, 158
Costner, Kevin, 165
Cotten, Joseph, 190-195
Cotton Club, The, 315
Court-Martial of Billy Mitchell, The, 233
Cover Girl, 13-21
Crawford, Joan, 20, 78, 91, 107, 117, 135, 149, 225
Crimson Pirate, The, 59
Criss Cross, 53-60, 82
Cronyn, Hume, 217
Crosby, Bing, 13
Crowd Roars, The, 135
Cry of the City, 233
Cukor, George, 98, 251, 283, 285, 288, 290
Cummings, Jack, 34
Cummings, Robert, 218, 268, 270-274
Curse of the Cat People, The, 182
Curtis, Cliff, 248
Curtis, Tony, 55, 58
Curtiz, Michael, 14, 133
Cyrano de Bergerac, 26

About the Author

JOHN DILEO's first book was *And You Thought You Knew Classic Movies* (St. Martin's, 1999), hailed by Pauline Kael as "the smartest movie quiz book I've ever seen." His second book was *100 Great Film Performances You Should Remember—But Probably Don't* (Limelight Editions, 2002), which Adolph Green called "a valuable and touching work." TCM host Robert Osborne said, in the *Hollywood Reporter,* that the book "delightfully throws the spotlight on some remarkable film work," and the *Washington Post*'s reaction was, "Not only is this helpful criticism, but *100 Great Film Performances* can serve as balm for anyone who has ever been disgruntled by the Academy's choices on Oscar night." John has been a contributing book reviewer for the *Washington Post*'s Book World and currently writes DVD and film-book reviews in three monthly columns, appearing in *Milford Magazine* (PA), *Allegany Magazine* (MD), and *Central Voice* (Harrisburg, PA). He frequently hosts classic-film series, appears on radio programs, conducts film-history seminars, and has been an annual participant in the Black Bear Film Festival in the Poconos where he interviewed Farley Granger (2005) and Arlene Dahl (2006) on the festival's stage. His web site is johndileo. com. Born in 1961 in Brooklyn, John was raised on Long Island and graduated from Ithaca College in 1982 with a B.F.A.